THE FACE
OF LIBERTY

Also by James Thomas Flexner:

Doctors on Horseback: Pioneers of American Medicine
America's Old Masters
William Henry Welch and the Heroic Age of American Medicine
 (with Simon Flexner)
Steamboats Come True: American Inventors in Action
First Flowers of Our Wilderness
John Singleton Copley
The Pocket History of American Painting
The Traitor and the Spy
The Light of Distant Skies: American Painting
Treason, 1780 (TV drama)
Gilbert Stuart
Mohawk Baronet: Sir William Johnson of New York
That Wilder Image: The Painting of America's Native School from
 Thomas Cole to Winslow Homer
George Washington: The Forge of Experience, 1732–1775
The World of Winslow Homer (with the editors at *Time*) 1836–1910
George Washington in the American Revolution, 1775–1783
George Washington and the New Nation, 1783–1793
Nineteenth Century American Painting
George Washington: Anguish and Farewell, 1793–1799
Washington: The Indispensable Man

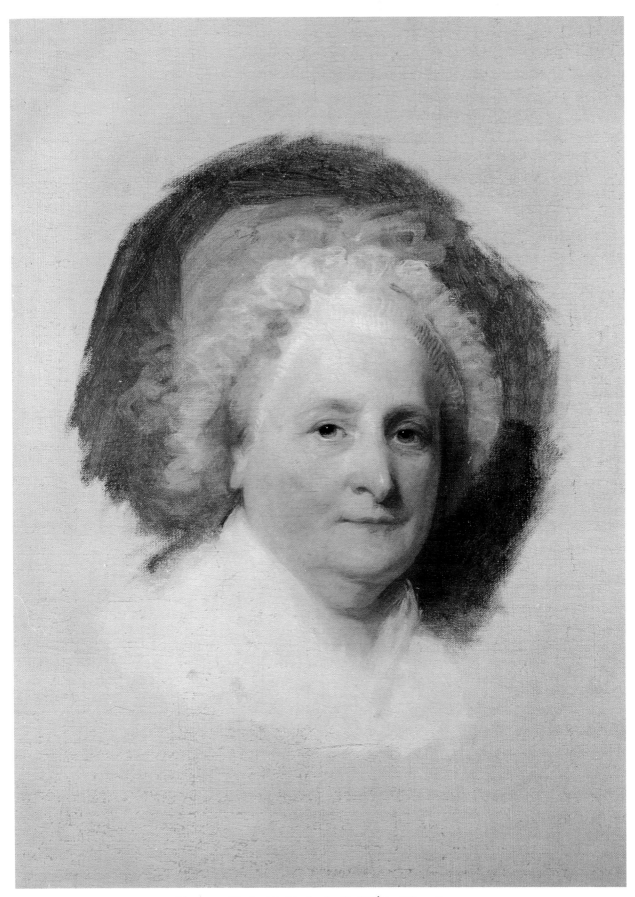

Plate 98. *Martha Washington* (1731-1802) by Gilbert Stuart.
On deposit at the Museum of Fine Arts, Boston. Lent by the Boston Athenaeum.

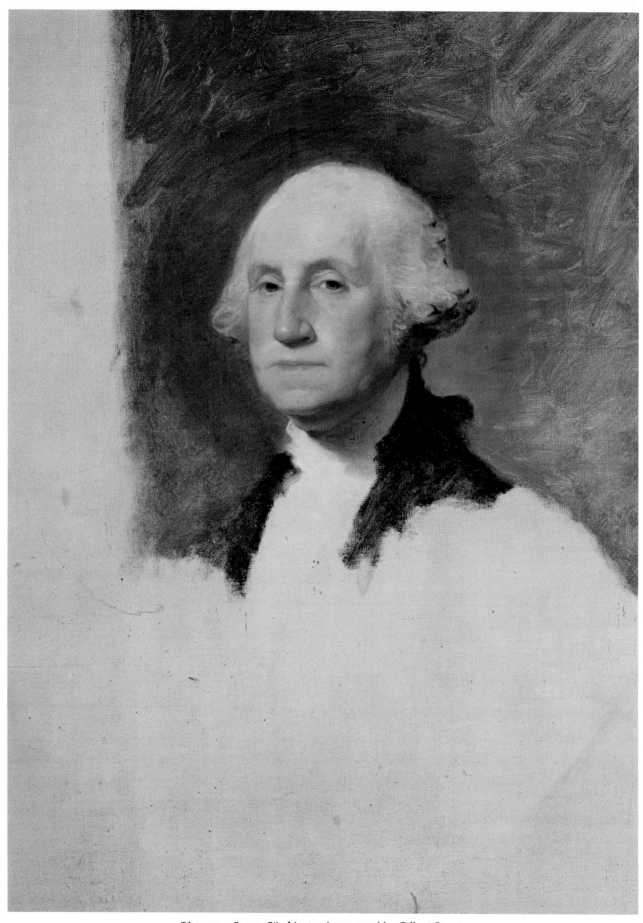

Plate 97. George Washington (1732-1799) by Gilbert Stuart.
On deposit at the Museum of Fine Arts, Boston. Lent by the Boston Athenaeum.

THE FACE
OF LIBERTY
Founders of the United States

BY JAMES THOMAS FLEXNER

Biographies of Sitters and Painters by Linda Bantel Samter

In cooperation with the Amon Carter Museum of Western Art, Fort Worth, Texas

Clarkson N. Potter, Inc./Publisher NEW YORK

DISTRIBUTED BY CROWN PUBLISHERS, INC.

The authors and publishers gratefully acknowledge permission to reprint excerpt from the following works:

Alistair Cooke's America by Alistair Cooke. New York: Alfred A. Knopf, Inc. Copyright © 1973 by Alistair Cooke. Reprinted by permission of Alfred A. Knopf, Inc.

John Brown's Body by Stephen Vincent Benet. New York: Holt, Rinehart and Winston, Inc. Copyright 1927, 1928 by Stephen Vincent Benet. Copyright © renewed 1955, 1956 by Rosemary Carr Benet. Reprinted by permission of Brandt & Brandt.

The Americans: The Colonial Experience by Daniel J. Boorstin. New York: Random House, Inc. Copyright © 1958 by Daniel J. Boorstin. Reprinted by permission of Random House, Inc.

The Ideological Origins of the American Revolution by Bernard Bailyn. Cambridge, Mass.: Harvard University Press. Copyright © 1967 by the President and Fellows of Harvard College. Reprinted by permission.

Printed in the United States of America

Published simultaneously in Canada by General Publishing
Company Limited

Inquiries should be addressed to Clarkson N. Potter, Inc.,
419 Park Avenue South, New York, N.Y. 10016

FIRST EDITION

Designed by Shari de Miskey

Library of Congress Cataloging in Publication Data
Flexner, James Thomas, 1908–
The face of liberty.
Includes a catalog of an art exhibition held at
Amon Carter Museum of Western Art, Fort Worth, Tex.
Bibliography
Includes index.
1. United States—History—Revolution, 1775–1783—
Biography. 2. United States—History—Revolution,
1775–1783—Portraits—Exhibitions. 3. Portraits, Ameri-
can—Exhibitions. 4. Painters—United States—Biography.
I. Samter, Linda Bantel. II. Amon Carter Museum of
Western Art, Fort Worth, Tex. III. Title.
E206.F59 1975 757'.9 75-30662
ISBN 0-517-52491-0

The Museum has been assisted by the National Endowment for the Arts, a federal agency, and the Sid W. Richardson Foundation of Fort Worth in publication of this catalog and the accompanying exhibition.

Contents

List of Illustrations

ILLUSTRATIONS IN COLOR

ILLUSTRATIONS IN BLACK AND WHITE

Preface

The American Revolution, the most successful political/social upheaval of modern history, was the handiwork of able individuals who fortuitously matched a cause with action. While the intervening decades have provided time and opportunity to assess their importance in history, we are ever further from the individual—the personality, the appearance, and the qualities of the man. The years have added to their reputation as revolutionaries, yet it is most unlikely that our heroic patriots saw themselves in any greater role than that of outraged citizens. The American did not come to his decision by any easy route; rather, the wracking uncertainty and choice between loyalty and revolt found men teetering in their choice—a choice which has today assigned them either to immortality or virtual oblivion. Greatness hangs by such a delicate balance.

The times were troubled and judgments tempered by practical as well as emotional factors. In the crisis of decision, simple opinion became forged into resolute conviction; ordinary people were thrust into roles of leadership and action. It was this unique quality, the quick yet elastic response of independent, resolute character, which carried the American cause to success. In a world about to be turned upside down, some catalyst was producing a new likeness—the Face of Liberty.

Thoughtful contemplation of the portraits of the Revolution inevitably prompts observations on the appearance of sitters and the skills of artists. We are at once struck by the strength, the directness, the character of the subject. Common sense tells us that everyone cannot be so visibly endowed with these

virtues, so perhaps we are reading the introspective genius of the artist when we associate these characteristics with the subject of a painting. This is an advantage we enjoy today when we may view the portraits as creations of the artist, apart from the subject, and yet have the measure of our man in the secure knowledge that two hundred years of history has placed him in some permanent niche. Now we may truly appreciate the "startling conjunction of historical and artistic creation" identified by Mr. Flexner.

The American Bicentennial has been the incentive to assemble this selection of paintings and sculpture in an exhibition, "The Face of Liberty." It has been possible only through the generous understanding of the lenders—that the occasion merited truly magnanimous cooperation in permitting these pictures to be shown in the American Southwest. Mr. Flexner's contribution to our understanding of both the historic event and the works of art is fitting commemoration of the occasion.

MITCHELL A. WILDER
Director, Amon Carter Museum of
Western Art, Fort Worth, Texas

The American Man/The American Portrait

1

INTRODUCTION

At the birth of the United States there was a startling conjunction of historical and artistic creation. It is as if the muses had summoned up, to make a visual record of men who were to change the history of the world, a succession of effective portrait painters.

The Revolution was bracketed, so to speak, by two American portraitists of important stature in the world procession of art. As the furies tuned up to war, John Singleton Copley recorded the semblances of the future combatants. During Washington's presidency, Gilbert Stuart painted the military victors and the statesmen who fashioned history's first major and lasting republican government. Neither Copley nor Stuart saw any fighting, but the military camps were haunted by an artist of only slightly lesser skill: Charles Willson Peale. There was, indeed, in America during the Revolutionary years, an explosion of artistic creativity, which is represented in this exhibition by the work of thirty-three American painters.

"What do we mean by the American Revolution?" John Adams wrote Hezekiah Niles in 1818. "Do we mean the American war? The Revolution was in the minds and the hearts of the people: a change in religious sentiments of their duties and obligations. This radical change in the principles, opinions, sentiments, and affections of the people was the real Revolution."

Adams pointed out to Jefferson in 1813 that "before the establishment of the United States, nothing was known to history but the man of the old world,

crowded within limits either small or overcharged, and steeped in the vices which the situation generates. A government adapted to such men would be one thing, but a very different one for the men of these states." Meditating on the contrast between his own and the French Revolution, Adams continued: Americans could "safely and advantageously reserve to themselves a control over public affairs and a degree of freedom which, in the hands of the *canaille* of the cities of Europe, would be instantly perverted to the demolition and destruction of everything public or private. The history of the last twenty-five years in France and of the last forty in America, nay of the last 200 years, proves the truth of both parts of this observation."

The upheaval of 1776 fell far outside the reiterated world pattern. Ours was the only major revolution in the history of the modern world that did not in the end subvert the objects for which it was begun: we had no Cromwell, no Lenin, no Hitler, no Chairman Mao.

The American revolutionaries were not, like those of other lands, propelled over the edge of a political Niagara to drop dizzily into chaos. They did not become so battered, bruised, and wounded that at last the survivors were glad to climb out of the whirlpools into any system that promised stability and control. The Americans did, of course, have to win their independence in a war with invading armies, but as revolutionaries they needed only to push down an already tottering wall, more psychological than physical, which separated them from a flowering garden for which their experience and subconscious reactions had already prepared them.

The American experience had created a new variety of man, and it is that American Man whose physical being is shown in the portraits here discussed and reproduced.

The exhibition at the Amon Carter Museum of Western Art, which is the foundation for this book, is dedicated to supporters of the Revolutionary cause. American Tories who remained loyal to the British crown, British soldiers, or Hessian mercenaries are not included. However, respect is paid to the French alliance by showing likenesses of French officers who fought beside the Americans and of French leaders who supported the emerging United States.

Although the French made a major contribution to the defeat of the British, their experiences and beliefs were in marked contrast with those of their American allies. France had entered the conflict, not because of ideological, but for cold war reasons. Her purpose was to weaken Great Britain. The French Man was in many ways the antithesis of the American Man. Lafayette, that disciple of Washington was, during the early days of the French Revolution, a major leader on the popular side, but because he tried to shape the revolt along American constitutional lines, he was forced to flee for his life. The radical leaders who took power considered this exponent of American republicanism almost as far to the right as the king they executed. Many of the French officers who fought beside the Continental Army ended their careers on the guillotine.

In America, the Revolutionary period extended for a quarter of a century. The actors having been depicted, some in their youth, some in old age, the por-

traits here reproduced from the Amon Carter exhibition exemplify several generations of American creation. The oldest painter, Robert Feke, was born about 1705; the youngest, Asher B. Durand, in 1796. Here, then, is represented the whole span of America's golden age of portraiture. Feke was the first truly accomplished American-born painter. As the roster of our artists comes to a close, the painting of likenesses is sinking from supremacy in American art, giving way to landscape and genre. Durand was soon to abandon the portrait mode to become the most influential of the landscapists in the rising Hudson River School.

In selecting which of our exhibits should be reproduced in color, we have included at least one example of every American painter shown. Containing ninety-nine full-page illustrations, sixty of them in color, this book is the most lavishly illustrated volume yet to appear on American portraiture's golden age.

A project like this is of necessity a centaur, half history and half art. Since no animal or piece of writing can have two heads and no hindquarters, the author of this introductory essay has had to decide which part of the project should lead, which follow. I have opted for seeing the pictures in terms of history rather than the other way around. This is quite possible since, despite the pedantic lucubrations of art-for-art's-sake scholars, the pictures communicate much more than artistic influences and exercises in technique.

The portraiture here discussed was a social art. It was not an individual staring in his mirror or soliloquizing in his diary. It was not an artist amusing or edifying himself with his private interpretation of his neighbors. It was two individuals cooperating on an image of one of them, which would not only be satisfactory to them both but would be accurately communicative, when sent out into the world, of then accepted conceptions concerning human character and the role of the individual in the social structures of the time.

The development of the Revolutionary movement can thus be followed in the works of the portrait painters. We shall here see exemplified, in paint on canvas, how the attitudes of Americans toward themselves changed as they moved down the road to freedom.

The indebtedness of the authors to many individuals and institutions is manifest on the pages of this volume. We wish, however, particularly to thank the Amon Carter Museum of Western Art and its staff, who initiated and supported this project, and without whose activity at every stage in its preparation this book would have been an impossibility. Other institutions that have been, both through their facilities and their staffs, of outstanding assistance are the New-York Historical Society, the Frick Art Reference Library, the Metropolitan Museum of Art, and the National Portrait Gallery.

2
EXPLANATIONS THAT LEAVE A MYSTERY

It is a paradox of present and historical experience that the more deeply motivated a series of events, the less motivated they will seem. If two brothers fall in love with the same girl and fight over her, their subsequent estrangement would seem to require no further explanation. But let us say that, as the brothers live together down the years, a thousand little things of which they were often hardly conscious, rising from day to day, indicate increasingly that their ways of life and thought are becoming inimical. But their relationship goes on, more or less automatically, until one brother behaves in a manner particularly annoying to the other. The other gives way to a sudden rage. He shouts that he will not stand such browbeating: the brothers come to blows and then separate forever. Spectators will try to comprehend the breach in terms of the argument that preceded it, but a haunting feeling will remain that the issues enunciated hardly justify a break so violent.

The American Revolution was, in its physical manifestations, a fratricidal conflict. Down the centuries, it has usually been explained in terms of the political events of the preceding dozen years. There have been English versions and American versions. But again and again there has arisen, often against the will of the historian, a sense, often not expressed: a feeling that pinpricks mysteriously detonated an explosion.

A retelling of the standard English version, with some personal variations, has recently been broadcast across the United States as no other discussion of American history has ever been. The English-born American citizen Alistair

Cooke begins his account of the Revolution with the French and Indian War during which the British army expelled France from the North American continent. This support by the "protector" of the colonies had cost England much money and made British minds conscious that they had allowed their transatlantic dependents to wander around on "a very loose rein." Any claims made by the Americans to existence in their own right do not move Cooke: he sees the various colonies as "trading corporations that gave Britain preferential rights to their crops in exchange for manufactures and supplies." Such subcorporations needed, of course, control from the center. It was reasonable, even if in the upshot a "mistake," for Parliament to make clear that the colonies were "subordinate and dependent." They should be taxed from London to make them pay back what had been spent on the French and Indian War and to support further efforts initiated by Parliament for their welfare. English troops would have to be kept on a more or less permanent basis in the colonies to protect frontiersmen from Indians and any lurking Frenchmen, and London would have to regulate the movement west lest Americans become "spread out too thin for their own safety." No reasonable individual could object to Parliament's taking the necessary organizational and financial steps to carry out the duties placed upon it by sovereignty.

But the Americans were anything but reasonable. The Stamp Act, to which they so loudly objected, was, in fact, Cooke explains, "simplicity itself, something none of us today [would think] twice about, a means of paying the government through the retailer; a revenue stamp such as is stuck . . . on a deck of cards, a bottle of liquor," etc., etc. But merely because the British, satisfied with the profits achieved by regulating and taxing trade, had not previously used their powers to levy an internal tax, the Americans rose in protest. "Dazed by the viciousness of this response," the British withdrew the tax. But they could not abandon the basic principle: their authority to rule their own territory and their expensive duty to see that it was well ruled.

Cooke then describes how British measures and American countermeasures escalated into war. The British acts, hindsight enables him to admit, may not have been altogether politic, but he remains puzzled by the strength of the American response. His best explanations are pettishness and a plot.

On the pettishness front, he comments concerning the Boston Massacre, "As any child knows—as any black child or man knows—it takes only so much continuous taunting to provoke a reaction out of all proportion to the original prod." And concerning the objections of the Virginia planters to the laws that put them at the economic mercy of English factors: "As everybody knows who has ever quarreled with a business partner or started a divorce action, one real grievance sprouts a host of fancies. . . ."

On the plot line, Cooke writes, "A revolutionary chain does not forge itself. It has to be secured by a conspiracy." He sees the Committees of Correspondence as master agitators stirring up a population otherwise contented.

Amusingly enough, the conspiracy theory has recently been getting quite a run among American writers. This explanation for what has a way of seeming inexplicable reflects the advertising aspects of our culture. If one can sell deodorants by persuading people that they and their closets stink, why could not

our ancestors have similarly been sold a Revolution? As they say on TV commercials, "It figures."

Cooke's failure to consider worth mentioning the issue of "taxation without representation" is a true reflection of British eighteenth-century attitudes. The conception that a man could not be taxed unless he could cast his ballot for those who imposed the taxes did not become law in England until more than a century after the American Revolution. Why should the American colonies squeal when the new English industrial cities of Liverpool, Birmingham, and Sheffield had no representatives in Parliament?

As every schoolchild remembers, the issue of "taxation without representation" looms large in the conventional explanations of the Revolution that are promulgated on this side of the Atlantic. Incited by a series of specific British outrages, which can conveniently be memorized by pupils and regurgitated in examinations, the Revolution is put forward as not a positive act by Americans but a defensive one. Had George III not been pigheaded; had his ministers been brighter; had the cards of British politics fallen differently in the years immediately after 1760, the American people would have continued happily as British colonials. In other words, the creation of the United States can be stamped "made in England."

There are other reasons for doubting this than the realization that British exactions were mild in relation to the fracas that resulted. Had the Revolution been made in England it could have been unmade there. Long before the fighting came to an end, the British promulgated peace offers that conceded everything—and more—that the Americans had petitioned for before the fighting started. Why were concessions not eagerly grasped by a people whose land and population was being ravaged by war? Why did not General Washington, who was no fire-eating devotee of bloodshed, but rather a moderate man longing to return to his farmer's contentment at Mount Vernon, lead the Americans back into the British fold? Had that been the popular wish, he would have earned the gratitude of his compatriots and also been able to claim, as his transatlantic reward, a high rank in the British peerage. Why was the disreputable Benedict Arnold, who tried to sell his soldiers for gold, the only influential American officer who was willing to withdraw, as no longer apposite, the Declaration of Independence?

It has, of course, been argued that when blood is up it is difficult to get it down again—fights are hard to stop—but this is another one of those contentions concerning the Revolution which seems, on careful consideration, to be asked to carry much more weight than it actually can bear. It would have been perfectly possible, at any moment during the Revolution, for the people to have deserted those leaders who are pictured as the perpetrators of a radical plot.

If we embrace the theory that the British had set the Revolution spinning by mismanagement of governmental conceptions otherwise acceptable to Americans, we would deduce that, when the Americans set up their own government, they would follow those conceptions with only the mismanagement expunged. As a matter of fact, the government established by the United States severely bent or threw out the window almost every aspect of the British constitution.

And, although the government they created was almost completely new in the history of the world, it suited the mass of the people so well that theirs be-

came one of the stablest governments in the history of the world, suffering no serious upheavals until the Civil War, and still functioning after almost two centuries.

Clearly forces of tremendous power are overlooked in the conventional accounts of why the American Revolution took place.

3

COLONIALS HAVE NO HISTORY

If the reasons that men put forward to explain their deeds could be accepted at face value, how much less complicated the activity in drawing rooms and art galleries and historical arenas would be! The process by which the American Revolution grew has been mightily obfuscated by the participants themselves. On any intellectual plane, the Americans who drifted into war and advanced toward nationhood did not know who they were or foresee what they were about to become. Thus the arguments they put forward in their snowstorm of polemical writings do not represent the forces that were actually propelling them. It was only on an emotional plane that they truly expressed themselves. When cornered in an argument with the experienced rationalist the Rev. Samuel Seabury, the youthful Alexander Hamilton burst out, "The sacred rights of mankind are not to be rummaged for among old parchments and musty records. They are written with a sunbeam on the whole *volume* of human nature, and can never be erased or obscured by any mortal power."

The normal human gap between personal explanation and personal behavior was greatly widened by the situation in which American colonial society had developed. Their own history had shaped the Americans of 1776 to a very unusual degree—few people had lived as much as they, generation after generation, in the midst of unprecedented environmental magnetic fields. However, their past was to them largely unknown.

The types of stresses which had shaped the American Man were considered in the centuries that preceded the Revolution (and until recently) beneath the

notice of Clio, history's muse. Clio has traditionally been concerned with wars, the succession and reigns of rulers, political leadership, and administration. This has automatically raised her eyes from the microcosm of individual living to the macrocosm of state. She has attended at the centers of power. And, although there was much prophetic bickering in American colonial capitals, the centers of power had never been on the western shore of the Atlantic. If the English colonies got embroiled in a war, it was because the king of England had got into a bloody argument with another European monarch. Even frontier warfare with the Indians flooded and ebbed with the foreign policies of the various western European powers that impinged on the North American continent. The economics of agrarian America was primarily a vast patchwork quilt, each piece contiguous to, but largely independent of, the one beside it. Overseas trade was initiated on these shores by a large number of historically anonymous small operators. But the local operations became visible when woven together by European economic forces and mercantile legislation.

Americans of the colonial period did not argue with Clio's lack of concern with their affairs. When, decades ago, I began my researches in the American mid-eighteenth century, I stumbled almost at once on what seemed a strange phenomenon. If you were pursuing a man's pre-Revolutionary career, you would normally find that almost no personal documents had been kept concerning his life. There were only business or legal records. But with the Revolution, the whole situation changed. From then on every kind of memorabilia was preserved: private correspondence, diaries, artifacts. This would not be so remarkable if the individuals concerned had exclusively been important actors in the Revolutionary struggle. The change had taken place across the board. In every walk of life, men and women who had previously been tossing away the records of their existence, were tying up packets of papers with ribbon and squirreling them away in the attic. As creators and citizens of the new United States, Americans developed an interest and pride in their own careers.

It is axiomatic that as long as people adhere to colonial attitudes, they believe that they and their communities have no history worth preserving. It is indeed better to forget, to rub out. This is because the colonial mind of intellectual preference does not seek the new, but rather wishes to reproduce the institutions and the society of the mother country. Deviations, however strongly forced by a different environment, are regarded as provincial mannerisms that will eventually be overcome and should in the meanwhile not be stressed.

Significantly, the greatest burst of writings concerning events in America erupted at the very beginning, when settlement was most intimately linked with England. Voluminous accounts exist of the first two white invasions: habitation in Virginia and Massachusetts. America's most widely published historian in all the years until after the Revolution was John Smith who spent, between 1607 and 1614, only a few years on the continent. His reports on what he experienced were mingled in his own writings with accounts, true or concocted, of his tribulation and triumphs in various other exotic places—Hungary, Transylvania, Russia, and also Turkey, where he claimed that the pasha's wife had fallen in love with

him and rescued him from death even as he later claimed Pocahontas did in Virginia. His extensively printed adventure stories were, like other accounts by the first secular settlers of America, printed in England not to satisfy any particular interest in the new continent, but rather because of a general curiosity about parts of the earth that were being brought into view by increased mobility.

The other determining source of early interest in America was religious. Led by able English dissenters and peopled by their English followers, the settlements in New England were extensions of English religious life. Fellow sectarians in England were anxious to find out how their transatlantic brethren fared.

The books on exploration and religious development, having been written red-hot by Europeans who had not been on the continent long enough to be really influenced thereby, gave some information on the geographical lay of the land and on the Indians as they appeared to white men at first contact, but could communicate little of what the continuing American experience would prove to be. The texts were all published abroad and went soon out of print.

When the American experience really began to dig into the American psyche, interest waned both in England and the settlements themselves. Europe found nothing eye-catching in the procession of unimportant people who straggled across the ocean to behave in a crude manner in a barbarous environment, nor were their emerging political institutions and sometime squabbles with royal power of interest to anyone except minor functionaries in the Colonial Office. And in America, provincialism followed its self-conscious, myopic course.

Most of the publications that purported to summarize American day-to-day life were brought out abroad as real estate tracts aimed at luring land purchasers to cross the ocean. Naturally, the texts played down everything about America that was strange and thus might be frightening. The New World was depicted as differing from the Old only in showering greater abundance. And, in any case, the books had no American circulation, except as imported in new settlers' pockets.

There was, of course, an occasional more informative volume, such as Hugh Jones's *The Present State of Virginia* (London, 1726), the work of an Anglican clergyman who had been in America long enough really to look around, and whose object was accurately to inform the British leaders concerning Virginia and the Virginians, so that the colony and the Anglican Church there would be better ruled. Much studied and cited by modern historians, this little volume came and went in its own day in utter obscurity.

A high percentage of the publications dealing with colonial events, whether printed in England or America, were accounts of Indian wars and Indian captivities. Here was dramatic material to lure cash from a potential reader's pocket! An American housewife, who was adapting herself and her family to American environmental imperatives, was of interest only to herself and the narrow circle in which she moved until some Indian sneaked up through the tall corn, bound her hands and those of her children, and carried them off to his lair. Then if she could survive and get back to civilization, if she was literate herself or could interest a ghost writer, she had something to relate that would be of interest abroad or at home, while the true development of the American psyche ticked on subliminally.

George Winship stated in *The Cambridge History of American Literature* concerning Virginia, "In the days of the gentlemen adventurers, nine men wrote the history of the Colony. In the days of the tobacco growers, a century could not show so many." Virginia had, indeed, only two historians of any importance. While visiting London in 1705, Robert Beverly wrote rapidly and without any sources *A History of Virginia*. The Rev. William Stith, president of the College of William and Mary, started on a more ambitious work. The first volume of his *History of the First Discovery and Settlement of Virginia*, which was published in 1747, only carried the story to 1664. He continued his manuscript, but the first volume sold so badly that the printer refused to bring out another.

Stith was not the only historian silenced by America's indifference to her past. A great collector of documents, the Rev. Thomas Prince, undertook a *Chronological History of New England in the Form of Annals*. The narrative up to 1630 was published in 1736. It roused so little interest that Prince abandoned the project for almost twenty years. He then began a continuation, which he hoped to sell in parts for sixpence each. After three parts had failed to sell, he abandoned his history.

Today's studies of American history are inclined to overlook a phenomenon which is extremely important in defining the attitudes of our Revolutionary forefathers. The same colonial shyness that kept the forefathers from keeping the records of their lives prevented the publication of what records were kept, what historical facts compiled. It is not noticed that almost everything we rely on to comprehend the colonial period was not available in that period itself. This phenomenon even extends to the two most basic sources on the first settlement of Massachusetts, as they were written by the leaders of the two major thrusts: William Bradford's *History of the Plymouth Plantation* was first published in 1856; and John Winthrop's *Journal* was, although excerpted by Prince and others, not considered worth printing in its own right until 1790.

Modern students seek an intimate vision of American colonial life in the diaries kept by travelers. Almost all the diaries we relish were published after the Revolution. To take three examples: Madam Sarah Knight's account of the trip she took during 1704 from New England to New York became available during 1825; William Byrd's famous *The History of the Dividing Line* (an account of running the line between Virginia and North Carolina in 1728) was, with others of his important writings, first printed in 1841; Dr. Alexander Hamilton's account of his trip from Annapolis to Portsmouth, New Hampshire, in 1744 saw the light in 1907.

It is much less of a paradox than it seems on the surface that the American political histories which appeared on the eve of the American Revolution were not by revolutionaries. Samuel Smith, author of *History of New Jersey* (1767), was a Quaker and thus by religion one of those noncombatants who were considered by most patriots to be at heart Tories. Thomas Hutchinson, whose three volume *History of the Colony of Massachusetts Bay* was published between 1764 and 1828 was, as the American-born lieutenant governor of Massachusetts, perhaps the most conspicuous of all American Tories. And William Smith, author of *History of New York* (1757), was to serve the British occupation force in New

York City as chief justice. This triple phenomenon indicates that, at the eve of the Revolution, the record of America's political past was considered more usable by the Loyalists than by the protesters.

Supposing an incipient American Revolutionary, feeling strangeness in his blood and sensing a matching strangeness in his neighbors', had determined to seek for causes in American experience. How could he have penetrated further back than the memories of aged people or cast his intellectual net any distance over the huge area of settlement? The answer is that neither was possible. Even if he was fortunate enough to have access to one of the very few good colonial libraries, he would have found practically nothing on the shelves to enlighten him.

4

WHAT THE PAMPHLETEERS WROTE

How immune the American Revolutionary propagandists were to examining their situation in terms of their own experience is demonstrated by the justification universally given for one of their favorite contentions. Jefferson stated this contention in the Declaration of Independence when he argued that governments, having been "instituted among Men" to secure their "unalienable Rights" derived "their just powers from the consent of the governed."

In almost all revolutionary writings this denial of the divine right of kings was based on an historical fable. Here is how it was recounted, for the thousandth time, in the most influential pamphlet of all, Thomas Paine's *Common Sense*: "In order to gain a clear and just idea of the design and end of government, let us suppose a small number of persons settled in some sequestered part of the earth, unconnected with the rest. They will then represent the first peopling of any country, or the world. In this state of natural liberty, society will be their first thought." They will need neighbors to break their solitude, to help them meet rigors and dangers. "This necessity, like a gravitating power, would soon form our newly arrived immigrants into a society." Government would be unnecessary "while they remained perfectly just to each other." But, since perfect justice existed only in heaven, they would be led to establish "some form of government to supply the defect of moral virtue. Some convenient tree will afford a state house, under the branches of which the whole colony may assemble to deliberate on public matters." As the colony increases in population, power will have to be delegated to representatives, but the source and object of the govern-

ment will (unless perverted by kings) not be changed: it will be a compact of the people to promote their own happiness.

A development in essence the same as that described in such passages had worked itself out again and again down more than two centuries on the extensive American continent, where community building was always the basic activity of the people. Most revolutionary pamphleteers did not refer to this fact, and the few who did merely mentioned it as a local corroboration of a principle elsewhere established. If American writers wished to give their theoretical reasoning a specific historical base, they followed English political theorists into a mythical description of what could be assumed to have happened when, under the dim skies of prehistory, the first Saxon settlers landed in Britain.

Amusingly enough, it was the Tory writers who contended that the American past had been determining: The revolutionaries were stupid yokels harboring untenable ideas because they had been debased by the rude American environment. From this charge, patriot writers felt it necessary to defend themselves. They insisted that there was nothing of American origin in what they believed and demanded. They were on the contrary demonstrating that in their semi-isolation they had remained, after the fountains of the Old World had become polluted and defiled by modern heresies, a pure font of mankind's older glories. One of the most celebrated passages in *Common Sense* shouted, "Freedom has long been hunted round the globe. Asia and Africa have long expelled her. Europe regards her like a stranger and England hath given her warning to depart. O! receive the fugitive and prepare in time an asylum for mankind." Paine, of course, knew nothing about the history of Asia or Africa, but he did know how to put forward in a telling manner a philosophical contention.

The need to visualize virtue not in the future but in the past was a European import. Looking back down the perspective of the years, we today see the American Revolution taking place at a time when the waters of history were flowing with increasing speed from classicism to romanticism. Classicism wished to revive golden ages mankind was assumed to have lost; romanticism saw "progress" leading to ever greater consummations. We now recognize that the Revolution was a riptide sweeping Western man toward new horizons. But whatever tingling they felt in their blood, the Americans could not, without demonstrating themselves hopelessly naïve in sophisticated eyes, claim that their path was rising through unexplored territory to unknown yet glorious heights. They had to find precedents for everything they felt and put forward.

In citing as precedents matters about which they knew little, Americans not uncommonly took advantage of their ignorance by fashioning whatever they talked about into a symbol that snugly fitted their present concerns. Thus in the early nineteenth century, when no works by major Italian painters had reached North America, writers on art, who had never even entered a European gallery, used the names of various artists as verbal counters. "Raphael" meant draftsmanship and intellectual values; "Michelangelo" stood for power; "Correggio" for sensuality and chiaroscuro; "Titian" for color. William Page (1811–1885), who had never seen a Titian, was dubbed by Boston critics equally ill informed "The American Titian." How strong such a conviction could be was demonstrated

when Page finally got to Italy and was faced with actual Titians which his work hardly resembled. Seeing only what he wanted to see, he felt confirmed in his own personal style.

Another example of the same phenomenon was an aspect of the career of the pioneer American genre painter, William Sidney Mount (1807–1868). Mount, who admired the reputation of Rembrandt, was a spiritualist. What was more natural than for him to receive from Rembrandt's ghost advice on how to paint which exactly described Mount's own practice!

Bernard Bailyn's brilliant book *The Ideological Origins of the American Revolution* (Cambridge, Mass., 1967) reveals how this approach manifested itself in the innumerable pamphlets written to justify the protests of the colonials against British rule.

Most copiously, American propagandists kidnapped great names from classical antiquity. To be a sophisticated eighteenth-century gentleman was to be able to toss around classical references, and, not to be outdone in this arena, the colonial polemicists threw them around with such profusion that an occasional pamphlet had more footnotes than text.

Insofar as they concerned themselves with actual ancient history, the polemicists referred to Roman developments from the first century before Christ to the establishment of the empire on the ruins of the republic three centuries later. They got their information from such writers as Plutarch, Livy, Cicero, Sallust, and Tacitus, men who lived when the republic was on its way out and looked back nostalgically to vanished times which they described as characterized by simplicity, nobility, and patriotism. But the pamphleteers did not confine themselves to this relatively safe area. They could not resist using to conjure with any name that occurred to them, even putting forward Plato as a champion of civil liberties.

Draped in imaginary togas, Americans did not have to face up to the strangeness of the clothes they really wore. The classics, Bailyn writes, were "everywhere illustrative not determinative of thought."

Bailyn reached the same conclusion in relation to the writers of the seventeenth and eighteenth-century "enlightenment." Voltaire, Rousseau, Beccaria, Montesquieu, Grotius, Pufendorf, and so on, were mentioned by the Americans with enthusiasm as "the theorists of universal reason." Only Locke, Bailyn states, was truly influential, and many a writer cited even this well-known authority "in the most offhand way, as if he could be relied on to support anything the writers happened to be arguing."

Another body of precedent perpetually referred to was English common law, particularly as expounded by the seventeenth-century jurists Coke and Blackstone. Legal principles were, Bailyn reports, "manifestly influential in shaping the awareness of the Revolutionary generation." But the Americans, without any sense that they were violating precedent, drew from the principles their own conclusions.

In Bailyn's view, the greatest outside influence on American pre-Revolutionary thought was exerted by the political and social ideas of the English Civil War and Commonwealth. These were consumed not in their original form but

as reformulated by radical writers at the turn of the eighteenth century and thereafter. From this source, the Americans conned their conception of natural rights; of government not coming down from on high but as a contract initiated by the people for their own happiness; and of the glories of the English constitution in its uncorrupted form.

The gloss of history preached by the English radicals and endlessly repeated by American polemicists was that an ideal constitution, based on the elected assemblies of Saxon England, had been destroyed by the Norman conquest but had been regained with modifications as the result of a perpetual struggle which had culminated in the Glorious Revolution of 1688. But since then the British constitution had become again endangered.

The radicals who praised the simple virtue of a simple yeomanry and feared power in the hands of those who lusted for it; who saw in the expenditures and dissipation of England's political leaders the very forces that had destroyed the Roman Republic and then Rome herself, these writers were in England a small minority crying havoc into the deaf ears of a prosperous nation. But as soon as their publications crossed the ocean in square-riggers, Americans lapped them up. The obscure English pamphlets were excerpted in newspapers, reprinted entire. Americans could read in any one of three locally printed editions James Burgh's *Britain's Remembrancer: or The Danger Not Over* (London, 1746). How Americans relished the statement that the English people were wallowing in "luxury and irreligion . . . venality, perjury, faction, opposition to legal authority, idleness, gluttony, drunkenness, lewdness, excessive gaming, robberies, clandestine marriages, breach of matrimonial vows, self murders . . . a legion of furies sufficient to rend any state or empire!"

Although many Americans, undoubtedly dreaming of enervating luxuries, stirred in bed beside their work-hardened wives as they envisioned luscious nymphs awaiting them lying idle, naked, and amorous between the tall tassels of frontier corn, the fact was that even in the cities Americans, harnessed as they were to practical necessities, lived what would have seemed to European gentlemen dull and workaday lives. It was natural for Americans to envision their society as pure compared to the corruptions of the old world. But they rarely contended that this freshness gave them new insights.

Advanced spirits like John Adams, who saw America creating a new and brighter dawn for mankind, were a small minority compared to those Americans who described themselves as conservatives desiring to restore to the world, and England in particular, what had once been possessed and was now lost. They were a reincarnation of older, purer, English generations. They were the champions of the authentic British constitution laboring, for the advantage of Englishmen on both sides of the ocean, to reestablish previous freedoms. As Bailyn points out, Americans protested, even after the bloodshed at Lexington and Bunker Hill, "before God and the world that the utmost of [our] wish is that things may return to their old channel."

The revolutionary situation was helped along by a significant change in the British monarchy. The first two Georges were German born, not altogether at home with the English language, and more concerned with their original Duchy

of Hanover and the fatness of their German mistresses than with exerting power over England. But George III was English born, energetic, and extremely moral in his personal life. He viewed, with the same horror as the radicals, the luxury, vice, and intrigues of the great families who had seized power during the previous reigns. But his solution was not that of the radicals: he had no interest in returning leadership to the rural gentry. He decided to clean things up himself, and as a means toward this end used the perquisites of the crown to seek personal control of Parliament.

This elicited from statesmen of the old regime, including Burke and Pitt, the cry that an effort was being made to undermine for all time the foundations of British liberty. England was not seriously alarmed. However, what was on its native heath a worry sometimes bothersome and a partisan political contention of the opposition became in the minds of Americans an immediate hazard that seemed as tangible as a drought withering crops within view of the farmhouse window. The Americans believed that they were slated to be the first victims of a deep-seated conspiracy against the traditional freedom of Englishmen. American patriots became, indeed, like the heroine of some Gothic melodrama who is persuaded that her husband is trying to murder her. Under this suspicion, what would be under ordinary circumstances incivilities and annoying aggressions took on the most sinister aura. The Stamp Act and the various clumsy British maneuvers that followed were regarded as only the very beginning, like the first strange-tasting sip that was the start toward a lethal dose of poison.

In explaining his personal road to revolt, Washington stated that he had been at first "unsuspicious of design and then unwilling to enter into disputes with the mother country." But he was left no choice after he had become convinced that America was being subjected to "a regular plan at the expense of law and justice to overthrow our constitutional rights and liberties."

The mother country was so unmoved by the claim of her colonials to be nobly protecting her against a tyrannical plot of her own leaders that the use of force to put the rebels down elicited no effective opposition in Parliament, and the American war was, until clearly lost, popular with the English people. Latter-day historians, who have secured access to even the intimate records of British political leaders, have found there political maneuvering, with its concomitant of more influence for some and less for others; have found efforts of Parliament to claim in relation to America powers that under the British constitution it was their right (and thus their duty) to exert; but have found no evidence of a significant conspiracy against either British or American liberties. Why did Americans believe so strongly in a plot that did not exist that the presumed threat impelled them to fight a fratricidal war and break away into a new nation?

5

EVOLVING MEN IN A NEW LAND

"It would be as difficult," John Adams wrote, "to say at what moment the Revolution began, and what incident set it in motion, as to fix the moment when an embryo becomes an animal."

To carry Adams's metaphor far beyond what he intended, it could be said that the revolution began as tens of thousands of embryos grew in the wombs of mothers scattered across western Europe, but mostly on the British isles. Lower class or lower middle class mothers. The babies they finally bore looked surely like other infants, yet each carried in his brain, more than others, the seeds of adventure, ambition, dissatisfaction with his or her lot.

Such babies had, of course, been born in random beds for centuries. But within the highly structured society of Europe there was very little that the individuals so born could do to express in their worldly lot their eagerness and wildness. The divisions between classes were so many impediments—like the walls and barbed-wire entanglements of modern police states—to keep people from moving from where they were to where those in control considered that they did not belong. A very few did manage to escape, but the vast majority could find no openings. The individual who had been imbued with powers beyond his station died, metaphorically and often physically, in the very bed where he had been born.

If we assume (for there can be no proof beyond general observation of human behavior) that men and women endowed with unusual energy and courage tend to mate together, we can reason that within the lower classes of Europe a

special race developed, a continuing trial to magistrates and to parsons, but inconspicuous on the larger scene, unconscious of each other's existence, each awaiting in his own narrow world an outlet. Century after century, they were born and died and reincarnated, until news filtered across the Old World countryside that hinted at escape. There existed a New World, not beyond the ultimate possibility of being reached, a place where men and women could shape their own destiny.

This news struck different people, even within the same family, differently. Everyone was, of course, excited by the stories, curious, but only in very particular brains did the intelligence spark a note of personal hope. To transfer that hope into action required much more originality of mind than can easily be appreciated in today's world where mobility is so basic a condition of life. In those days the next township was for poor people almost a foreign land. To be separated from your local roots, from the ancestral occupation that had descended to you, meant becoming a vagrant, one of the disinherited of the earth. And the new call was to travel, when ten was a considerable distance, thousands of miles to what might almost be a new planet.

Governor Bradford wrote of the arrival of the Pilgrims at what became Plymouth Plantation:

> Being thus passed the vast ocean and a sea of troubles before in their preparation . . . they had now no friends to welcome them, nor inns to entertain and refresh their weatherbeaten bodies, no houses or much less town to repair to, to seek for succour. It is recorded in scripture as a mercy to the apostle and the shipwrecked company that the barbarians showed them no small kindness in refreshing them, but these savage barbarians, when they met with them (as after will appear) were readier to fill their sides with arrows than otherwise. And for the season it was winter, and they that know the winters of that country know them to be sharp and violent, and subject to cruel and fierce storms, dangerous to travel to known places, much more to search an unknown coast. Besides, what could they see but a hideous and desolate wilderness, full of wild beasts and wild men, and what multitudes there might be of them they knew not. Nor could they, as it were, go up to the top of Pisgah to view from this wilderness a more goodly country to feed their hopes, for which way soever they turned their eyes (save upward to the heavens) they could have little solace or content in respect to outward objects. For summer being done, all things stand upon them with weatherbeaten faces; and the whole country full of woods and thickets represented a wild and savage view. If they looked behind them, there was the mighty ocean which they had passed, and was now a main bar and gulf to separate them from all civil parts of the world.

Obviously, many who arrived later than the first settlement Bradford so eloquently described faced prospects much less desperate—people, for instance, who joined brothers or cousins in established cities where no war whoop sounded. But many later immigrants stood up to rigors more terrifying even than those incurred by the Pilgrims. The settlers of Plymouth came not as individuals

but as members of a sustaining group, and they were inspired by faith that they were a chosen people guarded by God. How much more desperate the plight of poor men—and, even more, young women in a male-dominated world—who in order to pay their passage across the ocean bound themselves for a term of years —usually three to five—to sea captains who would, upon arrival at an American port, sell their services to whatever buyer would pay the most. Many of these "indentured servants," their terms eventually lived through, set out on their own into the howling wilderness to become the progenitors of great American families.

In the nineteenth century, it was the pattern of immigration that the new arrivals joined the proletariat in cities. During the colonial period there were few cities and no proletariat. The new arrivals, who had not dared and suffered so extremely only to sink again into servility, preferred to avoid working for anyone else. They moved rapidly to the frontier. In the generation before the Revolution, the two major waves had been the Germans and the Scotch-Irish. The Germans, like the Pilgrims and Puritans before them, came over primarily as religious groups. They settled like swarms of hiving bees in eastern Pennsylvania. The Scotch-Irish spread in loneliness along the western frontier from northern New York to Georgia.

Making the journey to America was, during those static times, in itself a revolutionary act, but the settlers were rarely revolutionary in any intellectual sense. The most radical immigrants arrived as groups of sectarians who were in opposition to established church law. These, however, were a small minority. The great majority came to America individually or in families, their objective being not to reorganize anything, but merely to break the straitjackets in which they were personally confined. What they wanted to shift was not the structure of society, but their own position in that structure. Any violent shattering of institutions would remove from their possible grasp the very objectives which, in their upward mobility, they sought.

That the settlers brought to America European dreams did not preclude the more basic fact that there lurked in every breast that had made the adventurous crossing an eagerness, a hidden openness to further and wilder change. The American environment had from the first ductile minds on which to work its magic.

The new continent's most basic upsetter of old ideas was space, with its concomitant emptiness, complete or relative. The Old World from which the settlers had come was always cramped, every inch of usable land preempted by somebody for something, massed bodies above and ancestral bones beneath. Now there were boundless reaches where a man could, for little more than desiring, daring, laboring, possess land that would in Europe have been the immemorial possession of an entire village.

For Americans, space became a mental conception in addition to a physical fact. This was demonstrated years later, after the eastern part of the nation was long settled, when the United States developed a landscape school of its own. Although the American land included such secluded gardens, such misty pools and narrow flowered fields as the Barbizon School was then painting in France, the Hudson River School artists felt called upon to stand on a hillside from

which they could depict a panoramic view. And even when homegrown American painters did direct their vision to restricted crannies in the land, they communicated, in the intangible language of visual art, that this was a close-up extracted from a larger whole.

Concerning Thomas Cole's pioneering depictions of the American land, the poet William Cullen Bryant remembered "the delight expressed at the opportunity of contemplating pictures which carried the eye over scenes of wild grandeur particular to our country, over our aerial mountain tops with their mighty growth of forest never touched by the axe, along the banks of streams never deformed by culture, and into the depths of skies bright with the hues of our own climate, skies such as few but Cole could ever paint, and through the transparent abysses of which you might send an arrow out of sight." (Fig. 1)

That in early America improvisation and self-education were more the norm than study and tradition is a recognized aspect of our national background, but few acknowledge to what extreme and extent this situation prevailed. Perhaps some subconscious shame among moderns at having pushed so far to one side the conception of independent thought makes historians resist the abounding evidence. It seems to academics an obscenity, not to be mentioned, that during the generation of great leaders who fostered the Revolution and created the nation, all the American colleges together graduated annually only about eighty men. (George Washington had little formal education beyond what we would today consider the eighth grade.) The word *autodidacticism* has been exhumed from dictionaries to give some gloss of respectable pedantry to the raw and shocking phenomenon of self-education.

Finding proof that a particular book was in one library somewhere on the vast continent occasions a sigh of relief. It can then be stated that the works of that author were known in Colonial America. From that the conclusion is happily drawn that he had a great influence on American thought.

There can be no doubt that the colonials did not will to go off on their own. What happened has never been more eloquently put than by Stephen Vincent Benét in the "Invocation" to America with which he opened *John Brown's Body*:

> *They tried to fit you with an English song*
> *And clip your speech into the English tale.*
> *But even from the first, the words went wrong,*
> *The catbird pecked away the nightingale.*
> *And homesick men begot high-cheekboned things*
> *And wit was whittled with a different sound*
> *And Thames and all the rivers of the kings*
> *Ran into the Mississippi and were drowned.*
>
> *They planted England with a stubborn thrust*
> *But the cleft dust was never English dust.*

On the frontier, European knowledge was almost useless. So General Braddock discovered when his two expertly trained British regiments were decimated

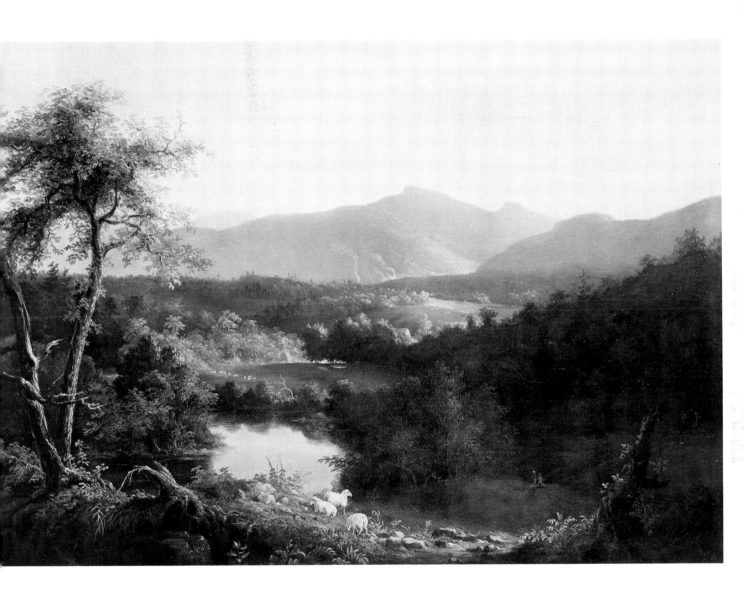

Fig. 1. Thomas Cole. *View near Catskill Village*. Oil on wood panel, 24-1/2″ x 35″. 1827. Private collection. Courtesy, Kennedy Galleries, Inc., New York.

by a few Indians. In England, wood was so scarce that scavengers picked up for sale every fallen stick. What was a recently arrived Englishman to make of a world where trees rose so high that their interwoven branches threw on the ground twilight at midday, and yet these trees were weeds to be extirpated by any means that a man eager to grow crops could devise? The usual method was to bleed the forest to death by "girdling," cutting from each tree a complete circle of bark.

Although the frontier is enshrined in American legend, it passed quickly across the land. It started wherever the first settler's foot waded ashore and it advanced ever westward, often carrying its denizens along. The true frontiersman was a misfit who was made uneasy by finding civilization clotting around him. The pioneer's legacy was an extreme of individualism which underlay every community that grew up in America.

American institutions began with the second wave. This was when settlement became, like a blowing seed that has finally taken root, moored to the ground. Now it was only a question of time and circumstance to what extent the settlement would grow—it could remain a village or become a great city—but the process of growth was in its essence consistent, like the passage up from an acorn into a scrub oak or onward to a forest giant. In American communities, there were always efforts to create the traditional and always warping forces.

The Virginians, for instance, seemed in an ideal situation for re-creating the life of English country gentlemen, so much so indeed that many a romance and history book tells us that this is exactly what they did. They certainly tried and they often fooled themselves into believing that they had indeed succeeded. Yet everything came out wrong.

The English landed estate was manned by proprietor, steward, and tenant. The stewards and the tenants belonged to hereditary classes with pride in their work and knowledge of their duties. The Virginia estate housed proprietor, overseer, and slave. The overseers were usually stupid and brutal men who lacked the git-up-and-git to take advantage of American opportunities by establishing farms on their own. The laborers were forcibly imported slaves who were permitted no fruitful contact with American life, allowed no excuse for being proud of their work. The English proprietor could spend most of his time in London and become a true sophisticate, confident that his estate would run smoothly without him. As George Washington observed, a successful Virginia planter had to be forever on the spot, tending to his affairs.

The management of a Virginia estate was infinitely more complicated than that of an English one. The Virginian was his own master farmer, his own gardener, his own manager of livestock and timber. His wife supervised the preservation of meats—Martha Washington was so proud of her hams that her husband sent some across the ocean to Lafayette—and managed a small clothing factory on the estate. The proprietor was his own surveyor and except in extreme situations his own lawyer. He and his wife doctored, unless illness threatened to be mortal, the inhabitants of the estate. The economy forced the proprietor to be a land speculator, not only because so much was to be gained from possessing land in the path of settlement but because the standard tobacco crop exhausted the soil, forcing the opening of new fields.

The Virginian needed also to be a merchant since, apart from what was grown to feed himself and his dependents, he raised a cash crop that had to be sent abroad for sale. Daniel Boorstin writes in his *The Americans: The Colonial Experience* (New York, 1958) that a Virginia plantation was less like an English rural village than a company town. He adds, "The plantation system, exemplified in the West Indies and Virginia, was, according to some historians, the first great experiment in large-scale commercial agriculture since the Roman Empire." If a Virginian, dreaming of himself as a British country gentleman, tried to act like one, his American environment punished him with bankruptcy.

Like their English counterparts, the Virginia proprietors were concerned with government. Since democracy was less rife in their colony than in New England, their method of achieving office was similar to that in old England—the

great proprietors did little more than stand for office, treating the voters to drinks on election day. Yet the Virginian legislators shared many problems with legislators in all the other twelve colonies, however differently these may have been elected—even with the egalitarian choices of New England town meetings.

In the widely separated statehouses, so isolated from each other that rumors of proceedings rarely moved between them, the legislators all insisted that they were operating under that "best of constitutions," the British. But in fact, the British constitution hardly fitted their situation at all.

As set up after the Glorious Revolution of 1688, that "mixed" constitution was based on having three separate orders of society balance each other. The Crown was the executive and symbol of state. The House of Lords stood for the aristocracy, envisioned as leaders across the nation who had no axes to grind and were therefore able to decide impartially what was best. The Commons spoke for the people and were supposed to check the other two "estates" if their own rights and needs were ignored. In every colony, an effort was made to set up a similar structure.

The Crown represented itself in America in a double form, one unreachable and austere, the other close by and despicable. All important colonial laws had to be approved in England; many were vetoed by hands invisible to the sharpest American eye. On the American continent, the crown was represented by governors, appointed from abroad, one for each colony. But, months of sailing away from your friends and relations and pleasures, to preside over barbarians in some colonial capital did not appeal to upper-class Englishmen. The governors were likely to be scapegrace dependents whose important families had wished to get them out of the way while at the same time giving them a means to pay their debts. Usually, the governors were both rapacious and incompetent, more eager to extract cash than supply benign authority. Fighting governors from overseas became as much an American characteristic as cutting down trees.

The imported bureaucracy was rarely supplemented by any other members of the British ruling class who could inspire respect. Anglo-American legend hates to face this situation. Thus, that powerful nobleman Lord Fairfax, who owned much of Virginia, actually moved there, and befriended a neighboring boy called George Washington, is depicted as a paragon of English culture, who had contributed to the *Spectator* and made Washington's career possible by bringing him the best Britannia had to offer. Actually, Lord Fairfax was a crude eccentric who had been unable to get on in polite English society. He had three passions: the offhand exertion of power over all those under his control, a love of fox hunting, and a hatred of women. His idea of an agreeable gesture was to bring his hounds to a party of ladies and then release a fox from a bag so that, without exertion, they could be in at a kill.

The lack of able English civilians who had ever set foot in the colonies weakened transatlantic ties on both sides of the ocean. When the American Revolution was fermenting, there was no one in or near the centers of power in London, except for a few myopic soldiers left over from the French and Indian War, who had any American experience whatsoever. The English leaders were so uninformed that they were incapable of realizing their ignorance. No Royal Commission was sent across the ocean in an effort to fathom why the colonials

were behaving in what seemed so crazy a manner. And, for their part, the Americans had been vouchsafed nothing visible on their shores to encourage their inherited loyalty to the Crown.

The second "estate" in the British constitution, the aristocracy, did not exist in America. Those native equivalents of the House of Lords, the governors' councils, were in some colonies appointed by the governor, in others elected by the lower house. In either case they were, because no other Americans were available, made up of the type of men who made up the Commons: richer perhaps, of older families, but with the same economic and social interests as plain citizens on the rise.

Here was a profound novelty. Everywhere in Europe there was an hereditary upper class, the custodian not only of money and power, but also of polite manners and artistic taste. In America, society was, in effect, decapitated. We had no true upper class. Our richest and most impressive citizens would in the Old World have been looked down on as members of the upper bourgeoisie. Dozens of our largest "mansions" could have found room within the walls of a single English stately home. No American male was granted the boon (or curse) of leisure. Furthermore, there was nothing static about American family position. As Boorstin points out, what upper class the colonies had was made up in essence of families who had been here longer and thus had more time to establish themselves. But every day that newcomers stayed in America their tenure increased.

Commoners existed in quantity in America. There was no lack of men suited for the lower houses in the various colonial legislatures. But on the question of how they should be chosen there was from the start a conflict with English practice.

Behind the British "mixed" constitution lay the theory that each of the three estates was monolithic. There was a single king and he would be succeeded by his heir without any change in the nature of royal power. In the House of Lords, the sons would fill in imperceptibly for their fathers. In the Commons, indirect representation was, of course, necessary. However, since that body spoke for the common people not as individuals but as a class, all ordinary citizens would be represented even if only a few had the vote. This is very much the theory behind the contemporary method of rating television shows: a few viewers, who are supposed to carry in their own persons the preferences of all Americans, determine what is broadcast over the publicly owned airwaves. It was just as reasonable for the inhabitants of large areas of England to have no vote as for you and me never to be consulted on what enters everybody's television tubes.

The theory of token representation assumes an accurate sample. If the Americans had been (as during the high colonial period they considered themselves) ordinary Englishmen, they would have been, according to the conceptions of the British constitution, represented in Parliament. But as they were to be taught by events, they were not represented at all.

However much he might talk about the glories of the British constitution, the American who had made his own way in the world did not really think of himself as one small, identical part of an inclusive social "estate." How could

anyone dare to contend that the farmer in the next valley, who was so unsound on the right method for sowing wheat, might speak for him? He wished to speak for himself. Property qualifications for the franchise were then so common that they existed throughout America during the colonial period, but every voter who was considered qualified had an equal vote. Almost a century was to pass before the conception that every qualified person should have an equal vote was incorporated into the British constitution.

How far Americans had leaped ahead in their personal psyches is revealed by what happened when, having declared and then achieved independence, they had to find a government for themselves. Although every important nation was then ruled by a king, whether America should have a king was not (except among a few despairing men at the lowest point of war) even a matter for speculation. America had had enough of kings. The most radical of conceptions came to Americans altogether naturally: the chief executive should be elected by the people.

There was also no question of establishing some hereditary body like the House of Lords. A nation made up largely of self-made men had, despite the ambitions of a few social leaders, an antipathy to hereditary distinctions. (Washington expressed amused unconcern about his ancestry.) Every member of the government should either be elected or appointed by an elected body. And the federal Constitution flew against all precedent by setting up no property qualifications for the franchise.

Every year during the colonial period the Americans, although neither eagerly nor consciously, were becoming less like Englishmen. Change was the new continent's most universal crop. There was, for instance, a perpetual and historically amazing mixture of peoples who had previously been rooted in different areas—often different nations—where various skills and customs had prevailed. Ideas that had never before come in contact were jostled together in a place and time where new solutions were categorically demanded by a new environment.

Farmers dealing with the rocky fields of New England or the savannahs of Georgia faced problems which, however different in detail, were alike in being unknown to European farmers. Imported agricultural manuals felt nice in the hands but were useless in the fields. Hunting in virgin forests was very different from hunting through England's well-pruned timber—a different firearm had to be developed—and there was no need in America to risk being arrested as a poacher. In Europe, people clamored for employment, but in America there was always a shortage of labor, as the population spread itself thinly over vast spaces.

Everywhere there was a much greater demand for skills than specialization could supply. If a man demonstrated an ability to make things, he was called on to stray across the lines that in Europe separated different "mysteries," different trades. Watchmakers worked out how to build fire engines; silversmiths became printmakers; the painter Gustavus Hesselius found himself constructing church organs. Charles Willson Peale was apprenticed to a saddlemaker and taught himself to be an upholsterer, chaise maker, watch and clock silversmith, print-

maker, sculptor, miniature painter, oil painter, inventor, naturalist, paleontologist, museum director, soldier, politician, etc., etc.

In England, the legal profession was divided into three specialties: barristers, solicitors, and attorneys. In America, one man performed all three functions. He conned his law from books, but the law he read often did not fit the actual dispute to be solved, and thus common sense had a way of creeping in.

Describing Americans in 1724 for his English audience, the Reverend Hugh Knox wrote, "Through their quick apprehension, they have a sufficiency of knowledge and fluency of understanding, though their learning for the most part be superficial. They are more inclined to read men by business and conversation than to dive into books, and are for the most part only desirous of learning what is necessary in the shortest and best method."

Washington considered "a knowledge of books" as no more than the first step, "a basis on which other knowledge is to be built." The other knowledge was not abstract but derived from the problem to be solved. The method not of philosophy but of science, this placed the specific before the general, built systems not from the air down, but from the ground up.

Theory did not root in the American soil. The New England Puritans brought with them theological speculation, but when they unpacked their baggage in the New World they found they had no use for this raiment. No important theological work came out of Puritan New England, unless we include works written by Roger Williams after he had shaken from his feet the pragmatic American dust and returned to England. Although the American Revolution was one of the most politically creative events in the history of the world, it was not inspired or accompanied by any revolutionary political writings. What was brought forward was, as we have seen, a flood of statements that the Revolution was something entirely different from what it actually was: a return to ancient virtues, a shoring up of the British constitution.

6

THE AMERICAN MAN EMERGES

Space, which played so major a part in creating the American Man, also did much to prevent him from realizing who he was. There existed no single American center which received from across the land ideas that were pulsed out again in a synthesized form. As Anglo-America stretched north and south for more than a thousand miles, it was divided into thirteen separate political entities, each with its own political center. The capitals usually regarded each other as rivals and did not keep in touch.

Although some of the colonial capitals were villages like Williamsburg, Philadelphia had become before the Revolution the second largest metropolis in the British empire. But geography was such that the influence even of Philadelphia covered only a small section of the huge settled area. The best lines of communication flowed across the ocean to England. On the continent, news moved haphazardly, and the total sum was according to modern conceptions almost unbelievably small. Even when spurred on by Benjamin Franklin, the colonial post office was rudimentary. Newspapers were few and far between, none of them dailies. To travel any distance in America was more of an adventure than it is today to travel to Europe. Even locally people had difficulty getting around: a rural township, which an automobile will traverse in ten minutes, contained four or five villages that were, when farm horses pulled a wagon at three miles an hour, different communities.

The forces that were shaping the American Man emerged independently in individual countinghouses, or workshops, or farms. America could be visualized

as a sea of separate test tubes in each of which similar chemical reactions were bubbling. Before realization could come, the thousands of results had to be mingled together and compared.

Every colony had from its very beginnings bickered with royal power, but the greater dissatisfactions that led to the Revolution were the first that seemed to Americans really to have continental bearing. The horsemen sent crisscrossing the land by Committees of Correspondence were America's first organized communication network. Although America had been settled for more than a century and a half, not until the Continental Congress convened at Philadelphia in the fall of 1774 did leaders from all the thirteen colonies meet together. As the crisis deepened, so did the need for continental cooperation. Soon there was a second body of men gathered from all over the nation: the army.

These fateful first minglings of Americans came at a time when an augmenting earthquake shook the foundations of every temporal and psychological edifice. And the Tories, those Americans who were too deeply colonial to allow the old spell to break, were forced to flee, leaving on the scene those compatriots more susceptible to change.

Change came by no means all at once. Even major leaders entered the war without recognizing their motivations. It was America's native teacher, experience, that moved the Revolution from one stage of revolt to another. The war started as a "loyal protest": the King surely would intervene with his Parliament to protect his transatlantic subjects. When George III proved the most rabid enemy of all, even hiring German mercenaries to massacre his American subjects, the final thread of loyalty was fatally frayed. Yet it was not an urge to express new conclusions, but rather practical considerations that brought on the Declaration of Independence. Royal officials were still hanging around, legally protected, making trouble. They needed to be outlawed. More importantly, a United States that had declared itself independent could negotiate for assistance from England's global enemy, France.

It is not commonly recognized that the new human dispensation became clear less in Congress than in the army. Once the ties with Britain had been cut, the next great need was to break down the traditional walls that had separated one set of colonials from another, thus allowing the American Man to bestride his continent. The various state governments, where local politicians were entrenched, were far from sure that they wanted to lose the autonomy they had always possessed, although previously under the crown. They were still suspicious of their neighbors, whom they still regarded as strangers. This attitude was strong in Congress, whose members were selected by the states and who often did not stay in the common Congress for long. If a congressman, after having been thrown together with Americans from elsewhere, adopted a continental point of view, he was likely to be recalled by state officials who had not shared his broadening experience.

But the army, particularly the officer corps, was of necessity a permanent body. Americans from all over the country were exposed to each other year after year, and they served together under conditions most effective for breaking down between men artificial divisions. When the life of a Massachusetts

soldier was saved by a Virginian, they were brought into deep emotional contact. It was in the army that Americans first came to realize the fundamental fact on which the United States was to build: that beneath the diversity of American experience there was a fundamental unity; that American men from anywhere on the continent were more like each other than they were like the British or Hessian soldiers against whom they battled.

It was by the recognition and use of this diversity that the war was won. At first, Washington fought the British according to accepted European strategy: armies confronting armies as two masses of automatons, each operating as a machine. In such battles, the Americans were always defeated. The situation changed when Washington began using his army not as a machine but as a team to which each soldier made his contribution as an individual. The German drillmaster Baron von Steuben, who had volunteered into Washington's army, explained to a European comrade: "The genius of this nation is not to be compared with the Prussians, the Austrians, or the French. You say to your soldier, 'Do this,' and he doeth it, but I am obliged to say 'This is the reason why you ought to do that,' and then he does it."

The ability of American soldiers to think for themselves made them an altogether different military arm from the European troops who were trained to obey orders without thinking why. A European army could fight only under orders and in formation, but self-reliance made guerrilla warfare possible. And personal concern created a new psychological climate. A soldier who is in his own right deeply committed to what he is fighting for will engage in heroism, will undertake hardships unknown to opponents who are merely professionals engaged in their calling. How exciting it was for the American troops, who had so many of them hardly looked beyond their neighborhoods, to find that they had thousands of brothers from all over the continent, men who might have a different twang to their voices but yet thought in the same manner!

Although many American citizens, who were neither congressmen nor soldiers in continental campaigns, did not have the experience of mingling with persons from other colonies, they too were concerned with continental issues and shaken mightily in their private lives. Neighbors and relations came back from the fighting after their enlistments had expired (there was a continual turnover in the army); every person was faced with new political issues; local dissensions between rebels and loyalists emerged; in many areas armies marched, murderous shots were fired. While some Americans found their pro-British colonialism enhanced; while some groped vainly to find footing under the waves of change; the great majority felt fall from them the old colonial disguises. The term would never have occurred to them, but they were revealed as the "American Man."

Had the British at any time in the war been able to secure the loyalty of a large part of the population, they could easily have squeezed off Washington's army. This was their only real hope, but every year the Americans became more united.

The British abandoned the war not because of defeat on battlefields. The final major engagement, the capture of Cornwallis's army at Yorktown, would have been no more than an unfortunate check to an otherwise promising opera-

tion. Unable to defeat a people on their own territory who had become firm and united in resolve, the British accepted American independence because it was now much more than a political declaration. It was a human fact. The war was won by the emergence of the American Man.

Revealed to himself not by introspection but by happenings in the middle of a hurricane, the American Man was not altogether conscious of the change. He was too occupied by the often stupendous events of day by day to seek in quiet for synthesis. Every patriot followed his own monitions, which chimed in automatically with the convictions of his compatriots. The face of liberty was a composite of innumerable faces. Many of these were recorded by a fruitful school of portrait painters.

7

ARTS OTHER THAN PAINTING

Fig. 2. Gravestone of John Foster. In graveyard, Dorchester, Massachusetts. c. 1681. Photo courtesy Harriette Merrifield Forbes.

During the colonial period no American artist, whether a writer, or composer, or architect, or sculptor, or painter, consciously yearned to express the reality he saw and felt around him. The twinges of guilt felt by colonists at the realization that they were separated from traditional culture were the more insistent the more man engaged in activities that seemed to demand sophistication. American practitioners of the arts wished to appear as barbarians before the refined eyes of European taste to as small an extent as they could possibly manage.

Had America been a facsimile of Europe, it would have been fruitful for Americans to apply to our society European forms. At the very beginning, indeed, when American settlement was still a group of twigs leafing out on a branch that extended across the ocean, European art did flourish here. Some seventeenth-century New England gravestones are masterpieces of English folk sculpture (Fig. 2), and the double portrait *Mrs. Elizabeth Freake and Baby Mary* (Fig. 3), which was painted in Boston about 1674, achieved a naïve beauty that was not to be equaled again in America until generations later, when our artists began standing on their own feet.

It was inevitable that, as the basic aspects of American existence swept off in their own direction, European forms lost their relevance to the artists' own experience and those fundamental personal emotions which are the fuel of true art. Imitation became affectation, yet the colonial mind could not resist imitating whenever it had the chance. American art therefore flourished in exact proportion to the difficulty or impossibility of importing models from Europe.

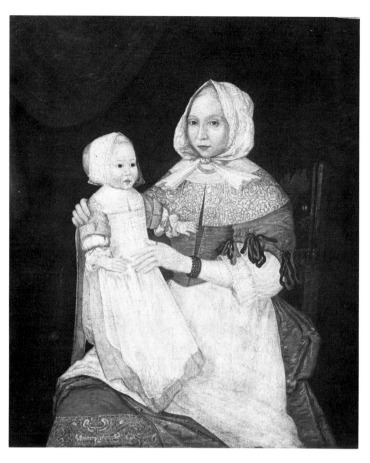

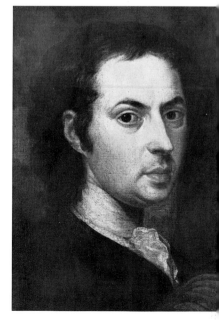

Of all European models, the most easily importable were books. Hundreds would take up little space in the hold of a transatlantic vessel and a few fitted comfortably into a saddlebag. An American reading Pope's *Rape of the Lock* in a backcountry farmhouse was seeing exactly the same words as a London fop reading the same passage in his town house. If the words as perceived in the American environment sounded different, tinkled hollowly, the colonials were determined not to admit it. Those poetically inclined felt that they were hearing the pure voices of the muses themselves, urging them to do likewise.

Although the muses sometimes appear as angels elevating to sublime achievements, they manifest themselves more often as sluts beckoning to literary stews where dreadful deeds are committed which their lovers are too besotted to hide. American newspaper printers included quantities of verse in their meager columns. How slavishly American poets substituted imported metaphors for any direct reaction to living is exemplified by a rhymed review of an exhibition held by the painter John Smibert (Fig. 4), in Boston during the 1730s. The author (probably the Congregational clergyman Mather Byles) claimed, in a part of the interminable poem that has been omitted, that the refinement he was exhibiting was introducing the muse of poetry to benighted America.

Thy Fame, O Smibert, shall the Muse rehearse
And sing her Sister-Art in softer Verse.
'Tis yours, Great Master, in just Lines to trace
The rising Prospect, or the lively Face,
In the fair Round to swell the glowing cheek,
Give Thought to Shades, and bid the Colours speak.
Touch'd by thy Hand, how Sylvia's Charms engage,
And Flavia's Features smile thro' ev'ry Age!
In Clio's Face th' attentive Gazer spies
Minerva's reasoning Brow, and azure Eyes;
Thy blush, Belinda, future hearts shall warm,
And Celia shine in Citherea's form. . . .
Still, wondrous Artist, let thy Pencil flow.
Still warm with Life, thy blended Colours glow,
Raise the ripe Blush, bid the quick Eye-balls roll,
And call forth every Passion of the Soul. . . .

The novel of manners made its debut in England so close to the end of the colonial period that—colonials being ever artistically behind the times—no American dared the form until the Revolution was well over. It may well be that the first adventure novel (in the footsteps of *Robinson Crusoe*) written wholly or in part in America was penned by a painter, William Williams, whose *Conversation Piece* and *Self-Portrait* (Figs. 5 and 6) are here shown. Williams, an English sailor, was shipwrecked (so one gathers) in Central America. After rescue he came to Philadelphia and New York, where he painted every kind of picture he could sell, designed stage scenery, restored old pictures, taught drawing and music, wrote verses, and worked on a novel, which was published posthumously in England in 1815 as *The Journal of Llewellyn Penrose, a Seaman*. Had some of his contemporaries in America seen the manuscript, they would have gained insight into the manners of Central American Indians and lizards, not a glimmer about colonial North Americans.

What depictions there were of American manners were likely to be humorous in tone, based on the work of benign and often sentimental English satirists like Addison and Steele. In 1721, for instance, Benjamin Franklin began publishing in the *New England Courant* a series of letters he had concocted for a fictitious character named Silence Dogood, which were amusingly indicative of American thoughts and mores. However, like all such effusions whenever they originally appeared, the letters were as ephemeral in their own time as a butterfly. Typically, the Dogood Papers were not republished until long after the Revolution had been won.

When the conflict exploded, American literature was still a book unopened. It finally emerged as a force about a half century later with the works of Bryant, Cooper, and Irving. The opening gun was Bryant's *Thanatopsis* (1817), which he had difficulty in getting published since an editor of the *North Ameri-*

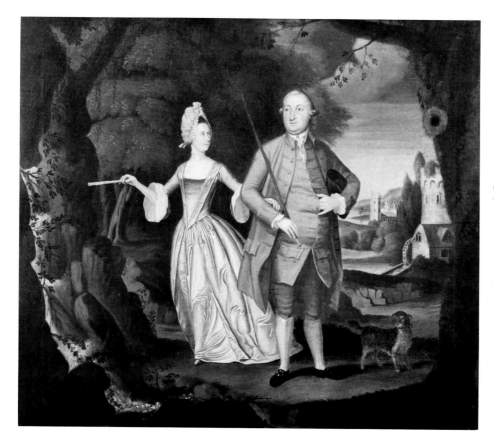

can Review suspected fraud. He could not believe that any poem so effective could possibly have been written by an American.

Music, like the written word, is easily distributable in printed form, and, unlike most other arts, it has two levels of creativity: that of the composer and that of the performer. It was natural in a colonial setting for performance to take over almost completely. Francis Hopkinson, who seems to have begun composing around 1759, was to state, when his *Seven Songs for the Harpsichord* was published in 1788, "However small the reputation may be that I shall derive from this work, I cannot, I believe, be refused the credit of being the first native of the United States who has produced a musical composition." His charming songs reveal, as John Tasker Howard wrote, "that the people of that time had access to the best of contemporary musical literature."

Several composers of psalm tunes published books of music before Hopkinson. The most important of these was William Billings, whose *The New England Psalm-Singer* appeared in Boston in 1770. A backwoods Handel, Billings wrote with a verve that kept his songs alive long after they were forgotten by more cultured congregations, until, as culture swept its circle, they were rediscovered by admirers of "American folk art." Today Billings's crude work seems more impressive than the well-informed work of Hopkinson, but neither achieved the stature of the portrait painters who were their contemporaries.

Whittling was a natural occupation in a wooded land, but sculpture as a conscious art form never got off the ground in colonial America largely because of the intimate association in sophisticated minds of statuary with the antique. It seemed a desecration not to work in marble and wrap your figures with Roman grandeur in togas. But in the colonies no local men or events seemed worthy of

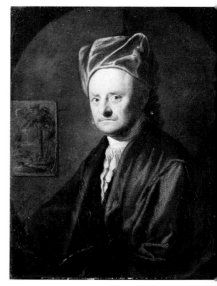

such monumental sculpture: What statues there were showed Englishmen and were cheaply manufactured abroad. George III bestrode a horse at the bottom of Broadway until his lead semblance was pulled down on July 4, 1776, to be melted into bullets.

Architecture is commonly the most conservative of the arts. Partly because a building is so expensive in time and money; partly because it protrudes as a conspicuous symbol, visible to friend and foe alike; partly because public buildings are cooperative ventures and private ones are entangled with the ancient mystique of the hearth, there is always strong pressure against architectural forms that might seem eccentric. This ordinary pressure is, of course, doubled and redoubled in a colonial environment.

In early New England, where space expanded not only as a gift but as a frightening void, even isolated buildings repeated an architectural device which had been developed in crowded cities to give more interior room over the heads of passers-by in narrow streets: the second story jutted out in front beyond the first. Although this "framed overhang" developed an unexpected use—if there were slits in the floor you could pour boiling water through them should an attacking Indian try to force the front door—it was basically pointless in the American environment. Yet it was so cherished that, when the framed overhang gave way to practicality, the conception was preserved as a decorative element by a "carpenters' overhang": the second story jutted just far enough to allow placing below it a molding that drew a line across the facade.

The history of the log cabin reveals how determinedly building resisted the pressure of the environment. In the Old World, forts were fashioned of squared logs so that they could resist cannon fire. In a frontier New England village, the residence that had been designated as a community gathering place in case of Indian attack was thus built. But it was not observed that, if simplified, construction with logs in a forested world was much more practical for small houses than the board sheathing used in Europe where wood was scarce. The houses in the rest of the village, however humble, were built with clapboard. It took European precedent to popularize the log cabin, which was brought to America by settlers from another area with forests: Scandinavia.

Plans for elaborate buildings could be engraved and printed and were thus, like the written word, easily distributed in books. American builders, whether artisan, gentleman, or one of the very rare architects, used those books as anthologies of details which were put together in a conventional manner. When, well after the Revolution, the national capital was being planned for Washington, D.C., Jefferson wrote that for the capitol building "I should prefer the adoption of some one of the models of antiquity which have had the approbation of thousands of years. And for the President's House, I should prefer the celebrated fronts of modern buildings which have already received the approbation of all good judges." It never occurred to the author of the Declaration of Independence, who was himself a skillful architect, that America could have an architecture which was not an application of accepted European forms. His marvelous complex at the University of Virginia was conceived of as a pedagogic sampling of the various classical orders.

8
LIKENESSES OF THE EMERGING AMERICAN MAN

During the colonial period, whatever paintings could be imported were imported. Thus, when George Washington, at the age of twenty-five, wanted "a neat landskip" to go over his fireplace at Mount Vernon, he ordered it from England, specifying only the dimensions. He received a scene aimed at the unsophisticated eye by having crowded into it as much of everything as possible: shepherds, sheep, a harbor, ships. The picture, he was assured, was "in the style of Claude."

During the 1940s, as scholarly interest in American art augmented, there appeared here and there, and then in many places, small oils showing figures down to the waist, which seem to date from the first half of the eighteenth century. Some bear the name J. Cooper and all are in a single style (Fig. 7). The narrow picture space is crammed with jewels, medals, shining silk and gleaming armor, wigs, heavy drapery, and monstrous lace. The subjects are mythological worthies, kings, or queens. Since indefatigable research has failed to locate the prolific artist anywhere in America, and since the subjects are never American, J. Cooper was in all probability the name of some English manufacturer who ran up decorative figures, lavish in detail and small enough to be easily shipped, for the colonial trade.

The colonials would have been glad to import their own portraits. Virginians routinely sent their measurements to London tailors so that they could be supplied with elegant clothes in the latest styles. If the result did not really fit, it could be doctored by seamstresses at home, and anyway a weird shoulder line

Fig. 7. J. Cooper. *Allegorical Figures.* Oil on canvas, 22″ x 18″. c. 1714. Lyman Allyn Museum, New London, Connecticut.

might perhaps be the ultimate in up-to-date fashion. But efforts to send written descriptions of faces abroad produced a result that, however culturally correct, was personally unacceptable. Despite all their colonial yearnings, Americans who did not happen to be in Europe were forced, if they wished to be painted at all, to be painted in America.

To forego their likenesses because the pictures could not be done correctly was for prosperous Americans not an open option. It was an aspect of the European societies from which they had sprung and which they sought to imitate that people of importance left their likenesses behind them. Had they not become in the New World people of importance? The best they could hope for was that portraits could be produced in America that were not too shockingly different from those produced abroad. Toward this end both sitters and artists strived. But there were great blocks in their path.

The printing press, that messenger of transatlantic culture, was, of course, appealed to, and it did have a contribution to make. Many European portraits had been engraved. Yet the fact remained that, compared to a printed text or a musical score or an architectural plan, a printed picture supplied to imitation only extremely limited hints. To begin with there was scale: even a full-length portrait, which could be six feet or more high, would be reduced to a plate measuring at its largest about eight inches. Then there was color: the prints were exclusively black and white. Perhaps even more important, the medium was altogether different: the engraver had his own methods, which had no relation to the stroke of brush on canvas, for depicting form, light and shadow, depth—everything, indeed, that made a painting "painterly."

What the European engravings did communicate was costume and composition. These were the aspects of seventeenth- and eighteenth-century European portraiture that had the least connection with the personal appearance of the sitter and could be of the least use to Americans in depicting what they themselves saw. The accessories shown did not exist in the colonies any more than the social realities that justified such portraiture.

In the aristocratic world of Europe, where power evolved from being born in the right bed, rank had only a slight connection with the individual personality. It would be unrealistic to depict a king with a weak face and no chin, since he was in fact extremely powerful. A countess was by definition decorous and gracious, even if she was as ugly as a skunk. The obvious solution for portrait painters was to subordinate the sitter's own appearance to costumes and accessories and background settings indicative of rank. American art's bad boy, Gilbert Stuart, thus described the perfect aristocratic portrait, "How delicately the lace is drawn! Did one ever see richer satin? The ermine is wonderful in its finish. And, by Jove, the thing has a head!"

A lesser contribution of the printing press to colonial taste was books on art. The most useful were handbooks that communicated the techniques of putting pigment on canvas. Critical works, with their verbal raving about pictures no colonial had seen, started the game of symbols—Titian standing for this quality, Raphael for that—which has already been discussed. The books also persuaded artisans that, when they turned from making pots to making pictures, they were rising to a higher form of creativity. Thus the adolescent Benjamin West (who

was eventually to become an intimate friend of George III) learned from a book that "a painter is a companion for kings and emperors." This heady knowledge made him jump off a horse when his companion in the saddle boasted that *he* intended to become a tailor.

There were, of course, no museums where painters could find European models to study. Since Protestantism banned art in churches, what foreign pictures existed on these shores were locked behind private doors. They were in any case few and inferior. The paintings which had been brought from Holland, which then abounded in middle-class art, to New Amsterdam, went so far out of fashion when their habitat became New York that almost all vanished. The German peasants who became "the Pennsylvania Dutch" brought with them a folk art tradition which continued medieval conceptions, but their antique designs did not speak to their neighbors. For the rest, all across the extended areas of settlement, the inhabitants had not come from backgrounds which supplied persons of their class with pictures to bring along.

Fig. 8. Justus Engelhardt Kühn. *Eleanor Darnall*. Oil on canvas, 54″ x 44-1/2″. c. 1712. The Maryland Historical Society, Baltimore.

The later Americans who took a grand tour of Europe were, although they could afford this luxury, poor compared to European travelers: the "Old Masters" they brought home belonged to the lowest orders of those fabricated for tourists. The impecunious American picture market did not encourage European dealers to supply it with anything but junk. How greatly competent if inaccurate copies of European masterpieces rose above the ordinary visual fare is revealed by the influence of those which John Smibert had painted in Italy and carried to Boston. When John Singleton Copley finally saw the originals, he wrote that Smibert's versions were miscolored and badly drawn, yet Smibert's version of Van Dyck's *Cardinal Bentivoglio* was in itself America's first art academy. Copley, John Trumbull, and Washington Allston all found in this inept version their first hints of a rich portrait style.

Fig. 9. John Smibert. *Nathaniel Byfield*. Oil on canvas, 30″ x 25″. c. 1730. Metropolitan Museum of Art, New York. Bequest of Charles Allen Munn, 1924.

The obvious answer was for American artists to study in Europe. But painting was not then considered, in England or the colonies, a profession for gentlemen. The American artisans who graduated themselves from other crafts to painting could not afford what was then the extremely long and expensive trip to the Old World.

The movement of artists was the other way. Throughout the colonial period, Europeans, bringing with them some knowledge of how to paint, appeared, now and then, here and there, somewhere along the far-flung American coastline. With the single exception of Smibert, they were unknown or practically unknown as artists in their homeland. The colonial market, indeed, offered nothing to lure into the long journey an artist who was making any passable living at home. The arrivals were either professional artists who had failed, or amateurs who decided, when they saw the lack of competition in the New World, to make professional use of a former hobby or unrealized ambition.

One of our earliest pictures, *Mrs. Thomas Lynch* by Jeremiah Theus (Plate 3), illustrates this phenomenon. Theus came to South Carolina from Switzerland in 1735, at the age of about twenty, bringing with him what instruction we know not. Some of the male portraits he produced in Charleston lean toward character study, but he usually made use of standard features, brightly com-

plexioned. His faces all have the same mouth and chin; shoulders all slant fashionably; gleaming clothes cover columnlike bodies that have no shape of flesh. But the result is elegant and decorative and far removed from any facts of colonial living. For thirty-four years, Theus dominated South Carolinian art, making a small fortune.

Native-born painters rushed eagerly to learn what they could from painters who carried the cachet of having come from abroad; but this created no consistent practice. For one thing, the various foreign artists had brought their styles from widely separated places. Among the painters who worked British America during the first half of the eighteenth century there were in addition to Englishmen and Scotchmen, Dutchmen in New York, the Swiss Theus, the German Justus Engelhardt Kühn (Fig. 8), and the Swede Gustavus Hesselius. What influence each had was usually local, since communication from one colony to another was rudimentary at best. A considerably longer shadow was thrown in the mid-century by John Wollaston, for he himself traveled extensively. He had been trained in London as an artisan who added costumes to portraits on which more exalted painters had already inscribed the likenesses. That he remained better at costumes than faces did not bother the colonial sitters who, though only vaguely recognizable, were glad to be shown elegantly dressed.

Since the heavy-handed Wollaston had come so recently from Europe, John Hesselius abandoned the sounder style of his father Gustavus to follow the star of a newer fashion. Having no real flair for costume, and following Wollaston into meaty faces, John produced such portraits as those of Thomas Johnson and John Hanson (Plates 1 and 2).

John Smibert died in 1751, so early that he is not included in this exhibition, yet his arrival in America was the most influential aesthetic event in the pre-Revolutionary period. He brought for the first time to the North American shores a competent oil-painting style. This had happened by inadvertence. Smibert had joined the philosopher Bishop George Berkeley in an effort to establish a "universal college of arts and sciences" for the Indians in Bermuda. When the project foundered for lack of funds, Smibert was stranded in New England.

The son of a Scotch dyer, Smibert had been apprenticed to a house painter. After a long and painful struggle, he penetrated the art galleries of Italy. Then he established some custom as a portrait painter in London. Humbly born and raised, he was never able to get the aristocratic trappings right or make a social impression on highborn sitters. Since he continued to be regarded as an artist of the second rank, he decided to emigrate.

Arriving in simple America, he began by moving in what was eventually to be the direction of American portraiture: painting faces as his eyes saw them without any consideration of social fashion. But he quickly discovered that this suited neither his environment nor himself. The colonials expected a British artist to make them look like English aristocrats, and the man who had been snubbed in London as lowborn, was considered such a catch in Boston that he married a beautiful heiress, twenty years his junior. Naturally, in depicting her and her compatriots, he endowed them with all the graces he could achieve (Figs. 9 and 10).

The whole pre-Revolutionary New England school was strengthened by the

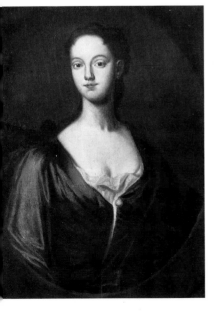

Fig. 10. John Smibert. *Mrs. John Smibert (Mary Williams).* Oil on canvas, 28-1/2" x 24". Massachusetts Historical Society, Boston.

technical know-how Smibert brought to America. Robert Feke, who had been born on Long Island the son of a Baptist minister, frequented Smibert's painting room at the opening of his own painting career. He so gulped down Smibert's lessons that he was at first overpowered. But that influence proved not rich enough for his spirit to feed on. He went on to collect from imported English engravings conceptions more elegant and expansive. In the process, he was carried beyond the possibilities of Smibert's technical example. He was forced to improvise expedients for himself. This necessity unlocked the treasure-house of his own creativity, encouraging him to modify everything in a way that expressed his personal vision. The resulting pictures, painted in the exact center of the eighteenth century, are the greatest works America had produced in any art up to that time. The portraits of Mr. and Mrs. James Bowdoin (Plates 4 and 5) are fine examples.

Feke gave the ultimate expression to the dominant social ideal of the high colonial period. His pictures are no more realistic than was that vision: they are high-spirited, gently colored, benign, innocent dreams. They resemble a milk-maid's reverie of what it would be like to be a leader of high society—the reverie of an American milkmaid. For an American milkmaid would not be staring across social and economic barriers at what she or her children could not hope to achieve. There was no wistfulness, no envy in Feke's vision. He was taking to his heart what he felt was his own. He expressed the happiness of an heir fore-seeing his legacy, of an animal awakening from a long winter's hibernation to emerge into the soft, intoxicating air of spring. To Americans everything seemed possible. Their mood could not be sadness. It had to be joy.

Even when one of Feke's compositions was altogether gleaned from an imported English engraving, in the process of enlarging, laying down oil paint, and coloring, he went off on his own, seeking always greater simplicity. Elaborate European efforts were beyond his abilities. He had the courage and the integrity to make his ends fit his means. Reducing his figures to uncomplicated shapes— his men are cones, his women an interplay of expanding and contracting forms —he achieved, without losing the sense of the body, semiabstractions that enabled him to communicate, for the first time in native American art, a plastic sense of shape in the round.

It was typical of the rapidly changing American society that even when Feke achieved his triumph, it was already becoming obsolete. As colonial life flowed on toward the waterfall of the Revolution, the paean of joy that he painted was beginning to be modified by sounds of anger and discontent. The greatest painter of pure colonial exaltation was also to be the last.

In Philadelphia (and later New York) the exciting newcomer from Europe was William Williams, the onetime English amateur painter whose adventure novel has already been mentioned here. Somehow, as is revealed by his canvas, *John Wiley, His Mother and Sisters* (Plate 19), Williams had caught that latest English fashion, the "conversation piece": group portraits which broke through eighteenth-century formality by showing families gathered together at their ease. According to the transatlantic conception, the sitters were shown in a naturalistic

setting. Williams by no means always did this. In those neoclassical times, when a taste for the medieval was still in embryo, Williams often demonstrated himself an early romantic by imagining backgrounds for his structures in the medieval taste.

It was Williams who first encouraged the eager genius of Benjamin West, then a small boy but eventually to be considered by many Europeans the greatest of all living painters. On a trip to backcountry Lancaster, Pennsylvania, West, now a teenager, did not hesitate to paint *The Death of Socrates* (Fig. 11) although he had never before heard of Socrates. The subject had been suggested to him by the gunsmith William Henry. His portrait of Henry (Plate 6) was painted at the same time; the viewer will note one of Williams's romantic castles in the background. The portrait of Mrs. Henry (Plate 7) is more conventional, the pose and background surely copied from an engraving.

West, who was thirty-eight at the time of the Declaration of Independence, belonged to the high Revolutionary generation, and his life story, although it ends up in England, is in many ways indicative of that era of great flux. That he had never heard of Socrates did not make him draw back in embarrassment. He was glad to re-create the classic hero—he knew no Latin or Greek—in his American imagination. Soon the citizens of Philadelphia, concluding that they had a genius on their hands, took a step that combined nationalism with deep respect for European culture. They took up a subscription to send, for the greater glory of America, the young artist abroad for European study. He would reward his donors by sending back good copies of Old Masters. On this basis, West became, when he reached Italy in 1760, the first American artist recorded as having set foot on foreign shores.

In Rome, West discovered that when he had painted *The Death of Socrates* he had been anticipating the latest European fashion. He became, as his *Agrippina Landing at Brundisium with the Ashes of Germanicus* shows (Fig. 12), the principal messenger who carried to London the international neoclassical style that was beginning its triumphal run of half a century. His depictions of classical scenes—he still knew no Greek or Latin—took London by storm and made him the favorite painter of George III.

As West's achievement was disseminated by the great English engraving industry throughout the Western world, he found himself on so large a stage that he could not abandon it by returning to America. But he used his London studio as a free art school for any American beginner who appeared, and he never hid from his royal friend, George III, that his sympathy was with the American rebels. More advanced in his thinking than the political pamphleteers, he broke in the early 1770s with the established rule that great events had to be found in the past or made to appear as if they had indeed taken place there. According to the neoclassical taste which he himself had done so much to promulgate, the toga was the correct costume for elevated figures old and new, mortal and immortal. (We still visualize angels in modified togas.) Yet West, recognizing that for him classical culture was just a veneer, resolved to paint his *Death of General Wolfe* (Fig. 13), a scene from the siege of Quebec during the French and Indian War, realistically, as it might have happened, with the participants in modern

Fig. 11. Benjamin West. *The Death of Socrates.* Oil on canvas, 34" x 41". c. 1756. Private collection.

Fig. 12. Benjamin West. *Agrippina Landing at Brundisium with the Ashes of Germanicus.* Oil on canvas, 64-1/2" x 94-1/2". 1768. Yale University Art Gallery, New Haven, Connecticut.

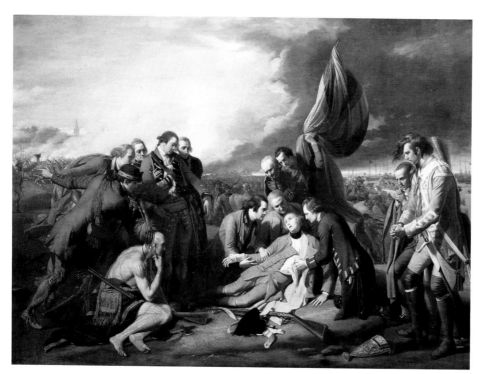

Fig. 13. Benjamin West. *Death of General Wolfe.* Oil on canvas, 59-1/2" x 84". 1771. The National Gallery of Canada, Ottawa. Gift of the Duke of Westminster, 1918.

costume. The great success of this canvas made it a milestone in the development of modern art. The demonstration that the present need not, to achieve validity and greatness, present itself in terms of the past, opened current events to brushes across the Western world.

While Feke was the first effective American creator in any of the arts, John Singleton Copley was our first truly great artist. His career was sped by his mother's second marriage. At the age of ten, he acquired as a stepfather Peter

Pelham, an English engraver resident in Boston, who painted an occasional portrait. More importantly, Pelham was a close associate of Smibert's. For three of his most formative years, Copley shared one of the few household environments in America that was primarily devoted to art. Then both Pelham and Smibert died. With his mother and an infant half-brother to support, Copley began at the age of fifteen his career as a professional artist.

Like his American contemporaries who were preparing to twist the tail of the British lion, Copley wrapped self-assertion in unassertive, colonial thoughts and explanations. He wished to climb "that mighty mountain where the everlasting laurels grow to adorn the brows of those illustrious artists who are so favored of heaven to unravel the intricate maze of its rough and perilous ascent." Yet it did not occur to him that a spur of that mountain stretched across the Atlantic to his own exciting land. He saw no advantages in the pressure that forced him to self-reliance, but mourned that America "offered no examples of art, except what is to [be] met within a few prints very indifferently executed, from which it is not possible to learn much. . . . I think myself particularly unlucky in living in a place where there has not been one portrait brought that is worthy to be called a picture."

Like a whale swimming through the ocean with its mouth open to gather in enough small fish to feed its immensity, Copley examined all scraps of information that he could find. He studied and was influenced by every painting he could locate, by the work of every colonial limner, however inferior. He pored over art books, complaining that the authors "seem always to suppose their readers to have the works of the great masters before them." He copied anatomical engravings, in his passion investing his renditions of skinned bodies with a macabre, sullen life (Fig. 14). Again following engravings, he clumsily but determinedly reproduced in drawings or in oils figure compositions after the Old Masters.

Since Americans who wished figure compositions could import them, Copley's moneymaking activity was portraiture. Having read in the right books that likenesses were an inferior form of art, and upset by the fact that fame could not be permanent when pictures disappeared into private drawing rooms, Copley nonetheless put his mind so hard on what he was doing that his fame, when the canvases did escape from drawing rooms, became immortal.

Feke, the poet, had turned to imported engravings to inspire visions, but Copley sought in the same sources the illusion of reality. He complained that the ladies he painted could not be shown in fashionable costumes "unless I should put myself to the great expense of having them made," but found a cheaper way of dressing his female sitters. He copied into his portraits costumes from imported prints. With a touching colonial ignorance of how rapidly in cosmopolitan centers styles go out of fashion, he pictured during the early 1760s three separate women wearing the clothes that had been worn fifteen years before by The Right Honorable Mary Viscountess Andover when she was painted by Thomas Hudson (Figs. 15, 16, 17, and 18).

Since two of the American ladies, Mrs. John Amory and Mrs. Daniel Hubbard (Plate 11), were first cousins, they must have been familiar with each other's

Fig. 14. John Singleton Copley. *Anatomical Drawing. Plate vi. Torsos.* Ink and red crayon, 10-3/4″ x 17-1/6″. 1756. British Museum, London.

pictures, which were not only identical in costume but fundamentally alike in composition, for Copley had adopted that too from the print after Hudson, even to the configuration of the clouds in the sky and the low relief on the stone pillar against which both ladies lean. That the cousins did not find the similarity objectionable; that the modern viewer, even when the duplication is pointed out to him, still sees the pictures as in essence different, reveals a major change that had taken place since the era of Feke. In Feke's art, the aristocratic aura was the soul of the picture. In Copley's art, the essence was the likeness. The pictures do not seem to resemble each other because the two women are shown to be very different.

In his concern with individual character, Copley was inclined to enlarge heads, sometimes to an extreme that makes the body seem dwarfed. Here, both heads, although not extreme, are bigger than the head Hudson had painted, and the copied composition has been subtly subordinated so that the elegant accessories do not, as they did in Hudson's picture, seem to typify the sitter. Setting and costume have become mere embellishments, which could be changed without notably altering the effect.

The faces of the two women dominate Copley's pictures. They have been strongly studied from life, revealing human beings of very different character: Mrs. Hubbard is pretty, softly rounded, coy; Mrs. Amory is handsome, bony, intellectual. Copley's genius has enabled him, in putting down the copied costumes, to indicate underneath them the stance of two different bodies. Mrs. Hubbard relaxes kittenlike within her finery, while Mrs. Amory's sinews, although at the moment relaxed, are prepared for nervous action.

No more than the pamphleteers who claimed they were supporting the British constitution did Copley admit that his portraits were verging over into a new attitude toward man. He wrote of an emphasis on individual likeness only to complain—he was a great complainer—of the abysmal taste in America that did not care whether a picture was elegant or not as long as it preserved the resemblance "of particular persons." Yet Copley's continuing practice revealed that he was very concerned with individual persons.

A very strange experience had come to Copley at an early age, when he was about twenty. Without seeking originality, while indeed repudiating that concept, he had started painting more accomplished pictures than he had ever seen. He lashed around to escape from this dilemma. He sent his *Boy with Squirrel* to London, where it was exhibited at the Society of Artists, and tried to profit from criticisms sent him in writing by West and Reynolds. When advice sent from abroad only confused his style, he made up his mind that he would have to go in person to Europe. But then he did not go, marrying the daughter of a rich Boston merchant instead. Now he was artistically altogether on his own. He worked out all kinds of things for himself: color harmonies, how to use shadow, how to indicate weight and depth, how to hold together his compositions into inevitable wholes. Some of his achievements remained crude— his shadows, for instance, so lacked transparency that they were inclined to black out parts of the face—yet the total effect was extremely powerful for the most fundamental of reasons: his technique and what he wished to express

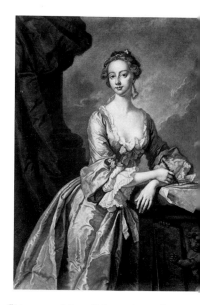

Fig. 15. John Faber, Jr., after Thomas Hudson. *The Right Honorable Mary Viscountess Andover.* Mezzotint. 12-1/4" x 9-7/8". British Museum, London.

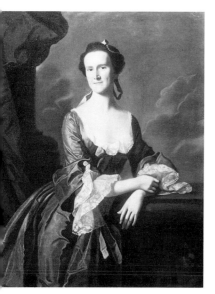

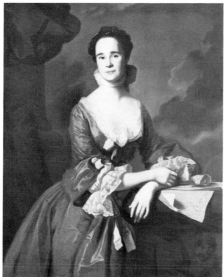

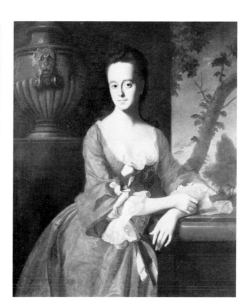

Fig. 16. John Singleton Copley. *Mrs. John Amory (Katharine Greene).* Oil on canvas, 49-1/2" x 40". c. 1763. Museum of Fine Arts, Boston. M. and M. Karolik Collection.

Fig. 17. John Singleton Copley. *Mrs. Daniel Hubbard (Mary Greene).* Oil on canvas, 50-1/4" x 39-7/8". c. 1764. The Art Institute of Chicago.

Fig. 18. John Singleton Copley. *Mrs. John Murray (Lucretia Chandler).* Oil on canvas, 49-7/8" x 40". 1763. Worcester Art Museum, Worcester. Bequest of H. Daland Chandler.

emerged as a single whole, fresh-minted by the insights and the convictions of his own extremely able mind.

Copley had now abandoned himself completely to the portrait. Underlying his art was what the political writers referred to as "natural rights": the importance, apart from his role in the state, of the individual. It was not a person's rank but his own personality that counted! But, like the propagandists, Copley only very rarely expressed radical conceptions without the addition of tags more conventional. In painting Paul Revere (Plate 17) he did go the whole way. The silversmith is presented to posterity not like a gentleman but conspicuously as an artisan, wearing his work clothes and with his tools and creation featured before him. By contrast, the other leading (and less radical) Boston silversmith Nathaniel Hurd (Plate 16) is shown in the fashionable undress of a gentleman: a frogged and elegantly lined silk dressing gown known as a "banyan" and on his head a black velvet turban.

In the twelve Copley portraits in this exhibition, the viewer will see many scraps of elegance that would seem incongruous were it not for the strength of the painter's art. The paintings of the two revolutionaries Joseph Warren and John Hancock have sticking in from the right-hand corner a bit of sumptuous drapery. James Warren's background is even more conventional, an often-used and unrealistic metaphor of grandeur. Samuel Adams is depicted presenting the protest of the outraged Boston citizenry to the Royal Governor after the Boston Massacre. It is symbolic of continuing colonial hesitations that Copley has flexed the hand with which Adams is pointing at the inflammatory documents as if it were the hand of an aristocratic lady pointing at her pet lamb.

9

PORTRAITS OF THE AMERICAN MAN

The ferment that made the American Revolution inevitable operated in many other aspects of American life. In art it stirred up a covey of young painters. The majority of the portraits shown here are by artists who began painting in the 1760s or the 1770s. Aligned in style to Copley was the pastelist from Salem, Massachusetts, Benjamin Blyth, who created charming portraits of John and Abigail Adams (Plates 20 and 21) when they were young and politically almost unknown. John Trumbull, of Connecticut, entered the Copley axis when he went to Harvard and demonstrated a gift for painting, as his intense self-portrait of 1777 (Plate 23) shows. In Newport, Rhode Island, a fierce young man named Gilbert Stuart was creating doll-like effigies of his neighbors that, for all their lack of naturalism, revealed an exhilarating plastic concern with shape and space (Fig. 19). While a teen-ager, Mather Brown wandered into New York state as an itinerant miniaturist. First appearing in New York City during 1766, John Durand traveled to Virginia, rendering in his portraits elegant transatlantic borrowings as elements in flat designs, the outlines of the figures blunt, the whole forming an agreeable pattern.

 In the small village of Woodstock in the northeast corner of Connecticut there appeared a rural painter whose great gifts and probable influence on subsequent American art have never been adequately considered. Winthrop Chandler's scantily recorded biography falls among "the short and simple annals of the poor." Orphaned at an early age, he became a house painter, but in the 1770s he began creating portraits of his relations and close neighbors. Struggling al-

Fig. 19. Gilbert Stuart. *Mrs. Aaron Lopez (Sarah Rivera) and Her Son Joshua.* Oil on canvas, 26 x 21-1/2". c. 1773. Detroit Institute of Arts.

Fig. 20. Winthrop Chandler. *Reverend Ebenezer Devotion.* Oil on canvas, 55" x 44". c. 1770. Brookline Historical Society, Brookline, Massachusetts.

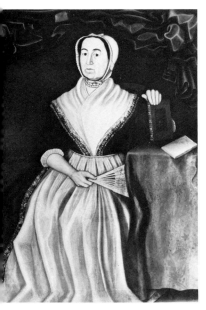

Fig. 21. Winthrop Chandler. *Mrs. Ebenezer Devotion (Martha Lathrop).* Oil on canvas, 55" x 44". c. 1770. Brookline Historical Society, Brookline, Massachusetts.

ways with debt, he died a pauper. The local newspaper stated that "embarrassment like strong weeds in a garden of delicate flowers, checked his enthusiasm and disheartened the man." Yet he seems to have been the founder of a painting style that flourished for more than a generation in Connecticut.

Chandler is said to have served his apprenticeship as house painter in Boston, where he would certainly have seen the work of Copley. But he had too strong a vision of his own to be impressed by any other. He applied to middle-class ends the aristocratic conception of emphasis on setting.

Not for Chandler the inconsistency, practiced by Copley, of bedding an egalitarian likeness in elegant surroundings copied from an English print. Chandler surrounded as shrewd a likeness as his technique allowed him to achieve with an environment that further specifically characterized the sitter: the realities of rural New England village life. Thus, the seminaïve Connecticut practitioner went further than the sophisticated Copley or the pre-Revolutionary pamphleteers in banishing all vestiges of colonialism.

Chandler's style was fully developed by 1770, the date of his earliest known pictures, the large, accomplished, three-quarter lengths of the Rev. and Mrs. Ebenezer Devotion (Figs. 20 and 21). He did, it is true, crush an irrelevant curtain over Martha Devotion's head, but the rest of the picture shows a rural housewife in her actual Sunday best. Her husband, a minister and thus a man of learning, poses before his library, some of the books with legible titles, some in fine leather bindings but one shown with the leather peeled from the spine. There is a brass tack missing from the chair on which Ebenezer lounges in an inelegant pose.

Two years later, Chandler painted the family of Ebenezer Devotion, Jr. (Plates 26 and 27). Although the husband was a judge, he is shown leaning in a most ungainly position against an unadorned high desk. He looks up as if the painter had just entered the room to find him recording accounts in his ledger.

Perhaps the most direct of all Revolutionary portraits is that of the artist's brother, Captain Samuel Chandler (Plate 24). What I wrote about the picture in 1947 has so often been quoted that I may be excused for quoting myself:

The composition of Captain Samuel Chandler is daring and brilliantly successful. The long body is placed far to the left, but kept from overbalancing the picture by the bias line of the crossed leg which is surmounted by a table, then a military hat, then a framed battle scene. The braid on the top of the hat waves in a subtle form that would fascinate an abstractionist. And the battle scene, although not too conspicuous for its secondary role in the portrait, is in itself a complete picture.

Warfare, as Chandler reveals it, is bloody enough for any sadist, but organized on strictly geometric lines. In the middleground, two groups of cavalry are set up with the regularity of chessmen; those on the left are blue, those on the right red, a color division, characterizing the opposing armies, which runs all through the picture. Further back, neat files of soldiers, bristling bayonets and emitting smoke, face each other in curving lines. The foreground is given over to individual action. Two large horsemen, conversing calmly as if they had paused on their way to market, strike

a bucolic note which is contradicted by a shot rider flying off a rearing steed, a stricken man displaying his bloody leg, and several corpses, one topped with an enlarged and horrible head. Setting the grisly mood is a dog, as large as his victim, who stretches his belly over the head of a dying man as he drinks the river of blood flowing from a monstrous wound.

Chandler's paintings, put down with the episodic color and flat design indigenous to naïve art, are powerful and highly decorative. They express, even more than did Copley's *Paul Revere*, the pride of self-made men not only in who they individually were but in their own possessions. No wonder that, although Chandler was lowered into a pauper's grave, the artistic conceptions he had invented for himself traveled out from his sequestered village into the surrounding world.

Fig. 22. Charles Willson Peale. *Mrs. James Arbuckle (Tabitha Scarborough Custis) and Son, Edward.* Oil on canvas, 48″ x 36-1/2″. 1766. Private collection.

We know that Ralph Earl, after working and studying in England, returned to Connecticut and became the most sophisticated exemplar of the conceptions Chandler had initiated. It is here postulated for the first time that Earl may have been influenced by Chandler at the very start of his career.

From a geographic point of view, this is reasonable. Earl grew up in Leicester, Massachusetts, which is within a few miles of Worcester. Worcester was the metropolis nearest to Chandler—he was eventually to work there as a house painter—and there were only twenty miles between the village where Chandler painted and the village where Earl lived, probably into young manhood.

Our first fact about Earl as a painter is that he set up a studio in New Haven in 1774, when he was twenty-three. Chandler had been practicing his mature style for at least four years. *Roger Sherman* (Fig. 23), Earl's early masterpiece, which was painted between 1775 and 1777, shows, despite its simpler composition and darker mood, much of Chandler's approach. There is that lip service to convention, an irrelevant background curtain, but for the rest we see determined realism. Sherman sits in a plain Connecticut Windsor chair; his pose and figure are ungainly; and the face of the elderly Revolutionary leader, who had started life as a shoemaker, is revealed with a realism that would be shocking in comparison to any sophisticated eighteenth-century art. The whole picture, down to the carpetless floor painted orange tan, seems a total expression of righteous New England at its starkest.

After the battles of Lexington and Concord had fired off the Revolution, Earl may have acted as a journalist by making schematic paintings of the engagements to be the basis of the well-known engravings by New Haven's busy craftsman Amos Doolittle (Plates 28–31). But this has not been proved.

In Maryland, one of the most fruitful careers was emerging. That jack-of-all-trades, Charles Willson Peale, having added painting to his other crafts, was forced to flee his debts to Boston where he studied canvases by Smibert and was befriended by Copley. When he was back in Annapolis, such portraits as his *Mrs. James Arbuckle and Son, Edward* (Fig. 22) seemed so impressive that the inhabitants, wishing to receive the kudos Philadelphia had earned by sending West to Europe, sent Peale to West. Farther south, Henry Benbridge succeeded Theus as the resident painter of Charleston. His wealthy father enabled him to

Fig. 23. Ralph Earl. *Roger Sherman.* Oil on canvas, 64-1/2″ x 49-5/8″. c. 1775. Yale University Art Gallery, New Haven, Connecticut.

study art in Italy, but, as his *Charles Cotesworth Pinckney* shows (Plate 52), of all the painters mentioned here he had the least gifts.

The startling aspect of this pre-Revolutionary burst of artistic activity by members of the younger generation is the erosion of colonial shyness. When residual scraps from transatlantic engravings do appear in compositions, they are gestures—rare, minor, and incongruous. Almost all the portraitists were now basically concerned with the characters of their sitters, or, in the Chandler tradition, the actualities of the sitters' environments. The most derivative of the painters here shown was, significantly, the most obscure: John Durand. A decisive turn away from foreign imitation characterized the younger portraitists whether they became, after the Revolution actually broke out, politically Whigs, Tories, or neutrals.

The geographic separation between American artists and actual European experience had already greatly weakened when the Revolution killed off at home

all but the humblest business for painters. As a group, the artists were surprisingly unbelligerent. Among the abler and more ambitious, only the Peales fought in the conflict and lasted it out in America. The capital of the American school moved to the enemy's capital, London.

Each artist's move to England grew out of his own personal relationship to the war. Copley was the first to go. Linked by his activity as a craftsman-artist to the proponents in Boston of protest, he had married the daughter of one of the merchants who had imported the famous tea. Although a very timid man, he tried by mediation to prevent the Boston Tea Party. Not only did his efforts fail, but his family suffered from the trained mob led by the very Samuel Adams he had so recently painted nobly defying the royal governor. Foreseeing mounting difficulties, Copley decided, in 1774, to undertake the European studies that would enable him, if necessary, to make his living in England. After a trip to Italy, he settled in London under the aegis of Benjamin West.

Stuart's Scotch-born parents were Tories. When Washington drove the British out of New England in 1775, they sailed for Nova Scotia. Stuart set out for London, to be followed in 1777 by Mather Brown. They were both to come under the influence of West.

The one convinced Tory among the painters, Earl, undertook secret missions for the British across Long Island Sound. In 1778, he found it expedient to flee across the ocean to England and eventually West.

Trumbull differed from all other known American painters up to the Revolution in being not from the artisan class, but born a gentleman. His father was governor of Connecticut. His social station might seem in the abstract an advantage, but within the American scene it was the opposite. As we have seen again and again exemplified, painting was saved from the artificiality of the other arts by the fact that it had been practiced as a craft local to the American soil. But this extended association between the artisan and the paint brush had given art a low social standing. No gentleman wished to be considered an artisan. Trumbull all his life long considered practicing his great natural artistic skills unworthy of a man "capable of higher pursuits."

Family pull secured for Trumbull important berths in Washington's army. However, he soon felt that his honor required abandoning his role as a soldier: the commission that made him a colonel at the age of twenty-one had been, in his opinion, somewhat misdated. In 1780, he went to France on a mercantile speculation. Only when this business venture failed did he turn again to painting. He went to London and Benjamin West.

West's studio, where Peale, Benbridge, and Joseph Wright had already studied, was now more than ever the spawning ground of future American painting. Significantly, the major concern of the master was not with portraiture. West, who was to succeed Sir Joshua Reynolds as president of the Royal Academy, preserved and enhanced his international reputation by continuing to put his greatest efforts into the "highest branch" of art: those large and crowded figure compositions which were known as "historical painting." With an American eagerness to experiment, he became on the international scene a major innovator, expanding the exalted mode from doctrinaire neoclassicism to the expres-

Fig. 24. Benjamin West. *Death on the Pale Horse.* Third Oil Sketch. Oil on canvas, 21" x 36". 1802. Philadelphia Museum of Art. Given by Theodora Kimball Hubbard in memory of Edwin Fiske Kimball.

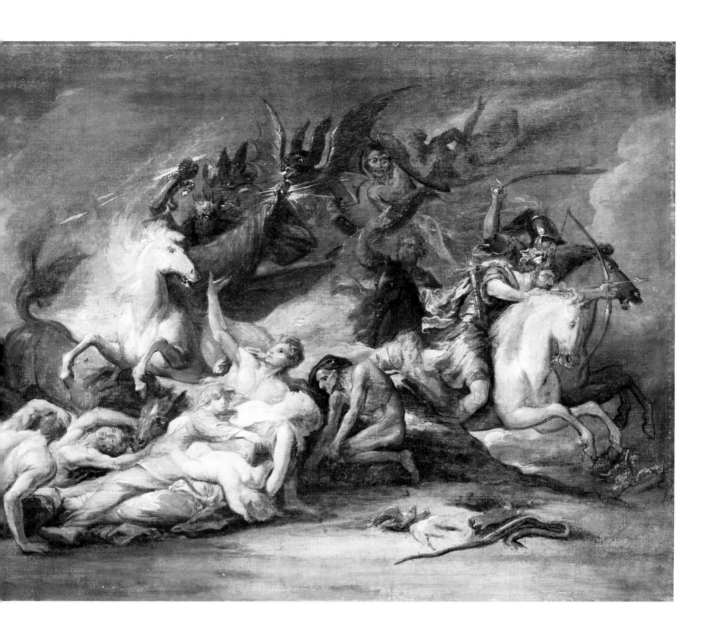

sion of every kind of subject matter and mood: Biblical, medieval, modern, exotic, and romantic horror such as his *Death on the Pale Horse* (Fig. 24). Yet West, who regarded himself as a universal genius, did not restrict himself to historical painting. He was the first man in England to employ the just-invented technique of lithography. That he could be an imaginative portrait painter his *Kosciusko* (Plate 46) makes clear. It is, on its small surface, a fascinating mixture of different forms and impressions. Showing the wounded hero lying in a squalid scene with grandeur behind it, West communicates a sense of mystery, of excitement, of derring-do.

His encyclopedic intellectual approach made West an excellent teacher. He was among the first in the British artistic establishment to appreciate that wild visionary William Blake and the transcendent father of naturalistic landscape painting William Constable. His door open to all Americans, he encouraged them to go in whatever artistic directions they pleased.

Copley attached himself to West's kite, and West was at first glad to pull him along. The Bostonian's European development makes clear how important a role isolation had played in his tremendous achievement as a portraitist in America. Free at long last to do so, he gave full vent to the colonial attitudes of

his upbringing. As quickly and thoroughly as he could, he abandoned the tense, controlled, powerful, sometimes clumsy manner that had blossomed in America from his personal experiments and obsessions. He labored to achieve what was almost the opposite: a fluent, brightly colored, richly painterly style.

Fig. 25. John Singleton Copley. *The Death of Major Pierson*. Oil on canvas, 97" x 144". 1782–1784. Tate Gallery, London.

Since he had great natural gifts, he practiced this technique with great effect —see his *The Death of Major Pierson* (Fig 25). He was soon rivaling West— the two men became enemies—as the leader of the British "historical" school. His *Henry Laurens* (Plate 40) reveals that as a portraitist he now reveled in all the graces, for which he had once vainly yearned, of the British aristocratic style.

Copley never returned to America, although as the years passed he dreamed of doing so. The only other of the recent artistic arrivals who stayed in London was Mather Brown. He followed West into historical painting, but with neither artistic nor financial success. As a portraitist he did better. His *Thomas Jefferson* (Plate 39) is, even if fancied up with a statue and a gargantuan lace ruffle, an attractive image.

Another American artist who had gone abroad before the Revolution was Joseph Wright. His mother, Patience Wright, was a modeler in wax. She had

moved from New York to London in about 1772. There she showed in a commercial "museum" her life-size three-dimensional historical groups and portraits. Joseph studied modeling with his mother, painting with the English portraitist John Hoppner (who married his sister), and with West. The first of the artistic exiles to return to America after the Revolution, Wright painted and modeled Washington, with the results here exhibited (Plates 35 and 36).

After George III officially acknowledged American independence, West planned a series of pictures based on the Revolution, but he soon discovered that thus publicly celebrating a British catastrophe would be pushing his tolerant royal patron too far. He handed the project over to Trumbull.

Had the famous West executed the pictures, they would have created an international sensation, and the new United States would undoubtedly have found a place to house the series of large canvases, even if the Americans had to build a special gallery, as they did later for West's *Christ Healing the Sick*. But Trumbull was an unknown student. West urged him to paint small canvases, the size of an engraving, and achieve circulation and sales by having the compositions engraved for the American market. The best of the resulting pictures, *The Death of General Montgomery* (Fig. 27), is a masterpiece of romantic battle painting, and Trumbull's *Declaration of Independence* (Fig. 26) was to become one of America's best-known compositions. Seeking to perpetuate truly the individuals who had created the nation, he went to great pains to secure accurate likenesses, often drawing, as in the case of *Israel Putnam* (Plate 37), the heads of the participants from life. As a formal portraitist he continued his directions as a young beginner in New England usually concentrating on the likeness against a plain background. His *Alexander Hamilton* (Plate 38) makes no effort to smooth over the sharp pitching of the features which Hamilton himself deplored. Trumbull caught the anxiety and strain which the neurotic but dashing statesman successfully hid from most of the world.

Since Trumbull needed to get subscriptions for his historical engravings before they were made, they had to be signed for sight unseen. Furthermore, communications were still so poor in America that nothing had yet been successfully sold nationally. Trumbull's series on the Revolution was not as strongly supported as he had hoped. Taking personal offense, he resumed his stance that art was beneath a man of his station. He turned to both diplomacy and trade, only painting when these preferred occupations failed him. As he grew older, his skill faded. Trumbull was the first (but far from the last) able American artist who, resentful of the craft basis on which American painting traditionally rested, destroyed himself as a painter through social pride.

Earl's course was exactly opposite. Accepting the role of an artisan-painter, he went, on his arrival in England, to the provinces, where he was able to sell portraits only slightly more smoothed out and knowing than *Roger Sherman*. Eventually, ambition did strike him. He came to London and West's studio, and actually exhibited at the Royal Academy. But his pictures, although veneered over with sophistication, remained angular and ungainly.

During 1785, Earl returned to America, where he offered to sell English-type

Fig. 26. John Trumbull. *Declaration of Independence.* Oil on canvas, 20" x 30". 1786–1797. Yale University Art Gallery, New Haven, Connecticut.

Fig. 27. John Trumbull. *The Death of General Montgomery in the Attack on Quebec.* Oil on canvas, 25" x 36". 1786. Yale University Art Gallery, New Haven, Connecticut.

pictures to the inhabitants of New York City. Drink was his vice as pride was Trumbull's. Pride carried Trumbull downward artistically; drink carried Earl into debtors' prison. Alexander Hamilton is said to have helped the painter earn money for release by sending his own wife behind the bars to be painted. Since Earl's is the only likeness of Mrs. Hamilton, I, as a biographer of Hamilton, have spent much time studying it for insight into her character. Visible is a competently rendered human shape; shining from the face are the dark eyes that Hamilton most admired in his bride, but there is no indication of character whatsoever. Earl had lost the human insight so conspicuous in *Roger Sherman*.

Since he had neither the urge nor the gifts to be a vapid society painter, since there was still active in him the desire to particularize his sitters, it was natural for Earl to return to the Connecticut countryside and the manner of Chandler that enabled him to define personality through environmental possessions.

Although his best painting years were behind him, Chandler was alive. And he had disciples. Reuben Moulthrop and Joseph Steward both earned their livings (as did Peale and Joseph Wright's mother) by creating "museums" which served a recreational need for people whose religious scruples prevented them from going to the theatre. Moulthrop exhibited in New Haven painted representations of dead heroes and current worthies and also events from the Bible reconstructed in wax. He advertised that his figure of Goliath was ten feet high. In Connecticut's other major city, Hartford, Joseph Steward exhibited portraits and paintings of Biblical and other subjects. "He has now," he advertised, "350 feet of painting." Since several of Moulthrop's canvases are based on portraits by Chandler, the New Havener must have penetrated to Chandler's village. Our exhibition contains two paintings by Moulthrop (Plates 47 and 48), two by Steward (Plates 49 and 50), and, also to demonstrate that the style traveled farther, a representation of a pudgy minister, the Rev. John Murray, by an unidentified hand (Plate 51).

Painted at the end of Moulthrop's career, *The Rev. Ammi Ruhamah Robbins* (Plate 48), which is one of the great American portraits, seems to show the combined influences of Chandler and Earl: Chandler in the clutter of the realistic setting, Earl in the rendition of depth which was not an aspect of Chandler's style. The minister's expression and pose, combining openness, disillusionment, and anxiety, create a most forceful characterization.

For years before *Robbins* was painted, Earl had been wandering Connecticut, often drunkenly, painting portraits that were sometimes daubs, sometimes lovely. There is no idiosyncrasy in the faces, but the compositions as a whole have true poetry. Earl's strange joining of the specific and the dreamlike is symbolized by the fact that, in his double portrait of Justice and Mrs. Oliver Ellsworth (Plate 44), he shows, outside the window, the facade of the house in which the couple sits. Landscape backgrounds were common in portrait art, but only as conventionalized indications of nature. Earl places Mrs. William Moseley and her son (Plate 42) in front of a true Connecticut landscape shown in depth, with New England church steeples rising from a village in the extreme distance. Col. Marinus Willett poses conventionally for his portrait (Plate 41), but he is being surveyed by two Indians from the deep background.

Earl made use of his English training to bring into the style of the Connecticut hedgerows ease and gracefulness and also visual depth. Yet it is possible to prefer the more powerful naïveté of works altogether homegrown: his own *Roger Sherman*, the best work of Chandler, Moulthrop's *Robbins*.

Charles Willson Peale's painting career in America covered a longer span than that of any other artist discussed in this volume. He picked up his brushes about 1762 and laid them down the year he died, in 1827. The second important American painter to study abroad, he joined his predecessor, West, at London in 1765. He stayed for only about two years. The Revolution had not yet broken out to kill business at home, and, as a political radical, Peale had no desire to make a career in England. He refused to pull his hat off when George III went by, and reappeared in America wearing the clothes he had worn when he left: he was boycotting British manufactures.

The portrait style he had found in London was very different from that which earlier American artists had adapted from earlier English engravings. Under the leadership of Reynolds and Gainsborough, the British school had broken with the old aristocratic conventions. The upper classes were no longer depicted as a formalized race apart. Walking the same world, they were separated from the commonalty by being more elegant, more graceful, richer, and handsomer.

Peale was described by John Adams as "a tender, affectionate creature. . . . He is ingenious. He has vanity, loves finery, wears a sword, gold lace, speaks French, is capable of friendship and strong family attachments." By his political conviction the graces of English portraiture did not appeal to him, yet his temperament was graceful, and he was a compulsive learner. Whenever he met anyone who practiced a skill he did not possess—even making false teeth or teaching the deaf and dumb—he could not wait to acquire it. He could not resist seeking the British skills that would enable him to record finery in all its charm.

Peale's style, between his return from England and the Revolution, is exemplified here by *Mrs. Jonas Greene* (Plate 54). Her costume is more elegantly rendered than silk and lace had ever been before in North America, but her face, with its double chin and homeliness of expression, is, though sympathetically rendered, the exact face of the woman who sat for the portrait.

All through his long career, Peale (he married three times and died of overexposure while seeking a fourth wife at the age of eighty-six) kindled when he had a chance of painting an elegant woman—if a man was elegant, he also enjoyed recording that—but most of the pictures in this exhibition were painted as historical records. After fighting in the Revolution and serving in Philadelphia as a radical political leader, Peale resolved to use his brush to commemorate the struggle in the old American manner. Instead of (as did Trumbull) painting historical compositions into which accurate likenesses were inserted, he would create a gallery of individual portraits. Some he had already painted in the army camps and elsewhere; others he now executed for his gallery, often making a replica for the sitter. An occasional subject, like the swashbuckling but now fattening Anthony Wayne (Plate 63), did not appeal to him at all, but usually he achieved a rapport that elicited an interesting psychological study.

Peale's gallery of portraits expanded into America's first major museum, in the process luring Peale, who conceived of and executed everything himself, into a half-dozen other careers: showman, manufacturer of mechanical moving pictures, taxidermist, creator of habitat groups, trompe l'oeil and still life painter, botanist, and paleontologist. His splashiest scientific adventure was digging up and assembling the first mastodon skeleton seen since the era of cavemen. In his old age, using a new style which he had learned from his son, he painted the huge portrait of himself standing before his museum which is one of the outstanding delights of this exhibition (Plate 62).

Peale's egalitarianism made him insist that artists were not "born such" but could be made by education. His family affections induced him to train the members of his own family. Shown here are the representation, by Charles's brother James Peale, of his family at play (Plate 64), and also two portraits by Charles's son Rembrandt (Plates 82 and 83), who became, despite a heavy, lightless style, a leading portraitist of the next generation. But these Peales are only a few of the members of a clan which was a powerful force in Philadelphia painting until the mid-nineteenth century. Under the leadership of brother James and Charles's son Raphaelle, the Peales set in motion America's first still life school.

The second major American creator in any art form was Gilbert Stuart. The first was, of course, Copley. Each was typical of his age. In the pre-Revolutionary manner, Copley had thought as a colonial, varying from transatlantic conceptions only because new departures were required of him by circumstances. Stuart's natural proclivity was to fight all convention, to repudiate exterior influence, following what his own mind, influenced by his own experience, made natural to him.

When Stuart was about fifteen, an opportunity had opened to him for which Copley would have given his eyeteeth: he accompanied as an apprentice a minor Scotch artist, Cosmo Alexander, back to Edinburgh. But Alexander died and Stuart was left in destitution and had to work his way home before the mast. This experience may have helped sour him concerning foreign models. In any case, when he got home to Newport and set up as a painter, he translated Alexander's superficial coquetries into primitive designs which, despite their lack of surface realism, communicate, through some imaginative alchemy, a sense of physical realities, of personality.

After Stuart had been, a few years later, dislocated by the Revolution, he proved just as self-willed. In London, the young American did not go to exhibitions or bother with the flourishing portrait school. He avoided West's hospitable studio. He tried to force down the throats of British purchasers such unnaturalistic images as he had sold in Newport. Only utter failure made him appeal at last to West. That benevolent painter introduced him to the sophistications of British portrait art and, recognizing almost at once his genius, made him his own first assistant.

As Saint Simeon Stylites might have abandoned himself to sensuous pleasures when at long last he climbed down from his pillar, Stuart absorbed in great gulps the technical virtuosities and the visual excitements of the British portraiture. He was particularly fascinated by what he called Gainsborough's

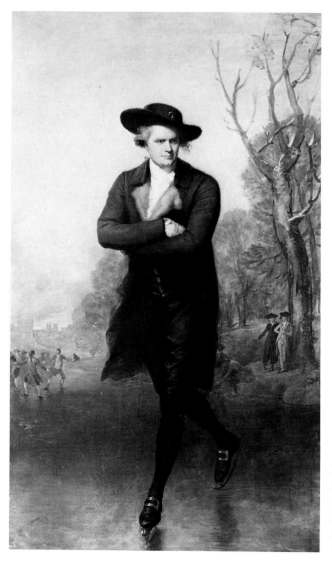

Fig. 28. Gilbert Stuart. *The Skater (William Grant of Congalton)*. Oil on canvas, 95-1/2" x 57-1/3". 1782. National Gallery of Art, Washington, D.C. Andrew W. Mellon Collection.

"dragging method of tinting." He learned so successfully that various of his English portraits, such as *The Skater* (Fig. 28), have been considered by experts to be major works by Gainsborough, Romney, and other English masters.

But, although fascinated with the technical possibilities that were now offered to him, Stuart had not abandoned his own way of thinking. He painted on West's "ten acre" canvases of heroic scenes without ever yearning to make this conventionally "exalted mode" his own. Although the son of Tories and utterly uninterested in matters political, he took in art the stand that nothing was more important than preserving the individuality of specific men and women. He teased West by stating, "No one would paint history who could paint a portrait."

On the English scene, his likenesses were considered too concerned with the sitter's actual appearance. "When we speak of him as the most accurate painter," a contemporary critic wrote, "we mean to say that, having a very correct eye, he gave the human figure exactly as he saw it, without any attempt to dignify or elevate the character, and was so exact in depicting its lineaments that one may almost say what Hogarth said of another artist, 'that he never deviates into grace.'"

Stuart was not patronized by the Tory aristocracy. But liberal Britons— sympathizers with the American Revolution; successful members of the middle

class—believed that Stuart would succeed Reynolds as the leader of the English portrait school. But one night he disappeared, leaving no address. Given to drink and other dissipations, he had been forced, despite great earnings, to flee his debts. After a period in Ireland, he returned, during the winter of 1792–1793, to the United States.

The techniques he now worked out in practice anticipated various later movements in art, on into Impressionism. At a time when draftsmanship was considered the foundation for a painted image, Stuart constructed a head altogether in terms of form. He asked his pupils—in the manner of West he befriended beginners—to imagine a face reflected back and forth between a series of mirrors. First you placed on the canvas the vague form seen in the third mirror. Then you achieved the image in the second mirror: the features clearer but still blurred. Finally you reached the first mirror, where everything was clear and sharp.

In laying on his pigment, he anticipated the Impressionists in seeking brightness by placing colors side by side and then being careful not to blend them with the brush. That was, he explained, "destructive of clear and beautiful effect." However, he denied another basic aspect of Impressionism: "My idea is as little colors in the shadows as you can."

When Stuart first reached the United States, he applied his whole English panoply of skills, as in his *Dr. William Samuel Johnson* (Plate 75). But as time went on he simplified his compositions placing, as in *John Barry* (Plate 73) and *John Adams* (Plate 74) and his best portraits of Washington, emphasis on the face to the exclusion of almost every other possible aspect of a portrait. Only enough body is shown to hold the head in place. Backgrounds are flat, unrepresentational colors designed to bring out the flesh tones. Flesh, Stuart stated, "is like no other substance under heaven. It has all the gaiety of a silk-mercer's shop without its gaudiness and gloss, and all the soberness of old mahogany without its sadness." He was a great flesh painter.

The brilliance of Stuart's color and the suaveness of his painting style hide, unless one looks carefully, the realism of his vision. The iridescent images show many a man or woman as a weakling, a rapacious four-flusher, or a fool. His portrait of John Adams, painted when Stuart was seventy-one and Adams eighty-nine, does not, for all its charm, hide the mottles and flushes of an old man's face.

10
THE NEXT GENERATIONS

Included in this exhibition are, because they depicted Revolutionary figures as older men and women, eight American painters who had been children or not even born when the Revolution raged. Their canvases exemplify the final phases of the American obsession with portraiture. They mark, indeed, the end of a tradition that reigned on this continent for two centuries, for more than half of the time that has elapsed between the first settlement of British America and 1976.

Up to the very brink of the Revolution validity had been forced on American portraiture by twin phenomena: likenesses had of necessity to be painted in America, where the artists lacked access to the models that would have been required for truly derivative expression. Portraiture grew humbly in American soil. Since every painter brought to his practice not the elevated attitudes of a fine artist but the practicality of a craftsman, likenesses were made in the same spirit as ploughs and teakettles. To a major extent, the artists relied on their ingenuity and beliefs.

When the Revolutionary period opened, European journeys became available to American artists. Although some of the painters penetrated to the continent, London was the Mecca. As it happened, this was the great period of English art, the time when London was briefly the painting capital of the European world. A great portrait school flourished under the leadership of Reynolds and Gainsborough.

In a reversal of the colonial situation, the portrait painters were flooded with persuasive models. Yet the American travelers were not, as a group, over-

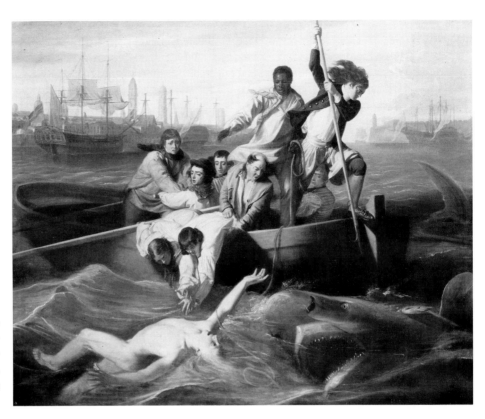

Fig. 29. John Singleton Copley. *Watson and the Shark*. Oil on canvas, 71-3/4" x 90-1/2". 1778. National Gallery of Art, Washington, D.C. Ferdinand Lammot Belin Fund.

whelmed. With the partial exception of Trumbull, who had been half an amateur, the artists had all been practicing professionals at home before they saw Europe. They had all been raised in the practical traditions of the crafts. And, most importantly, they were part of an American generation that was jubilantly if dangerously discovering its own destiny, giving its own barbaric yawp that was heard around the world. Most of the painters who returned to the United States reappeared as portraitists. They applied their acquisitions of more sophisticated techniques to expressing the revolutionary belief that a human being should be judged and recorded in his own right, not as a symbol of rank or power. This approach brought conviction to brushes wielded by many hands, for it expressed the basic conception of a time and place at which Western man was taking a giant step toward a fresh and exciting future.

But already there was blowing a wind inimical to portraiture. The conception that history painting was a much higher form of art than creating likenesses had been taken up by West with such success that engravings after his paintings traveled the civilized world, raising his reputation high. His triumphs and those of Copley, who was to rival him, were due to the unwillingness of members of the American Revolutionary generation to apply the high style only to conventional subject matter. They brought into figure painting the contemporary world and also that romantic surrender to the emotions which classicists considered not only artistically vulgar but socially lower class. Copley's *Watson and the Shark* of 1778 (Fig. 29), for instance, was in contrast to aesthetic convention because the endangered protagonist was not famous but just a young man swim-

ming, and the theme, being the rendition for sensation's sake of a frightening accident, taught no rational lesson. It took France more than a generation to catch up with this point of view. Géricault's *The Raft of the Medusa,* which was considered the first big gun in French Romantic painting, was executed thirty-nine years later and may well have been inspired by one of the ubiquitous engravings of Copley's composition.

As West, Copley, and even Mather Brown stayed abroad to paint history, Trumbull alone tried to import historical painting to the United States. When his effort failed, he painted portraits, but only spasmodically and resentfully. His belief that by doing so he demeaned himself as a gentleman was prophetic of the future.

Defensive colonialism was dead, but, once the ardors of achieving liberty and creating a new nation had been lived through, there appeared another attitude that led, though along a different path, to the same artistic conclusions. That attitude was defensive nationalism. Now that the United States was a nation among all others, national pride required that she hold up her head on the world scene. Although few Americans denied that she could do so in political institutions and would soon do so economically, culture seemed another matter. You could be proud of the Constitution, but how could you be proud of the painters from artisan backgrounds whose work deviated from what was most admired in Europe where sophistication reigned? No Americans were so eager for sophistication or so sure that they could achieve it as wealthy gentlemen, descended from socially correct families, college educated, and possessed of funds for extensive traveling abroad. These gentlemen resolved to make over American art.

This was to be an altogether new dispensation, completely based on the importation of culture from Europe. Gentlemen established as benefactions art academies, to which they presented casts from the antique so that beginners could draw from them just as art students did abroad. Gentlemen decided to elevate American taste as collectors. Spurred on by the confusions that then existed between originals and copies, encouraged by their own ignorance, they hung on the walls of their academy daubs attributed to great names. This left no room for the works of local artists. Most importantly for future developments, three of the four most able American painters of the early nineteenth century adopted the gentlemanly point of view. Two, Washington Allston and Samuel F. B. Morse, were born gentlemen; the third, John Vanderlyn, came from a line of artisan painters, but, under the patronage of gentlemen, became passionately converted to "elevated" contentions.

All three were sure of one thing: they had no intention of being portraitists. Unlike their American predecessors, all three went abroad for European study without first working as professionals at home. All three wished to learn in Europe to be history painters.

Vanderlyn sailed first (1796), being sent to Paris by that supporter of the French Revolution, Aaron Burr. Allston, who alone possessed a private fortune, journeyed to West's studio in London, but was in the long run more influenced by the Old Masters on the continent. Morse went to London in 1811, more a disciple of Allston than of West.

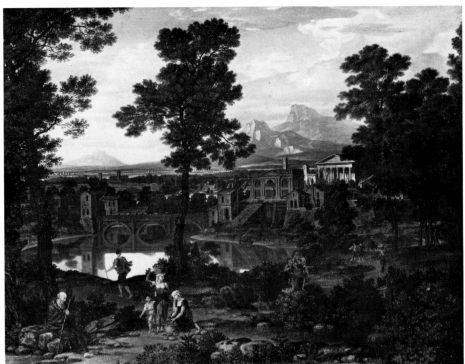

Fig. 30. Washington Allston. *Italian Landscape*. Oil on canvas, 39″ x 51″. 1805–1808. Addison Gallery of American Art, Phillips Academy, Andover, Massachusetts.

Fig. 31. Samuel F. B. Morse. *The Dying Hercules*. Oil on canvas, 96″ x 78″. 1813. Yale University Art Gallery, New Haven, Connecticut.

Fig. 32. John Vanderlyn. *Death of Jane McCrea*. Oil on canvas, 32-1/3″ x 26-1/2″. c. 1803. Wadsworth Atheneum, Hartford, Connecticut.

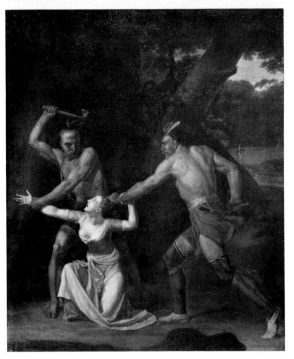

None of the three had the least interest in expressing or reflecting any aspect of American life or thought. The most aesthetically gifted, Allston developed a coloristic style from study of the Venetians. He applied it occasionally to history-soaked Italian scenery (Fig. 30) but more often to scenes from the Bible. Morse returned to classical themes (Fig. 31)—which he invested with a certain romantic ardor. In more artistically backward Paris, Vanderlyn became an exemplar of the pure neoclassicism which West had left behind a generation before. When Vanderlyn was commissioned by an American to paint a scene from the Revolution (Fig. 32), he based his figures of Indians on classic statuary.

All three artists began propitiously. Allston earned a considerable reputation in London. Both Vanderlyn and Morse won medals. Had these Americans stayed

Fig. 33. Washington Allston. *Study for Belshazzar's Feast*. Oil on mill-board, 25-1/2" x 34-1/4". 1817. Museum of Fine Arts, Boston. Bequest of Ruth Charlotte Dana.

abroad, as West and Copley had done, they might have been successful as history painters. But where their predecessors of the Revolutionary generation felt that they could be true to themselves as Americans in London, now that the United States was self-consciously trying to prove herself, the younger men felt impelled to return to America as missionaries of taste. They hoped to convert their homeland to the kind of art correctly admired in Europe. Allston, who brought back with him a considerable European reputation, was able to sell what he pleased to American connoisseurs: the huge canvas of *Study for Belshazzar's Feast* (Fig. 33), which he had started in London, was, although unfinished, subscribed for by ten Boston gentlemen. Morse, the youngest, found no market for his student works, but 112 New Yorkers subscribed to build a private museum for Vanderlyn.

Although far from unsympathetically received, all three of these artistic missionaries of culture lost, soon after their arrival on American soil, their ability to complete (or even start) the pictures, exemplifying the best imported taste, with which they had intended to elevate backward America. Unable to finish his *Belshazzar*, unwilling to paint anything that smacked of the United States whose egalitarian government he despised, Allston talked rather than painted. Vanderlyn devoted his energies to bitter denunciations of the American environment as soulless, money-grubbing, sterile. After excoriating the United States for being practical minded rather than aesthetically elevated, Morse put his own mind to the most practical of problems and invented the telegraph.

Allston's pupil, the sculptor William Wetmore Story, explained that in America the artist's heart "grows to stone." Allston had for instance "starved

spiritually." He had found "nothing congenial without and he turned his powers inward and drained his memory [of Europe] dry." To avoid such a fate, Story himself fled to Italy.

Allston had been protected by his financial position from making the least concession to his American environment, but both Vanderlyn and Morse had to make money by engaging their eyes and brushes in likenesses of their fellow Americans. When Morse had been forced in England to paint some portraits because his allowance from home had failed to arrive, he complained, "I have been immured in the paralyzing atmosphere of trade" until he had almost become reconciled to it. "Fie on myself: I am ashamed of myself! No, I will never degrade myself by making a trade of a profession. If I cannot live a gentleman, I shall starve a gentleman."

But no man likes to starve. Morse's and Vanderlyn's present reputations as artists depend largely on the portraits they were forced to paint. That they engaged in this "trade" with much resentment makes the effect of their work all the more remarkable. Again we feel the American genius, the inborn concern with practical things and individual men, pushing up despite and beside the creator's conscious will. Yet the fact remains that Vanderlyn's and Morse's portraits lack the passion and conviction of the best American likenesses of earlier days.

The resentment of the gentlemen against likeness-making as a "trade" was contagious to craftsmen artists not only for snobbish reasons. It was reinforced by the further ripening of a conception basic to the American psyche: concern with the individual. What had fostered strong portraiture was now undermining it.

The rise of the romantic movement was preaching that the artist should be a free spirit. Was not serving another person's ego denigrating to the artist as a free spirit? Was not the artist failing to respect his own individuality when he was devoting his talent to expressing the personality of a sitter in a way that could be made satisfactory not only to the paymaster himself, but to his sisters and his cousins and his aunts?

Even the fourth of the leading painters of the American era, who was frankly a portraitist and thus the best of them all, lost true power in his likenesses by seeking more direct self-expression than had Copley or Stuart. Thomas Sully occupied an uneasy middle ground between likeness-making and depicting a personal dream. He applied to his sitters a charm and elegance that was actually his own. The sitters accepted this with eagerness, because the result was flattering, and the best of Sully's portraits are eloquent, but often, finding too great the strain of merging his vision with the personality of another individual, Sully slipped off into a conventional sentimentality.

The other early nineteenth-century portrait painters had a discouraging tendency to accept the role of supertradesmen and paint frankly, sometimes cynically, for their market. One of the best, John Wesley Jarvis, who has four portraits in this exhibition (Plates 84, 85, 86, and 87), worked, when he was not

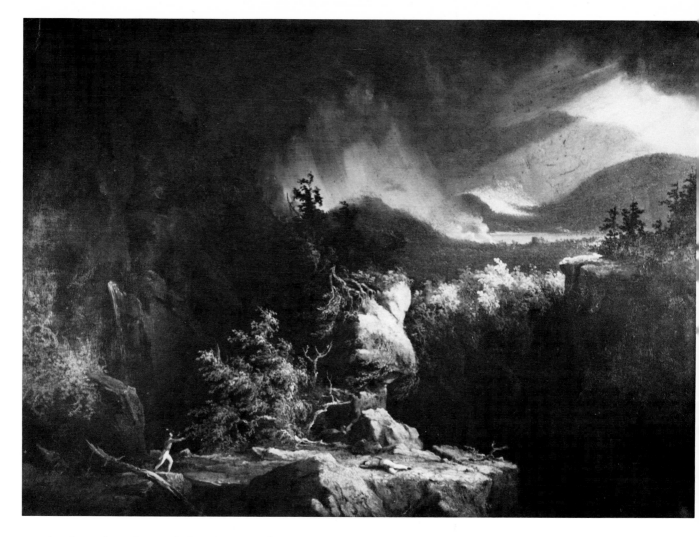

too drunk, with such speed that during a short career he produced between 750 and 1,000 likenesses.

Even among the hedgerows, vitality was giving out. There were no more Winthrop Chandlers. This was because opportunities to acquire technical skills had become widespread. To accept was to rise in everyone's estimation, to procure more impressive sitters, higher fees. The portraitists with ambition and power were drawn to the centers and to the practice that was generally admired. Benjamin Greenleaf's *Cotton Tufts* exemplifies the qualities to be found in nineteenth-century "folk portraiture": simplicity, graceful patterning, charm, but little force.

American art was in the doldrums. The "high styles" practiced in Europe were yearned for but failed to root in American soil. Although there was a tremendous demand for portraits and they were executed by the thousands—who in a republic was too insignificant to have his likeness recorded?—the conviction had drained out of portraiture. A new dispensation was desperately required.

The latest portrait in our show, Asher B. Durand's *James Madison* (Plate 99), strikes at the end of the line a surprisingly strong note. Here clearly is an artist with dedication! Yet Durand did not remain a portraitist for long.

The great shaper of American Man had always been the American land. From the start American men, women, and children were depicted. But a cultural taboo stood between the painters and their land.

Speaking for the conventional ideas, which extended in art criticism well into the nineteenth century, Alexander Pope wrote, "The proper study of man-

Fig. 34. Thomas Cole. *View near Ticonderoga, or Mount Defiance.* Oil on canvas, 24" x 34-1/4". 1826. Fort Ticonderoga Museum, Fort Ticonderoga, New York.

Fig. 35. Asher B. Durand. *In the Woods*. Oil on canvas, 60-3/4" x 48". 1855. Metropolitan Museum of Art, New York.

kind is man." Since landscape painting depicted nonhuman nature, it was by definition an inferior form. Its inferiority became greater in exact proportion to how little the scene shown had been shaped ("enriched") by human living. At the favorable extreme were renditions of the Roman campagna where so much traditional culture hovered: at the unfavorable extreme was the landscape of America. Its unsuitability was caused by the very characteristics that had made the New World so influential in shaping the American Man and thus inciting the American Revolution: its fresh, unencumbered wilderness that spoke not of the human past, but opened wide the arms of Nature to an unrealized dispensation.

Fascinatingly, the conventional attitude toward American scenery was protested in the late eighteenth century not by any cultural figure, but by a man who allowed his military and political originality to spill over into his view of art. After he had been changed and exalted by the Revolution, George Washington did his best to foster literal and loving views of wild American Nature. He failed because he could find no artists able to follow his urgings.

In the United States, government and ordinary living had shifted much further than in any part of Europe to the romantic conception that what Nature communicated was infinitely more important than the past history of man. But, during the first quarter of the nineteenth century, there was no equivalent springing forward in American cultural attitudes. It was Thomas Cole, an English immigrant self-taught as a painter in America, who with one hammer stroke smashed the imported taboo against glorifying wild American Nature. That the

exhibition during 1825 in the window of a New York frame store of four land-scapes by a complete unknown could have had so explosive an effect shows that, as had been the case with the American political Revolution, the ground was already amply prepared.

Cole, who had been lured from an English mill town by romantic dreams, often imbued American scenery with a dreamer's ardor (Fig. 34). Although he detonated the landscape revolution, he was a precursor rather than a true member of the Hudson River School that was to dominate American painting for half a century, until a new wave of artistic provincialism snuffed it out.

The true founder of the Hudson River School was Durand who, soon after painting Madison, turned all his energies to landscape painting (Fig. 35). With the other landscapists who rose around him, he revived the old American craft approach. Partly in reaction to the sterility of the previous artistic generation, the Hudson River School painters insisted, even more than the facts justified, that they were inventing their own style, independently of Europe. The true school of American art, they insisted, was American Nature. It was indeed dangerous for a beginner to look at pictures until he had developed his own style from a direct study of local hills, fields, and watercourses—as the old portraitists had done from a direct study of features.

Far from being embarrassed into imitation by the knowledge that he belonged to the youngest of nations, Durand called for "an original school of art worthy to share the tribute of universal respect paid to our condition of political advancement." The artists harbored no fear that popular American taste was vulgar. Their friend, the historian George Bancroft, postulated that democratic conceptions pointed the way to "the sublimest success" in art, since, by learning how to appeal to the people, the artist would penetrate to the "universal sense of the beautiful . . . that lies deep in every American soul."

The gentlemen connoisseurs were at first outraged by this revolt against their cultural hegemony, but were eventually gathered up into a national wave of enthusiasm for the Hudson River School artists who spoke directly and elegantly to the natural taste of the new nation. Their attitude toward American Nature parallelled the attitude toward the American Man of the portraitists who had risen as part of the Revolutionary generation. The Hudson River School felt no urge to conventionalize, to embellish American views with references to foreign vistas or European culture. They sought to express profoundly what they saw before them. "The artist as a poet," Durand wrote, "will have seen more than the mere matter of fact, but not more than is there and that another may see if it is pointed out to him." Gilbert Stuart and his contemporaries would have been happy to accept this dictum in painting "the Face of Liberty," the Founders of the United States.

Founders:

As exhibited at the Amon Carter Museum of Western Art, Fort Worth, Texas

JOHN HESSELIUS

Thomas Johnson (1732–1819)

Oil on canvas 30-1/4" x 25-1/4"

c. 1766

MARYLAND HISTORICAL SOCIETY, BALTIMORE
PURCHASED WITH FUNDS FROM THE BEQUEST OF
JOSEPHINE CUSHING MORRIS, IN MEMORY OF MISS MORRIS

Born in Maryland, Thomas Johnson was trained as a lawyer. In 1762, he was a delegate to the Provincial Assembly and later served on the committee that drafted proposals to the General Congress urging unification of the colonies and protesting the unjust taxes imposed by the Stamp Act.

In September 1774, Johnson took his seat as a representative of Maryland in the First Continental Congress at Philadelphia where he served on several of the most distinguished committees and was highly respected for his integrity, sound judgment, legal acumen, and fluent pen. In the Second Continental Congress, he had the honor of nominating George Washington as commander in chief of the Continental Army.

As a brigadier general of the state militia, Johnson went to Frederick, Maryland, to raise and equip troops, eventually leading 1,800 men to Washington's headquarters in New Jersey. Since Johnson was part owner of an ironworks, he also contributed guns and ammunition to the Revolutionary forces.

From 1777 to 1779, he served as the first governor of Maryland and thereafter played an important part in the formation of his state government. He was an associate justice of the United States Supreme Court from 1791 to 1793 and, as a member of the board of commissioners of the Federal City, was one of the men responsible in 1791 for recommending Washington as an appropriate name for the capital of the United States.

Due to illness, Johnson retired from political life in 1795. He made one final public appearance in February 1800, however, when he delivered a solemn eulogy in memory of his lifelong friend George Washington.

This picture was probably painted when Johnson was about thirty-four years old on the occasion of his marriage to Ann Jennings (c. 1745–1794) of Annapolis in 1766. The pose is virtually identical to that of the Hesselius portrait (which follows) of John Hanson, a man with whom Johnson had close political and business associations.

Plate 1

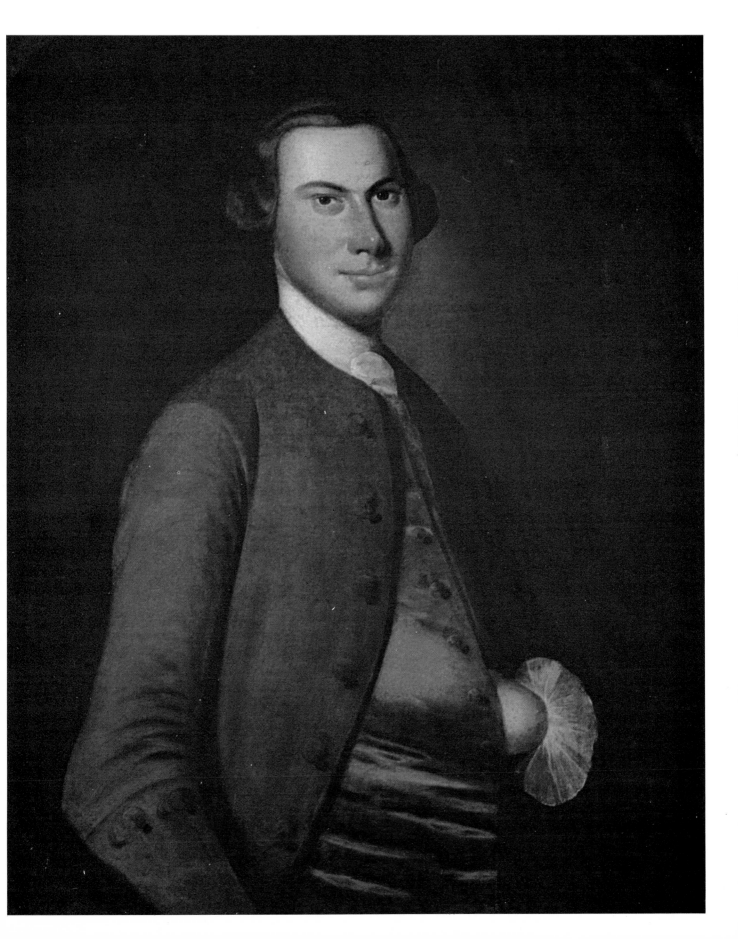

John Hanson (1715[1721?]–1783)

Oil on canvas 29-1/2″ x 25-1/2″
Undated

THE BALTIMORE MUSEUM OF ART,
THE HANSON RAWLINGS DUVAL, JR., MEMORIAL COLLECTION
BEQUEST OF ELIZABETH CURZON HOFFMAN WING

John Hanson entered the Maryland Assembly in 1757 and served intermittently until 1773. In 1769 he signed the nonimportation agreement Maryland adopted as a protest against the Townshend Acts.

When Hanson moved from Charles County, Maryland, to Frederick County in 1773, his leadership and organizational abilities blossomed. Although never a great orator, he chaired a mass meeting in Frederick Court House, where he was instrumental in the adoption of resolutions to cease all trade with Great Britain and the British West Indies until repeal of the Acts of Parliament closing the Port of Boston. At this meeting he and his son Alexander were appointed two of three delegates to the "General Congress at Annapolis" and members of the county government called the Committee of Observation. As chairman of this committee, the elder Hanson became responsible for raising and arming troops.

In 1775 Hanson personally organized two companies of trained riflemen who immediately were ordered to march to Cambridge, thereby earning the distinction of being the first southern troops to join General Washington. Hanson was also instrumental in the prevention of an invasion by Indians and Loyalists on the western frontiers of Maryland, Virginia, and Pennsylvania by the capture and arrest of the expedition's leaders.

In 1780 the Maryland Assembly elected Hanson as a delegate to the Continental Congress, where he particularly distinguished himself as a statesman and master politician. Arguing that the claims of states such as Virginia, New York, Connecticut, and Massachusetts to vast lands beyond the Alleghenies would eventually create internal instability and dissension, he and the other Maryland delegates refused to ratify the Articles of Confederation until all claims were relinquished. The Maryland delegation triumphed and the Articles of Confederation were completed March 1, 1781.

Hanson was the first president of the Continental Congress after Confederation, which has induced his descendants to claim that he was the first President of the United States. Due to failing health, he retired after only one year in office. He died at Oxon Hill, Prince Georges County, in November 1783.

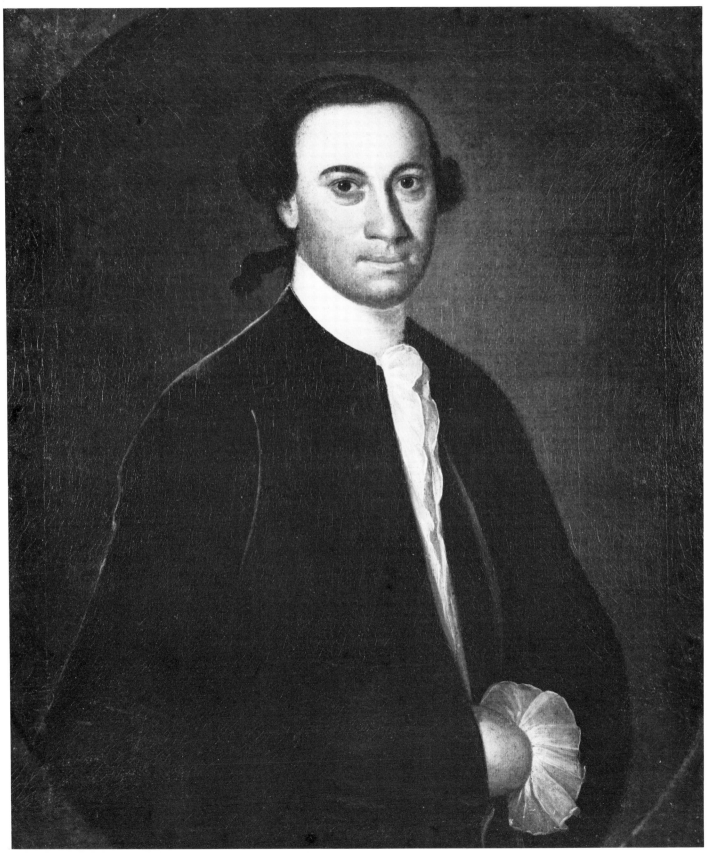

Plate 2

Mrs. Thomas Lynch (Elizabeth Allston) (c. 1728–?)

Oil on canvas 29-7/8″ x 24-7/8″

Signed and dated: Theus 1755

REYNOLDA HOUSE, INC., WINSTON-SALEM, NORTH CAROLINA

Elizabeth Allston was the daughter of William and Ester Allston. In 1745 she married Thomas Lynch of Charleston, South Carolina, an ardent patriot who opposed the Stamp Act and favored nonimportation as the best possible means of bringing the British government around to America's point of view. Active in local politics, he was made a delegate to the First and Second Continental congresses, but a paralytic stroke in the early part of 1776 prevented him from signing the Declaration of Independence. His son Thomas, Jr., who had been elected as an additional delegate to the Second Continental Congress, so that he could take care of his sick father, did sign the Declaration. Thomas, Jr., had also been active in local politics, notably in helping draft the state constitution.

This picture represents the mature style of Theus, while in its charming elegance it reflects the aristocratic taste of Charleston.

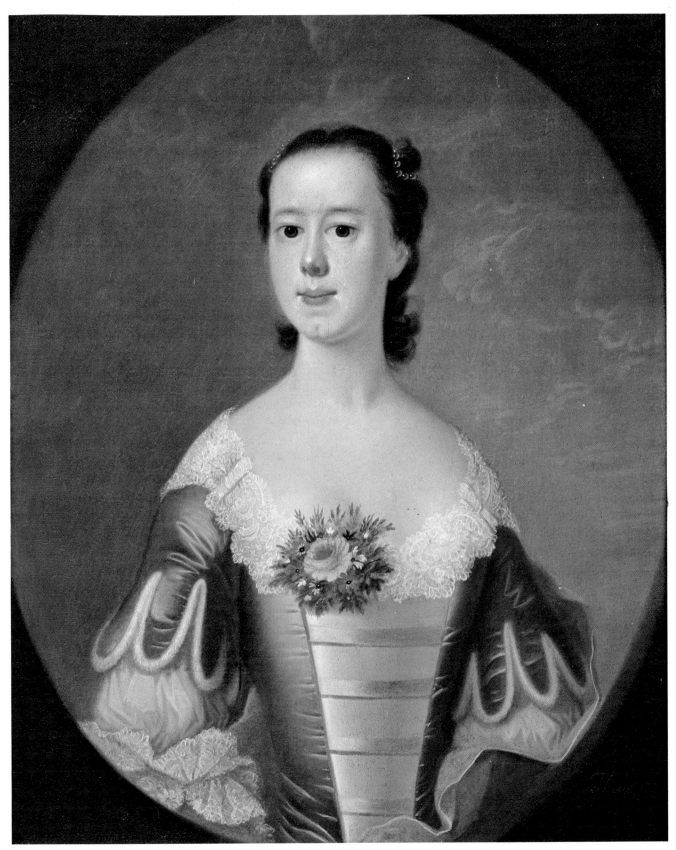

Plate 3

ROBERT FEKE

Mrs. James Bowdoin II (Elizabeth Erving) (1731–1803)

Oil on canvas 50-1/8" x 40-1/8"

Signed and dated: R Feke Pinx/1748

BOWDOIN COLLEGE MUSEUM OF ART, BRUNSWICK, MAINE
BEQUEST OF MRS. SARAH BOWDOIN DEARBORN

At the age of seventeen, Elizabeth Erving, one of three daughters of John Erving, a wealthy Boston merchant, married James Bowdoin. The young couple had two children, a boy, named after his father, and a girl, named after her mother.

Little is known of her life, other than the fact that she was of somewhat frail health. In a letter of December 3, 1763, to his brother-in-law George Scott, Governor of Grenada and Dominica, Mr. Bowdoin laments that his wife "knows the occasion of her ill state, and the means of removing it. She has nothing to do but to disuse tea and snuff, and in a few months she would again be the finest girl in Christendom. A few trials of this sort have had an excellent effect, but the force of habit is too strong for her resolution."

This picture and its companion piece of Mr. Bowdoin were painted in Boston in 1748, the year of James and Elizabeth's marriage. The portraits produced during this period are considered to be among Feke's finest, particularly showing his delight and skill in rendering sumptuous fabrics.

Prown points out that the pose is derived from an Isaac Beckett mezzotint after William Wissing of Princess Anne, c. 1683. Although the open landscape background has been reversed from left to right, Copley used a related pose in an early portrait of Mrs. Joseph Mann (1753).

ROBERT FEKE

James Bowdoin II (*1726–1790*)

Oil on canvas 50" x 40"

Signed and dated: R F Pinx/1748

James Bowdoin II was a man of many talents. A lifelong friend of Benjamin Franklin, he not only shared the great statesman's interest in scientific phenomena, but in politics as well. Bowdoin published various papers about telescopes and the "Phenomena of Life" and devoted almost thirty-seven years to public service.

Bowdoin officially entered politics with his election in 1753 to the Massachusetts House of Representatives. In 1757 the House elected him to the Governor's Council, a body similar to today's State Senate, and with the exception of one year, he served on this body until 1774.

In 1769 Bowdoin, who had been in constant opposition to Royal Governor Sir Francis Bernard, launched a campaign to have Bernard replaced. In retaliation, Bernard vetoed Bowdoin's reelection to the Council. This incident and Bowdoin's response to it—"Your Excellency's Censure is Praise . . . and Honour to the Man who is the Subject of it, and the best Evidence that he has done his Duty"—not surprisingly, won Bowdoin great fame with the Sons of Liberty. Bernard was replaced in 1770 by the Tory Thomas Hutchinson.

While Hutchinson linked Bowdoin with the rebellious Samuel Adams, Bowdoin still cast himself as a moderate Whig, particularly because he had many Loyalist friends and relatives. But the Tea Act of 1773 and subsequent revolt changed all that. Unlike the more conservative Whigs who abhorred the Boston Tea Party, Bowdoin fully supported the radicals.

On June 17, 1774, he was elected to head the Massachusetts delegation to the First Continental Congress in Philadelphia. But his wife's failing health forced him temporarily to retire from public life and John Hancock was elected in his stead. As a member of the Massachusetts Council he helped plan the reorganization of the Continental Army and was one of the first to reject British overtures for peace unless complete withdrawal of British troops from the colonies was guaranteed. Presiding at the proclamation of the Declaration of Independence, he offered the salute: "Stability and Perpetuity of American Independence."

In 1779 he returned to official public service as president of the constitutional convention of the Commonwealth of Massachusetts and chairman of the committee charged with drafting the state constitution. In this capacity he was often consulted and reportedly exercised considerable influence. In his last years he achieved considerable fame as governor of Massachusetts, particularly with his suppression of the insurrection known as Shays's Rebellion.

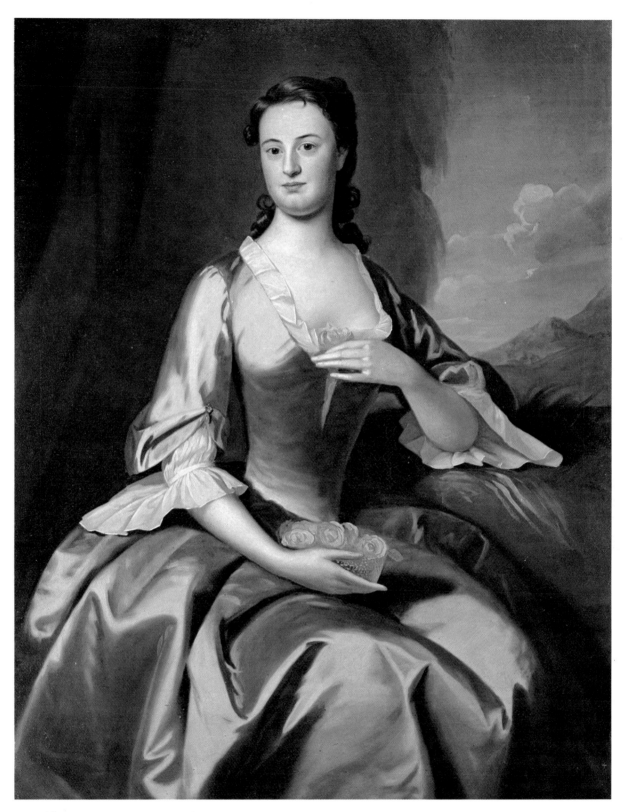

Plate 4

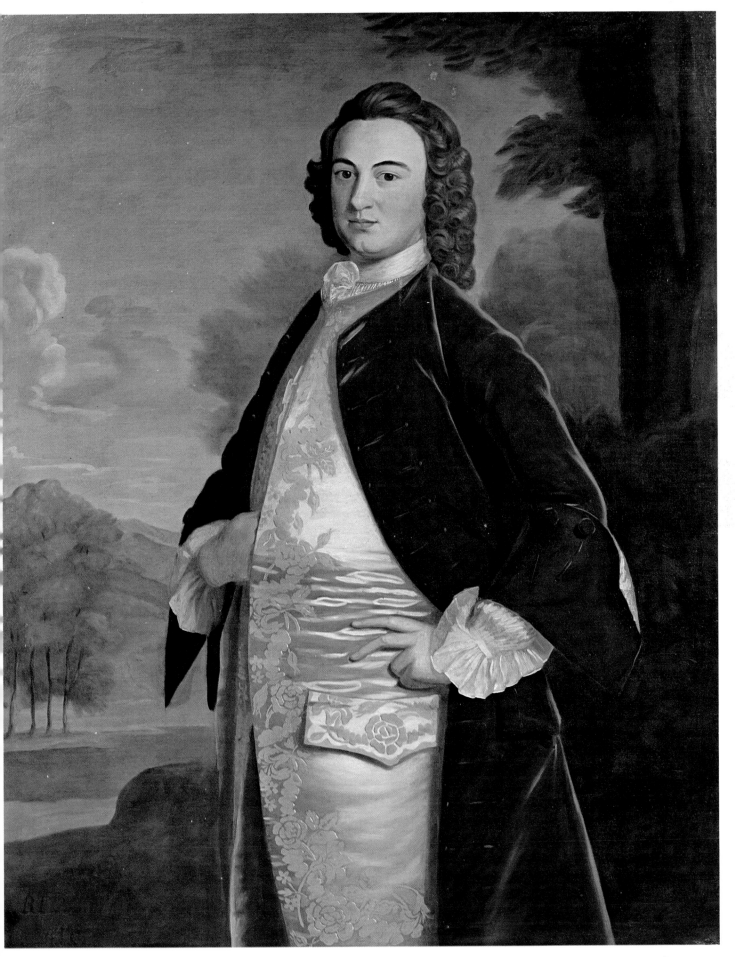

Plate 5

BENJAMIN WEST

William Henry (1729–1786)

Oil on canvas 36-3/4" x 30-1/2"

c. 1755, Lancaster, Pennsylvania

HISTORICAL SOCIETY OF PENNSYLVANIA, PHILADELPHIA

William Henry's fame lies in three areas. He was an engineer credited with the first attempt in America to apply steam to propel a boat; he was a patriot and a patron of the arts.

According to Henry's biographer Francis Jordan, Jr., in *The Life of William Henry* (Lancaster, Pennsylvania, 1910), his house in Lancaster, Pennsylvania, served as a military information center: "A sentinel was placed before his door, officers of the army were coming and going, delegates to congress and members of the assembly mingled in an anxious and busy throng." There he entertained George Washington, Thomas Paine, Lafayette, and others.

It was, however, in the capacity of assistant commissary general that Henry particularly distinguished himself. He was in charge of arming of the troops and the transportation of supplies of every description. A leading manufacturer of guns in the colonies, he developed an unusually accurate firearm. His employees were exempted from military duty so that they could work night and day to fulfill the need for weapons.

Henry also established workshops in Philadelphia, Lancaster, Allentown, and elsewhere in Pennsylvania for the manufacture of boots, shoes, hats, and other accouterments for the army. Often these activities were financed from his own pocket, and it was not until 1811 that his heirs were reimbursed for the large personal advances Henry made during the Revolution.

Henry was also active in the local politics of Lancaster. In 1776 he was a delegate to the State Assembly; in 1777 he became a member of the Council of Safety; and in 1784, the assembly elected him to the Continental Congress. He died while in office.

In about 1755 William Henry recognized the budding talent of young Benjamin West and invited him to stay at his house. He supplied him with the material essential to a painter's work and admonished him to "devote himself to historical subjects." Since West had no background in the classics, Henry opened his library to him and encouraged him to try his first historical work, *The Death of Socrates*.

West painted the portraits of Mr. and Mrs. William Henry during this visit, presumably on the occasion of their marriage. Henry holds what must certainly be one of his own rifles, while in the background across the stream rises an imaginary medieval-like structure.

Plate 6

Mrs. William Henry (Ann Wood) (*1732[1734?]–1799*)

Oil on canvas 36-1/2″ x 30-1/2″

c. 1755

HISTORICAL SOCIETY OF PENNSYLVANIA, PHILADELPHIA

Ann Wood, daughter of Abraham and Ursula Wood, was born in Burlington, New Jersey, married William Henry in 1755 and lived in Lancaster, Pennsylvania. Well-read and as patriotic as her husband, she was noted for her clear-headedness and strong convictions. For several months she stoically endured the radical pamphleteer Thomas Paine as a house guest. Although his indolence and atheism were in direct conflict to her Christian background, Mrs. Henry was persuaded that his patriotic essays, some written in her home, were an influential contribution to the American cause.

When her son John Joseph volunteered to serve in the Continental Army without the consent of his father, she helped and supported him.

Notable for her administrative and business abilities, Mrs. Henry, after the death of her husband, was appointed to finish his term as treasurer of Lancaster County. She served four years and retired with honor.

Plate 7

James Warren (1726–1808)

Oil on canvas 51-1/4″ x 41″

c. 1761–63

MUSEUM OF FINE ARTS, BOSTON
BEQUEST OF WINSLOW WARREN

Born in Plymouth, Massachusetts, and educated at Harvard, James Warren was a merchant and gentleman farmer. He held minor civic offices and later became involved in political activities by drafting an indictment of the Stamp Act, which was passed at the Plymouth town meeting. During his service on the General Court from 1766 to 1778, he continuously voted with the left wing of the patriot party. In his community he was chairman of the Committee of Correspondence and organizer of radicals and revolutionary committees.

He was a close personal friend of and adviser to the Adamses, and his home became a political club and meeting place for Boston's activists. As a member of the Massachusetts Provincial Congress, he served on many important committees and, after the death of Joseph Warren (no relation), succeeded him as president. Because of his overwhelming admiration of Washington, he used this position to urge the Continental Congress to create an army and make Washington its commander in chief. He was paymaster general of the Continental Army while it was at Cambridge and Boston.

In the meantime, Warren was elected as Speaker of the Massachusetts House of Representatives after the dissolution of the Provincial Congress. From this influential post he implored Congress to create a Continental Navy and draft a Declaration of Independence.

While he was appointed major general of the provincial militia, he resigned without ever fighting because he refused to serve under a continental officer of a lower rank. He lost his seat in the house, partly because his political arch-enemy John Hancock used the event to undermine his prestige.

General Warren agitated against ratification of the Federal Constitution, which he felt threatened the sovereignty of the states. Since this was an unpopular position, he soon retired from politics and pursued the study of scientific farming.

Copley has portrayed Warren as a country gentleman with ruddy complexion and walking stick in hand. Prown has pointed out that the composition and palette reflect the influence of Joseph Blackburn who worked in Boston between 1755 and 1762.

JOHN SINGLETON COPLEY

Mrs. James Warren (Mercy Otis) (1728–1814)

Oil on canvas 51-1/4" x 41"

c. 1761–63

MUSEUM OF FINE ARTS, BOSTON
BEQUEST OF WINSLOW WARREN

Born in Barnstable, Massachusetts, Mercy Otis acquired no formal education, yet she achieved fame as a dramatist, historian, and patriot. She grew up in a home that was a center of lively political discussions in which the children were welcome participants. In 1754, she married James Warren, the radical leader. Not surprisingly, when the conflict with the British accelerated, she became increasingly drawn into her relatives' political activities.

Since Mrs. Warren had composed poetry as early as 1759, she was encouraged to put her pen to the service of the Revolutionary cause. She wrote several political satires in the 1770s. One of them, *The Adulateur,* was in the form of a play meant to be read and was published in the *Massachusetts Spy.* It cast Royal Governor Thomas Hutchinson as the archvillain Rapatio, ruler of the mythical country of Servia, who hoped to crush "the ardent love of liberty in Servia's free-born sons."

Endowed with a powerful intellect and respected for her unwavering democratic convictions, Mrs. Warren had active correspondence about political matters with many of the major leaders, most notable of whom were Samuel and John Adams, Thomas Jefferson, and Henry Knox. Like her husband, she vigorously opposed ratification of the Federal Constitution and, by the end of the 1780s, her reputation and influence declined.

Mrs. Warren's major literary work is considered the three volume *Rise, Progress, and Termination of the American Revolution* (1805). Today, this lively history is useful primarily for the penetrating insights into the leading personalities of the era and analysis of events of which she had firsthand knowledge.

Mrs. Warren deplored the inferior education offered to women in her time and believed they could easily participate in many activities then considered the exclusive province of men. On the other hand, she once advised a friend that women should accept "the appointed Subordination," not because of any inherent inferiority but "perhaps for the sake of Order in Families."

Copley's masterful ability to render realistically contrasting textures, here of shimmering satin and the delicate tracery of lace, is particularly evident in this portrait. Since Mrs. Warren was a great lover of flowers, Copley depicted her tending orange and yellow nasturtiums, a delicate touch which is perhaps also an allusion to her poetic nature. Characteristic of many of Copley's early works, there is little spatial integration between the foreground figure and the background.

Plate 8

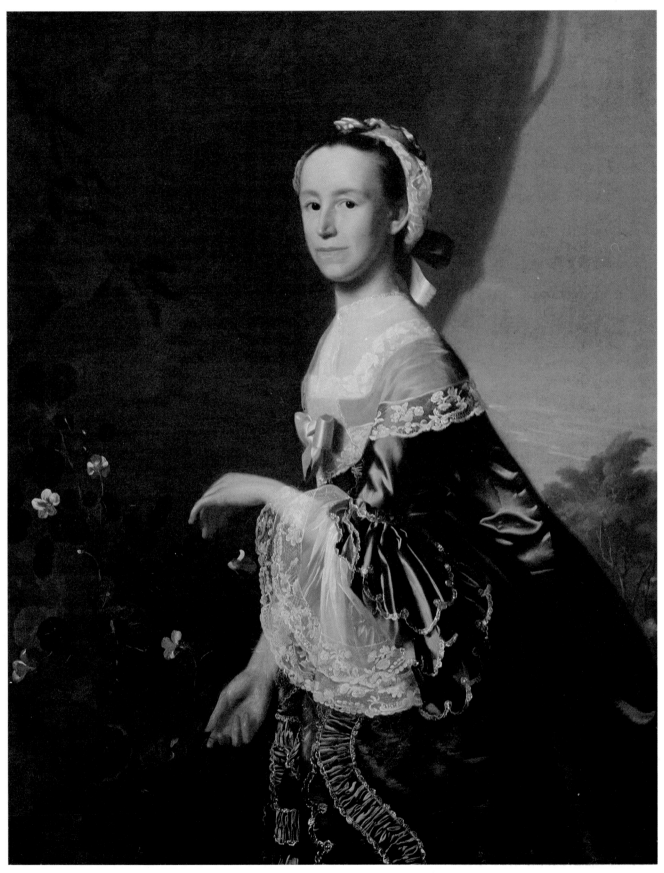

Plate 9

JOHN SINGLETON COPLEY

Daniel Hubbard (1736–1796)

Oil on canvas 50-3/8" x 39-3/4"

Signed and dated: John S. Copley pinx./1764

THE ART INSTITUTE OF CHICAGO
ART INSTITUTE PURCHASE FUND

Daniel Hubbard, the son of Daniel and Martha Coit Hubbard, was born in New London, Connecticut, where his father was county sheriff. After his father's death, his mother married Thomas Greene of Boston, where Daniel grew up and became a member of the substantial merchant class which John Singleton Copley so often depicted.

Hubbard is an example of the many Americans, particularly wealthy merchants, who opposed Great Britain in the 1760s with respect to the taxes, but rejected the idea of American independence and remained loyal to the Crown throughout the Revolutionary era. Thus on March 4, 1768, he put his name to a nonimportation agreement in protest to the Townshend Acts. However, in 1774 and 1775 he signed citations of commendation to Royal Governors Hutchinson and Gage.

Hubbard undoubtedly left America with thousands of other Loyalists shortly after the British evacuation of Boston in 1776. He spent the rest of his life conducting various mercantile activities from London, South America, Santa Cruz, and the Danish West Indies.

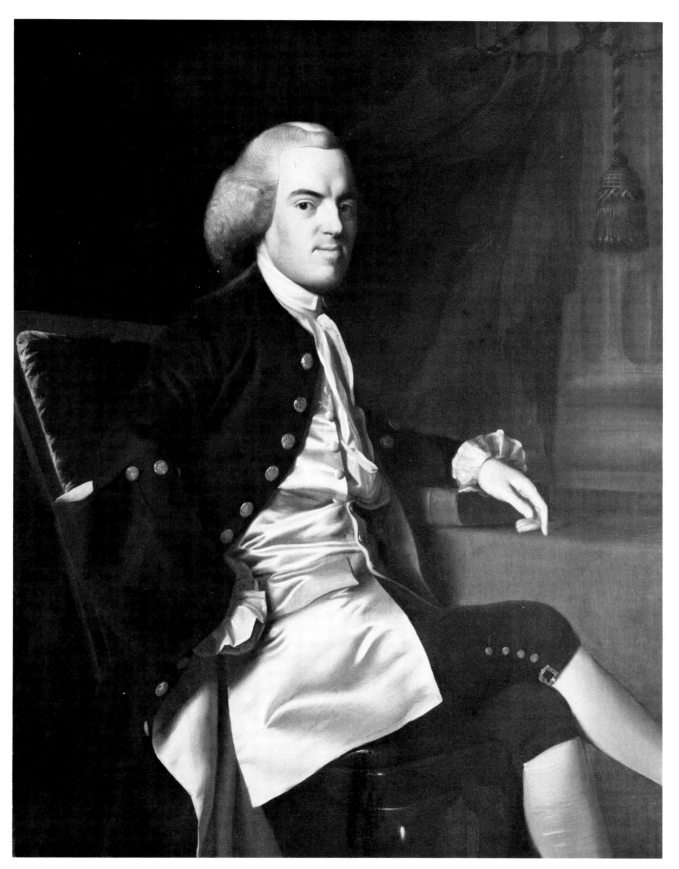

Plate 10

JOHN SINGLETON COPLEY

Mrs. Daniel Hubbard (Mary Greene) (1734–1808)

Oil on canvas 50-1/4" x 39-7/8"

c. 1764

Mary Greene, the eldest daughter of Thomas Greene and Mary Gardiner, was born in Boston. Her mother died when she was a child, and her father married Mrs. Daniel Hubbard, the mother of Mary's future husband. Daniel Hubbard and Mary Greene were married on July 13, 1757, and lived in Boston.

The pose and costume of this picture are closely based on a Faber mezzotint after Thomas Hudson's *Mary Viscountess Andover*. Copley used the same engraved model in his portraits of Mrs. Hubbard's cousin Mrs. John Amory (1764) and Mrs. John Murray (1763). (See pages 46–47.) The emphasis on the folds of her golden brown dress and the predilection for pearls reflect the influence of Joseph Blackburn.

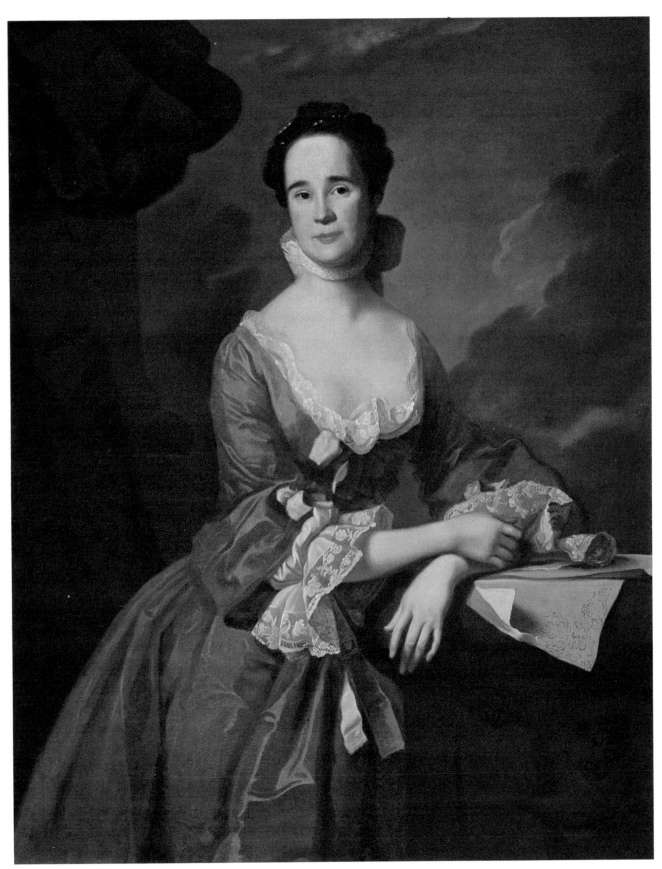

Plate 11

JOHN SINGLETON COPLEY

Samuel Adams (1722–1803)

Oil on canvas 50" x 40-1/4"

c. 1772

MUSEUM OF FINE ARTS, BOSTON
DEPOSITED BY THE CITY OF BOSTON

Born in Boston, educated at Harvard, Samuel Adams worked briefly and unsuccessfully as a lawyer, merchant, brewer, and tax collector before his talent for political organization emerged in his early forties. As a member of the influential Caucus Club and later the Sons of Liberty, Adams opposed the wealthy conservatives of Boston and incited popular hatred against them.

From 1765 to 1774 he served in the House of Representatives where as clerk he drafted most of the official papers. He directed opposition to the Townshend Acts and organized the Non-Importation Agreement. By 1766 the House and the General Court were controlled by the radicals with Adams as the outstanding leader.

During the early 1770s, when antipathy toward the British was declining, Adams kept the fires of revolution burning with his skillful propaganda and pamphleteering, warning the populace of the approach of tyranny. In 1772 he inaugurated the idea of the Committee of Correspondence "to state the rights of the Colonists . . . and to communicate the same to the several towns and to the world." He was one of the leaders of the Boston Tea Party of December 1773. From 1774 to 1781 he served in the Continental Congress, an advocate of immediate independence and confederation. He was a signer of the Declaration of Independence.

Essentially a Revolutionary agitator with no capacity for enlightened statesmanship, Adams did not have the influence after the Revolution that he had before. He was a reluctant supporter of the federal Constitution. He retained his popularity in Massachusetts, however, and served three terms as governor from 1794 to 1797.

Copley portrayed Adams as he appeared the day after the Boston Massacre of March 5, 1770, in his dramatic confrontation with Governor Hutchinson. Adams points to the Massachusetts Charter which, he argued, gave the governor, as commander in chief of the army and navy, the power to remove the redcoats from the metropolis. In his right hand he clutches a document inscribed "Instructions of Town/Boston," evidence that he was sent as spokesman of the residents of Boston. After Adams threatened a new round of violence and uprisings, Hutchinson capitulated and ordered removal of the British troops.

The sharply illuminated features, compelling stare of the eyes, and the alertness of the pose combine to create one of Copley's most dramatic pictures. In 1772 John Hancock commissioned Copley to paint this portrait and one of himself for his mansion on Beacon Hill.

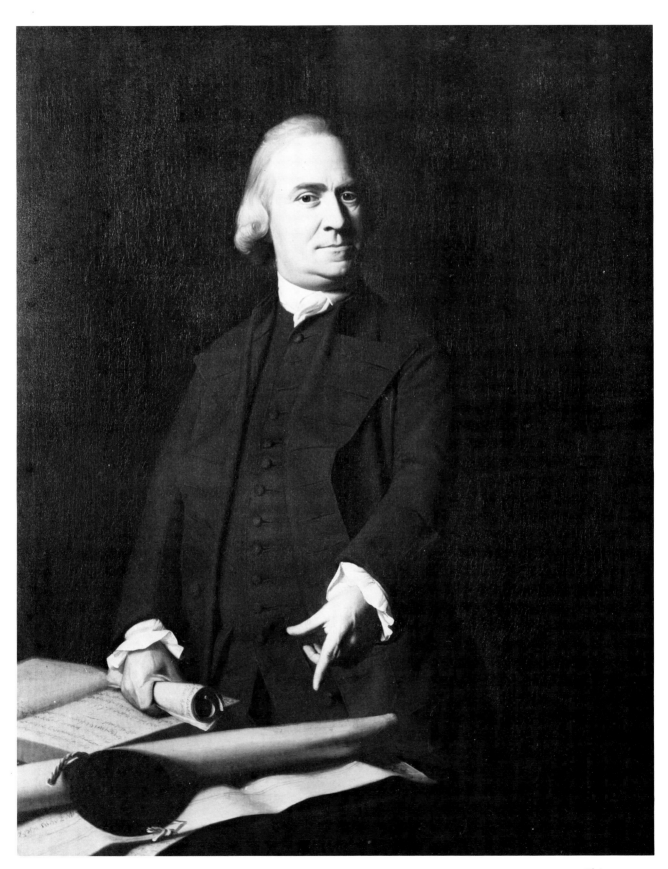

Plate 12

JOHN SINGLETON COPLEY

Mrs. Richard Skinner (Dorothy Wendell) (1733–1822)

Oil on canvas 39-3/4″ x 30-3/4″

Signed and dated: John Singleton Copley pinx/1772/Boston

MUSEUM OF FINE ARTS, BOSTON

BEQUEST OF MRS. MARTIN BRIMMER

Dorothy Wendell was the daughter of John Wendell, a well-to-do merchant in Boston. On June 16, 1756, she was married to Richard Skinner, the son of her stepmother, Mercy Skinner of Marblehead.

This portrait and the portrait that follows of Dorothy's first cousin Dorothy Quincy are closely related in pose and costume. While the portrait of Dorothy Quincy is obviously more ambitious in scale and details, this likeness is generally considered one of Copley's masterpieces.

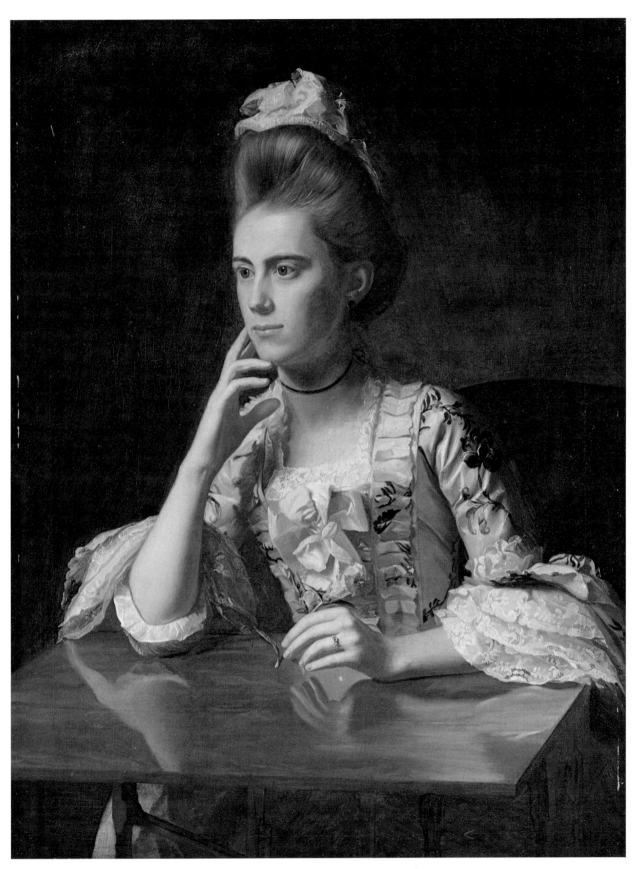

Plate 13

JOHN SINGLETON COPLEY

Dorothy Quincy (Mrs. John Hancock; later Mrs. James Scott)
(1747–1830)

Oil on canvas 50" x 39-1/2"

c. 1772

MUSEUM OF FINE ARTS, BOSTON

CHARLES H. BAYLEY FUND AND PARTIAL GIFT OF ANNE B. LORING

Dorothy Quincy was born in Boston on May 10, 1747, the youngest of ten children of Judge Edmund and Elizabeth Wendell Quincy. She spent her youth in Braintree, Massachusetts.

Since her father was an ardent patriot, such "rebels" as Samuel and John Adams, Dr. Joseph Warren, James Otis, and John Hancock were frequent visitors at her home. Thus, on the eve of the Revolution, as a precautionary measure, Dorothy went to live with John Hancock's aunt Lydia at the residence of the Reverend James Clark in Lexington. She was therefore a witness to one of the first battles of the Revolution, on April 19, 1775. A few days later Dorothy and Lydia went to Fairfield, Connecticut, where they stayed as guests at the residence of Thaddeus Burr. There John Hancock and she were married on August 28, 1775.

After the Revolution, the Hancocks became the leaders of the affluent society of Boston. Dorothy was renowned for her gracious hospitality and witty conversation.

In 1793 John Hancock died. Three years later Dorothy married James Scott, an old friend and a mariner. Her second husband died in 1809; she never remarried but remained a popular and fashionable hostess in Boston for the rest of her life.

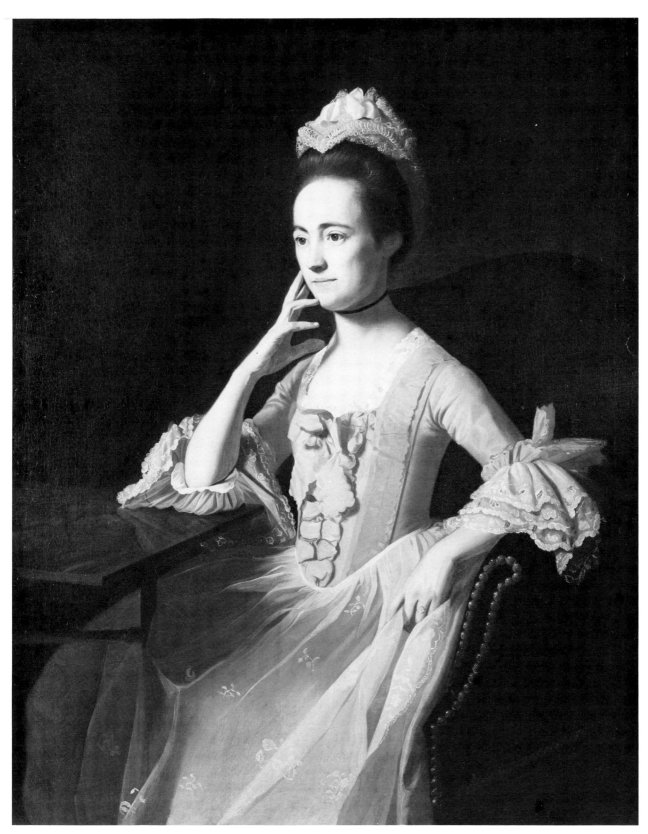

Plate 14

John Hancock (1736/37–1793)

Oil on canvas 49-1/2" x 40-1/2"

Signed and dated: J. S. Copley/pinx 1765

MUSEUM OF FINE ARTS, BOSTON

DEPOSITED BY THE CITY OF BOSTON

To most people the name of John Hancock means the defiance of George III with the large and elegant signature on the Declaration of Independence. Ironically, he was at first a vacillating patriot.

In 1764, principal heir to a highly successful import-export business, Hancock, like most merchants of his time, was politically conservative. In 1765 he privately agitated against the Stamp Act. "I will not be a slave. I have a right to the liberties and privileges of the English Constitution . . ." he wrote to an English correspondent.

It was not until 1768 when Hancock's sloop *Liberty* was seized by British customs officials that he came to the public's attention as an individual who would sacrifice his fortune and reputation for the sake of a principle. Such universal acclaim greatly appealed to the vanity of this "merchant prince."

By 1770 he was a highly visible figure at radical town meetings, but he soon renounced the politics of the Adamses, even transferring his legal business from John Adams to Samuel Quincy, a Tory. While Hancock declined a seat on the Governor's Council, he accepted a post as colonel of the Corps of Cadets, the governor's ceremonial honor guard.

In 1773 he again became active in radical politics—although still a member of the Cadets—and chaired the meeting prior to the Boston Tea Party. The next year he delivered the annual oration in commemoration of the Boston Massacre. This invective masterpiece induced the Crown to order that he be sent to London for trial for treason. That same year he served as president of the first Provincial Congress of Massachusetts and chairman of the Committee of Safety.

In 1775 he was elected president of the Second Continental Congress where, while intellectually inferior to most of the other statesmen, he played the valuable role of mediating between bitterly antagonistic factions. He was reelected the following year.

In 1780, Hancock was elected the first governor of Massachusetts, a position he held, with the exception of one term, until his death.

Noted for his good looks and love of extravagant clothes, Hancock is here portrayed as a businessman seated before an enormous ledger inscribed in the upper left corner with the date 1765, one year after his uncle Thomas died and left him a vast fortune. Prown notes that this "is one of the few instances [in colonial painting] in which there seems to be a direct relationship between the commissioning of a portrait and the passing of wealth from one generation to the next."

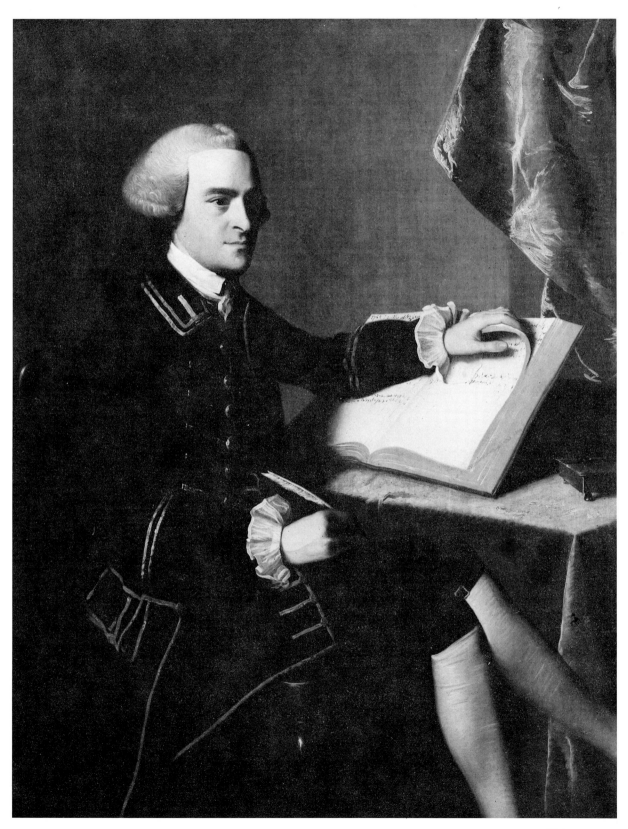

Plate 15

JOHN SINGLETON COPLEY

Nathaniel Hurd (*1730–1777*)

Oil on canvas 30" x 25-1/2"

c. 1765. Signed: I. S. C.

Born in Boston, Nathaniel Hurd followed the trade of silversmith, engraver, and die cutter. He was undoubtedly apprenticed to his father, the celebrated Boston silversmith Jacob Hurd.

Nathaniel first advertised in the *Boston Gazette* on April 28, 1760, that he was available "to do all sorts of Goldsmith's Work. Likewise engraves in Gold, Silver, Copper, Brass and Steel, in the neatest Manner, and at reasonable rates." While following closely in the tradition of his father, Nathaniel surpassed his teacher in the art of engraving. Nathaniel's numerous armorial bookplates stand out as the greatest artistic achievements of his career.

Hurd was only moderately active in local public affairs. He served as a "Fireward" and later on a committee to examine the accounts of several Boston lotteries.

Hurd was a member of the jury at the inquest into the circumstances of the death during the Boston Massacre of Michael Johnson, alias Crispus Attucks; who became a black hero of the Revolution. The jury found "That the said Michael Johnson was wilfully and feloniously murdered . . . by the discharge of a Musket or Muskets loaded with Bulletts two of which were shot thro' his body by a party of Soldiers . . . commanded by Capt. Thomas Preston of his Majesty's 29th Regiment of foot. . . ." Two Redcoats were ultimately identified, found guilty of manslaughter, and discharged from the British army.

According to Jules Prown, this picture is "Copley's first known use of the informal portrait, a device often employed in England by Hogarth, Hudson and Highmore." Hurd is represented in a dressing gown and wearing a black turban on his shaved head. On the table in front of him lie two books. The larger volume is titled "Display of Heraldry / I. Guillim." This work (the 1724 edition) was a basic source of heraldry. Kathryn Buhler has tentatively identified the smaller volume as Sympson's *New Book of Cyphers* . . . (1726). Hurd could have inherited both books from his father.

In the Memorial Art Gallery of the University of Rochester, there is an oil sketch for this portrait depicting Hurd dressed in shirtsleeves and more informally posed.

JOHN SINGLETON COPLEY

Paul Revere (*1735–1818*)

Oil on canvas 35" x 28-1/2"

c. 1768–70

MUSEUM OF FINE ARTS, BOSTON

GIFT OF JOSEPH W., WILLIAM B., AND EDWARD H. R. REVERE

Listen, my children, and you shall hear
Of the midnight ride of Paul Revere . . .

So begins the famous Longfellow poem of 1860 which immortalized the name of Paul Revere to generations of schoolchildren. And yet, this ride was only a minor event in a noteworthy and varied life.

Born in Boston of French Huguenot descent, Revere became a silversmith like his father. His works, highly prized by collectors today, are among the masterpieces of colonial silver. By 1764 he became interested in copper engraving, portraits, and songbooks. His patriotism spurred him to engrave a series of political cartoons in which he mercilessly exposed the injustice of British policy toward the colonies. He manufactured teeth, notably for Joseph Warren, and copper church bells, and eventually established a copper foundry.

He had considerable influence as the leader of the artisans, serving as the important link with the radicals of higher social class for whom he eagerly performed any task the leaders required of him. He helped plan, and participated in, the Boston Tea Party and thereafter became a familiar figure in the countryside as an official courier.

On that famous night of April 18, 1775, the Sons of Liberty noted that British troops were advancing toward Lexington and Concord, and William Dawes and Paul Revere were dispatched to warn the townsmen that the British were coming and to advise John Hancock and Samuel Adams to remove to a safer place, since their arrest was so ardently desired by the British. To make sure someone got through, Revere took a water route, Dawes a land route. Revere crossed the Charles River in a small boat, the sound of the oars muffled by a woman's woolen petticoat. When he reached the opposite shore, he mounted the awaiting horse and, eluding British patrols, rode to Lexington, saw the two leaders safely off and then, joined by Dawes and Samuel Prescott, headed toward Concord. All three were detained by scouting troops, but Prescott escaped and made his way to Concord with the alarming news.

This portrait is considered one of Copley's most successful half-length portraits. Unlike the wealthy merchants or politicians, Revere is informally posed in the work clothes of a craftsman. Seated behind his mahogany workbench on top of which are scattered various engraving tools, he holds a pear-shaped teapot of mid-1760 design, which is supported by an engraver's sand cushion. His chin resting on his right hand in a gesture of contemplation, Revere is shown at the moment of creativity as he prepares to transform the smooth surface of the teapot to a highly decorative one by engraving floral motifs or the patron's coat of arms.

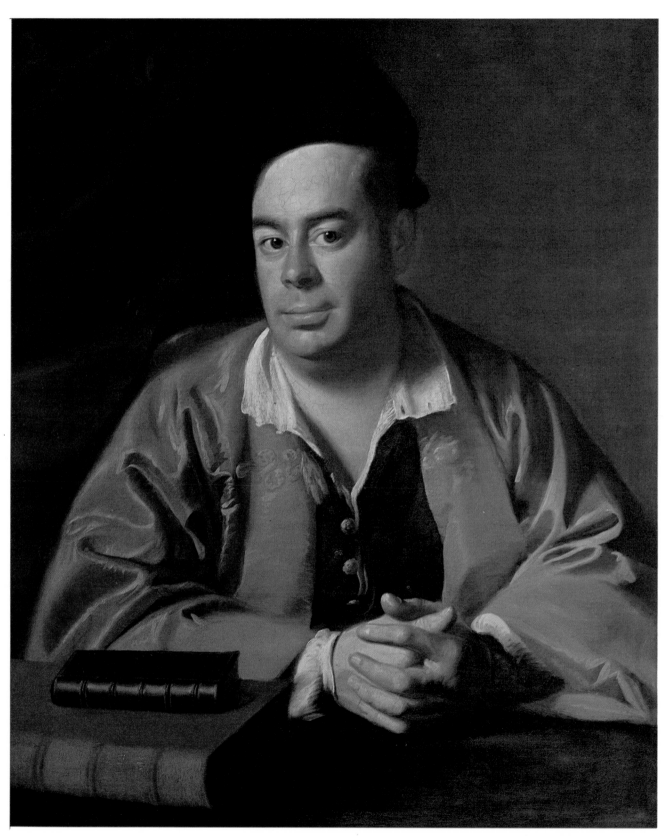

Plate 16

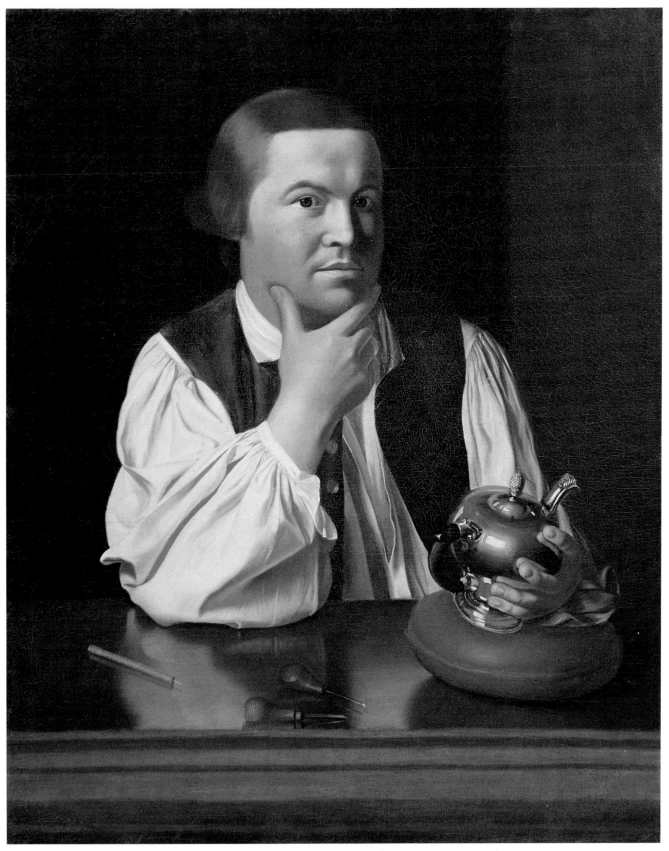

Plate 17

Joseph Warren (1741–1775)

Oil on canvas 50″ x 40″

c. 1765 (Prown) c. 1772–1774 (Museum of Fine Arts)

Born in Roxbury, Massachusetts, Joseph Warren was a physician by profession who was notable for his successful use of inoculation during the Boston smallpox epidemic of 1763.

As a patriot, he was among the most important figures in the Massachusetts Revolutionary movement, an ardent radical who was vocal in town meetings and local political clubs. He played a crucial role in the Boston Tea Party and had a gift for pamphleteering and propaganda equal to that of Samuel Adams.

He was chief author of the eloquent "Suffolk Resolves" of September 1774 which advocated self-government within the Empire. In the meantime, as a member of the first Provincial Congress, he served on most of the important committees, notably the one charged with raising troops. The following year he was elected president.

Warren dispatched William Dawes and Paul Revere on their famous midnight ride to Lexington to warn John Hancock and Samuel Adams that they were in danger of being captured by the British.

In June 1775 Warren accepted a commission as major general after having declined the less hazardous post of physician-general. He was killed by a British soldier on June 17 at the Battle of Bunker Hill. The tragic event inspired the artist John Trumbull's painting *The Battle of Bunker's Hill, Charlestown, Massachusetts, 17 June 1775* (1786, Yale University Art Gallery).

Copley portrayed Warren with his elbow resting on sheets of anatomical drawings, an allusion to his profession. Warren's gentle eyes and relaxed pose suggest the compassion of the physician, but belie the ferociousness of the radical leader who created ruthless propaganda and unhesitatingly advocated violence against the British.

Generally assigned a date of almost a decade later, this picture has recently been dated c. 1765 by Jules Prown because of its close relationship in pose and setting to Copley's portrait of John Hancock (Plate 15).

Plate 18

John Wiley (1748–1829), His Mother and Sisters

Oil on canvas 35-1/2″ x 46-1/2″

Signed and dated: Wm. Williams/fecit/1771

WALLACE AND CYNTHIA QUIMBY

John Wiley, the son of Mary Tillinghast and John Wiley, was probably born in Providence, Rhode Island. On the eve of the Revolution he was well established in New York City as a distiller and merchant, owning several brigs and schooners.

Although there is meager information about his political or military activities, there is little doubt that he was an ardent patriot. One story relates how he sold his house and moved to another part of the city to avoid the Tory who moved next door. In a letter to his intimate friend Colonel John Lamb, a propagandist and leader of the New York radicals, Wiley affirms his commitment to "a cause the most just, and therefore the most glorious, that ever was undertaken . . ."

From February to November 1776, he held the rank of captain of the First New York Regiment. After the Declaration of Independence was read on the Commons in New York City on July 9, 1776, Wiley, said to be a member of the Sons of Liberty, assisted in tearing down the statue of King George III on the Bowling Green. The broken pieces of lead—a scarce commodity at the time— were sent to Litchfield, Connecticut, melted down and made into cartridges by the town women.

In the great fire of September 1776 which followed the British occupation of New York, Wiley's distillery was burned down and he lost most of his fortune.

One source claims he served on the staff of Colonel Lamb at the battle of Springfield in 1780. He died in New York City.

Williams painted this conversation piece in New York. The characteristically doll-like figures appear in what is said to be the family garden, with the rear wall of Trinity Church in New York City in the background. Wiley's mother sits and suns herself, Wiley reflects upon his reading, the younger sister holds flowers, the elder one plays with a squirrel, a common house pet in colonial times. The landscape background, with its winding river, church steeple, and windmill, seems more a theatrical backdrop than the rendition of any actual view. The delicately rendered leaves in the upper left corner add a charming ornamental touch.

Plate 19

Abigail Smith Adams (1744–1818)

Pastel on paper 22-1/2" x 17-1/2"

c. 1766, Salem, Massachusetts

MASSACHUSETTS HISTORICAL SOCIETY, BOSTON

Abigail Smith was born in Weymouth, Massachusetts, the daughter of a clergy-man. She received no formal education but, possessed with a lively intellect, picked up a good deal through conversations and by reading. As a young girl she was familiar with Shakespeare, Milton, and the sermon writers and travel literature of the eighteenth century. She taught herself French.

After her marriage to John Adams on October 25, 1764, she became an avid reader of history. To the marriage Abigail brought wide connections with prominent Massachusetts families. Five children were born to the couple during their first decade together. Meanwhile, Abigail provided constant support and comfort which immeasurably strengthened her husband during the Revolutionary era. In August 1774 John went to Philadelphia to serve as a delegate in the Continental Congress, and it was ten years before the Adamses could again lead a normal life as husband and wife. Abigail was left with the task of educating the children and managing the household, farm, and John's business interests. Whether he was in New York, Philadelphia, or Europe, she continued to direct operations by correspondence. She carried out these complex tasks with such skill that John increasingly depended upon her.

The Adamses' long separations promoted the flowering of Abigail's genius for letter writing. Although her penmanship was not elegant and her spelling often inaccurate, in her perceptive, witty, and delightfully spontaneous manner, Abigail captured the spirit of her time, leaving a record of observations invaluable to later historians.

She deplored the discrimination between boys and girls with respect to educational opportunities, which she attributed to men's "ungenerous jealosy of rivals near the Throne." She also condemned racial discrimination as completely evil in its effects on character and society. Aside from these outspoken views, her ideas generally ran parallel to and reinforced those of her husband.

After 1800, the Adamses retired to devote themselves to their grandchildren and letter writing. Abigail was, of course, concerned with the political career and activities of their son John Quincy Adams.

BENJAMIN BLYTH

John Adams (1735–1826)

Pastel on paper 22-1/2" x 17-1/2"

c. 1766, Salem, Massachusetts

MASSACHUSETTS HISTORICAL SOCIETY, BOSTON

Born in Braintree, Massachusetts, John Adams graduated from Harvard and pursued a career in law. By 1768 he had moved to Boston and had written articles in newspapers on public affairs and law. The resolutions of protest he drafted in response to the Stamp Act became the model used by other towns. This led to his association with Jeremiah Gridley and James Otis, particularly in the long conflict with Royal Governor Thomas Hutchinson.

Unlike his cousin Samuel Adams, he abhorred violence, preferring to challenge the mother country strictly on legal grounds. Such cases as his defense of John Hancock, who was charged with smuggling, connected Adams with the patriotic cause and brought him considerable fame.

He served with distinction on the Continental Congress from 1774 to 1777, helped draft a declaration of rights and claimed a major role in Washington's selection as commander in chief of the army. He served on the committee that drafted the Declaration of Independence, was a signer and instrumental in obtaining its passage by Congress. After a brief and relatively uneventful service as commissioner to France, he returned to Massachusetts, where he was largely responsible for drawing up the state constitution.

In 1779 Adams was appointed to negotiate a commercial treaty with Great Britain and to act as American ambassador. Later he was minister to Holland where he secured Dutch recognition of the United States and arranged loans and commerce. In October 1782 he arrived in Paris to play a key role in the peace negotiations, preparing many of the articles and steadfastly refusing to sign those which did not meet his requirements. From 1785 to 1788 he was envoy to the Court of St. James's to resolve problems about the treaty. During this time he wrote and published his three-volume *Defense of the Constitution of the United States.*

Adams was elected vice president under Washington in 1789 and in 1796 defeated Thomas Jefferson to become the second President of the United States. Jefferson won the next time around. Adams retired to Quincy, Massachusetts, where he kept abreast of current political affairs, corresponded with Jefferson, and wrote about the people and events of his day.

This portrait of Adams wearing a gray wig and its pendant of Abigail Adams are the earliest known portrayals of this lively and intelligent couple. Probably drawn in Salem in 1766 when Adams had a law case there, these are Blyth's best-known and most often reproduced pictures.

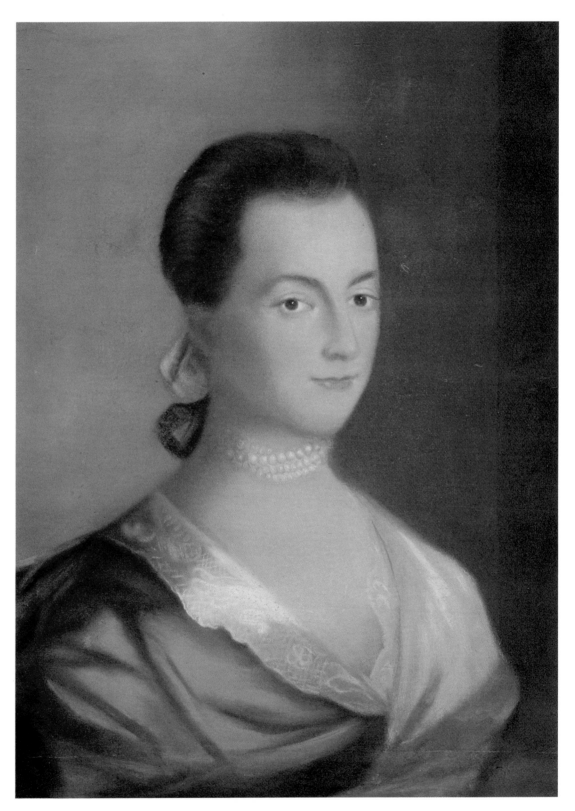

Plate 20

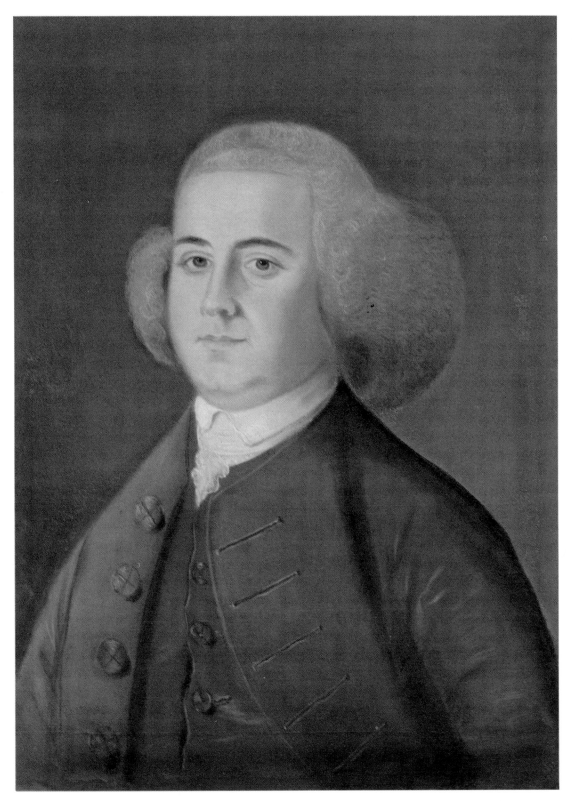

Plate 21

Roger Alden (*1748/54–1836*)

Oil on panel 14-1/2" x 11-3/4"

Signed and dated: J. T. 1778

PRIVATE COLLECTION

Roger Alden was born in Lebanon, Connecticut, the son of John and Elizabeth (Ripley) Alden. He graduated from Yale College in 1773 and taught school in New Haven. In September 1775, he joined Benedict Arnold's expedition to Quebec as a private soldier and met Aaron Burr with whom he remained good friends for many years. In January 1777, he was commissioned lieutenant and adjutant in Colonel Philip B. Bradley's Fifth Connecticut Continental Line. That July he was appointed brigadier major and served under General Jedediah Huntington for the remainder of his military career. He fought in various battles of the New Jersey campaign, notably Monmouth.

Alden resigned his commission in February 1781, after rising to the rank of major, and went to Stratford, Connecticut, to study law with William Samuel Johnson whose daughter Gloriana Anne he married in 1783. Thereafter, he held minor political offices. He was deputy secretary to the Continental Congress (1785) and chief clerk in the Department of State (1789). In 1790 Alden moved to Meadville, Pennsylvania, where, acting as an agent of the Holland Land Company, he became involved with land speculation.

In 1825 he was appointed ordnance storekeeper at West Point. He died there ten years later.

Unlocated until the mid-1950s, this portrait was listed as number 34, "small head—not bad" in Trumbull's autobiography. Alden, one of Trumbull's close friends during the early years of the Revolutionary War, is portrayed in Continental uniform. The red sash across his shoulder was added later by another hand.

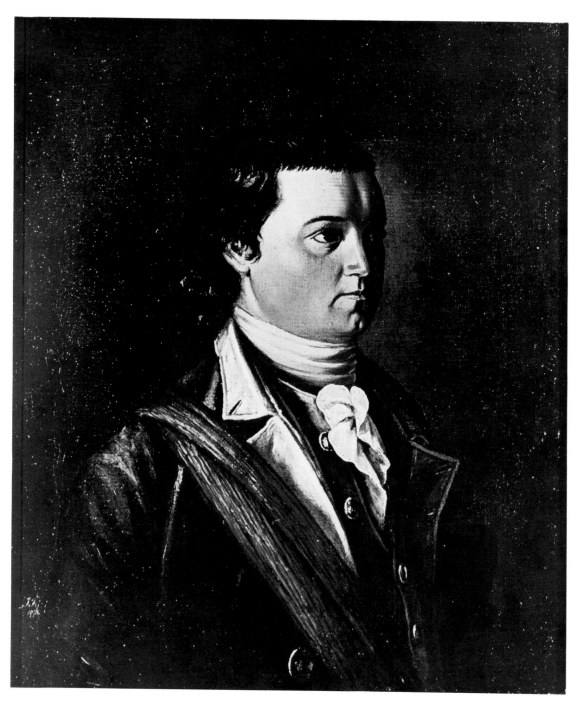

JOHN TRUMBULL

Self-Portrait (*1759–1843*)

Oil on canvas 29-3/4" x 23-3/4"

1777, Lebanon, Connecticut

Trumbull executed this self-portrait at the age of twenty-one, just after his resignation from the Continental Army. The pose, in a straightforward, rather linear manner so characteristic of his early works, reflects familiarity with the style of John Singleton Copley. On the table is a leather-bound volume labeled Hogarth, a reference to Hogarth's *Analysis of Beauty* (1753), one of the early influences in Trumbull's artistic career. To further emphasize the tribute to Hogarth, Trumbull's artist palette rests on the volume and his pigments are laid out in seven classes as recommended by the English master. Instead of the more complicated five tonal registers, however, there are only three in each class.

Plate 23

116

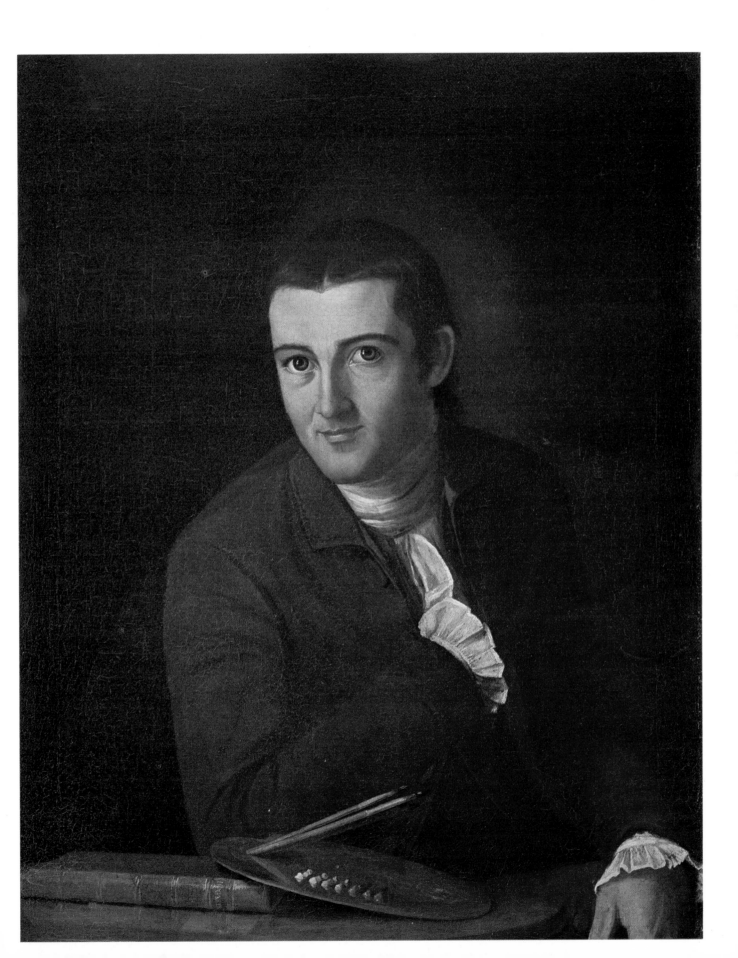

WINTHROP CHANDLER

Samuel Chandler (1735–1790)

Oil on canvas 54-7/8″ x 47-7/8″

c. 1780

Samuel Chandler, the brother of the artist, was born near Woodstock, Connecticut. In 1760 he moved to a 300-acre farm just west of his father's home where he maintained a tavern during the Revolution. He was captain of a company of Connecticut militia which marched to Westchester in 1776. He was also active in the Connecticut legislature.

In one of Winthrop Chandler's most extraordinary compositions, he depicted the captain dressed in a military uniform of the Revolutionary period and holding a sword with a silver hilt and point. On the mahogany tabletop rests his tricorn hat whose curvilinear braid forms a delightful abstract pattern.

In the background hangs another complete picture, presumably representing one of the battles in which Samuel took part. But this is not just an ordinary battle scene. It is a biting editorial comment on the ugliness of war.

WINTHROP CHANDLER

Mrs. Samuel Chandler (Anna Paine) (1738–1811)

Oil on canvas 54-3/4" x 47-7/8"

c. 1780

NATIONAL GALLERY OF ART, WASHINGTON, D.C.

GIFT OF EDGAR WILLIAM AND BERNICE CHRYSLER GARBISCH, 1964

Anna Paine was born in South Woodstock, Connecticut. She married Samuel Chandler in 1760. Although she had no children, Anna brought up her nephew John Paine as her own. After her husband's death in 1790, she married the Reverend Josiah Whitney, pastor of the Congregational Church in Brooklyn, Connecticut.

This portrait is an excellent example of Winthrop Chandler's use of rich surface patterns. With as stern a gaze as that of her husband, Anna stiffly sits, dressed in her finest frock, wearing gold jewelry and holding a fan. Great care is taken in rendering every decorative detail of her costume. The curtain, while generally a standard accessory of aristocratic portraiture, here becomes merely a fanciful frame, an abstract element of design. Chandler had used a similar device in his 1770 portrait of Mrs. Ebenezer Devotion (Martha Lathrop). (See page 49.)

Also characteristic of the naïve artist is spatial ambiguity. Here the oval mahogany table is irrationally squeezed between the picture plane and the curtain. It nevertheless successfully functions in the composition as an important element of balance. A similar role is played by the rather unlikely placement of the book, with its pages facing out, in the right background. Indeed, shelves of books are a distinguishing feature in many of Chandler's pictures.

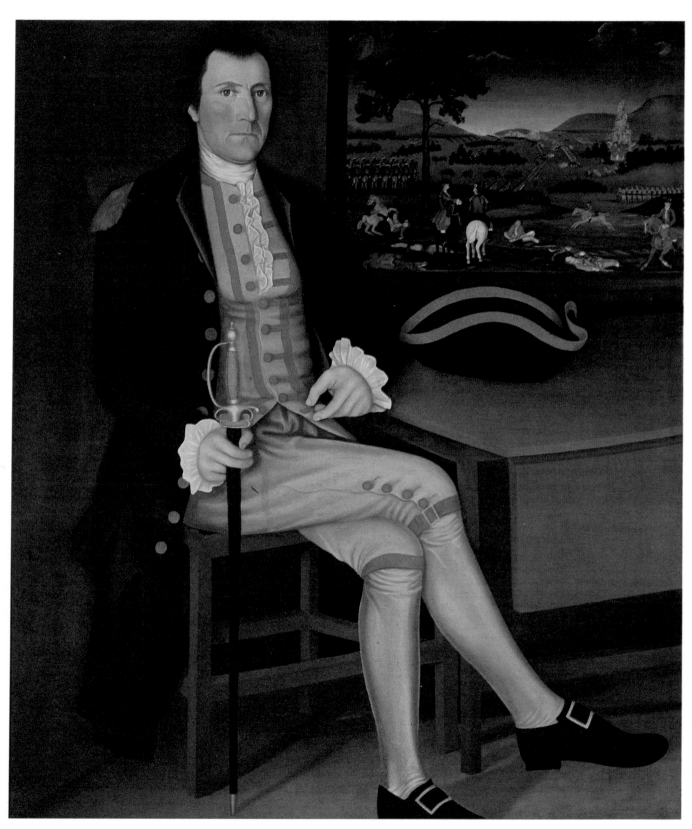

Plate 24

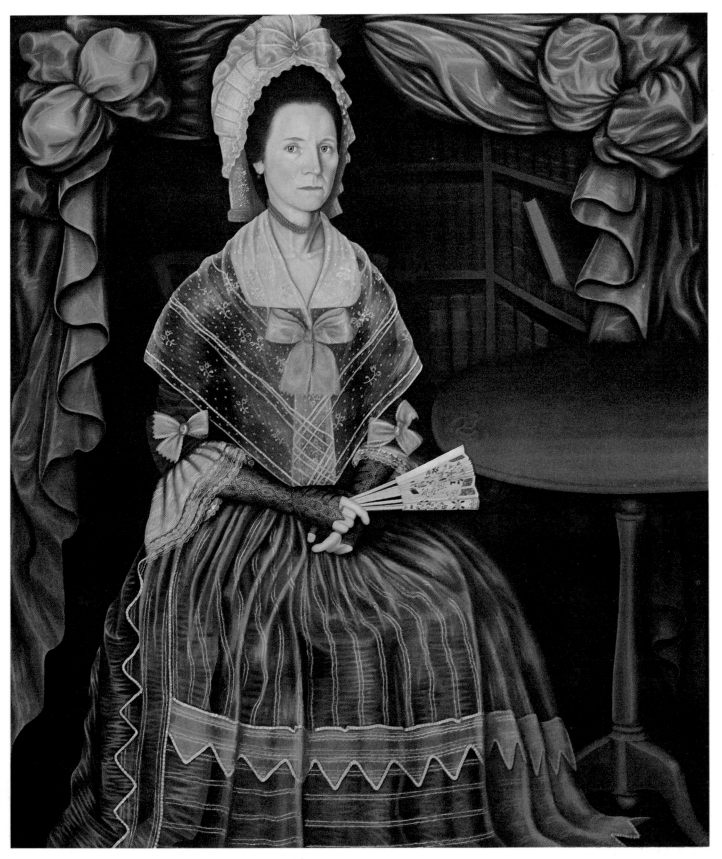

Plate 25

Mrs. Ebenezer Devotion (Eunice Huntington) (1742–1827) and her daughter Eunice Devotion (1770–1854)

Oil on canvas 52-1/2″ x 37″

c. 1772

LYMAN ALLYN MUSEUM, NEW LONDON, CONNECTICUT

Eunice Huntington, the daughter of Jonathan and Elizabeth Huntington, was born in Scotland, Connecticut. She was a first cousin of Samuel Huntington, who served in the Continental Congress from 1775 to 1784, where he signed the Declaration of Independence and, in September 1779, succeeded John Jay as president. From 1786 to 1796 he served as governor of Connecticut. A strong proponent of the federal Constitution, he worked for ratification in his state.

Eunice married Ebenezer Devotion in 1764 and had nine children. Seated on Mrs. Devotion's lap, clutching a piece of fruit, is her daughter Eunice who would have been just over a year old when this picture was painted. Yet, typical of eighteenth-century representations of children, she appears considerably older, a kind of miniature adult. She even has the same stern and humorless expression as her mother.

Seated in a Chippendale chair, Mrs. Devotion is superbly outfitted in laces, ribbons, bows, flowers, ruffles, and lace gloves. It is said that she later wore this elegant gown to a state dinner in Philadelphia during the Revolution. That odd heart-shaped pin at her neckline is somewhat of a hallmark of Chandler's, since similar pieces appear in several other of his portraits, notably that of her husband Judge Ebenezer Devotion.

Plate 26

Ebenezer Devotion (1740–1829)

Oil on canvas 70" x 44-1/2"

c. 1772

EDWARD WALDO COLLECTION,

ANTIQUARIAN AND LANDMARKS SOCIETY, INC., OF CONNECTICUT

ON LOAN TO LYMAN ALLYN MUSEUM, NEW LONDON, CONNECTICUT

Ebenezer Devotion was born in Scotland, Connecticut, son of the Reverend Ebenezer Devotion whose portrait, along with several other members of the Devotion family, Winthrop Chandler painted.

After graduating from Yale College, Ebenezer became first a farmer and then a highly successful storekeeper. An ardent patriot, he represented Scotland in the General Assembly at various times between 1774 and 1801. From about 1791 to 1811 he sat on the bench as judge of the Windham County Court. He died in Scotland.

Standing next to a high slant-top desk under which is a dog on a box foot-stool, the judge holds a quill in his right hand. As a symbol of his profession as a merchant and storekeeper, he rests his arm on an open ledger. On the left page is written "1772 (194) L D S/ Jan^y."

The pose and composition of this full-length portrait is related to a small oil portrait on copper formerly in the Thomas B. Clarke Collection. Bearing a purported signature of John Singleton Copley and the date 1757, this picture was said to represent James Tilley, a ropemaker. It was reattributed to John Trumbull by Theodore Sizer who dated it c. 1784, stated it was painted in London, and tentatively identified the subject as Alexander Moore, a Boston merchant. However, the attribution of the picture remains a problem.

Plate 27

AMOS DOOLITTLE

Colored line engravings (Numbered Plates I-IV)
Each inscribed in the plate: A. Doolittle, sculpt. 1775

The following series of engravings by Amos Doolittle represent various scenes of the battles at Lexington and Concord on April 19, 1775. Tradition maintains that when Doolittle visited the sites the following month, he was accompanied by the portrait painter Ralph Earl who sketched the views and, often using Doolittle as a model, relied on eyewitness accounts to reconstruct the battles. This tale, however, has recently been questioned. The prints were advertised for sale on December 13, 1775. While there is little understanding of the laws of perspective and the human figure is woefully distorted, they nevertheless have an underlying charm as a result of this naïveté. The honesty and straightforwardness of these works have proved an invaluable resource to historians, even though their intent was primarily propagandistic. A legend under each view explains the key buildings and individuals. The following descriptions are based on Ian M. G. Quimby's definitive article on Doolittle.

Plate 28

I The Battle of Lexington, April 19th, 1775 13-3/4" x 18"

On the night of April 18, 1775, Paul Revere and William Dawes embarked on their famous journey to warn the people of Lexington and Concord that the British were coming. At sunrise the following morning five companies of light infantry arrived at Lexington Common to be met by only forty minutemen and a few unarmed townsmen. The odds must have seemed so ridiculous that simultaneously Captain Parker, commanding the Americans, and Major Pitcairn, commanding the redcoats, ordered their men not to fire. But someone fired and mayhem broke out. Only one British soldier was wounded but eight Americans were killed and nine wounded. This print depicts that confrontation.

Since accounts on both sides stress the disorderliness of the incident, the major discrepancy seems to be the well-ordered ranks of soldiers. It should also be noted that not a single minuteman is firing at the British. Doolittle did not suggest that the Americans made a historic stand because it was more effective propaganda to show them being slaughtered on their home ground by a vastly superior military force.

II A View of the Town of Concord 13-1/4" x 17-1/2"

In the meantime about 250 minutemen had assembled in Concord to meet the British. As the opponents drew close, the Americans did an about-face and marched into Concord accompanied by fifes and drums of both armies. The

Plate 29

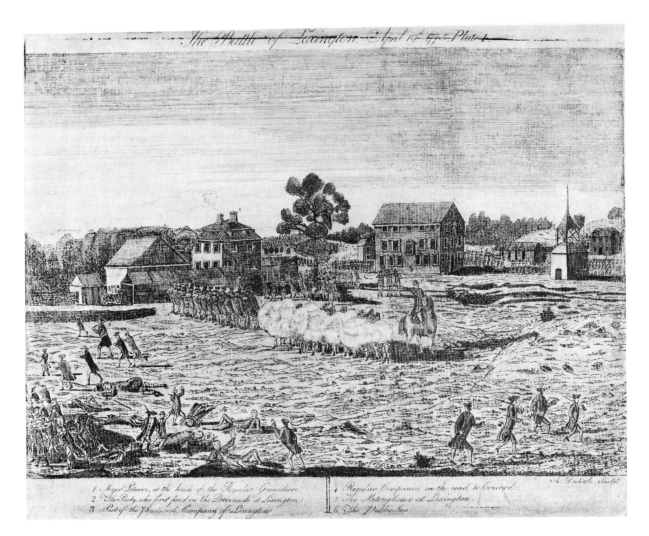

The Battle of Lexington. April 19th 1775. Plate I.

A. Doolittle Sculpt.

1. Major Pitcairn at the head of the Regular Grenadiers.
2. The Party who first fired on the Provincials at Lexington.
3. Part of the Provincial Company of Lexington.
4. Regular Companies on the road to Concord.
5. The Meetinghouse at Lexington.
6. The Public Inn.

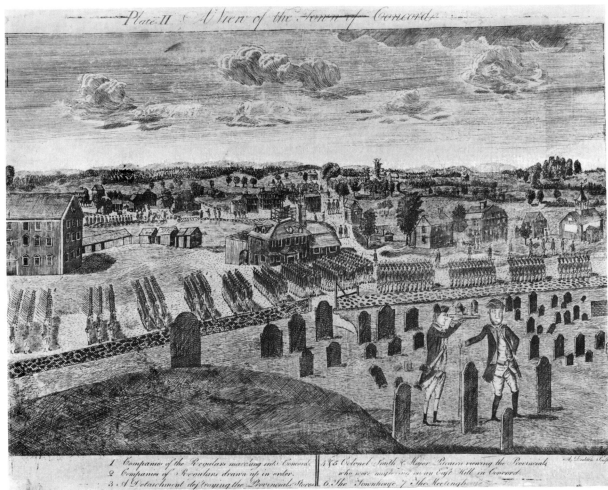

Plate II. A View of the Town of Concord.

A. Doolittle Sculpt.

1. Companies of the Regulars marching into Concord.
2. Companies of Regulars drawn up in order.
3. A Detachment destroying the Provincials Stores.
4 & 5. Colonel Smith & Major Pitcairn viewing the Provincials who were mustering on an East Hill in Concord.
6. The Townhouse. 7. The Meetinghouse.

militia continued across the North Bridge to a hill beyond to await reinforcements, and the Regulars marched into Concord while Colonel Smith and Major Pitcairn (with the telescope) climbed the ridge overlooking the Concord Center. Among the gravestones, he observed the movement of the rebels. It is this moment that Doolittle shows. There is a slight disorientation of time, however, since the scene in the background where the British are throwing military stores into the millpond actually took place later. The three-story building on the left is the old meetinghouse where the Provincial Congress met.

III The Engagement at the North Bridge in Concord 13" x 17-1/2"

After the grenadiers ended their search for military stores, they burned some gun carriages and wooden tools. To the minutemen watching from the hill, it looked as if the town were burning, and they determined to save it. Thus, 400 Americans started across the Concord River at North Bridge and were met by only about 100 British soldiers. Again someone fired a shot, and a brief skirmish ensued. But this time the Americans were victorious and the enemy was forced to retreat, leaving one rank of rear guard to protect them. This is the moment Doolittle represents. The prominent house in the background belonged to Major John Buttrick, second in command of the Concord militia.

Plate 30

IV A View of the South Part of Lexington 13-1/8" x 17-7/8"

The American ranks swelled as news of the battle swept through Middlesex County. It was now about noon. The exhausted regulars had been on the march almost fourteen hours. Sensing the danger when no British reinforcements had arrived, Colonel Smith ordered his men back to Boston. To protect his flanks he spread out his light infantry on both sides of the roads. About a mile out of Concord, the provincials, safely hidden behind stone walls, barns, trees, and rocks, began relentless sniping into the British ranks. As they neared Lexington, the orderly retreat turned into an undisciplined flight, leaving several killed and wounded. In Lexington the regulars were greeted by the long-awaited reinforcements under the command of Lord Percy. Percy placed a cannon on each of two hills flanking the road and, to prevent the militia from using the houses as snipers' nests, ordered them set afire. The Americans regarded this as an unnecessary act of vandalism, and it became a valuable propaganda item. Again Doolittle has compressed these sequential events into one view, as though they were taking place simultaneously, a technique that enhanced the print's journalistic value.

After several incidental confrontations and more losses on both sides, the beleaguered British troops finally reached the safety of Charlestown Heights about eight o'clock in the evening. It was a stunning victory for the provincials.

Plate 31

Plate III. The Engagement at the North Bridge in Concord

1. The Detachment of the Regulars who fired first
on the Provincials. 2. The Provincials headed by Colonel Robinson &
Major Buttrick. The Bridge.

A. Doolittle Sculp.

Plate IV. A View of the South Part of Lexington

1. Colonel Smith's Brigade returning before the Provincials. 6, & 7. The Flank guards of Percy's Brigade.
2. Earl Percy's Brigade meeting them. 8. A Field piece pointed at the Lexington Meetinghouse.
3, & 4. Earl Percy & Col Smith. 5. Provincials. 9. The Burning of the Houses in Lexington.

A. Doolittle Sculp.

LOUIS-NICOLAS VAN BLARENBERGHE

The Siege of Yorktown

Gouache 23-1/4" x 37"

Signed and dated: van Blarenberghe—1784

MUSÉE NATIONAL DU CHÂTEAU DE VERSAILLES, PARIS

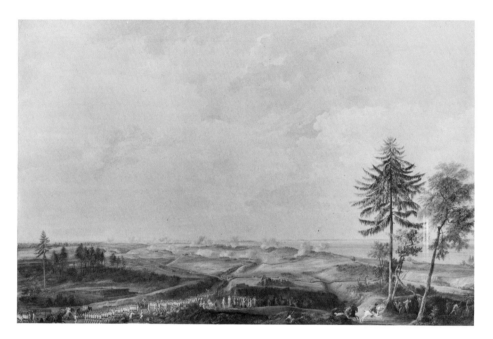

Plate 32

Van Blarenberghe based these scenes on eyewitness accounts, maps, and documents in the French War Office, and topographical sketches made on the spot by Louis-Alexandre Berthier, a French engineer and illustrator who at one time worked at the War Office and later joined Rochambeau's army. None of the portraits were taken from life. But individual participants often can be identified by the uniforms they wear.

In the central group, decorated with the cross of St. Louis, is Rochambeau with raised right arm. Facing him, to the left, is a bareheaded figure with sword down at salute, which represents the colonel of the Soissonnais Regiment. The other officer, with the tip of his sword in his left hand, is the colonel of the Bourbonnais Regiment. The man in the center of the gathering, behind Rochambeau and looking at a map, is probably Duportail, the Continental Army chief engineer who played a vital part in the Yorktown campaign. The man in the yellowish coat, mounting a horse, is a drummer of the Royal Deux-Ponts and is probably off to beat an order for the troops. On the far left the French troops march into the trenches, where they would be protected from the cannon on the walls of Yorktown. On the far right advance the Americans into their sector. In the distant center is Yorktown, and across the river is Gloucester Point. Puffs of smoke rise from the redoubts.

The Surrender of Yorktown

Gouache 23-1/4" x 37"

Signed and dated: van Blarenberghe. 1785

MUSÉE NATIONAL DU CHÂTEAU DE VERSAILLES, PARIS

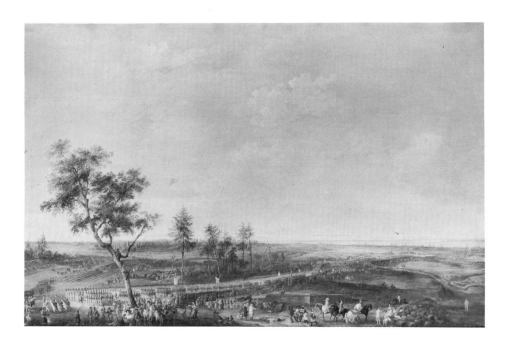

Plate 33

At two o'clock in the afternoon of October 19, 1781, the British surrendered at Yorktown. This delightfully colored view shows Cornwallis's army, colors cased, as they marched from Yorktown. The defeated troops are flanked on the left of the road by the French army and on the right by the Americans. Various regiments can be identified by their flags. On the side closest to the viewer, the blue flag with the white stars is that of Washington's headquarters. When the British reached the surrender field at the lower left, they grounded their arms as specified in Article 3 of the Articles of Capitulation. That same afternoon, a similar ceremony took place on the Gloucester side of the York River.

Rejoicing Virginians are depicted in the foreground to suggest local ambience. Berthier, on his journey back to France, had sketched similar scenes when he visited the Comte de Ségur's plantation in Santo Domingo.

With minor variations, van Blarenberghe executed replicas of the *Siege* and *Surrender of Yorktown* for General Rochambeau in 1786. These views are now at the Château de Rochambeau.

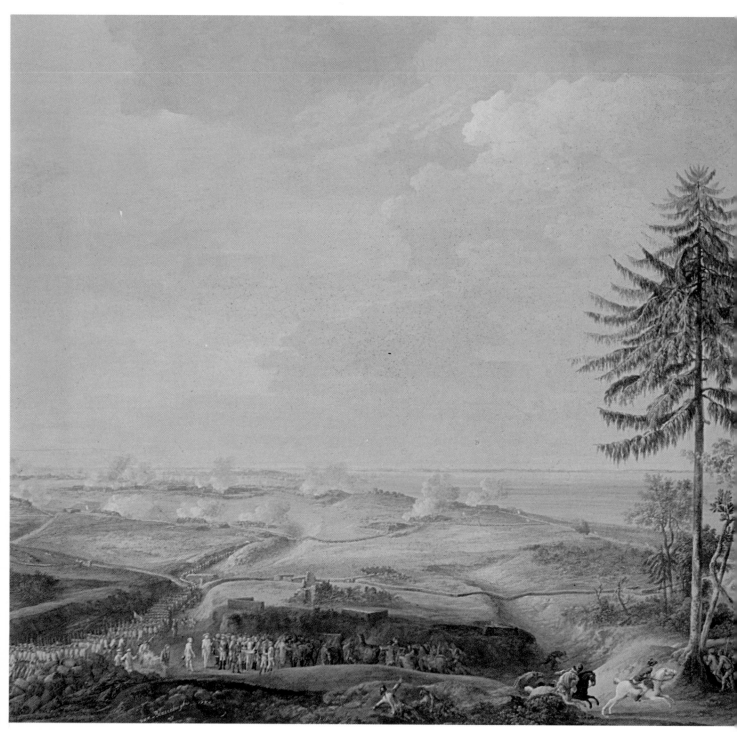

Detail, *Plate* 32

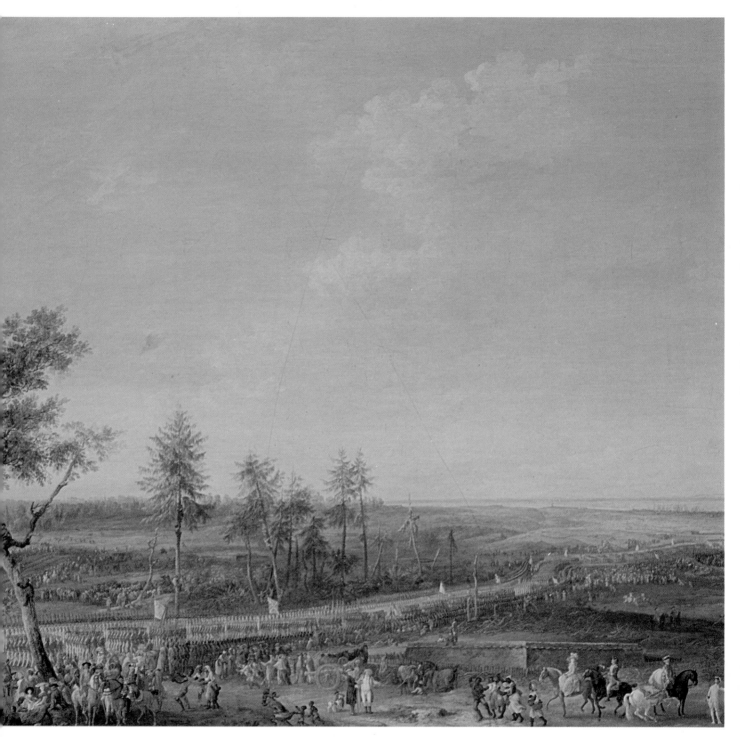

Detail, *Plate 33*

Dudley Woodbridge (*1747–1823*)

Oil on canvas 50″ x 40″

c. 1770–75

MR. AND MRS. WILLIAM KELLY SIMPSON

Dudley Woodbridge was born in Stonington, Connecticut, the son of a clergy-man. He studied law at Yale, but professional prospects were so poor during the Revolutionary War period that he was forced to open a general store in Norwich, Connecticut. He served as a Connecticut minuteman during the Revolution. From 1782 to 1787, he held the position of the first postmaster of Norwich.

Around 1790 he moved to the newly founded settlement of Marietta, Ohio, where, operating a general store and practicing law, he became an important member of his community. He was a judge of the Court of Common Pleas under the territorial government and, from 1804 to 1808, chairman of the Town Meet-ing. He also superintended the building of the first and second courthouses in Washington County, Ohio. His son William was active in politics and became governor of Ohio and a United States senator.

In one of the largest extant portraits by Durand, Woodbridge is elegantly posed next to various lawbooks, a symbol of his profession. One of the calf-bound volumes on the right is inscribed *Pleas of the Crown;* another, under Woodbridge's left hand, bears a partial title, . . . *Pleading.*

Plate 34

134

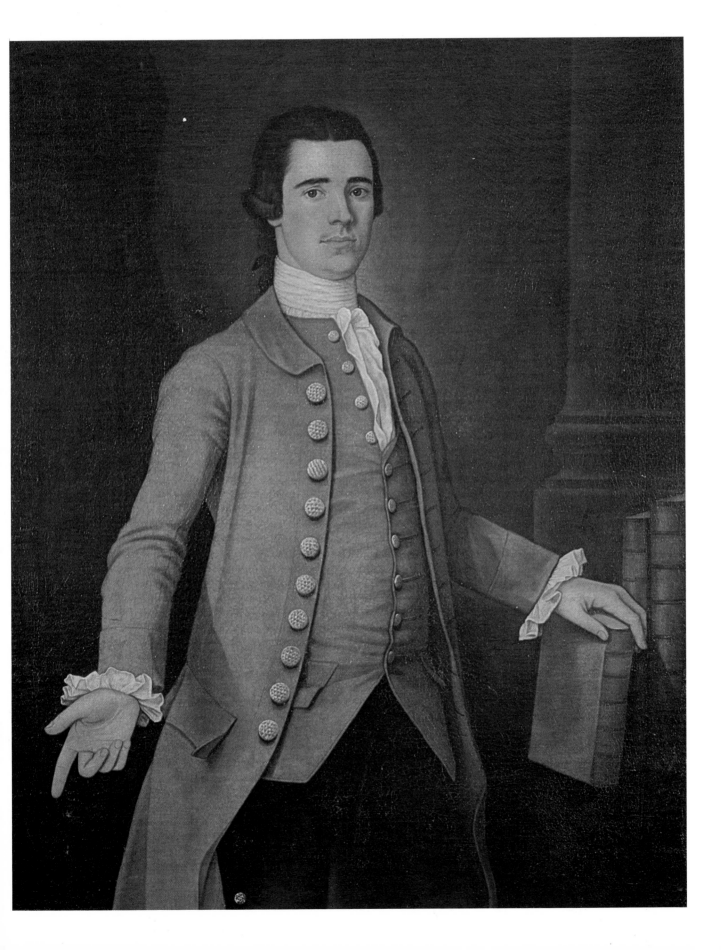

JOSEPH WRIGHT

George Washington (1732–1799)

Plaster medallion 20-1/2″ x 17″ (oval)

c. 1784

MRS. GERALD SHEA

Originally attributed to Jean Antoine Houdon, this classically inspired representation of Washington was reattributed to Wright by comparison with an almost identical wax medallion inscribed "J. Wright, fecit." (1931, The Heirs of Benjamin Smith).

Depicting Washington crowned with a laurel wreath, this profile bust may have been derived from a sitting in 1784 from which Wright produced a bust that was eventually presented to Congress.

In his memoirs the merchant and agriculturist Elkanah Watson paraphrased Washington's description of the experience of having a life mask made. "Wright came to Mount Vernon with the singular request that I should permit him to take a model of my face, in plaster of Paris, to which I consented, with some reluctance. He oiled my features over; and placing me flat upon my back, upon a cot, proceeded to daub my face with plaster. Whilst in this ludicrous attitude, Mrs. Washington entered the room; and, seeing my face thus overspread with plaster, involuntarily exclaimed. Her cry excited in me a disposition to smile, which gave my mouth a slight twist, or compression of the lips that is now observable in the bust which Wright afterward made."

A derivation of this laureate type inspired the wreathed profile of Washington by Saint-Mémin, who began engraving the year after Wright's death.

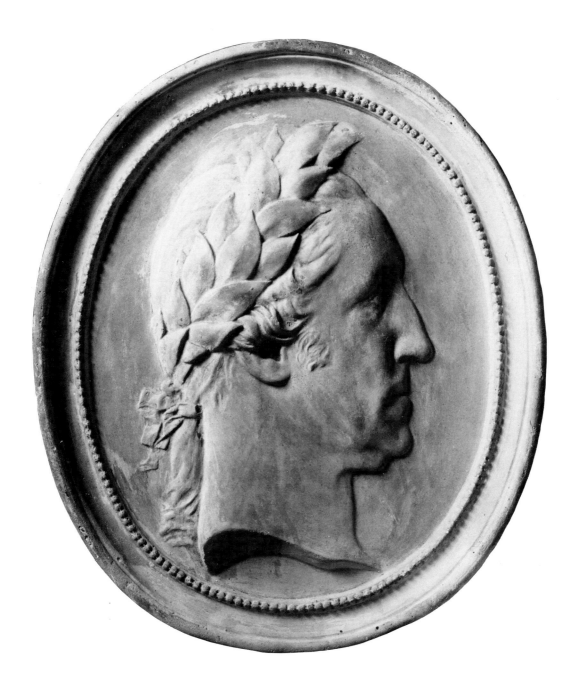

Plate 35

JOSEPH WRIGHT

George Washington (1732–1799)

Oil on canvas 21″ x 17″

c. 1790

THE CLEVELAND MUSEUM OF ART

HINMAN B. HURLBUT COLLECTION

> Everything about him suggested the commander—
> height, bearing, flawless proportions, dignity
> of person, composure, and ability to create
> confidence with calmness and with unfailing
> courteous dignity . . .
>
> —Douglas Southall Freeman

Indeed Washington was a man of heroic stature, about 6′ 3″ tall and weighing perhaps 220 pounds. Wright here represents him in the buff and blue uniform of the Continental Army.

This portrait, along with related medallions and engravings, is based on a crayon drawing, now lost, which Wright made at St. Paul's Church in New York City in 1790. According to tradition, Washington had declined to sit for him so "Wright being determined on his purpose, obtained permission of the occupant of the pew immediately opposite, to use that position for a Sunday morning or two, to make a deliberate miniature profile likeness of the President in crayon, as he sat attentive." This drawing was then etched and printed on cards which were widely distributed.

Washington's step-grandson, George Washington Parke Custis, believed this representation to be an excellent and faithful likeness. "It gives a more correct and perfect expression of his countenance than any other I have ever seen . . . none of them are as correct. They make his forehead too straight and massive, while the General's receded in a line with his nose . . ."

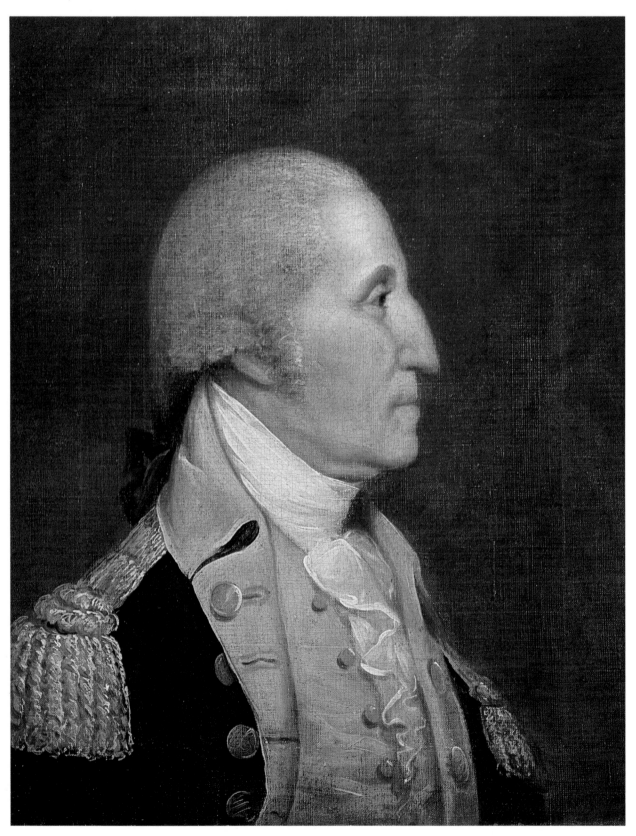

Plate 36

Israel Putnam *(1718–1790)*

Pencil on paper 3-7/8" x 3-7/16"

c. 1790

WADSWORTH ATHENEUM, HARTFORD, CONNECTICUT

ON DEPOSIT FROM THE PUTNAM PHALANX, HARTFORD

Israel Putnam, or "Old Put" as he was affectionately called, was born in Salem Village (now Danvers), Massachusetts. He became a prosperous farmer in Pomfret (now Brooklyn), Connecticut.

His prowess as a fighter was legendary long before the Revolution. One tale related how he bare-handedly killed a large she-wolf in her den the winter of 1742–43. Rising to the rank of lieutenant colonel in the French and Indian War, he narrowly escaped being burned at the stake. During the ill-fated expedition to capture Havana in 1762, he was one of the few survivors of a shipwreck off the coast of Cuba.

In the 1760s he was active in Pomfret politics as a prominent member of the Sons of Liberty and a representative in the General Assembly. His political horizons were considerably broadened when he opened a tavern called the General Wolfe, which became a noted rendezvous of ex-soldiers and patriots.

As an officer of a regiment of the Connecticut militia, he was one of the first to receive news of the battles of Lexington and Concord. It is said he was plowing his fields at the time. He immediately dropped his plow, unhitched one of the horses, left word for the militia to follow him, and rode a remarkable 100 miles to Cambridge in eighteen hours.

During action in the Battle of Bunker Hill, he has been called a "rock and rallying post" and is supposed to have given the historic order (also attributed to Colonel William Prescott) "Don't fire until you see the whites of their eyes." Two days later he was appointed a major general in the Continental Army.

Putnam saw action in the New York and New Jersey campaigns, but Washington soon realized that the old officer was a weak and ineffective field commander whose troops viewed him as "the exemplar of an outdated type of warfare." Finally, his frequent defiance of Washington's orders resulted in a court of inquiry. Although he was exonerated, he was ordered back to Connecticut and put in charge of the recruiting service. He saw his last military service in 1778/79, when he commanded forces quartered around Redding, Connecticut, and later on the west side of the Hudson. A paralytic stroke forced him to retire in December 1779.

This sketch may have been drawn from life just before Putnam's death, or it may be a posthumous portrait after a print. An excellent example of Trumbull's skillful draftsmanship, this likeness may have been a study for sword-brandishing "Old Put" depicted in the far left of Trumbull's *Battle of Bunker's Hill*, begun in 1785. The expression and attitude of the head, however, is somewhat different from that in this portrait.

Plate 37

JOHN TRUMBULL

Alexander Hamilton (*1755/57* (*?*) *– 1804*)

Oil on canvas 30-1/4" x 24-1/4"

c. 1806, New York

NATIONAL GALLERY OF ART, WASHINGTON, D.C.

Alexander Hamilton was born in the British West Indies, probably on the island of Nevis, the son of an exile from an important Scottish family and a local woman who had run away from her husband. Raised in considerable penury, he was thrown on his own at the age of about eleven by the death of his mother. Becoming a clerk in a mercantile house on Saint Croix, he so impressed the community that a subscription was taken up to send him to North America for an education. Landing in New York City, probably in 1772, he briefly attended King's College (Columbia) and became, at about seventeen, the leading pamphleteer in that colony for resistance to Great Britain. When fighting reached New York, he enlisted as a captain of artillery. In 1777, he was made aide to the commander in chief. His abilities were such that the youth quickly became, in effect, chief of staff.

Having married the daughter of Gen. Philip Schuyler and thus into the New York aristocracy, Hamilton, who had unsuccessfully sought service more glamorous than his staff appointment, picked a fight with Washington and resigned. However, Washington gave him the opportunity at Yorktown to lead the storming of a redoubt which he effectively accomplished.

Hamilton joined the bar in New York and became, under the tutelage of Robert Morris, an expert in financial affairs. Washington appointed him the first secretary of the treasury. Hamilton's successful restoration of national credit brought him into conflict with the agrarian Thomas Jefferson and spurred the creation of political parties. After his resignation from Washington's cabinet, Hamilton returned to the practice of law in New York and served as a leader of the Federalists. However, he lacked the common touch, and his political fortunes declined. He was killed in a duel with his political opponent and fellow member of the New York bar, Aaron Burr.

Trumbull painted this portrait after Hamilton's death. It is one of at least ten recorded replicas that were based on a marble bust executed by the Italian sculptor Giuseppe Ceracchi in Philadelphia in 1791. It is also the version on which the engraving on the ten-dollar bill is based. Trumbull did in fact paint Hamilton from life in 1792.

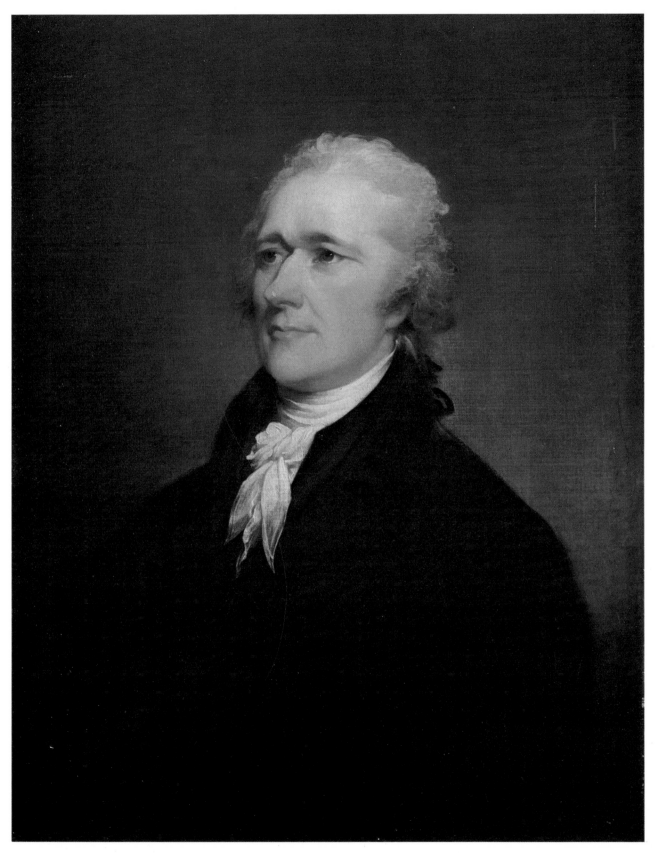

Plate 38

Thomas Jefferson (1743–1826)

Oil on canvas 35-3/4" x 28"

Signed and dated: M Brown pt./1786

CHARLES F. ADAMS

Virginia statesman, diplomat, scientist, architect, third United States President: indeed, among the founders of the nation, the extraordinarily versatile figure of Thomas Jefferson looms as one of the largest.

Jefferson became associated with the radical movement in 1774 when he published *A Summary View of the Rights of British America*. Based on the assumption that the colonists possessed historical and philosophical natural rights, this widely read and visionary pamphlet was among the most important of the Revolutionary period. This work established Jefferson's "reputation of a masterly pen," and, therefore, despite his youth, he was appointed to the Continental Congress committee to draft the Declaration of Independence. While all members made valuable contributions, Dumas Malone (D. A. B.) believes that the "political document as a composition belongs indisputably to Jefferson" and is considered "his noblest literary monument."

He returned to local politics thereafter, devoting his energies between 1776 and 1781 to framing new laws for and governing the state of Virginia.

In 1785 he succeeded Benjamin Franklin as American minister to France, and, in 1789, Washington appointed him the first secretary of state. Because of a political schism that developed between Jefferson and Hamilton, Jefferson refused to serve beyond December 31, 1793.

After a brief retirement at Monticello, he was elected vice president under John Adams in 1796 and, in 1800, became President of the United States, a post he held for two terms.

Along with the Declaration of Independence and the Virginia statute for religious freedom, Jefferson considered his most important contribution to the nation to be his role in the development of the University of Virginia. He helped establish the curriculum and, by aiding in the design of the original buildings, created an architectural masterpiece. Like John Adams, he died on the fiftieth anniversary of the Declaration of Independence.

Mather Brown painted the earliest known portrait of Jefferson when the diplomat was in London in the spring of 1786. While the original is lost, the replica commissioned by John Adams is here represented. In the general style of English portraiture of the last quarter of the eighteenth century, Jefferson is depicted wearing fancy lace, with hair powdered, tightly rolled, and tied in a queue. The classical figure in the background has been identified as a statue of liberty. This dandified representation seems in marked contrast to the democratic nature and political career of this man who was particularly noted for simplicity in dress and personal conduct. While the portrait was disliked by William Short, Jefferson's secretary, critics consider it one of Brown's most attractive works.

JOHN SINGLETON COPLEY

Henry Laurens (1724–1792)

Oil on canvas 54-1/8" x 40-5/8"

Signed and dated: J S Copley. R.A. pinx 1782

NATIONAL PORTRAIT GALLERY, SMITHSONIAN INSTITUTION, WASHINGTON, D.C.

Born in Charleston, South Carolina, of French Huguenot ancestry, Henry Laurens was a planter and a highly successful merchant specializing in overseas commerce.

After 1757 he took an active part in the political affairs of the colony, serving many years in the lower house of the legislature and agitating against the Stamp Act. In the mid-1770s, he was a representative in the First Provincial Congress and later president of the General Committee, then South Carolina's government. Subsequently he helped write his state's first constitution.

Unhesitatingly he accepted the inevitable loss of property and crops that would result from a protracted war, viewing it as "no small sacrifice at the shrine of Liberty, and yet very small compared with that which I am willing to make— not only crops, but land, life, and all must follow, in preference to sacrificing Liberty to Mammon."

He was a delegate to the Continental Congress and served as its president from 1777 to 1778. As a staunch supporter of Washington, Laurens played an important role in defeating the Conway Cabal, an effort of Washington's enemies to have him replaced as commander in chief by General Horatio Gates.

On a diplomatic mission to Holland in 1780, Laurens was captured by the British. After his release in 1782, he served with John Adams, John Jay, and Benjamin Franklin as a peace commissioner in Paris. His most notable contribution to the negotiations was in securing fishing rights off Newfoundland, indispensable for the prosperity of New England fishermen, and the stipulation that the British must not carry away any American property. For the next year and a half he was an unofficial United States representative in Great Britain, conferring with the ministry primarily on commercial matters. After 1784 he declined all future public honors because of his poor health and retired on his plantation.

Copley painted this portrait in London shortly after Laurens's release from the Tower of London, where he had been imprisoned for high treason in 1780/ 1781. Laurens is represented in his role as president of the Continental Congress. On the table are documents approved during his term of office—the French Alliance, providing military and other assistance to the colonies, and the Articles of Confederation.

Painted less than a decade after Copley's arrival in London, this picture has none of the somberness and directness of his American period. Rather, with its lighter palette, sumptuous accessories, expansive setting, and more plastic rendering of the figure in space, it reflects the influence of aristocratic English portraiture.

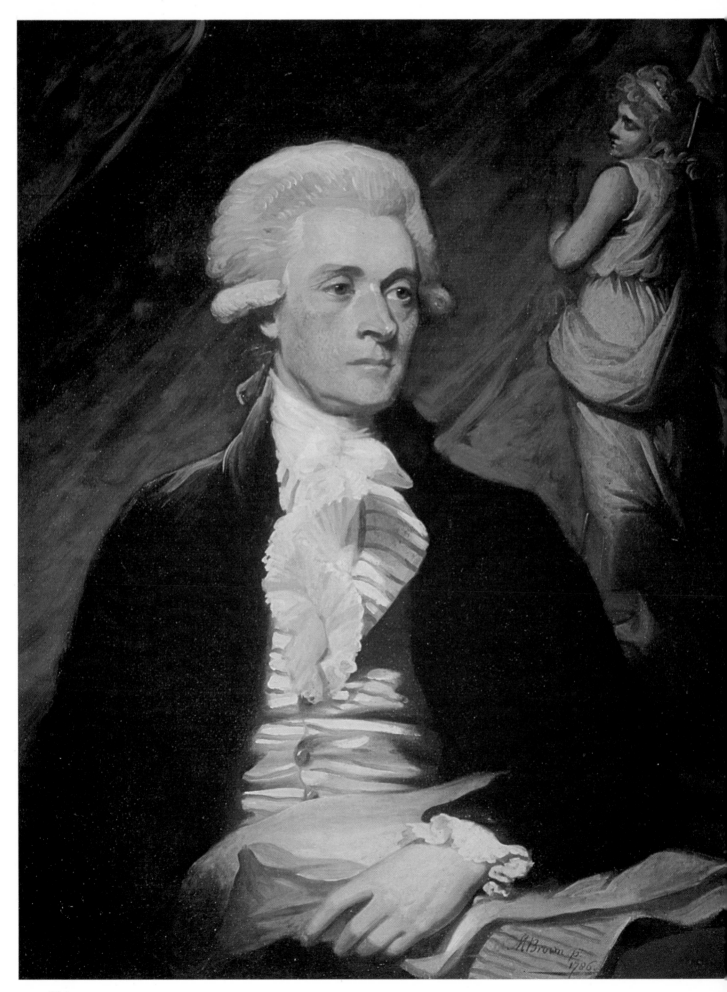

Plate 39

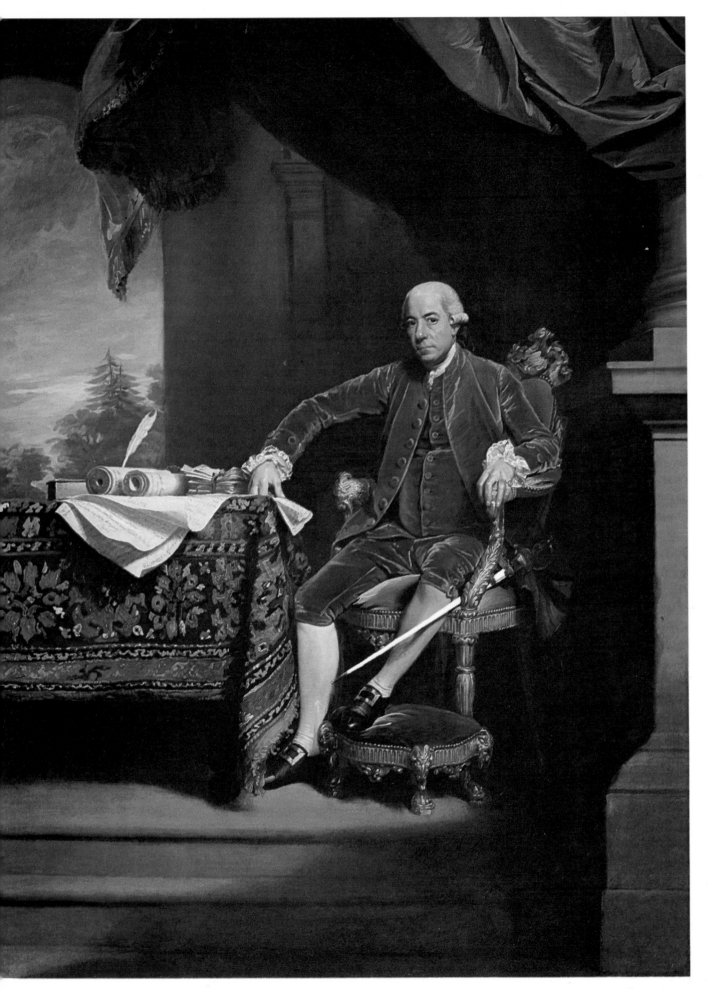

Plate 40

RALPH EARL

Marinus Willett (1740–1830)

Oil on canvas 91-1/4" x 56"

c. 1791

METROPOLITAN MUSEUM OF ART, NEW YORK

BEQUEST OF GEORGE WILLETT VAN NEST, 1917

Marinus Willett was born at Jamaica, Long Island, New York, and resided in New York most of his life. He attended King's College, became a cabinetmaker and eventually a wealthy merchant and property owner.

His military career began in 1758 when he fought in the French and Indian War. In the Revolutionary era, he was a leading member of the Sons of Liberty and, 1775/1776, served as a captain in Alexander McDougall's First New York Regiment and participated in the invasion of Canada. Subsequently he was commissioned lieutenant colonel and particularly distinguished himself at Fort Stanwix, where he led a successful attack against the British. For his bravery Congress voted to present him an "elegant sword."

In Washington's army during 1778, he fought at Monmouth, New Jersey, and the next year he fought the Iroquois. In 1781 he led the successful battle of Johnstown, New York.

At the close of the war, Willett began to take an active part in local New York politics. He succeeded DeWitt Clinton as mayor of New York City from 1807 to 1808 and was president of the electoral college in 1824. In 1790 Washington appointed him to negotiate a treaty with the Creek Indians.

Dressed in the uniform of the New York militia, wearing the eagle badge of the Society of the Cincinnati and the sword presented him by Congress (now at the Metropolitan Museum of Art), Willett grandly poses in a landscape setting. The two Indians in the background symbolize his prowess as an Indian fighter or perhaps refer to his negotiations with the Creeks.

Plate 41

148

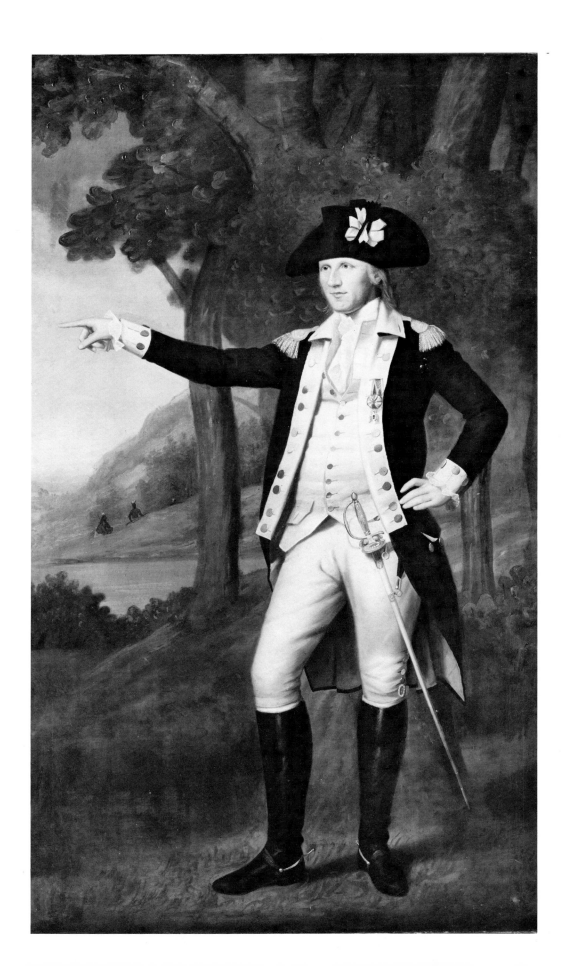

RALPH EARL

*Mrs. William Moseley (Laura Wolcott) (1761–1814) and
Son, Charles (1786/7–1817)*

Oil on canvas 86-3/4" x 68-1/4"
Signed and dated: R. Earl Pinxt 1791—

Laura Wolcott was born in Litchfield, Connecticut, the daughter of Oliver Wolcott, a signer of the Declaration of Independence and later governor of Connecticut. Her brother was secretary of the treasury under President Washington.

As a young woman, Laura herself made a valuable contribution to the Revolutionary war effort. On July 9, 1776, the equestrian statue of George III was torn down on the Bowling Green in New York City after the reading of the Declaration of Independence. The broken pieces of lead were sent to Litchfield, Connecticut, where the women transformed them into cartridges so desperately needed by the Continental Army. Of the estimated 42,000 cartridges made, Laura is recorded as making 4,250.

In 1785 she married William Moseley, a Hartford lawyer. The following year their only child Charles was born. He graduated from Yale and also practiced law in Hartford.

In a letter to her brother from Hartford of September 28, 1791, Mrs. Moseley laments that Earl was trying her patience over the last three months, while the "painting goes on steadily, though slowly." The city in the background is assumed to be Hartford where the Moseleys lived and worked, and where this picture must have been painted. Characteristic of many colonial painters, Earl has depicted the boy as looking much older than his three or four years.

Plate 42

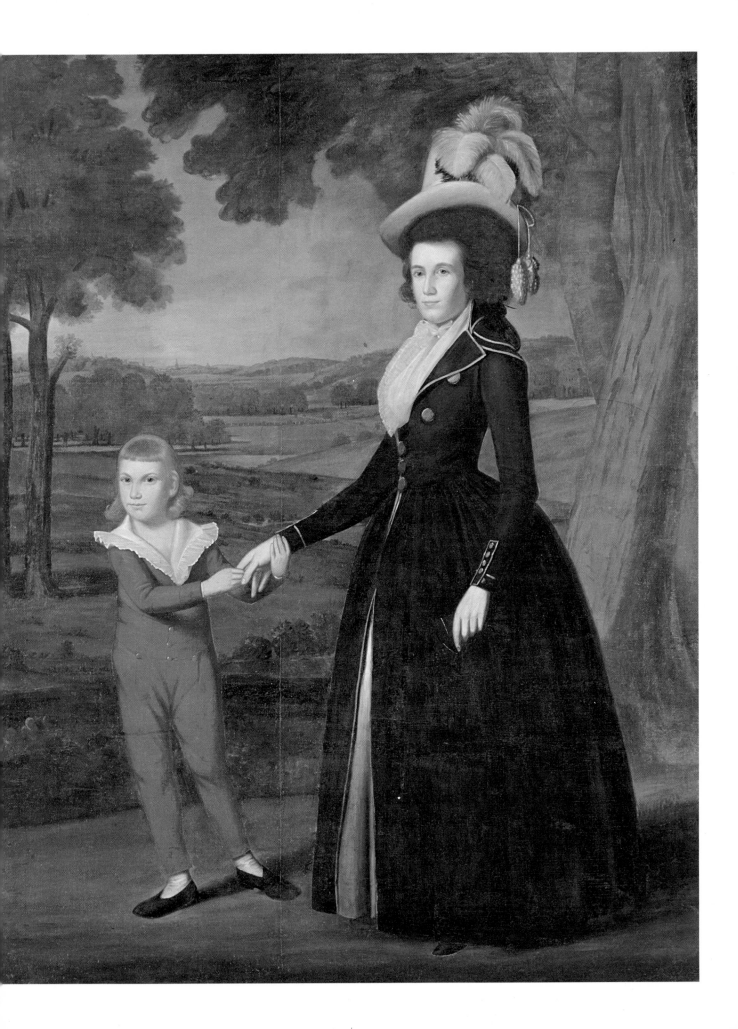

RALPH EARL

Amos Doolittle (1754–1832)

Oil on canvas 36″ x 28″

c. 1785

LYMAN ALLYN MUSEUM, NEW LONDON, CONNECTICUT

Amos Doolittle was born in Cheshire, Connecticut, and, after learning the trade of silversmith and jeweler, settled in New Haven. He soon turned his attention to engraving on copper. Self-taught, he produced numerous portraits and book illustrations, engraved music, maps, money, and diplomas.

He showed his patriotic zeal by signing a petition to the General Assembly of Connecticut to establish an independent military company. The Governor's Second Company of Guards was formed in response, and he joined. In the spring of 1775, news of the battles of Lexington and Concord reached New Haven, and a few days later Doolittle marched under the command of Captain Benedict Arnold to Cambridge. Before the militia returned to New Haven three or four weeks later, Doolittle visited the sites of the battles, perhaps accompanied by Ralph Earl. He returned home and by December had produced his famous series of historical engravings representing scenes from the battles of Lexington and Concord, included in this exhibition. These are considered among the rarest and most visually accurate of early American prints and are the only pictorial record by a contemporary American of the events of April 19, 1775. Doolittle also took part in resisting the punitive British raid on New Haven in July 1779.

The other notable work for which he is best remembered is his "Display of the United States of America" in which Washington is the central figure surrounded by the coats of arms of the states.

Earl painted this portrait shortly after he got back from Europe. The sitter is identified by the signature on the rolled sheet of paper.

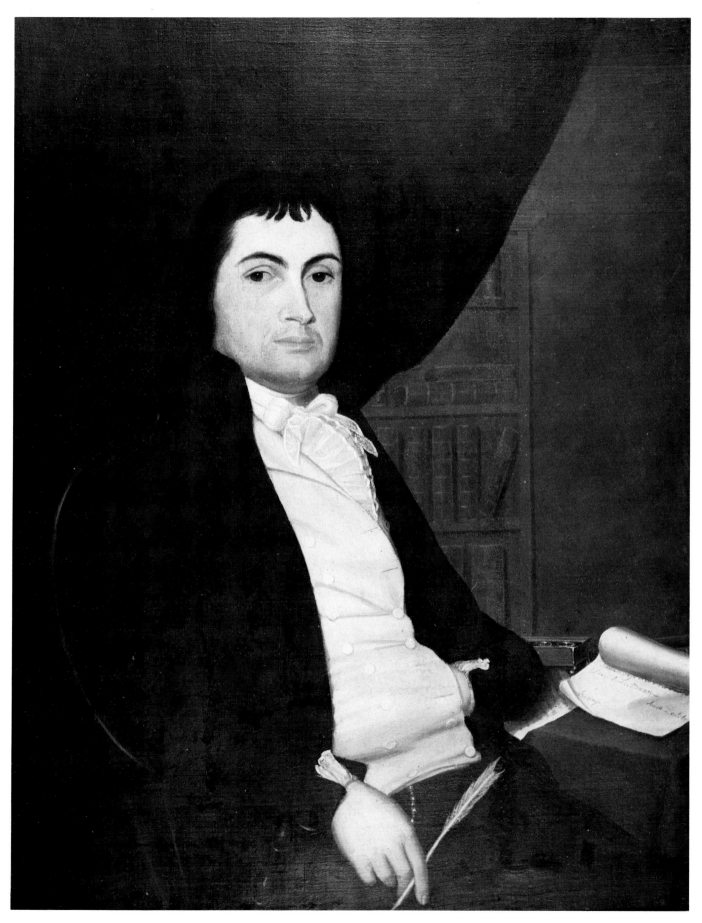

Plate 43

RALPH EARL

Chief Justice (1745–1807) and Mrs. Oliver Ellsworth (1756–1818)

Oil on canvas 75-15/16″ x 86-3/4″

Signed and dated: R. Earl Pinx^t 1792

COURTESY WADSWORTH ATHENEUM, HARTFORD, CONNECTICUT
GIFT OF ELLSWORTH HEIRS

Oliver Ellsworth was born in Windsor, Connecticut, and graduated from Princeton. After a false start in the ministry, he studied law and became one of the most successful and affluent lawyers in Connecticut.

In 1775 he moved to Hartford, and, a few years later, Noah Webster studied law in his office. In 1780 Ellsworth became a member of the Governor's Council and later held several judicial offices in his native state.

As a delegate to the Continental Congress from 1777 to 1782, Ellsworth was noted for his conscientiousness and hard work on several important committees. He was one of three Connecticut delegates at the Constitutional Convention in 1787 and was instrumental in conceiving the two-house system of representation—the Senate with equal representation by states, the House with representation proportional to population—a plan which became known as the "Connecticut Compromise." He served on the committee which prepared the first official draft of the Constitution and thereafter actively agitated for ratification.

From 1788 to 1796 he was a United States senator from Connecticut and from 1796 to 1801 chief justice of the United States Supreme Court. The last important public service Ellsworth performed was as commissioner to France in 1799–1800, where he negotiated an agreement with Napoleon that helped to keep the United States out of a war with France. When he returned to the United States, he retired and wrote articles on agriculture and theology.

Oliver married Abigail Wolcott in 1772.

The Ellsworths are shown seated in the "Washington Room" of their Windsor, Connecticut, home, where it was said Washington once sat. A disjunction of place exists, however, because through the window is a view of the very house in which they are sitting. It is surrounded by thirteen elms which Ellsworth had planted in honor of each of the original states. Oliver holds in his hand a copy of the first draft of the Constitution, open to the last Article VII.

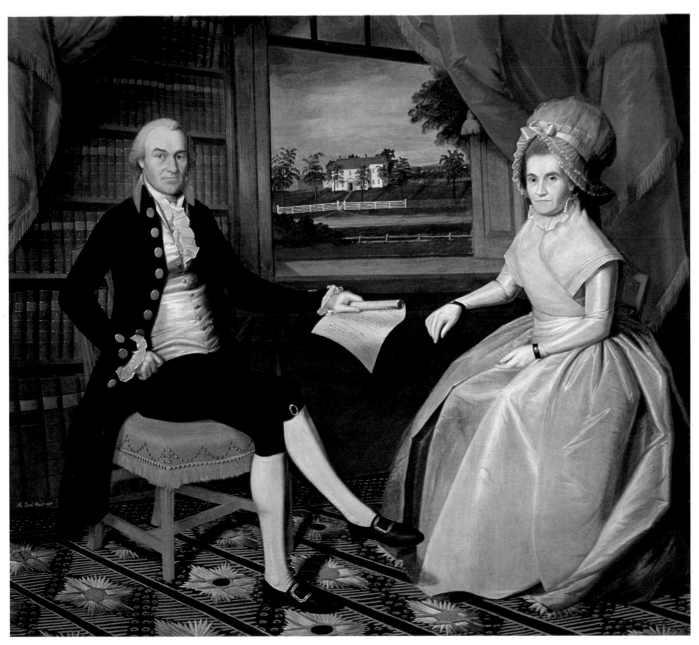

Plate 44

Robert Troup (*1756/57–1832*)

Oil on canvas 29-3/4" x 33"

Signed and dated: R. Earl Pinx^t 1786

MR. AND MRS. JAMES D. IRELAND, CLEVELAND, OHIO

After graduating from King's College in 1774, Troup studied law, most notably under John Jay.

As a soldier during the Revolution, Troup was first a lieutenant stationed on Long Island and later aide-de-camp to Brigadier General Timothy Woodhull. Troup's capture with three other officers in the summer of 1776, while on a reconnaissance mission at Jamaica Pass, enabled the British to outflank Washington's army at the Battle of Long Island. After his release from captivity, he was promoted to lieutenant colonel and served on the staff of General Horatio Gates. He participated in the campaign which resulted in the surrender of Burgoyne at Saratoga in October 1777. In 1778 he was appointed secretary of the Board of War and later secretary of the Board of Treasury. He favored adoption of the federal Constitution and was an intimate friend of Alexander Hamilton.

Upon Troup's return to civilian life and completion of his law studies, he established what soon became a lucrative practice in Albany and New York. Conservative in politics, he was elected to the state assembly and in 1796 was appointed judge of the United States District Court of New York.

In 1814 he became a permanent resident of Geneva, New York, and was an early promoter of the Erie Canal.

Troup is portrayed dressed in the robes and bands of a counselor-at-law, in a pose and composition strikingly similar to Earl's portrait of Amos Doolittle (see Plate 43).

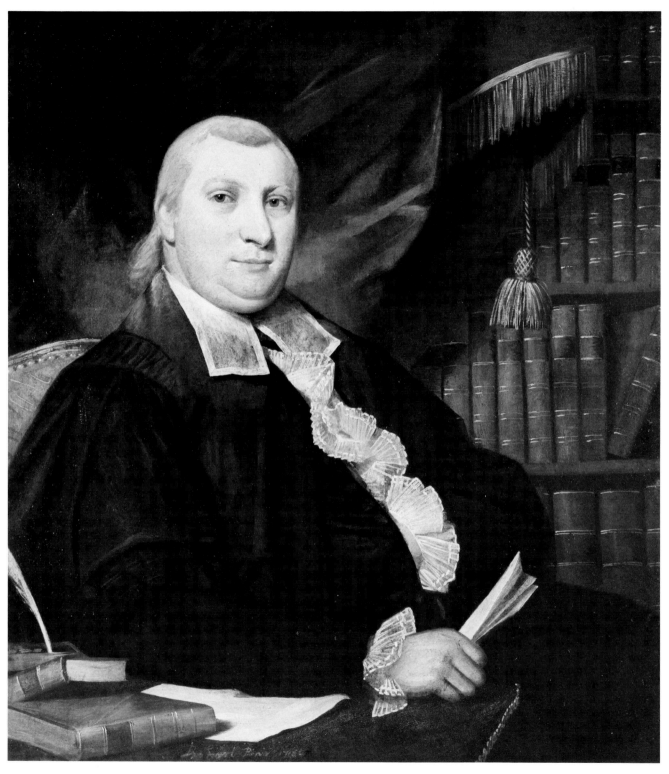

Plate 45

Thaddeus Andrew Bonaventure Kosciusko (*1746–1817*)

Oil on panel 12-15/16″ x 17-5/16″

Signed and dated: B. West/1797.

ALLEN MEMORIAL ART MUSEUM, OBERLIN COLLEGE, OBERLIN, OHIO

Born in Poland, Kosciusko acquired the military education of the lower gentry. Since his own country was torn apart by political strife, he came to America and volunteered to serve in Washington's army.

Commissioned a colonel of engineers in 1776, Kosciusko saw active service at Ticonderoga and because of his superb direction of the building of entrenchments at Bemis Heights, contributed to the American victory in the Saratoga campaign. As engineer at West Point he was in charge of building the fortifications which were a key element in the network of defense of navigation along the Hudson River.

Later, while serving in the Southern Department under General Greene, Kosciusko, amidst constant danger of being captured, executed the earliest surveys of the western North Carolina rivers, documents which were invaluable to Greene's campaign. He also participated in many of the battles in the South, either as an officer on the line or involved in gathering of intelligence.

Kosciusko returned to Europe eight years later, a brigadier general, but virtually penniless because Congress could not afford to pay him his back salary. Called the "Washington of Poland," he tried to lead his countrymen in their own revolution. While initially successful, in 1794 he was finally defeated. Critically wounded, he was captured and imprisoned in Russia. Two years later he set out for America. On the way through London, West painted this fresh and unpretentious picture. Kosciusko is shown still suffering from the wounds of the Polish Insurrection. He holds his hand to his bandaged forehead, alluding to the chronic headaches he suffered from a neglected saber wound. The crutch behind the couch and his outstretched legs are further evidence of untended wounds that resulted in paralysis of his left leg. Lying on the table in the foreground is a saber, perhaps the one presented to him by the Whig Club of England as "a public testimony of . . . his exalted virtues and his gallant, generous and exemplary efforts to defend and save his country." Through the back window is a view of St. Paul's Cathedral.

After a brief stay in America, Kosciusko returned to Europe. He died in Switzerland where, in exile, he had continued his futile ideological support of the Polish revolution.

Thomas Jefferson, an intimate friend and correspondent for several years, was named executor of his American will. Long sympathetic to the misery of the American slaves, Kosciusko left all his funds for the cause of Black freedom and education.

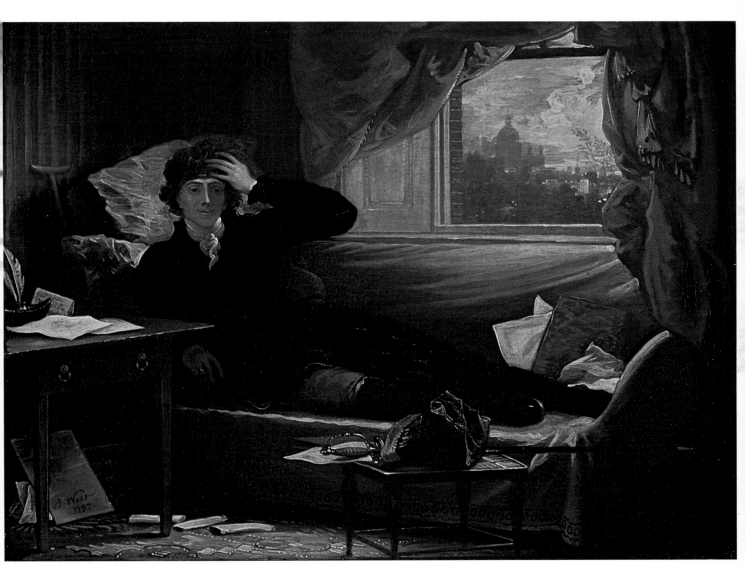

Plate 46

Mrs. Ammi Ruhamah Robbins (Elizabeth LeBaron) (*1745–1829*)

Oil on canvas 31-3/8" x 27-1/2"

1812

THE DETROIT INSTITUTE OF ARTS

GIFT OF MR. AND MRS. HAROLD R. BOYER AND

MR. AND MRS. FREDERICK M. ALGER, JR.

Elizabeth LeBaron was born in Plymouth, Massachusetts, the daughter of an eminent physician and a descendant of a Mayflower Pilgrim. She was married to the Reverend Mr. Robbins on May 13, 1762, and had nine sons and four daughters.

Moulthrop's background as a self-trained artist is illuminated here in the characteristic play of surface patterns. What extraordinary care is taken in meticulously rendering the decorative patterns of the lace of Mrs. Robbins's cap and the cloth of her dress! Suggesting the sitter's domestic talents is the simple still life composition of knitting on the table, its charm enhanced by the delicate meandering line of the ball of yarn. On her lap, Mrs. Robbins holds a book, undoubtedly the Bible, a common female attribute.

The large full-length version of the Reverend Mr. Robbins that follows is not in fact the companion piece to this portrait. The companion piece is a half-length likeness of similar dimensions which is also in the collection of The Detroit Institute of Arts.

The dates of this painting and other portraits by Moulthrop of members of the Robbins-Battell family were derived from family letters in the collection of the Connecticut Historical Society.

Plate 47

REUBEN MOULTHROP

Ammi Ruhamah Robbins (1740–1813)

Oil on canvas 59-1/8" x 59-1/8"

c. 1812

Born in Branford, Connecticut, Ammi Ruhamah Robbins graduated from Yale and briefly taught school in Plymouth, Massachusetts. In 1761 he became minister of the Congregational Church in Norfolk, Connecticut, a post he held the rest of his life. Under his direction, the church grew to be one of the largest and most prosperous in the state.

At the outbreak of the Revolution, Robbins volunteered as an army chaplain. In Colonel Burrall's Litchfield County Regiment, he served in the Northern Department and Canada. He was disheartened and appalled by the suffering and hardship he saw all around him and soon succumbed to illness himself. He lamented in his journal on July 29, 1776:

> I envy brother Avery his health. He will go through the hospital when pestiferous as disease and death can make it with a face as smooth as a baby's and afterward an appetite as healthy as a woodchopper. I cannot— after inhaling such diseased breath, am sick and faint, besides their sorrows take hold of me.

The army life finally proved too strenuous for Robbins. He resigned after six months service.

Between 1783 and 1796, Robbins made several missionary tours through the northern part of Vermont and New York. He was a trustee of Williams College from 1794 to 1810, when his health began to decline. In the meantime, he had published several sermons. His best known was the "Half Century Sermon" of 1811. He died of cancer in his seventy-fourth year.

Moulthrop has represented the old theologian seated in his study. Reflecting the artist's background as a wax modeler, the face and hands are treated in a sculpturally linear, hard manner devoid of the softness of human flesh, a trait particularly characteristic of the artist's late works. Robbins is surrounded by a myriad of superrealistically rendered objects intended to reflect his personality and occupation. The books stacked on the table next to him, inkwell nearby, quill in hand, eyeglasses propped on top of his head, all suggest that he has just finished writing one of his sermons. Notice the white clay pipe whose delicate curvilinear shape offers a delightful foil to and relief from the massive rectilinearity of the books.

Characteristic of the untrained limner, realistic spatial relationships are subordinated to abstract rules of design. The ground plane, for example, is irrationally tilted upward, thereby emphasizing the decorative floor patterns. The position of Robbins's legs in relationship to his feet is impossibly awkward, although the overall effect is all the more pleasing for the simplification.

Plate 48

John Phillips (*1719–1795*)

Oil on canvas 32-1/2" x 28"

c. 1793–1795

THE CONNECTICUT HISTORICAL SOCIETY, HARTFORD, CONNECTICUT

John Phillips, born in Andover, Massachusetts, entered Harvard College before his twelfth birthday. After graduating with an M.A. at the age of sixteen, he dabbled first in teaching and then in the ministry before becoming a highly successful businessman. He made a fortune speculating in real estate and loaning money at high interest rates.

Phillips held several local public offices during the Revolution. From 1771 to 1773 he served in the General Court, in 1778 and 1779 was moderator of the town meeting, and was colonel of the Exeter Cadets.

He is best remembered, however, for his influential role in the establishment and development of Phillips Academy, Andover, and the Phillips Exeter Academy. He served both institutions as president of the board of trustees and by contributing large sums of money.

As a trustee of Dartmouth College, Phillips also made liberal gifts to this school, notably the endowment of a professorship of Biblical history and literature. Understandably, the trustees wanted to immortalize their generous benefactor and, on August 28, 1793, they commissioned Joseph Steward "to take a whole length portraiture of the honorable John Phillips LL.D. to be deposited in one of the public chambers of this University at the expense of this board; said Steward having agreed to do it at the price of twelve guineas including his expenses of travelling to and from Exeter for this purpose."

This portrait shows the head and shoulders as represented in the full length at Exeter. Whether Steward painted the detail first as a preliminary study or later as a special commission has not been determined. The sitter is clearly identified by an inscription on the bottom.

JOHN Phillips Eqr. L. L. D.

Plate 49

JOSEPH STEWARD

Benjamin Boardman (*1731–1802*)

Oil on canvas 40″ x 37-1/2″

c. 1796

THE CONNECTICUT HISTORICAL SOCIETY, HARTFORD, CONNECTICUT

A graduate of Yale College, Benjamin Boardman entered the ministry in 1760. He spent a brief and rather tumultuous period as a tutor at Yale where, for alleged misconduct, he was severely beaten by a group of students. A court of inquiry vindicated him, however. In 1762 he became pastor of the Congregational Church in Middle Haddam (now Chatham), a position he held until the outbreak of the Revolution.

As chaplain in the Second Connecticut Regiment from 1775 to 1776, Boardman saw action in Massachusetts and New Jersey. Excerpts from the journal he kept during this period suggest a lively personality and provide small and intimate details—about minor events in the life of a soldier.

On August 28, for instance, he notes "A deserter (from the enemy) came over to our people last night. He swam off naked. He had been confined for insulting an officer, and his desertion seemed evidently occasioned by this rather than any dislike to fight against America."

On September 18, he writes that of thirteen British bombs fired, five "never broke, our people got the powder out of them . . ."

During his service in the army, Boardman had accepted a reduced salary from his parish, but in 1783, antipathy arose between him and his congregation and. he was "dismissed on a question of expediency." A successor, the Reverend David Dudley Field, wrote that "he had more talents than prudence" and was "rash and violent in temper."

During 1784, Boardman accepted an appointment in Hartford at the South Church. When, in 1789, the financial loss the church had suffered during the Revolution made it impossible to support their new pastor, Boardman resigned, apparently to the cheers of the congregation which had become dissatisfied with his services anyway. Boardman continued to preach in neighboring destitute churches until his death in Hartford at the age of seventy-one.

In a composition particularly characteristic of Steward, Boardman is seated in his study framed by a bookshelf on one side and on the other by an open window revealing a landscape with houses. On the center right is inscribed "Aetat. 65," Boardman's age.

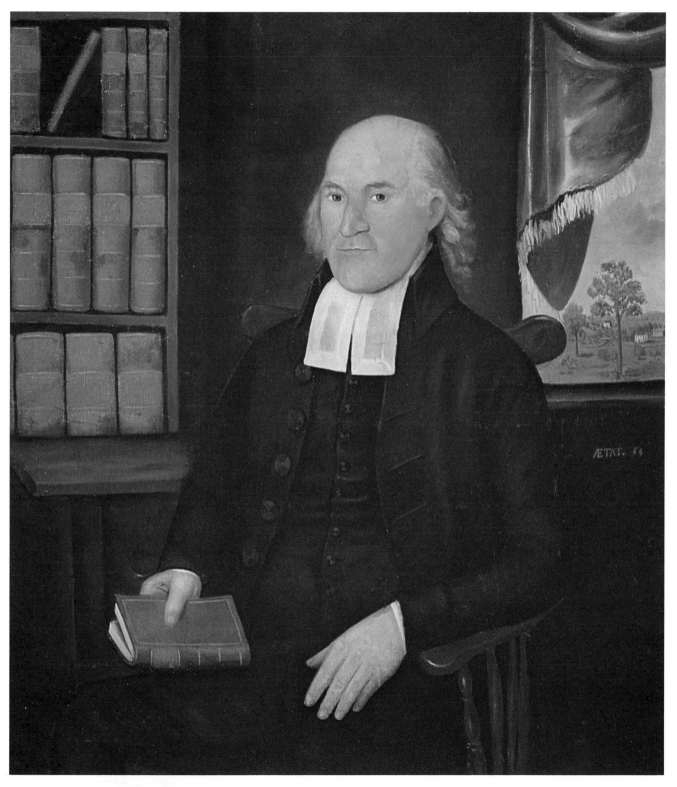

AETAT. 64

Plate 50

John Murray (1742–1793)

Oil on canvas 55″ x 40″

c. 1781

HISTORICAL SOCIETY OF OLD NEWBURY, NEWBURYPORT, MASSACHUSETTS

John Murray was a native of Ireland and educated for the clergy at Edinburgh. He settled first at Booth Bay, Massachusetts, where, in 1775, he was chosen as a delegate to the Provincial Congress.

In 1781, the Reverend Mr. Murray moved to Newburyport, Massachusetts, and was installed as minister at the First Presbyterian Church. He was particularly praised for his eloquence and extraordinary abilities as an orator. To distinguish him from another clergyman of the same name, Murray, who was known for his portrayals of the terrors of eternal punishment, was called "Damnation." The second minister, who stressed the doctrine of universal salvation, was called "Salvation."

In a funeral sermon delivered April 7, 1793, three weeks after Murray's death, the Reverend James Miltimore tells of one of Murray's contributions to the Revolution. In the face of depreciated currency and disheartened soldiers, three days had been spent in vain trying to raise troops in Newburyport. Finally, on the fourth day, Murray was asked to address the regiment then assembled. He "viewed with sensible pain the ill success of every effort which had been made. . . . He consented to be escorted to the parade and from thence with the whole Regiment to the Meeting house. There he pronounced a spirited and guided address. His whole audience was all attention and tears gushed from many eyes. Soon after the assembly was dismissed, a member of this Church appeared to take command of the Company, and in the short term of two hours the Company was filled, and in a few days actually marched to join our distressed Army."

The Reverend Mr. Murray is shown wearing a wig and his liturgical gown. His left arm rests on a monumental Bible. In his right hand he holds a sheet of paper inscribed: "John III 16 (. . .)/ For God so loved the World that he/ gave his only begotten Son that/ whosoever believeth in him should/ not perish but have everlasting life./ Mark XVI 15 Go ye into all the . . ."

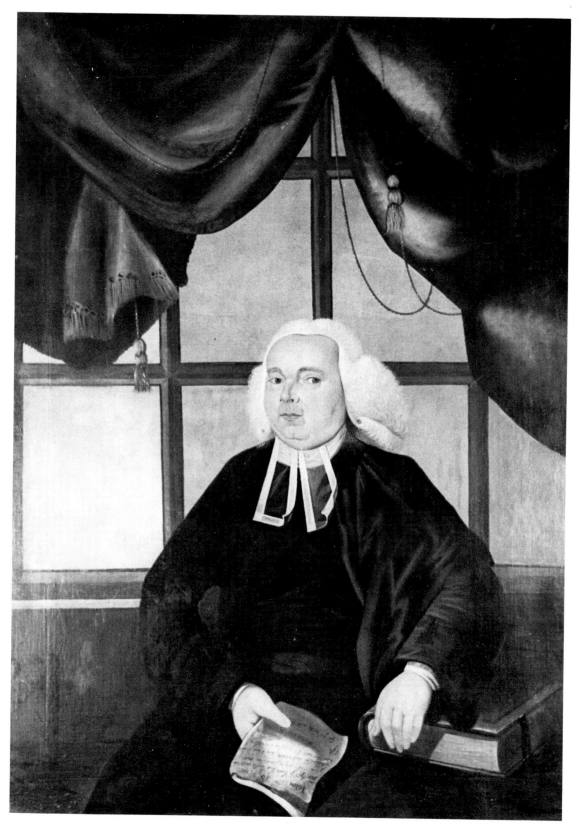

Plate 51

Charles Cotesworth Pinckney (*1746–1825*)

Oil on canvas 30″ x 25″

c. 1773–1775

NATIONAL PORTRAIT GALLERY, SMITHSONIAN INSTITUTION, WASHINGTON, D.C.

Charles Cotesworth Pinckney was born at Charleston, South Carolina, the son of a prosperous and influential family. At an early age, he moved with his family to England where he was educated at Oxford. He later studied at the royal military academy at Caen.

Returning to South Carolina in 1769, he pursued a law career and almost immediately became involved in local politics. During the 1770s he was successively a member of the provincial Assembly, the provincial Congress, the Council of Safety, and the lower house of the State Legislature. In 1779 he became president of the South Carolina Senate.

At the same time Pinckney had maintained his interest in military affairs by serving in the local militia. As an officer in the First Regiment of South Carolina troops, he participated in the defense of Fort Sullivan in June 1776. He fought in the Florida Campaign of 1778 and in the Siege of Savannah. At the fall of Charleston in 1780, he was captured with other American officers. During his two-year incarceration, Pinckney was repeatedly asked by the British to pledge allegiance to the Crown. Rumors spread that he had indeed changed sides. But when asked by his friend Edward Rutledge if there was any truth to the gossip, Pinckney replied, "If I had a vein that did not beat with love for my country, I myself would open it. If I had a drop of blood that could flow dishonorably, I myself would let it out." Exchanged in 1782, he rejoined the army and was brevetted brigadier general.

Pinckney played a prominent role in the Federal Convention (1787) and the state convention that ratified the Constitution. In 1796, he was appointed American ambassador to France, but the government in revolutionary Paris refused to receive a representative of the United States. Pinckney was later joined by John Marshall and Elbridge Gerry on a special mission to the French government which culminated in the so-called XYZ Affair and almost embroiled the United States and France in war. Pinckney remained active in politics for the rest of his life.

Benbridge painted this picture, along with a portrait of Pinckney's wife, in the fall of 1773 or the spring of 1774. X rays revealed that Pinckney was originally depicted wearing his red militia uniform. After the First Regiment of South Carolina troops was organized in June 1775 and Pinckney was made captain of the Grenadier Company, Benbridge painted over the old uniform with the blue uniform of the patriot army.

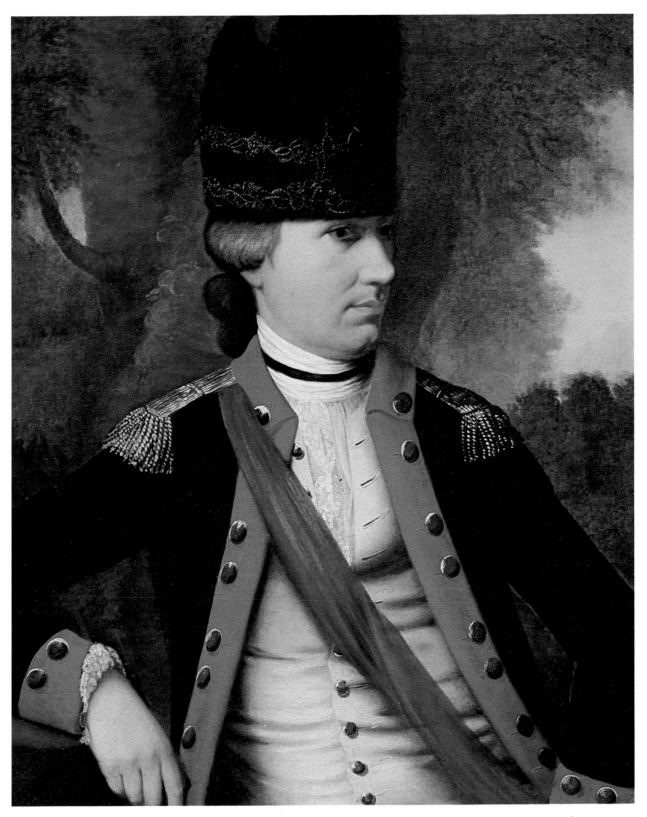

Plate 52

CHARLES WILLSON PEALE

Baron Friedrich Wilhelm Augustus von Steuben (1730–1794)

Oil on canvas 30" x 25"

1780

PENNSYLVANIA ACADEMY OF THE FINE ARTS, PHILADELPHIA
GIFT OF M. L. M. PETERS 1881

Steuben, called the "first teacher of the American Army," was born in Magdeburg fortress where his father, a lieutenant engineer, was stationed. After a Jesuit education, the young man entered the officer corps of the Prussian Army and served in the Seven Years' War. By 1761 he was a member of the general staff and ably performed confidential military-diplomatic negotiations. Subsequently he was attached to Frederick the Great's headquarters. Discharged in 1763, he later fell on hard times.

In 1778 he volunteered his services to the Continental Army and immediately reported to Washington at Valley Forge. Although he spoke no English, he drafted a military training program and established a model company of 100 men which he himself drilled. By using these troops as models for the rest of the army, discipline quickly improved and Congress approved Steuben's appointment as inspector general with the rank of major general. Beloved by the troops for his eccentricities, when he could no longer curse a delinquent company in German or French, he asked his interpreter to swear for him in English.

Steuben served in the Southern campaign in Virginia, most notably at Yorktown where his siege warfare experience was particularly beneficial. In 1783 he assisted Washington in making future defense plans and demobilizing the Continental Army. He was honorably discharged in March 1784 and, having become an American citizen, settled in New York City where he was socially prominent and popular. Among his close friends was Alexander Hamilton.

Steuben is depicted wearing the uniform of the Continental Army. Hanging on the ribbon around his neck is the star of the Prussian Order of Fidelity, on his breast its jeweled badge. Peale later painted a bust-length oval replica (c. 1781–1782), adding the two stars of a major general to the epaulettes. It now hangs in Independence Hall.

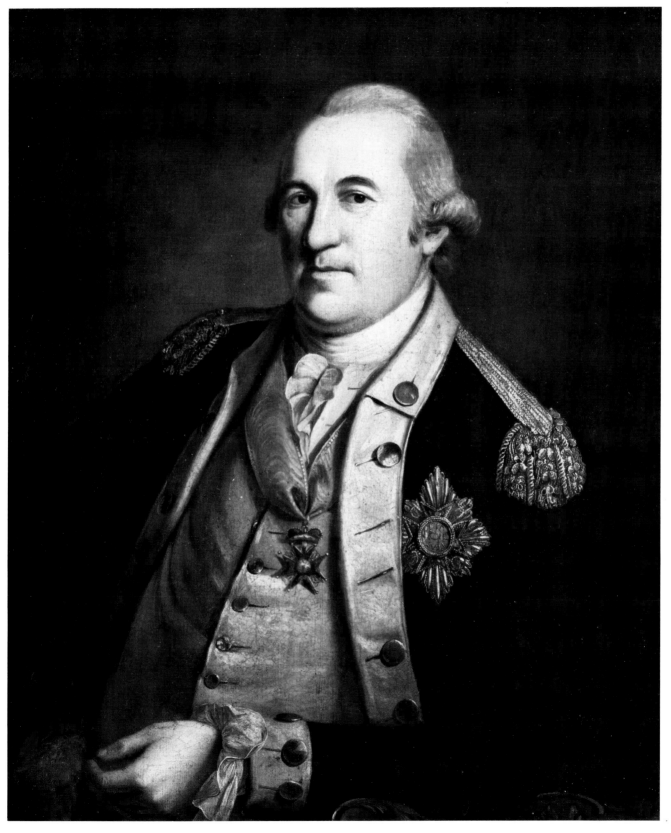

Plate 53

Mrs. Jonas Green (Anne Catherine Hoof) (c. 1720–1775)

Oil on canvas 35-1/4" x 28"

c. 1770

PRIVATE COLLECTION

Anne Catherine Hoof was probably born in Holland and brought to Pennsylvania as a child. She married Jonas Green, a journeyman printer from Boston, in 1738 and bore fourteen children, six of whom lived to maturity. The Greens moved from Philadelphia to Annapolis, Maryland, in 1739 and Jonas soon became printer for the Province of Maryland and publisher of the *Maryland Gazette.* He died in 1767, and Mrs. Green, with the help of one of her sons, continued the business. The following year the Maryland assembly appointed Mrs. Green "printer of the Province," a post she held until her death.

Among her publications were an almanac, some political pamphlets and satirical works, and various documents for the province. Since the *Maryland Gazette* was the only newspaper in Maryland before 1773, it was indispensable in reporting the various political events and protests in the northern colonies that led up to the Revolution. John Dickinson's *Letters from a Pennsylvania Farmer,* influential essays presenting constitutional objections to the Townshend Acts, appeared in her columns. After her death, her son Frederick carried on the business.

This picture, until recently unlocated, appeared in a list of his paintings Peale casually prepared between 1770 and 1775. Mrs. Green is shown holding a document on which are printed the words "Annapolis Printer '68."

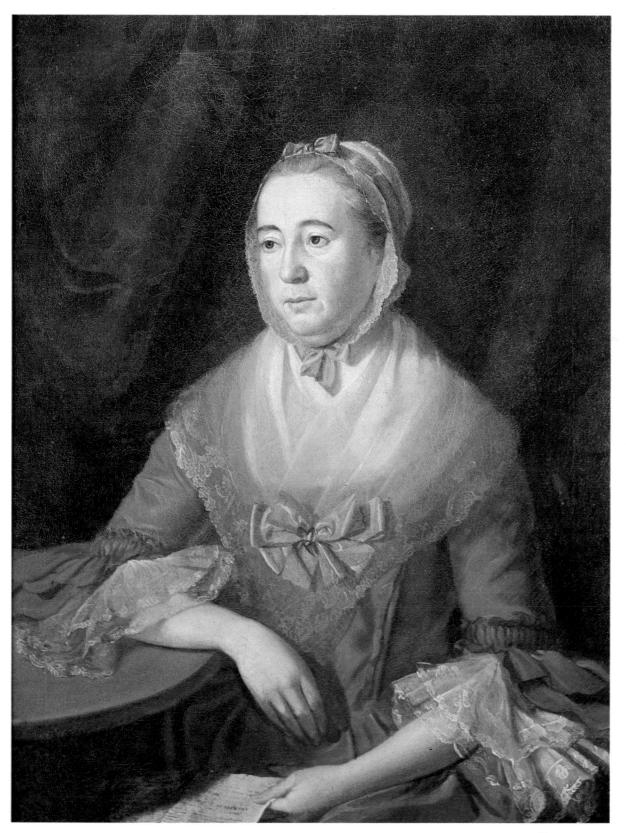

Plate 54

William Moultrie (1730–1805)

Oil on canvas 26-1/2" x 22-1/2"

1782

NATIONAL PORTRAIT GALLERY, SMITHSONIAN INSTITUTION, WASHINGTON, D.C.

William Moultrie was born in Charleston, South Carolina, and spent eight inconspicuous years in the South Carolina Commons House of Assembly. Thereafter he served as captain in the Cherokee War and became a recognized leader in the military affairs of his province. Since he had held several political posts, he was elected to the First Continental Congress, but did not serve.

His claim to national fame in the Revolution was his courageous defense of the Palmetto Fort on Sullivan's Island which guarded one of the entrances to Charleston harbor. Here, on June 28, 1776, with four hundred men and thirty-two guns he received the attack of the British fleet. His heroism in that battle is reflected in this family portrait, an enlarged replica of the one Peale painted for his museum in 1782. The background scene is based on *Sir Peter Parker's Attack Against Fort Moultrie, 1776* (Colonial Williamsburg, 1782), attributed to James Peale who often painted the background of his father's portraits of Washington.

On the left is a palmetto, the South Carolina state tree that thrives along the coastal region and, after the battle, was incorporated into the flag. Because it was constructed of spongy palmetto logs and resilient sand, the fort successfully resisted British cannonball. On the right is the fort, over which flies the flag which during the battle was reportedly shot away, and then heroically replaced. The ship, flying the British Red Ensign, is undoubtedly supposed to represent Sir Peter Parker's (the commodore's) fifty-gun frigate *Bristol* which played an important role throughout Moultrie's account of the incident: "At one time, the commodore's ship swung round with her stern to the fort, which drew the fire of all the guns that could bear upon her: we supposed she had the springs of her cables cut away." The next morning the ships reappeared and when the patriots fired on one frigate, the damage was extensive enough to warrant her being set on fire and abandoned. The patriots then boarded her and fired her two guns at the commodore's ship, which soon blew up. Moultrie completes his account of the battle by writing: "from the explosion issued a grand pillar of smoke, which . . . to appearance, formed the figure of a palmetto tree."

The following September, Moultrie was appointed a brigadier general in the Continental Army. He was captured during the Charleston expedition in May 1780 and was imprisoned for nearly two years. Upon his release he was made major general and in this portrait wears two stars reflecting that promotion.

In 1783 he served in the State House of Representatives. Later he served two successful terms as governor of South Carolina.

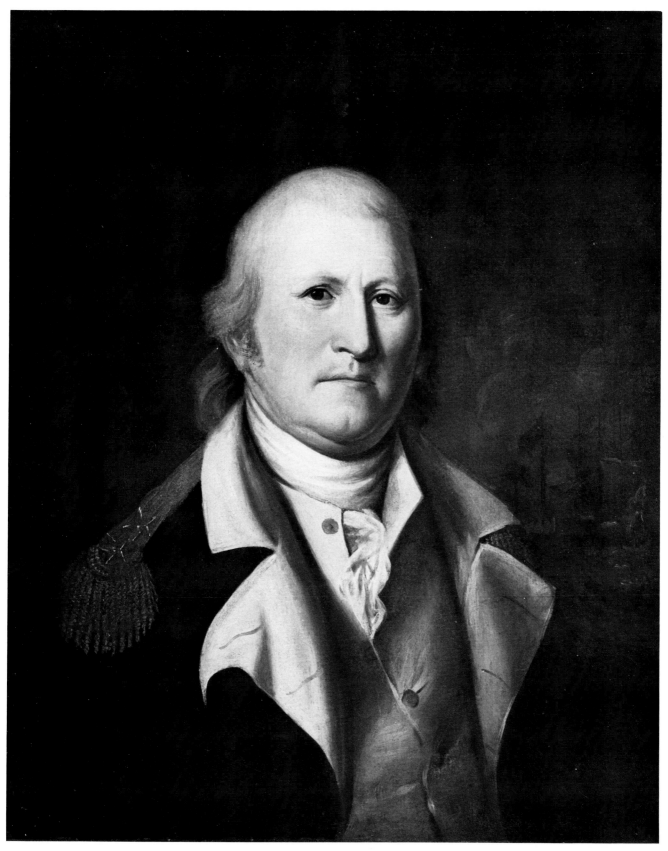

Plate 55

Benjamin Franklin (1706–1790)

Oil on canvas 23" x 18-3/4"

c. 1785–1787

PENNSYLVANIA ACADEMY OF THE FINE ARTS, PHILADELPHIA

JOSEPH AND SARAH HARRISON COLLECTION 1878

At the start of the Revolution Benjamin Franklin was seventy years old and had already achieved an international reputation as a scientist, inventor, writer, editor, printer, and philanthropist. Born in Boston, he had only a brief and rudimentary education before he entered his father's business—tallow chandler and soap boiler. Dissatisfied, he soon procured an apprenticeship in his brother's printing shop. After repeated quarrels with his brother, at the age of seventeen he left for Philadelphia. Arriving with only a Dutch dollar and a copper shilling in his pocket, within seven years he was owner of the *Pennsylvania Gazette.*

From 1732 to 1757 he edited *Poor Richard's Almanack,* in which he increasingly printed witty aphorisms on the value of thrift, hard work, and the simple life. By 1750 he had helped establish a debating club (which became the American Philosophical Society), a circulating library, Philadelphia's first fire department, and an academy that was the nucleus of the University of Pennsylvania. He had invented a stove and bifocals and had conducted experiments in electricity.

Beginning in the mid-1750s Franklin became increasingly involved in public affairs. He was deputy postmaster general of the colonies from 1753 to 1774. At Albany in 1754 he presented a plan to unite the colonies in the war against the French and Indians. From 1757 on, he spent several years in England on various diplomatic missions and was instrumental in the repeal of the Stamp Act.

He returned to America in March 1775 to serve in the Second Continental Congress. With Samuel Chase and Charles Carroll he was sent on an unsuccessful mission to Canada to win the people over to the American side. He helped draft the Declaration of Independence and was himself a signer. In December 1776 he arrived in Paris as one of three commissioners to negotiate a treaty. His popularity with the French was indispensable in securing secret aid and bringing about the French Alliance. Later, along with John Adams, Jay, Laurens, and Jefferson, he helped negotiate the peace with Great Britain.

He returned to Philadelphia in September 1785 and became an influential member of the Constitutional Convention. His last public act was to sign a memorial to Congress for the abolition of slavery. He died at the age of eighty-four in Philadelphia.

Peale painted this portrait for his museum, where it remained until 1854 when the collection was sold. Unlike some artists who tended to idealize the great statesman, Peale depicted Franklin as realistically as possible. He included his two moles and the silver-rimmed bifocals which had virtually become Franklin's trademark.

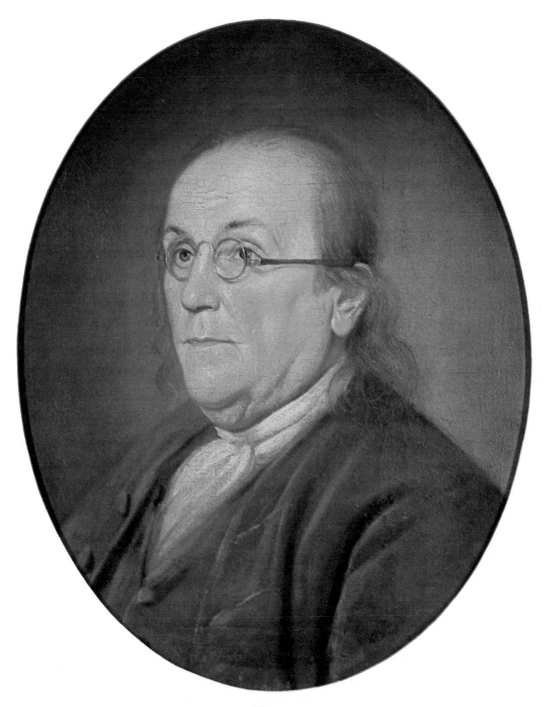

Plate 56

CHARLES WILLSON PEALE

Gouverneur (1752–1816) and Robert (1734–1806) Morris in the Office of Finance

Oil on canvas 43-3/8" x 51-3/4"

Signed and dated: C. W. Peale/Pinxt. 1783

PENNSYLVANIA ACADEMY OF THE FINE ARTS, PHILADELPHIA
BEQUEST OF RICHARD ASHHURST 1969

The Morrises were not actually related, but mutual talents and careers brought them closely together.

Gouverneur, born in the manor house at Morrisania, New York, became a lawyer and helped draft the New York State Constitution. As a member of the Continental Congress (1778–1779), he displayed unusual ability in financial and diplomatic matters. In 1780 he wrote a series of articles on Continental finances which brought him to the attention of Robert Morris. After Robert was appointed superintendent of finance, he invited Gouverneur to be his assistant, a post he held from 1781 to 1785.

As a delegate to the Convention of 1787, Gouverneur was largely responsible for the wording of the Constitution. From 1789 to 1794 he performed various ministerial duties in France and England. Having returned to New York, he spent his last years trying to rebuild his estate, which had been wrecked during the Revolution.

Robert came to America from Liverpool, England, at the age of thirteen. In Philadelphia he joined a shipping merchant firm and soon became a wealthy partner. He opposed the Stamp Act, was a member of the Pennsylvania Council of Safety and later the Continental Congress, where he was indispensable in procuring arms and munitions. He signed the Declaration of Independence and the Articles of Confederation.

Appointed superintendent of finance in 1781, Robert was confronted with enormous fiscal problems that proved to be unsolvable since the states would neither pay their debts to Congress nor permit Congress to raise its own funds through taxation. After keeping the national finances afloat for a while by various expedients, including the establishment of a national bank based on hard currency, Robert finally resigned in disgust.

By the end of the century Robert was in debtors' prison having lost his vast fortune in land speculation. He spent his last days in Philadelphia, supported by his wife's annuity, which had been secured for her by Gouverneur Morris.

In 1783 Robert Morris commissioned Peale to paint this double portrait of him and his assistant in the Office of Finance "as a souvenir of their historic association which had done so much to bring the new nation into being." Robert, standing with an air of authority and determination, points to a sheet of paper inscribed "A plan of Finance to/ restore public credit & for/ establishing a national/ Bank." Gouverneur sits with his body inclined deferentially toward his boss. A paper near his hand bears the date 1783.

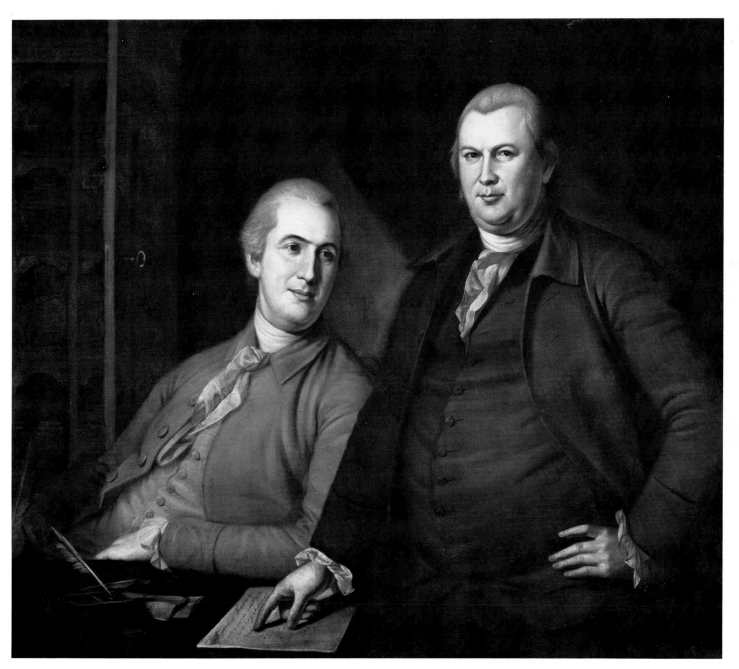

Plate 57

CHARLES WILLSON PEALE

Mrs. David Gelston (Phoebe Mitchell) (1740?–1811) and Daughter

Oil on canvas 29" x 22-1/2"

Signed and dated: C. W. Peale/pinxt/1792

MR. AND MRS. JAMES D. IRELAND, CLEVELAND, OHIO

Phoebe Mitchell married David Gelston in New York in 1769. David was a wealthy New York City businessman who was active in local politics and served in the last Continental Congress of 1789. Their eldest daughter, also named Phoebe, married Nicoll Floyd, the son of William Floyd, who was involved in civic and military affairs in New York and was a signer of the Declaration of Independence.

Peale executed this portrait and a companion portrait of David Gelston during a visit to New York in 1792. According to a June entry in Peale's diary, he was just about to leave New York when Mr. Gelston "called on me to know if I would paint the portraits of his lady and daughter, one also of himself in head size." He "began the daughter in the same piece with Mrs. Gildton [sic]." This was an unusual sequence for Peale, since generally he preferred to paint the parent first and afterwards add the child. This may account for the unusual coherence and success of this charming so-called "madonna group."

Mrs. Gelston's daughter in this portrait has remained unidentified.

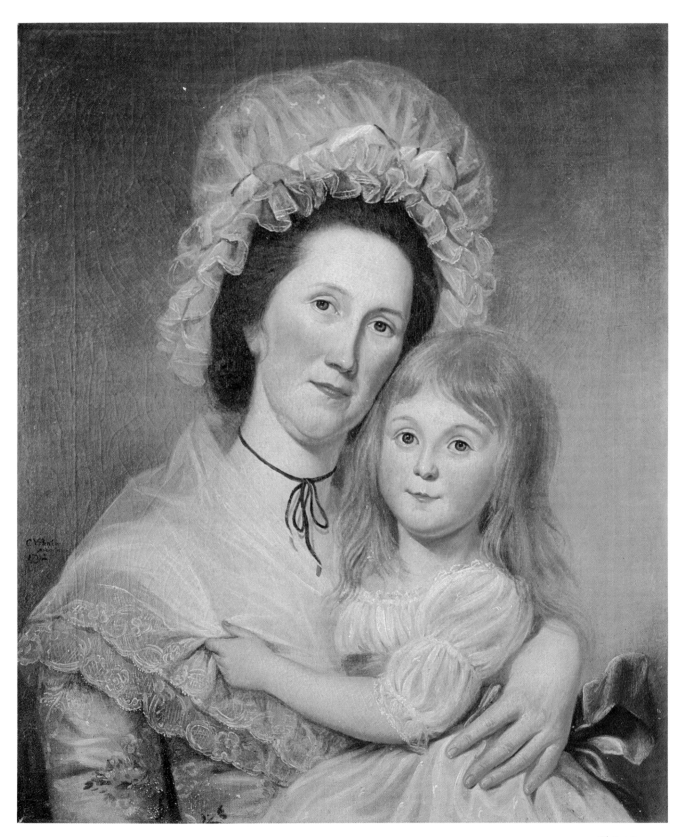

Plate 58

Horatio Gates (1727?–1806)

Oil on canvas 21-1/2″ x 19-1/8″

1782

Horatio Gates, probably born in Maldon, England, entered His Majesty's service overseas and was rapidly promoted. He married in 1754 in Nova Scotia, and the following year moved to New York. Here, through his association with a group of young radicals who belonged to the Whig Club, Gates became acquainted with liberal ideas. After participating in many of the campaigns in the Seven Years' War, he retired in England in 1765. In 1772, with the help of his old comrade in arms George Washington, he settled on a Virginia plantation and lived there quietly for the next three years.

Regarded as one of the best-qualified soldiers in America, in 1775 Gates was commissioned adjutant general with the rank of brigadier general in the Continental Army. He joined Washington in Cambridge to help organize the desperate troops and gather supplies. It was at the Saratoga campaign, however, that Gates achieved his fame. In October 1777, British General Burgoyne surrendered to him after two fierce battles. This event marked the turning point of the war. Although Gates's role in the victory is still a hotly disputed issue, he received the credit for the triumph which stood in marked contrast to Washington's lack of success during the same period. In hopes of replacing Washington with Gates, Washington's enemies seized the opportunity to undermine the commander in chief's reputation. The so-called Conway Cabal failed, leaving Gates's reputation somewhat tarnished.

Gates's greatest debacle was at the battle of Camden, South Carolina, in the summer of 1781. After half his army had fled, he himself rode rapidly off, not stopping until he reached Hillsboro, North Carolina. Alexander Hamilton remarked, "Was there ever an instance of a general running away . . . from his whole army? And was there ever so precipitous a flight? One hundred and eighty miles in three days and a half! It does admirable credit to the activity of a man at this time of life. But it disgraces the general and the soldier." Congress never pressed charges.

After the war, Gates freed his slaves and moved from Virginia to New York City. He served in the New York legislature from 1800 to 1801.

This picture was painted when Gates was in Philadelphia right after his victory at Saratoga. It was listed in *The Freeman's Journal* (October 13, 1784), the first catalogue of Charles Willson Peale's collection of "celebrated personages." The two silver stars on Gates's epaulette denote the rank of major general.

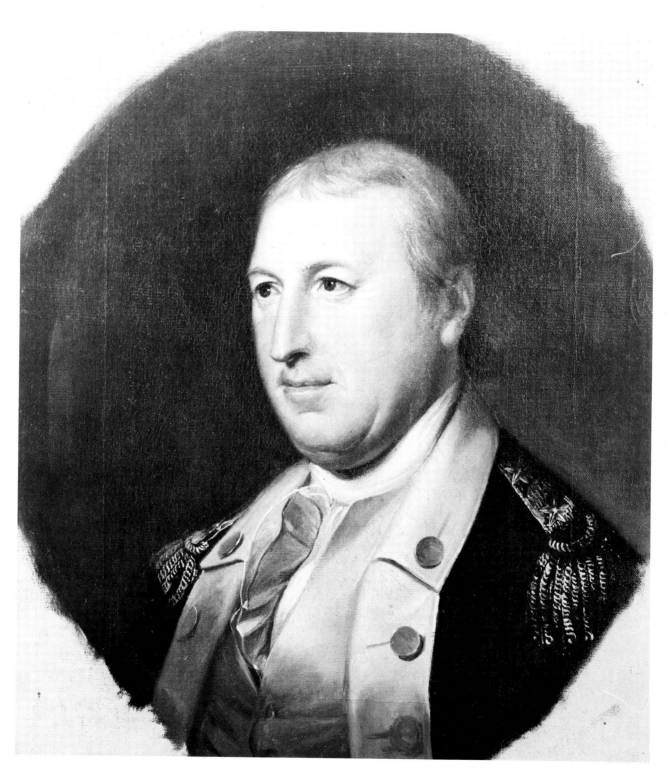

Plate 59

CHARLES WILLSON PEALE OR JAMES PEALE (?)

Charles Armand Tuffin, Marquis de la Rouërie (1750–1793)

Oil on canvas 30" x 25"

c. 1783–1784

HISTORICAL SOCIETY OF PENNSYLVANIA, PHILADELPHIA

Charles Armand, as he preferred to be called in America, was born in Brittany, France, of noble ancestry. At seventeen, he was commissioned in the elite Corps de Gardes Françaises and seemed destined for a successful career as a soldier. Spirited and impetuous, he fell in love with a beautiful opera star whom his parents wouldn't let him marry. In despair, he entered a Trappist monastery. Shortly after his release he seriously wounded the king's cousin in a duel, some say over the favors of an actress, and was forced to flee to Switzerland to avoid the king's wrath. As it was considered inadvisable to return to Paris, Armand joined the Americans against the English, a traditional French enemy.

In the spring of 1777, Armand reported to Washington at Morristown, New Jersey, prepared to spend his own money to organize, equip, and pay a force. The corps he organized was subsequently attached to Pulaski's legion of cavalry. He fought in the New Jersey campaign and in Westchester County, New York. Washington particularly commended him for his hit-and-run guerrilla tactics. In October 1779 he succeeded Pulaski as commander of the legion, and later served with distinction at Yorktown.

After the war, Armand, who was particularly noted for his talent as a cavalryman, tried to persuade Washington to let him found a cavalry school. When Washington rejected his offer, the disappointed nobleman returned home as a brigadier general, but broke. After a brief period of isolation, he married a rather wealthy lady. Washington was "pleased if not surprised" to find Armand thinking "quite like an American on the subject of matrimony and domestic felicity, for in my estimation more permanent and genuine happiness is to be found in the sequestered walks of connubial life, than in the giddy rounds of promiscuous pleasure."

Since Armand's political sentiments in his own country were pro-Royalist, he spent his last days leading a counterrevolutionary movement in Brittany before he succumbed to a prolonged illness.

Armand is depicted in the traditional colorful Hussar uniform topped by an elegant chapeau. He wears two decorations; the cross of the high order of Chevalier of Saint Louis, presented him by his king, and below, the eagle of the Order of the Cincinnati. William Sawitzky originally attributed this picture to Charles Willson Peale, but more recently Sellers has suggested it may be by James Peale.

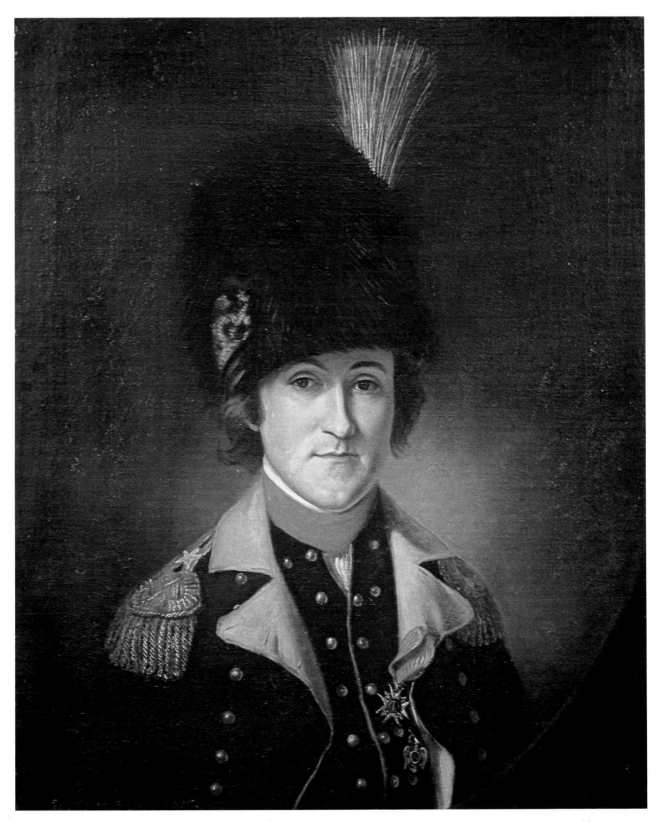

Plate 60

CHARLES WILLSON PEALE

Artemas Ward (1727–1800)

Oil on canvas 24" x 20"

c. 1794–1795

INDEPENDENCE NATIONAL HISTORICAL PARK COLLECTION, PHILADELPHIA

Artemas Ward, born in Shrewsbury, Massachusetts, of strict Puritan ancestry, graduated from Harvard. Initially he pursued a career as a teacher but later opened a general store. He held several local political posts before 1762 when he was appointed justice of the Worcester County Court of Common Pleas.

A veteran officer of the French and Indian War, Ward also was an able and conscientious leader of the Massachusetts radical point of view, allying himself with Samuel Adams and James Otis in their warfare on Governor Bernard, royal authority, and the various taxes. As a member of the First and Second Provincial congresses and the conventions held in Worcester County to champion colonial rights, Ward organized resistance to General Gage as governor.

Ward is best remembered, however, as a revolutionary soldier who may have lacked spectacular military abilities, but whose personality and moderation served to hold his army together. Although ill when news reached him of the battle of Lexington, he sped to Cambridge the next morning to assume command of the patriot forces. From his headquarters at Cambridge he began shaping up the disheveled troops and later directed the Battle of Bunker Hill. In May 1775 he had been formally commissioned general and commander in chief of the Massachusetts troops. But a month later, Congress selected Washington as supreme commander, and Ward became second in command with the rank of major general. On March 4, 1776, Ward submitted his resignation for reasons of health.

As president of the Executive Council, Ward was chief executive of Massachusetts from 1777 to 1780. Thereafter, he was a member of the Continental Congress and active in the State Legislature. In 1786, as speaker of the Massachusetts House and chief justice of Worcester Court, he shared with Governor Bowdoin the responsibility for combating Shays's Rebellion. He was the Massachusetts representative of the First and Second congresses (1791 to 1793; 1793 to 1795) where he primarily concerned himself with military affairs.

This picture was painted when Ward was sixty-seven years old. Sellers suggests that Ward's sympathy for the French Revolution must have prompted Peale to include him belatedly in his gallery in recognition of his former services in the Revolution.

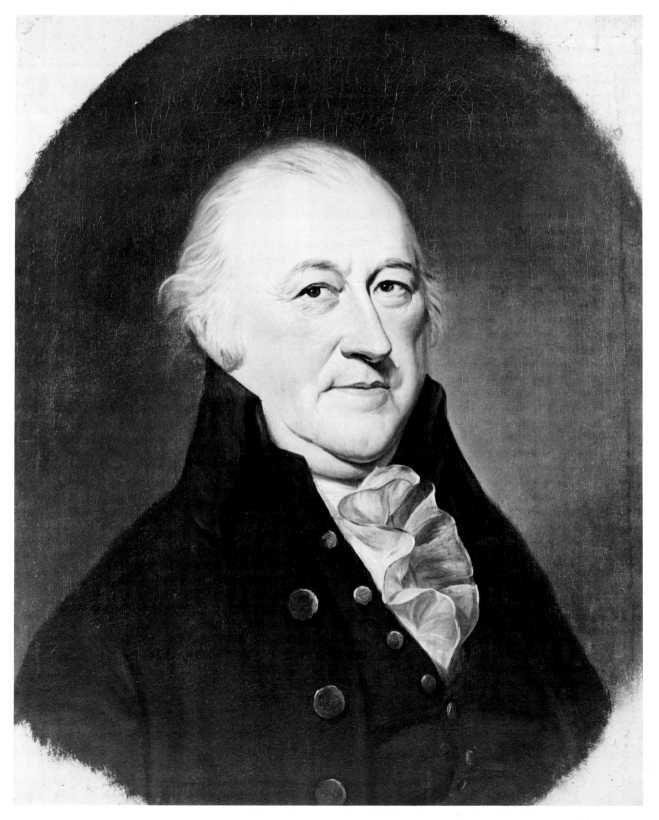

Plate 61

CHARLES WILLSON PEALE

The Artist in His Museum

Oil on canvas 103-3/4″ x 79-7/8″

1822

PENNSYLVANIA ACADEMY OF THE FINE ARTS, PHILADELPHIA
JOSEPH AND SARAH HARRISON COLLECTION 1878

As a patriot, Charles Willson Peale joined Washington's army in 1776 and was present at the battles of Princeton, Trenton, and during the campaign ending with the evacuation of Philadelphia. At about this time he began painting miniatures of the Revolutionary War officers and later made enlarged replicas for a gallery he established in 1782. Washington sat for him at least seven times over a twenty-year period, which resulted in about sixty known portraits. Peale's earlier portraits are considered the best likenesses of Washington as he appeared during the Revolutionary War.

As a scientist Peale devoted his later life to studying, collecting, and exhibiting natural specimens in his museum of natural history, organized in 1784. In 1801, after reading about a group of unusual bones discovered on a farm in Ulster County, New York, he set out to the site. Launching the first American scientific expedition, he excavated the bones of two almost complete mastodons and recorded the event for posterity in his celebrated *Exhuming the Mastodon* (1806). After one of the mastodon skeletons was mounted, it was included in his museum along with the other examples from nature.

For further details of Peale's biography, see page 277.

Peale painted this self-portrait when he was eighty-one years old, at the request of the trustees of the recently founded Philadelphia Museum. He explained his intent in a letter to his son Rembrandt: "I think it important that I should not only make it a lasting monument of my art as a painter, but also that the design should . . . bring . . . into public view the beauties of nature and art, the rise and progress of the Museum. . . ." He is portrayed in his museum, his left hand extended in a gesture of exposition while he lifts the curtain with his right hand to show the display of natural curiosities. Over these hang his portraits of revolutionary figures. Partially visible in the background is the mastodon skeleton, his palette and brushes as a symbol of his artistic profession, and nearby more bones. The small figures in the gallery were meant to add a narrative element. In a letter to his son Rembrandt, Charles Willson explains these additions: "At the further end is a figure of meditation, a man with folded arms looking at the birds, next a father instructing his son, he holding his books open before him and looking forward as attentive to what the parent says—and a Quaker lady . . . turns round and seeing the mammoth skeleton is in the action of astonishment. . . ."

The wild turkey placed on a mahogany box in the foreground was brought from Missouri by his naturalist son Titian. On the extreme left, the following inscription appears on the case containing a paddle fish: "With this article the Museum commenced, June, 1784. Presented by Mr. R. Patterson."

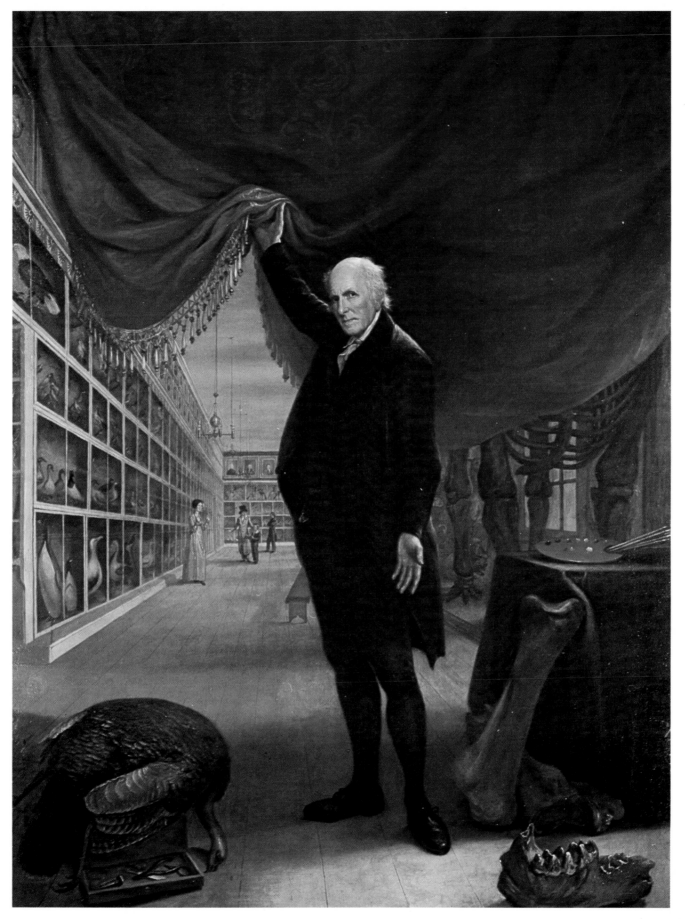

Plate 62

CHARLES WILLSON PEALE

Anthony Wayne (*1745–1796*)

Oil on canvas 21-1/2" x 19"

c. 1784

PRIVATE COLLECTION

Considered one of America's great soldiers, "Mad" Anthony Wayne, the "Hot-spur of the Revolution," acquired his epithets as much because of his easily aroused temper as his fiery military exploits.

Born in Chester County, Pennsylvania, the son of a prosperous tanner, Wayne worked briefly as a surveyor and later took over his father's tannery. His military career began in January 1776 when he was appointed colonel of a Chester County regiment of the Continental Army. His first assignment was to reinforce the faltering Canadian expedition. Against overwhelming odds, he valiantly covered the retreat of the patriot forces to Fort Ticonderoga. His performance so impressed General Schuyler that he placed Wayne in command of Old Ti, where he had his first experience in handling a mutiny of sick and starving troops.

In February 1777 he was promoted to brigadier general and was active in repulsing the British in their campaign against Philadelphia. In September 1777 the British surprised him in a night raid in what became known as the Paoli Massacre. Accused of negligence, he was acquitted by a court-martial.

Wayne scored one of the most difficult and impressive victories of the Revolution at Stony Point in July 1779. He surprised in a night attack the northernmost British post on the Hudson River which was strategically important as a main crossing for military units and civilian travelers. He personally led his corps of light infantry and captured five hundred prisoners, five cannon, and military stores. Wounded in the battle, his execution of the daring plan earned him a Congressional Medal.

Having displayed remarkable skill in handling the mutiny of the Pennsylvania Line in January 1881 near Morristown, New Jersey, Wayne promptly presented his soldiers' demands to Congress.

In 1782 he fought the Creek Indians in Georgia and negotiated a treaty of submission. Later he repulsed the Indians of the Old Northwest, bringing peace to that frontier. He died at Erie, Pennsylvania, on his return from occupying the post of Detroit.

This picture, for many years unlocated, was on Peale's original list of "celebrated personages" included in his gallery.

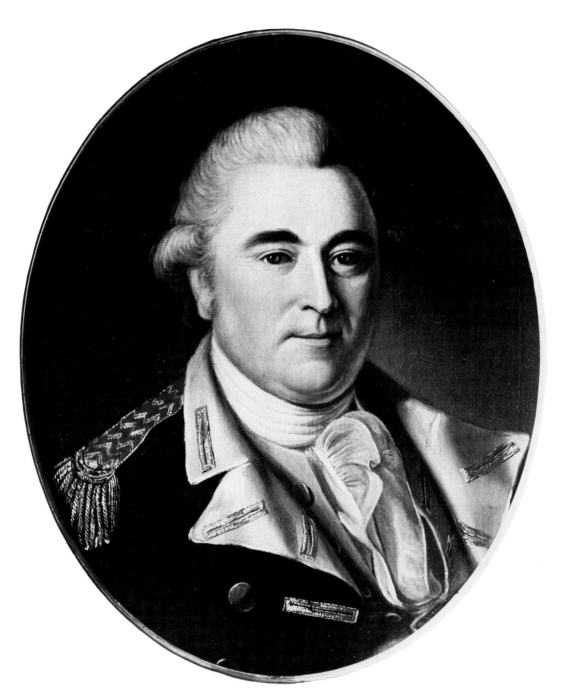

Plate 63

The Artist and His Family

Oil on canvas 31-1/4″ x 32-3/4″

c. 1795–1798

James's biography as an artist appears on page 278. As a patriot, he served in the Continental Army, notably in the Battle of Monmouth and in the Yorktown campaign. He resigned with the rank of captain, the military experience leaving him in delicate health for the rest of his life. He was a member of the Maryland Society of the Cincinnati.

In a lush landscape setting framed with meticulous renderings of vegetation, James is shown with his wife Mary Chambers Claypoole (1753–1829), whom he married about 1785, and five of his six children (the youngest, Sarah Miriam, was not born until 1800). They are, from left to right, Jane Ramsay (1785–1834), James, Jr. (1789–1876), Maria (1787–1866), Margaretta Angelica (1795–1882), and Anna Claypoole (1791–1878). With the exception of Jane, all the children became artists like their father.

While James looks directly at the viewer, his left hand extended in a friendly gesture of introduction and exposition, the rest of the family seems totally unaware of the intrusion of the painter or the viewer. The conception is thus as refreshing and spontaneous as a candid camera shot. Mrs. Peale is represented as the affectionate wife and mother, one arm resting on her husband's, the right hand holding the hand of her daughter Jane. James, Jr., crouches while he offers an apple to young Anna who eagerly scurries toward him. Meanwhile Maria proudly cradles the latest addition to their family.

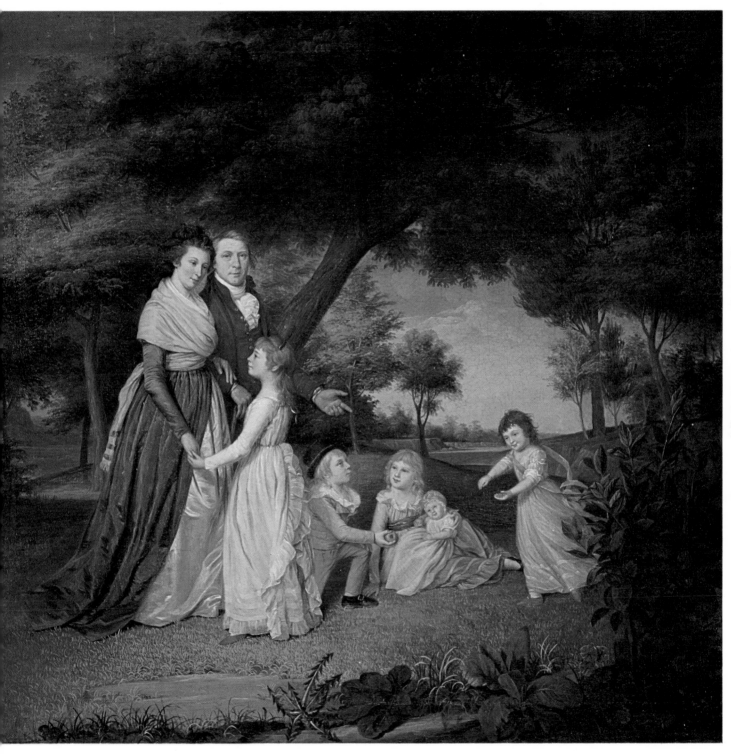

Plate 64

CHARLES B. J. FÉVRET DE SAINT-MÉMIN

Richard Bassett (*1745–1815*)

Crayon on pink paper 20-3/4″ x 15-1/2″

c. 1802

THE BALTIMORE MUSEUM OF ART
BEQUEST OF ELLEN H. BAYARD

Born in Cecil County, Maryland, Richard Bassett, the son of a tavernkeeper, was later adopted by an affluent lawyer, Peter Lawson.

Bassett spent most of his adult life in Delaware where he was trained for the law by his stepfather. In the Revolutionary War, he became captain of a local troop, "Dover Light Horse," and between 1776 and 1786 served in both branches of the State Legislature. He was a delegate to the Annapolis and the Federal conventions. A signer of the Constitution, he worked for its ratification.

From 1789 to 1793, he served as a state senator; from 1793 to 1799 as chief justice of the court of common pleas; and from 1799 to 1801 governor of Delaware. To his contemporaries, his statesmanship was noteworthy for its common sense and efficiency.

Despite his relatively humble beginnings, Bassett accumulated considerable wealth during his lifetime. From his stepparents, he had inherited the large property of Bohemia Manor. In addition, he owned several other homes. An ardent Methodist, Bassett paid half of the cost of the construction of the First Methodist Church in Dover.

Plate 65

CHARLES B. J. FÉVRET DE SAINT-MÉMIN

Charles Carroll of Homewood (1775–1825)

Crayon on pink paper 25" x 19-1/2"

c. 1804

THE BALTIMORE MUSEUM OF ART
BEQUEST OF ELLEN H. BAYARD

Charles Carroll was the son of Charles Carroll of Carrollton (see plate 83), one of the richest men in the country and a signer of the Declaration of Independence. On the occasion of young Charles's marriage to Harriet Chew of Philadelphia, his father gave the newlyweds a 155-acre tract about three miles north of Baltimore, for the purpose of building an estate, which became known as Homewood. Charles enthusiastically threw himself into the elaborate decoration and furnishing of his new home. Six children came in rapid succession, and Homewood became a center of brilliant and extravagant social gatherings. Of an easy-going and self-indulgent nature, Carroll eventually succumbed to alcoholism, and his wife was forced to take the children back to Philadelphia to the home of her parents. Destitute and lonely, Charles spent his last days at Homewood.

J. H. B. Latrobe described the colorful personality of this sociable young man:

Charles Carroll of Homewood was unquestionably one of the most elegant and distinguished looking men that in a large intercourse with the world I have ever met. Of a noble presence and a most gracious manner, of an urbanity that marked his intercourse with everyone who approached him, that was remarkable even in his treatment of the domestics that waited on him; with the most scholarly attainments, ready in conversation, full of anecdote and quick at repartee—it was impossible to be in his presence without admiring him. His likeness to the best portraits of George IV was singular, and persons who had seen the two reported that the manner of Mr. Carroll was that of the Prince Regent.

Plate 66

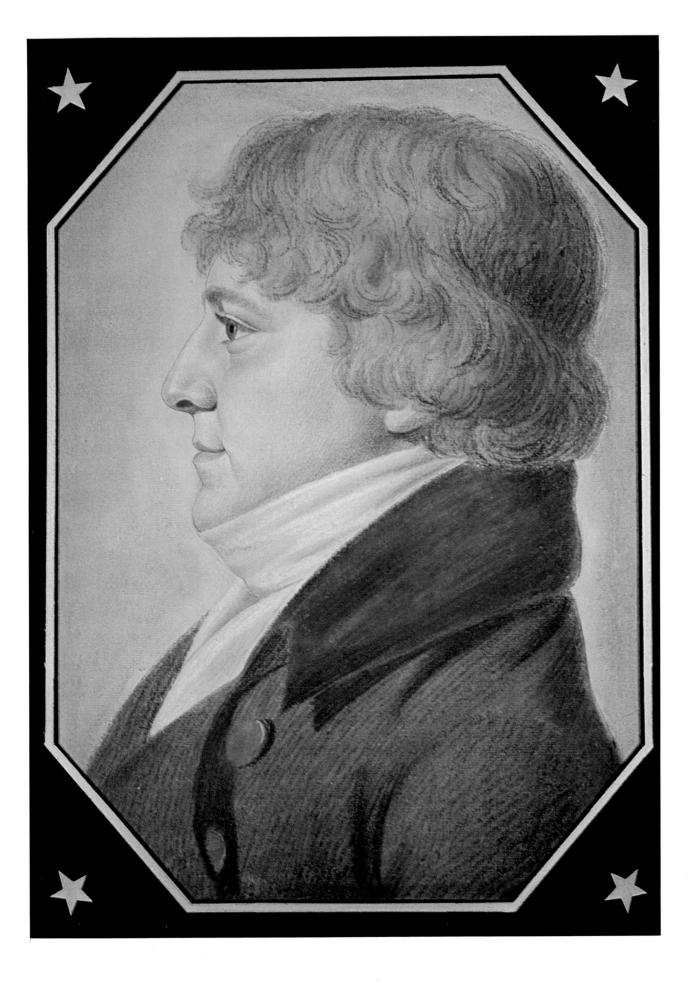

John Paul Jones (1747–1792)

Plaster 28-1/2" high

Signed and dated: houdon 80

COLUMBUS GALLERY OF FINE ARTS, COLUMBUS, OHIO

BEQUEST OF FREDERICK W. SCHUMACHER

What schoolchild doesn't recognize that famous cry allegedly uttered during the *Bonhomme Richard–Serapis* battle—"I have just begun to fight!" Indeed, John Paul Jones, the best-known of the Revolutionary War naval officers, has been immortalized in novels, operas, and ballads.

Born in Scotland as John Paul (without the Jones), he worked as a merchant seaman until about 1773 when, charged with two murders, he was forced to take refuge in America and add *Jones* to his name to conceal his identity.

In December 1775, with the help of influential friends, he was commissioned a first lieutenant in the Continental Navy. His reputation as a remarkably successful fighting sailor was established during his command of the sloop *Providence* in 1776 when he captured several prizes. He repeated these exploits the following year, while cruising along the British coast, as commander of the *Ranger*. From this time, the English referred to him as a pirate.

Jones's fame spread to Paris, and the French, who were about to join America in the war against England, placed under his command a merchantship, which he converted and renamed *Bonhomme Richard*, as a compliment to Benjamin Franklin. Jones again cruised around the British Isles. In September 1779 near York in the famous *Bonhomme Richard–Serapis* engagement, he demonstrated the superior seamanship and courageous fighting spirit that made him a legendary folk hero. Outclassed in guns, size, and maneuverability, Jones nevertheless pursued the enemy. He maneuvered the *Richard* alongside the *Serapis* and lashed the ships stem to stern, with the muzzles of their guns touching. He then relied on the use of musketry in close action. Both ships suffered damage, and only continuous use of pumps kept the *Richard* afloat. The *Serapis* was finally compelled to strike her colors. The *Richard* sank two days later.

Upon his return to Paris in 1780, Jones was lionized by the court and the populace, and Houdon was commissioned by the Masonic Lodge of the Nine Sisters to make a bust of him to be presented at a festival in his honor at the French court. Jones is depicted wearing an admiral's uniform, decorated with the Cross of Military Merit presented to him by Louis XVI at this festival. This is undoubtedly one of the several plaster replicas ordered by Jones and shipped to America as gifts for various friends, such as Washington, Jefferson, Franklin, and Lafayette.

After the war, Jones briefly returned to the United States and was awarded the only gold medal given to a Continental Navy officer. He fought briefly under Catherine the Great against the Turks and spent his last years in Paris.

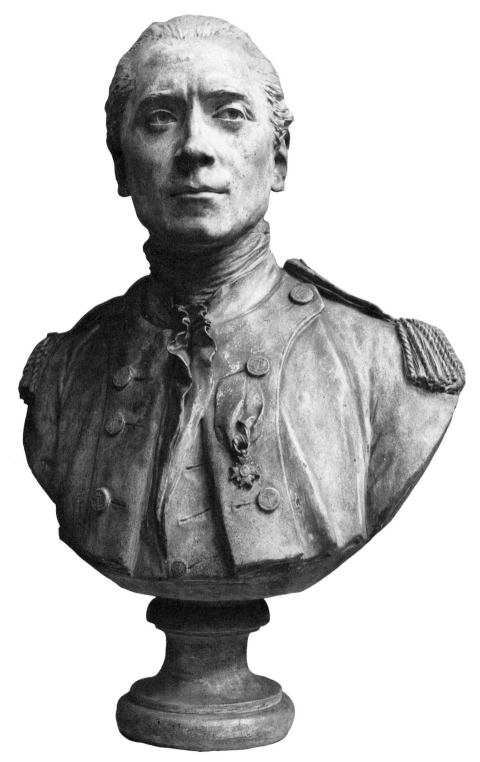

Plate 67

Marie Joseph Paul Yves Roche Gilbert du Motier,
Marquis de Lafayette (1757–1834)

Marble 26-3/8" high

Signed and dated: houdon fecit an 1790

MUSÉE NATIONAL DU CHÂTEAU DE VERSAILLES, PARIS

The Marquis de Lafayette was born in Auvergne, France, the son of a notable family. Following the military profession tradition of his ancestors, he entered the Royal Army in 1771, eventually attaining the rank of captain. In the meantime, his marriage to Marie Adrienne Françoise de Noailles allied him with one of the most powerful families in France. He began frequenting the Court at Versailles, but was never as popular there as his charming friend and brother-in-law, the Comte de Noailles.

Stirred by romantic ideas of attaining glory, Lafayette, determined to fight in the Revolution, embarked for America. Because of his important position at the royal court, his appearance in Philadelphia in the summer of 1777 created a diplomatic crisis with England. Lacking practical military experience, he joined Washington's staff as a volunteer. But he quickly learned to be a skillful soldier, and Washington, who regarded him as an adopted son, gave him various important commands in New Jersey, Pennsylvania, and Virginia, where he demonstrated excellent abilities as a tactician and strategist.

He returned to France in the winter of 1781–1782 and became a major political leader at the beginning of the French Revolution, trying to conciliate the radicals and the crown and to lead the upheaval into a moderate course resembling that of the American Revolution. He eventually had to flee from more radical power and was imprisoned in Austria.

In 1824 he made a triumphal tour of America. As a symbol of a bygone, heroic era, he was greeted everywhere with unrestrained enthusiasm. Lafayette considered this period the happiest of his life, for as Jefferson noted, he never lost his one great foible—"a canine appetite for popularity and fame."

The following year Lafayette returned to France where he played a conspicuous role in the July Revolution of 1830.

Houdon made many busts of Lafayette, which fall into three types. The marquis is here depicted wearing a powdered wig and the uniform of the commander of the National Guard. This bust, exhibited in the Salon of 1791, was derived from a 1785 sitting on which a second version is based portraying Lafayette without the formal device of the wig and with medals—a plaster example is in the Boston Athenaeum. The third type, showing Lafayette with a large cloak draped around his shoulders, was commissioned by the Virginia Assembly and is now in the capitol at Richmond.

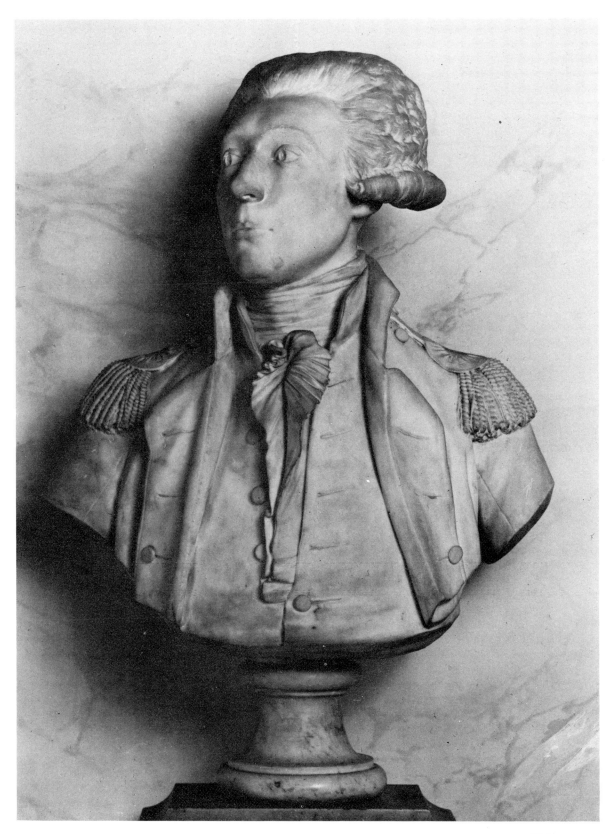

Plate 68

JEAN ANTOINE HOUDON

George Washington (*1732–1799*)

Marble 23-1/2" high
Signed: houdon
c. 1785

MRS. THOMAS S. KELLY

George Washington, who had established an excellent military reputation during the French and Indian War, was unanimously elected commander in chief of the Continental Army in June 1775. His most celebrated campaign was waged the following year in New Jersey. In a surprise attack on Christmas night at Trenton in the winter of 1776, amid driving ice, he led his starving, exhausted, and barely clothed troops across the Delaware River, crushing the Hessians and dislocating the entire line of British posts along the river. After a brief retirement from public life in the mid-1780s, Washington was the unanimous choice for the first president under the Federal Constitution. He was elected a second term, but refused a third. Succumbing to a brief illness, he died at Mount Vernon.

Houdon was considered "the first sculptor of his day." Through Thomas Jefferson, then the American minister to France (1785–1789), he was commissioned by the Virginia Assembly to create a full-length marble statue of General Washington. Although portraits of Washington by Charles Willson Peale and Joseph Wright were available as sources in Paris, Houdon insisted upon crossing the ocean to model the bust from life. After several unfortunate setbacks, he arrived at Mount Vernon on October 6, 1785. By October 17, he had taken a life mask, made a terracotta bust, and carefully measured the general.

Before returning to France, Houdon exhibited a bust of Washington at Congress in New York. Francis Hopkinson, a lawyer and statesman, wrote enthusiastically to Jefferson on October 25, 1785: "There is no looking at this bust without Admiration and delight. The noble air, Sublime expression and faithful likeness Evince the hand of a master." On November 2, 1785, Charles Thomson noted to Jefferson that the sculptor "by elevating the chin and countenance, has given it [the bust] the air of one looking forward into futurity."

Houdon originally conceived the full-length of Washington in classical draperies as an allegorical concept of protector of agriculture. Washington urged that he be portrayed, not artificially, but in modern dress. This statue, showing him in the uniform of commander in chief of the Continental Army, is now in the capitol at Richmond, Virginia.

Continuing to work in France, Houdon made busts in terracotta, plaster, marble, and perhaps bronze, all in his original concept of the classic mode, either draped or undraped.

The elegantly draped bust here represented is, with slight variations in the treatment of costume and hair, virtually identical to a terracotta in the Louvre. It emphasizes Houdon's concept of Washington as a wise and noble ruler, analogous to those of classical times.

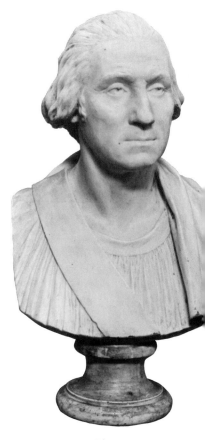

Plate 69

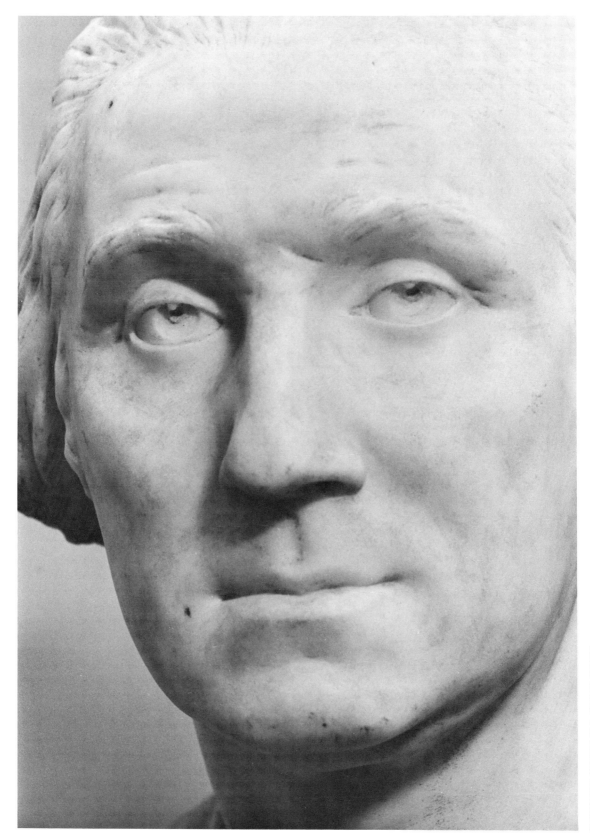

Louis XVI (*1754–1793*)

Oil on canvas 31-1/2" x 24-3/8" (oval)

c. 1775

MUSÉE NATIONAL DU CHÂTEAU DE VERSAILLES, PARIS

Louis, a son of the dauphin Louis and his consort Maria Josepha of Saxony, married the Austrian archduchess Marie Antoinette in 1770. Barely twenty years old when he succeeded to the throne of France in May 1774, he was inexperienced and lacked self-confidence. However, he was as eager as any Frenchman for revenge against England for the defeat suffered in the Seven Years' War. Thus he agreed secretly to furnish Americans with military supplies, particularly ammunition and weapons, which were indispensable during the first three years of the Revolutionary War effort.

Impressed by the spirit shown by Washington at Germantown and by the decisive victory at Saratoga, Louis approved an Alliance with the United States which was ratified by Congress on May 4, 1778. The Alliance recognized the independence of the United States and quickly brought France into the war as an active belligerent. If French aid had not been given to the American patriots, the Revolutionary War might well have had a completely different outcome.

In the meantime the French Revolution was gaining steam. Inept and lacking political insight, Louis ignored the challenge of liberal and democratic forces that inspired it. Rather, he supported the policy of defending the privileges of the clergy and nobility, thinking that the radical trend would burn itself out. His reliance on dubious prospects of foreign intervention and counterrevolutionary intrigues resulted in his being tried for treason and condemned to death by guillotine.

Louis is depicted in formal dress and pose. He wears two orders on his breast: the large badge of *Saint-Esprit* (Holy Ghost) and the smaller one of *Toison-d'Or* (golden fleece). This official portrait never left the royal collection and is undoubtedly the original shown at the Salon of 1775. More than fifty replicas or copies were made by Duplessis, or by his assistants and students under his direction. In 1784 a Gobelins tapestry was manufactured after this portrait to be presented to Prince Henry of Prussia who was traveling in France at the time.

Plate 70

CHRISTIAN GULLAGER

John May (1748–1812)

Oil on canvas 30" x 25-1/8"

Signed and dated: C. Gullager/pinx/1789

AMERICAN ANTIQUARIAN SOCIETY, WORCESTER, MASSACHUSETTS

John May was born in Pomfret, Connecticut, and came to Boston in his early youth. During the Boston siege, he and his family escaped to their hometown in a boat, allegedly with the help of a friendly British naval officer. After the British evacuation, May returned to Boston, was commissioned adjutant with the rank of captain in the Boston Regiment of the Massachusetts Militia, and was promoted to colonel in 1787.

In 1788 and 1789, he made two trips to Ohio to claim lands. Back in Boston, he served as fire warden from 1785 to 1805 and selectman from 1804 until his death.

May is here represented in a uniform of the Revolutionary War period. This picture, a key one in the study of Gullager because of its clear signature and excellent history, was painted just before May departed on his last trip to Ohio in 1789. The dashing likeness obviously pleased Mrs. May who noted in her diary entry of April 24, 1789:

> In the afternoon brother came, and brought me the image of my friend. What a present! the most welcome he could have made me, unless it had been the original himself . . . Much praise is due to the painter. He has done his work well and I don't wonder he says his hall is stripped of its greatest ornament.

Plate 71

CHRISTIAN GULLAGER

David Coats (*1736–1791*)

Oil on canvas 36-1/2" x 32-1/4"

c. 1787

David Coats was born at Falmouth (now, Portland), Maine. By 1765, he had settled in Newburyport, Massachusetts, where he married Mehitable Thurston. In 1779, he commanded one of four vessels which were sent from Newburyport by the merchants to drive the British out of Penobscot Bay. The action was a complete disaster for the Americans, who lost all their ships, while the British maintained a strong post at Penobscot for the rest of the war.

From 1783 to 1785, Coats served in the Connecticut legislature and was a selectman of Newburyport. After 1786, he commanded several ships involved with West Indian trade.

Coats is represented as a portly mariner, holding a spyglass as a symbol of his profession. Through the open window is a faint image of a brig at sea, a common motif in colonial painting. The red curtain is a traditional device in academic portraiture used to ennoble the sitter.

Originally attributed to John Smibert, this portrait was reattributed by comparison with the similar composition of Gullager's *Captain Boardman.*

Plate 72

John Barry (1745–1803)

Oil on canvas 30" x 25"

c. 1801, Philadelphia

THE OAK RIDGE COLLECTION

John Barry was born in Ireland and went to sea at an early age. About 1760 he settled in Philadelphia and became a prosperous shipmaster and owner. An enthusiastic supporter of the patriot cause, he volunteered his services and became commander of the brig *Lexington,* one of the first ships commissioned by the Continental Congress. On April 17, 1776, he took the British tender *Edward* and thus achieved the distinction of making the first capture of a British warship by a regularly commissioned American vessel.

While awaiting command of a new ship, Barry captured large quantities of supplies in operations on the Delaware River, for which he received commendation from Washington. As a volunteer in the army, Barry saw action in the Trenton campaign.

While Barry had been given command of the *Effingham,* the Philadelphia campaign prevented him from taking her to sea. Finally, to keep her from falling into enemy hands, the frigate had to be burned. Barry then took command of the *Raleigh* and participated in a valiant battle, but the superior strength of the British fleet forced him to beach his ship. Commanding the *Alliance* in 1781, he was left severely wounded after an obstinate fight during which he captured valuable prizes, including two British vessels, the *Atalanta* and *Trepassy.* Later that year he carried Lafayette and the Comte de Noailles to France.

Barry fought the last important naval battle of the Revolution in January 1783. Accompanied by another Continental ship, the *Duc de Lauzun,* he was sailing from Havana in the *Alliance* with a large amount of specie for delivery to Congress. They were pursued by three British frigates. After an indecisive but well-conducted engagement with the *Sybille,* the enemy's guns were silenced, and the two American ships made their way home.

In 1794 Barry was named senior captain of the new navy, and therefore became known as the father of the United States Navy. He was placed in command of the *United States* when Congress ordered construction of six frigates for operations against the pirates of the Barbary Coast. Thereafter he remained active in naval affairs but saw no more combat. James Fenimore Cooper placed Barry second in importance only to John Paul Jones among the naval officers of the Revolution.

On Barry's lapel hangs the eagle badge of the Society of the Cincinnati.

GILBERT STUART

John Adams (1735–1826)

Oil on canvas 30" x 25"

1824, Quincy, Massachusetts

MR. CHARLES F. ADAMS

Stuart portrayed John Adams, whose biography appears on page 111, on the eve of his eighty-ninth birthday. The painting was commissioned by his son John Quincy Adams who noted in his diary of September 3, 1824: "More than 20 years have elapsed since he [Stuart] painted the former portrait, and time has wrought so much change on his [John Adams's] countenance that I wish to procure a likeness of him as he is now." The first life portrait was painted in 1798. In this later portrait Stuart intended "to paint a picture of affection, and of curiosity for future times."

The second President of the United States told Boston's Mayor Josiah Quincy that he was pleased to sit "for he [Stuart] lets me do just what I please and keeps me constantly amused by his conversation." Quincy noted that Stuart's wonderful powers of conversation would help enliven the face of the sitter so that he caught the expression he liked the best "and with the skill of genius used it to animate the picture." Quincy considered the Adams portrait "a remarkable work, for a faithful representation of the extreme age of the subject would have been painful in inferior hands. But Stuart caught a glimpse of the living spirit shining through the feeble and decrepit body. He saw the old man at one of those happy moments when the intelligence lights up the wasted envelope, and what he saw he fixed upon the canvas."

This portrait of Adams, with his right hand resting on a cane, is one of the major works of Stuart's own old age. It has remained in the Adams family to the present day.

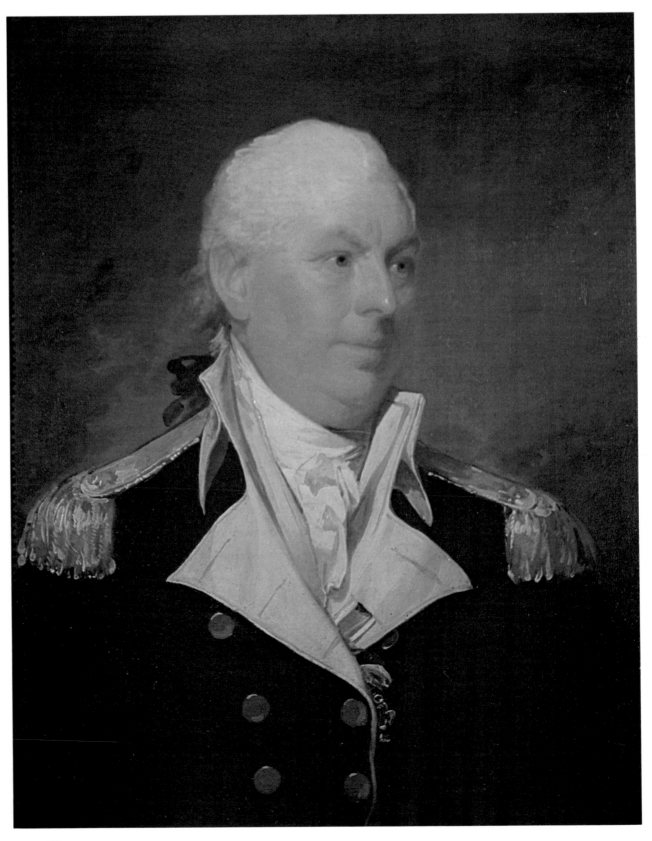

Plate 73

Plate 74

GILBERT STUART

William Samuel Johnson (1727–1819)

Oil on canvas 35-1/2" x 27-1/2"

1793, New York

MRS. S. B. RANDOLPH

William Samuel Johnson was born in Stratford, Connecticut, educated at Yale and Harvard, and subsequently received an honorary doctorate of law degree from Oxford. Although groomed for the Anglican ministry by his father, he soon turned to law. He was active in Connecticut politics as a member of the House of Representatives in 1761 and 1765, and the following year as a member of the upper house, a position he held until the outbreak of the Revolution.

Although Johnson's political leanings were basically conservative, he denounced the Stamp Act as reducing the colonists to "absolute Slaves." Soon he became one of the most prominent citizens of the colony.

From 1767 to 1771 he served as a commercial attaché in London to defend Connecticut's title to the Mohegan lands and other territorial claims. While a supporter of the nonimportation agreements in opposition to the Townshend Acts, Johnson nevertheless feared the consequence of independence both for America and for Great Britain and therefore declined to serve in the Continental Congress. He retired from politics shortly after the battles at Lexington and Concord, primarily because of incompatability with the dominant radical party. He reemerged in the summer of 1779 when the people of Stratford begged him to negotiate with the British commanders to prevent the burning of their town. The town was spared, but Johnson was accused of corresponding with the enemy and advising Stratford to renounce independence. He denied the charges, took an oath of allegiance to the state, and resumed his law practice with immediate success. Thereafter he continued to be active in provincial political affairs.

From 1785 to 1787 he was one of the most popular and learned members of the Continental Congress. As a member of the Constitutional Convention of 1787 he was widely respected, conscientious, and often eloquent. He was an important member and spokesman of the Committee of Style, was a Connecticut signer and worked effectively for ratification. He served as one of the first two senators from Connecticut and from 1787 to 1800 was the first president of Columbia College. Thereafter he retired to Stratford.

Johnson is here portrayed in his scarlet Oxford robes. Commissioned for his son Robert Charles, this portrait is said to be the first picture Stuart painted upon his arrival in New York.

Plate 75

Frances Cadwalader, Lady Erskine (1781–1843)

Oil on canvas 30" x 25"

c. 1802, Philadelphia

PRIVATE COLLECTION

Frances Cadwalader was the daughter of John and his second wife Williamina Cadwalader of Philadelphia. During the Revolution, Frances' father was a member of the Philadelphia Committee of Safety, a colonel of a Philadelphia battalion, and then a brigadier general of the Pennsylvania militia. Washington greatly admired him as a soldier, but twice Cadwalader declined an offer by Congress of a brigadier generalship in the Continental Army. He nonetheless served with distinction in the Trenton and Monmouth campaigns. He was a staunch supporter of Washington during the Conway Cabal and severely wounded General Conway in a duel near Philadelphia.

Frances married the Honorable David Montague, a British statesman, in 1799 and became a baroness in 1823. She had twelve children. A companion piece of her husband was painted at the same time. Commissioned by General Thomas Cadwalader, a brother of the sitter, this picture descended through the family to its present owner.

The naturalism and grace of pose combine with the wistful expression to make this portrait one of the masterpieces of Stuart's Philadelphia period.

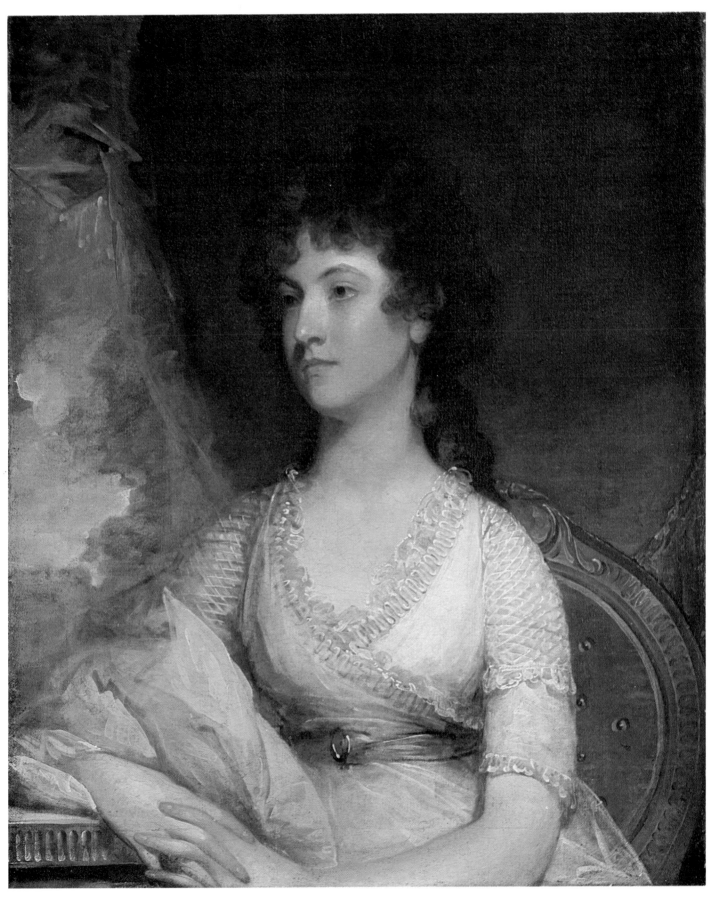

Plate 76

Henry Knox (1750–1806)

Oil on panel 47" x 38-1/2"

c. 1805, Boston

MUSEUM OF FINE ARTS, BOSTON
DEPOSITED BY THE CITY OF BOSTON

Henry Knox was born in Boston to a family of Scotch-Irish descent. His father, a shipmaster, died when Henry was twelve, leaving him to support his mother. He quit grammar school and went to work for a bookseller and soon opened his own establishment, "The London Book-Store." Here he acquired most of his education. His favorite subjects were military history and engineering.

At the age of eighteen he joined a local militia company of artillery and in 1772 was second in command of the "Boston Grenadier Corps." Although his patriotism never wavered, he married Lucy Flucker, the daughter of an influential Tory. Her father was enraged at her choice of a husband and never forgave her. Paul Revere and Nathanael Greene were frequent visitors at Knox's bookstore and, by the outbreak of the Revolution, Knox's anti-British sentiments were well known. Shortly after Lexington and Concord, he and his wife were forced to sneak out of British-occupied Boston. Knox joined the Continental Army as a volunteer and fought at the Battle of Bunker Hill. In November 1775 he was appointed colonel of the Continental regiment of artillery and, with his brother William, set out for Fort Ticonderoga to bring back valuable heavy artillery recently captured. Over three hundred miles of snow-covered difficult terrain, he successfully performed the task with surprising speed. Fortification of Dorchester Heights with these guns compelled Howe to evacuate Boston.

Admired for his daring and resourcefulness, Knox took part in the battles around New York and played an important part in the battle of Trenton on Christmas night 1776, which resulted in the capture of 1,200 Hessian prisoners. For his services he received public thanks from Washington and was promoted to brigadier general. After the siege of Yorktown, Knox was made a major general and given command of West Point. From 1785 to 1794 he was secretary of war. One of the greatest of the self-taught soldiers of the Revolutionary era, he was a close friend of Washington for many years. In 1794, he retired to manage his extensive farmlands in Maine.

Stuart portrayed Knox leaning on a large cannon, a symbol of his artillery specialty in the Continental service. His biographers have pointed out that this beefy man (he weighed almost three hundred pounds) was extremely self-conscious about the loss of the third and fourth fingers of his left hand when a fowling piece burst during a hunting trip. Thus, Stuart has artfully placed the hand in such a way that the defect is unnoticeable.

HENRY SARGENT

Benjamin Lincoln (*1733–1810*)

Oil on panel 17" x 15-1/2"

c. 1806

PENNSYLVANIA ACADEMY OF THE FINE ARTS, PHILADELPHIA
JOHN FREDERICK LEWIS MEMORIAL COLLECTION 1933

Benjamin Lincoln was born in Hingham, Massachusetts. A moderately prosperous farmer, he held a variety of civic offices. As the Revolutionary movement got underway, he became a member of the Hingham Committee of Safety and served as clerk and secretary of several of the provincial congresses.

Since he had been active in the county militia since 1755, Lincoln was given command of militia regiments raised to reinforce the Revolutionary army at New York. He served with considerable distinction at Saratoga where he was wounded during a reconnoiter. After a ten-month convalescence, he was sent to command the Southern Department.

Although courageous and determined, he was unable to oust the British from Savannah. Burdened with undisciplined troops, lack of supplies and cooperation, he was forced to surrender Charleston on May 12, 1780. After the British raised their flag, one amused British officer observed that "Lincoln limp'd out at the Head of the most ragged rabble I ever beheld. . . . The Militia, poor Creatures, could not be prevailed upon to come out. They began to creep out of their Holes the next Day." Blaming the northerners for misleading them, some of the militia reportedly took the oath of allegiance to the king and marched off with Cornwallis.

Lincoln was back in the field in time to serve at the Yorktown campaign. He was secretary of war from 1781 to 1783 and was instrumental in the suppression of Shays's Rebellion in 1787. He remained active in various political and civic affairs the rest of his life.

In 1806 a group of Lincoln's friends engaged Henry Sargent to paint two portraits of the old veteran, one for them (which this picture may be) and the other for the Massachusetts Historical Society.

Lincoln, who weighed about 225 pounds, is shown dressed in the Continental uniform, bearing the epaulettes with two stars which represent the rank of a major general. His right hand rests on a large cannon. In the left background is a battle scene over which flies the Stars and Stripes.

The composition of this work is almost the mirror image of that of Gilbert Stuart's portrait of *Henry Knox* (Plate 77) which Sargent could have easily seen around 1805 in Stuart's Boston studio.

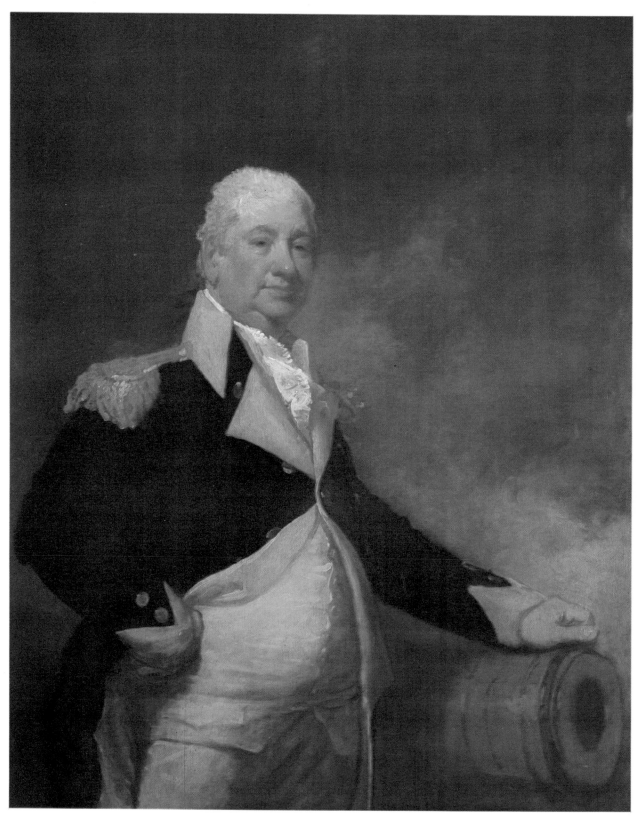

Plate 77

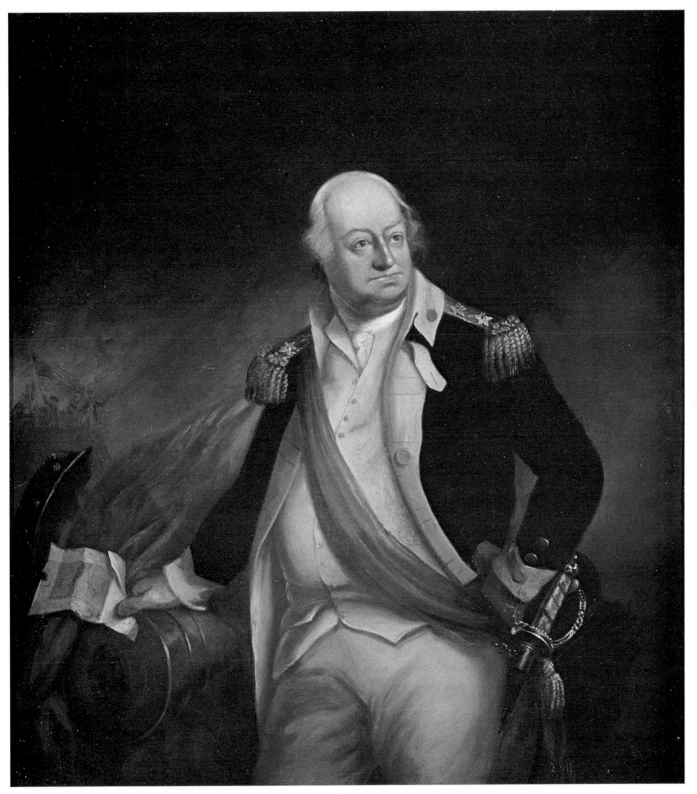

Plate 78

GILBERT STUART

Louis-Marie, Vicomte de Noailles (1756–1804)

Oil on canvas 50″ x 40″

Signed and dated: G. Stuart 1798

METROPOLITAN MUSEUM OF ART, NEW YORK
PURCHASE 1970, HENRY R. LUCE GIFT, ELIHU ROOT, JR., BEQUEST,
ROGERS FUND, MARIA DEWITT JESSUP FUND, MORRIS K. JESSUP
FUND, AND CHARLES AND ANITA BLATT GIFT

Noailles was born in Paris of noble ancestry. He received military training from his father, the Duc de Mouchy, a marshal of France. As a young man he frequented the court of Marie Antoinette and became known for his love of wine, dancing, and women. In 1779 he was attached as a colonel of cavalry to Comte d'Estaing's expedition against the British forces in the West Indies and the Carolinas. He distinguished himself in the siege of Savannah and landed at Newport with Rochambeau in 1780. In the Yorktown campaign, he led the capture of a British fort. Noailles, as representative for the French, and Colonel John Laurens for the Americans negotiated terms of surrender with Cornwallis.

Noailles returned to France and assumed his old role as a dashing military and court figure. In 1788 he was made colonel of the Chasseurs à Cheval d'Alsace regiment and was later promoted to brigadier general. He is best remembered in his homeland for his contribution to its revolution. On the night of August 4, 1789, he delivered a brief but highly effective speech advocating liberal reforms such as abolition of feudal rights. He was nonetheless forced to flee revolutionary France and to settle in Philadelphia, where he made a small fortune in land speculation. After several years in exile, Noailles returned to the French service. He died near Havana while attempting to prevent English conquest of Santo Domingo.

Probably commissioned for Noailles's children, this picture remained in the possession of the Noailles family until 1970. According to Gilbert Stuart's daughter, Noailles, a frequent visitor to Stuart's Philadelphia studio, gave the painter a "superb silver-mounted rapier" to use in the full-length portraits of Washington. Noailles may even have posed for the figure of the commander in chief since Washington hated sitting for portraits. After Stuart finished Washington, he painted Noailles wearing the uniform of a brigadier general commanding the first regiment of his Chasseurs à Cheval d'Alsace, shown parading in the background. The mounted gentleman in the right background is his body servant. The actual setting has not been identified: it may be Colmar or Sedan, both areas where Noailles fought in 1791.

The composition relates to a whole series of full-length portraits Stuart conceived between 1796 and 1800.

Plate 79

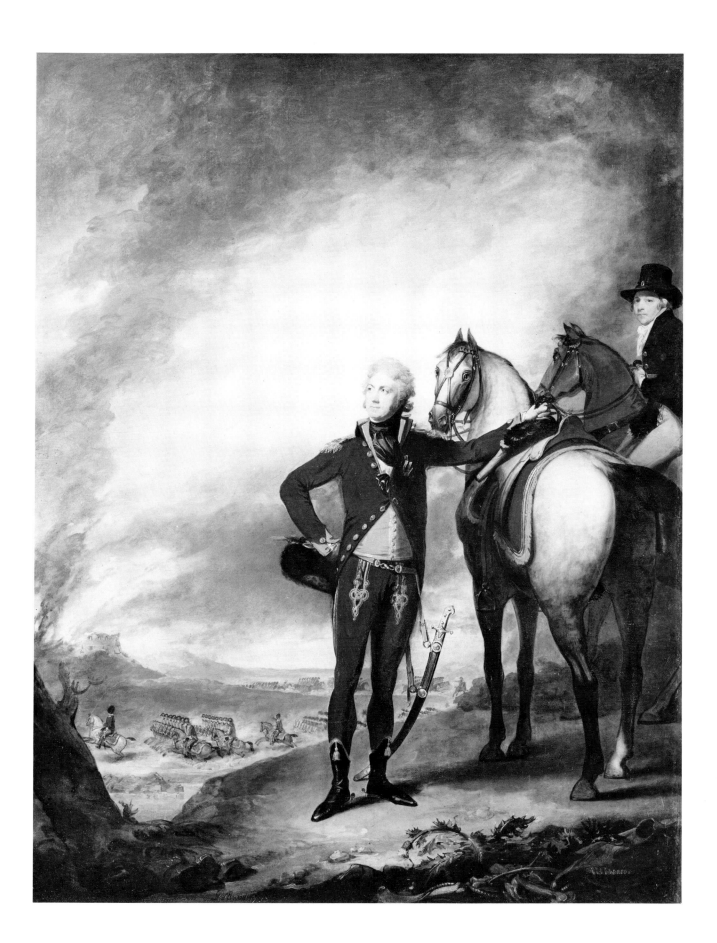

Mrs. James Bowdoin III (Sarah Bowdoin) (1761–1826)

Oil on canvas 30" x 25-1/8"

c. 1804

BOWDOIN COLLEGE MUSEUM OF ART, BRUNSWICK, MAINE
BEQUEST OF MRS. SARAH BOWDOIN DEARBORN

Sarah Bowdoin married her first cousin James Bowdoin III in 1780. They had no children. As a member of the Constitutional Convention of 1788, he voted for ratification of the Federal Constitution. From 1804 to 1808 he served as United States minister in Spain and France to negotiate the acquisition of West Florida and determine the western boundaries of the Louisiana Purchase. While he was unsuccessful, his objectives were achieved with the annexation of these lands in 1811, the year of his death.

In 1813 Sarah married Major General Henry Dearborn, an excellent military officer during the Revolution who had been present at most of the important campaigns from Bunker Hill to Yorktown. He was a congressman, and, under Jefferson, secretary of war from 1801 to 1809. In the War of 1812, he was a senior major general of the United States Army.

Shortly after the marriage, John Adams wrote to Thomas Jefferson on December 19, 1813, describing Boston's reception to Sarah's choice of a second husband, a man who, however distinguished, was considered less well born than a Bowdoin.

> I must make you and myself merry or melancholly by a little Phylosophical Speculation about the formidable Subject of Aristocracy. Not long after General Dearborn's return to Boston from the Army, a violent Alarm was excited and spread in Boston and through the country, by a report . . . that an Affair of Love was commencing between the General and Madam Bowdoin. . . . The exclamations, were in every mouth. "Impossible!" . . . "It is a scandalous fiction!" . . . "Would that Lady disgrace her Husband?" She was herself a Bowdoin: "Would she degrade her own and her Husbands Name and Blood?" "Would she disgrace the illustrious Name of Bowdoin which has been so long famous in France?" "Would she disgrace her Husband who has been an Ambassador? And her Father in Law, who was her Uncle, and had been Governor?" . . .

The dating of this portrait has been somewhat problematic. It was initially dated c. 1806 (Boston) by Park, but more recent evidence suggests that that date is unlikely since Mrs. Bowdoin accompanied her husband to Europe on his diplomatic mission and was not in America at the time. Thus it was probably painted just prior to her departure. It has also been suggested that Stuart added the lace "mantilla" after Mrs. Bowdoin returned from Europe, as a reference to her being the wife of a former United States minister to Spain.

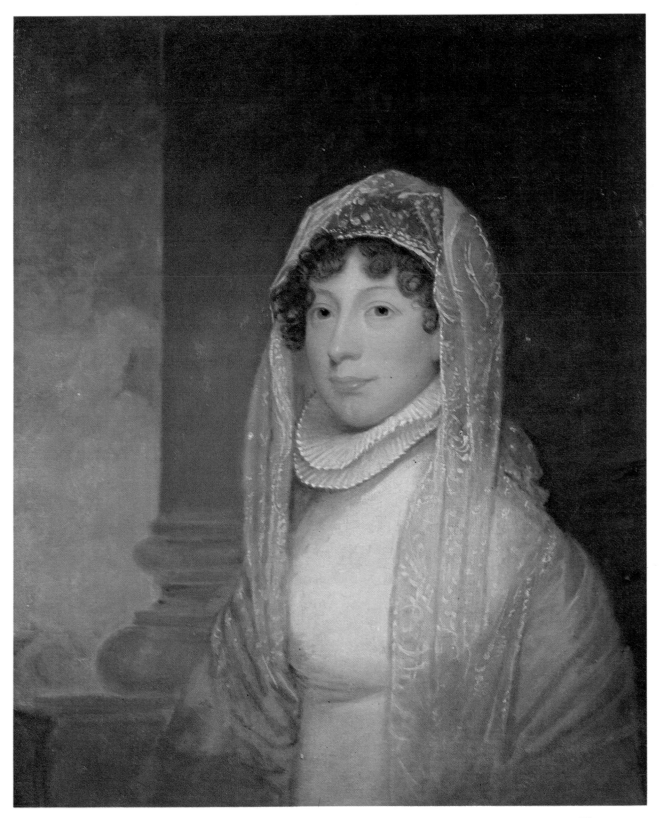

Plate 80

GILBERT STUART (HEAD, C. 1782, LONDON)
JOHN TRUMBULL (BALANCE OF FIGURE, C. 1785, LONDON)

John Jay (1745–1829)

Oil on canvas 50-1/2″ x 41-1/2″

NATIONAL PORTRAIT GALLERY, SMITHSONIAN INSTITUTION, WASHINGTON, D.C.

John Jay was born in New York City, the son of a wealthy merchant. He graduated from King's College and became an overserious but popular and successful lawyer known for his superior intellect. Basically a conservative aristocrat, he was initially opposed to independence, although he supported the patriot cause. He soon gave up his law practice to devote himself to public service, becoming a member of the New York Committee of Correspondence and a delegate to the First Continental Congress, where he served as president from 1778 to 1779. As a member of the New York provincial Congress he worked for ratification of the Declaration of Independence and helped draft the state constitution. He served until 1779 as chief justice of New York.

From 1780 to 1782 he was minister to Spain where he tried to induce the Spanish to recognize the independence of the United States and to secure financial aid and guarantees of continuation of military supplies. While only partially successful, he was summoned to Paris in the spring of 1782 to help negotiate the peace with Great Britain. Upon his return to America he served as secretary of foreign affairs until 1790. He negotiated several treaties, trying in vain to resolve issues between the United States, Spain, and Great Britain. His diplomacy was hampered by the impotence of the Union under the Articles of Confederation. Thus he happily supported a Federal Constitution which established a strong central government. In 1787 he collaborated with Alexander Hamilton and James Madison in the famous collection of essays designed to encourage ratification of the Constitution which were published as *The Federalist.*

From 1789 to 1794 he was chief justice of the United States Supreme Court and negotiated a settlement with Great Britain of unresolved issues that were bringing England and the United States close to another war. He served two terms as governor of New York and spent the remaining twenty-eight years of his life in retirement.

In a garret in London, John Trumbull found this portrait with only the head finished by Gilbert Stuart. It is possible that Stuart had not finished the portrait because Jay, who was in frail health most of his life, was indisposed. Trumbull added the figure and details, using Peter Augustus Jay, John Jay's eldest son, as the model for the figure. In 1794, Stuart, obviously pleased with the result, painted a similar version with small variations of pose, costume, and setting. This portrait, which is still in the possession of Jay's descendants, is currently on loan to the State Department in Washington, D.C.

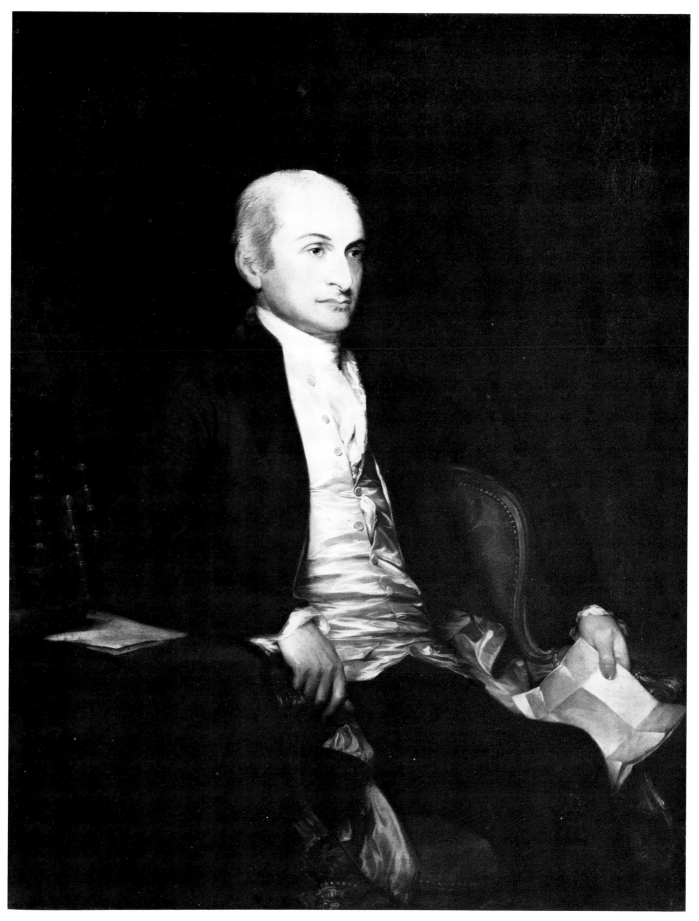

Plate 81

Mrs. George Washington (Martha Dandridge Custis) (1731–1802)

Oil on canvas 36" x 29"

Undated

Martha Dandridge was born in New Kent County, Virginia, and married Daniel Parke Custis in 1749. She had four children, two of whom died in infancy. Daniel died in 1757, leaving Martha to administer the affairs of a wealthy plantation. The following year George Washington began courting the rich widow. They were married in January 1759 and moved to Washington's Potomac plantation, Mount Vernon. As a result of her management, Mount Vernon soon became famous for its warm hospitality. The Washingtons remained childless. By the dawn of the Revolution, Martha's surviving daughter had died of epilepsy and her remaining son was married.

After George was appointed commander in chief of the Continental Army, Martha, uncomplaining and cheerful, joined him in his various winter headquarters from Cambridge, Massachusetts, to Newburgh, New York, although she hated traveling and being away from home. Her affable presence was indispensable to the morale of the general who longed for domesticity. Mercy Warren visited her in Cambridge and commented how well suited Martha was "to soften the hours of private life, or to sweeten the cares of the Hero, and smooth the rugged paths of War."

In November 1781, Martha's son died of "camp fever," and the Washingtons took his two youngest children, George Washington Parke Custis and Eleanor Parke Custis, to rear as their own. The family spent the next five years in semiretirement at Mount Vernon before talk of the presidency began. Martha lamented, "I had anticipated that . . . we should be suffered to grow old together in solitude and tranquility." After the inauguration, Martha joined him in the nation's capital, New York City. Basically domestic by nature, she cared little for the "gay" social life that she was compelled to live but continued to shine as Washington's affable hostess.

The Washingtons retired to Mount Vernon in 1797. Martha died in 1802 after a prolonged fever and was buried beside her husband at Mount Vernon.

Rembrandt Peale copied this portrait from an original painted from life by his father Charles Willson in 1795 when Martha was in her early sixties. Rembrandt added the surrounding stone "porthole" to make it a pendant to his celebrated "porthole" portraits of Washington. How many replicas he painted or the date he began them has not been clearly established, although evidence suggests that they were begun late in his career as somewhat of an afterthought. Peale's wife Harriet (Cany) Peale is also known to have painted some of these portraits.

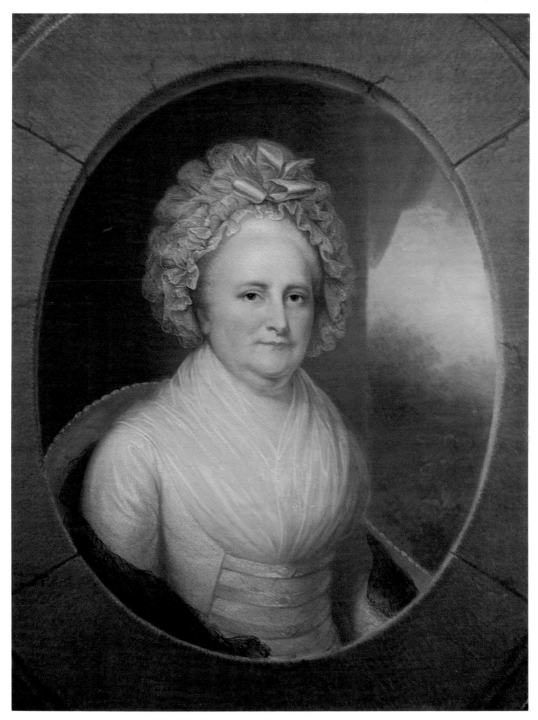

Plate 82

Charles Carroll of Carrollton (1737–1832)

Oil on canvas 22" x 18-1/2"

c. 1730

Charles Carroll was born in Annapolis and educated by the Jesuits, first in Maryland and later in France and Flanders. Thereafter he spent several more years studying civil law in France and England.

He returned to Maryland in 1765 and settled on his 10,000-acre estate of Carrollton. Although his Roman Catholic religion initially kept him out of public service, Carroll was soon drawn into opposition to the Crown and remained in the forefront of Maryland politics.

In 1774 he was active in the nonimportation proceedings, on the Committee of Correspondence, and later the Committee of Safety. He was a commissioner to Canada in 1776 along with Benjamin Franklin and Samuel Chase in the unsuccessful effort to form a union between Canada and the colonies. From 1776 to 1778 he was a delegate to the Continental Congress where he served on several important committees, notably the Board of War.

After signing the Declaration of Independence, he confined himself to local politics and declined a seat in the Federal Constitutional Convention, although he supported ratification. He helped draft the first Maryland constitution, served in the federal Congress as a senator from Maryland and later in the state senate. After 1800 he pursued various business ventures. When he died, he was considered one of the wealthiest individuals in America and was revered as the last surviving signer of the Declaration of Independence.

Among the least known of the many likenesses of Charles Carroll, this portrait is probably the last executed during his lifetime. It was originally attributed to Rembrandt Peale's father, Charles Willson Peale, who copied it in 1832 for his gallery.

Plate 83

James Wilkinson (1757–1825)

Oil on canvas 29-1/4" x 24-1/4" (sight)

c. 1812–1825

THE FILSON CLUB, LOUISVILLE, KENTUCKY

Born in Benedict, Maryland, James Wilkinson pursued the study of medicine. Even as a student, however, military life attracted him and at the outbreak of the Revolutionary War, he obtained a commission in Washington's army. After the siege of Boston, he served in Benedict Arnold's march to Quebec and subsequent retreat to Albany. He then became aide-de-camp to Horatio Gates and saw action at Ticonderoga and Saratoga. Given the task of reporting the victory at Saratoga to Congress at York, Pennsylvania, he stopped off in Reading to do some courting and moved so slowly that Congress was kept waiting three weeks for the news of this first great American victory. In a weak moment, Wilkinson dropped a bit of gossip that informed Washington's friends of what has come to be called the Conway Cabal, a movement to replace Washington with Gates. Despite these indiscretions, Wilkinson was promoted to brigadier general, served on the Board of War, and from 1779 to 1781 held the lucrative post of clothier general. Because of grave irregularities in his accounts, however, he was forced to resign.

After the war Wilkinson moved to Kentucky, became prominent in trade and politics, supplanting George Rogers Clark as leader in the region. He was involved in the so-called Spanish Conspiracy, a series of intrigues to encourage Spanish control in the area. In 1791, he returned to military service and fought the Indians north of the Ohio.

After the turn of the century, Wilkinson, along with his old friend Aaron Burr, became increasingly involved with dubious commercial, military, and political activities in the Louisiana Territory. He was briefly governor of Louisiana, but his mysterious involvement in the Burr Conspiracy made him so unpopular that he was not reappointed. Ironically, although he himself was implicated, Wilkinson was responsible for revealing Burr's plot, and narrowly escaped indictment during the subsequent trial. A second congressional inquiry and court-martial exonerated him.

As a major general in the War of 1812, Wilkinson so mishandled the northern campaign that he was a second time called before a court of inquiry, but he was again acquitted. Thereafter he retired to his plantation outside of New Orleans. In 1821, to secure a Texas land grant, he went to Mexico City where he died four years later.

Jarvis represents Wilkinson in a social full dress uniform of the period of the War of 1812. On the sword belt is an oval gilt plate ornamented with an eagle. While there are other examples of this portrait, Wilkinson's grandson maintains this is the only likeness of the general taken from life.

234

Plate 84

Thomas Paine (*1737–1809*)

Oil on canvas 25-13/16" x 20-1/2"

c. 1805

NATIONAL GALLERY OF ART, WASHINGTON, D.C.

GIFT OF MARIAN B. MAURICE 1950

Born in Thetford, England, Thomas Paine was the son of a poor Quaker corset maker. Basically self-educated, he unsuccessfully pursued various occupations before 1774 when, armed with letters of introduction from Benjamin Franklin, he arrived in Philadelphia. He supported himself as a free-lance journalist, writing articles on a broad range of subjects.

Paine is best remembered for his political pamphlets. At the urging of Benjamin Rush, he anonymously published *Common Sense* in January 1776. In a lucid, but simple and direct style, he argued that America had a moral obligation to the whole world to declare independence: "Tis time to part," he wrote. In the meantime, Congress had been moving cautiously toward the idea of independence, and Paine's enormously popular pamphlet was indispensable in helping to overcome reluctance of the various provincial legislatures.

In 1776 he published the first of a series of tracts called *The Crisis* which began: "These are the times that try men's souls. . . . Tyranny, like hell, is not easily conquered; yet we have this consolation with us, that the harder the conflict, the more glorious the triumph." Widely circulated, these pamphlets helped raise American morale during a dark period of the Revolution.

In the late 1780s, Paine traveled between London and Paris, managing to get built his cherished invention, an iron bridge, and establishing himself as a missionary of the world revolution, notably with the publication of *The Rights of Man.*

Made a French citizen in 1792, Paine was briefly active in politics. During his one year of imprisonment under the Reign of Terror, he began *The Age of Reason.* An attack on organized religion that shocked America, this book became "the atheist's bible." But Paine really became a pariah when he published his infamous *Letter to George Washington* in which he attacked the military reputation and presidential policy of this national idol.

Paine returned to the New York City area in 1802, his last years characterized by poverty, drink, declining health, and social ostracism.

Unlocated until 1949–1950, this portrait had been known only through an engraving by Julius R. Ames. It is the last, and at present, the only extant painting from life of Paine. Other likenesses by George Romney, Charles Willson Peale, and François Bonneville are known through engravings.

Those who knew Paine personally often commented on his penetrating gaze. To Charles Lee he was "the man who had genius in his eyes." Jarvis, who roomed with Paine in New York from November 1806 to April 1807, skillfully captured that animation.

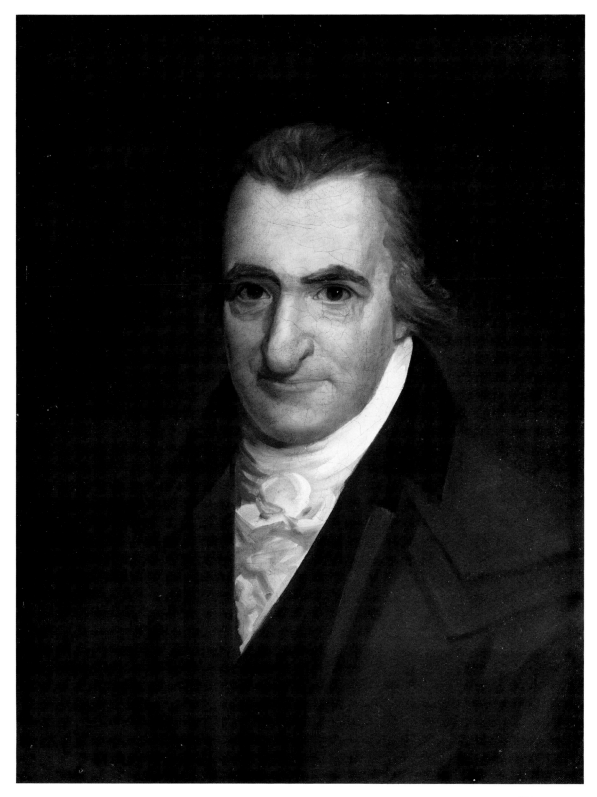

Plate 85

JOHN WESLEY JARVIS (ATTRIBUTED TO)

John Armstrong, Jr. *(1758–1843)*

Oil on panel 30" x 24-3/8"
Undated

NATIONAL PORTRAIT GALLERY, SMITHSONIAN INSTITUTION, WASHINGTON, D.C.

John Armstrong was born at Carlisle, Pennsylvania. The Revolutionary War interrupted his studies at Princeton, and he joined Washington's army, serving first as an aide-de-camp to General Mercer (1775–1777) and then, until the end of the war, on the staff of Horatio Gates.

Armstrong is best remembered for his part in the so-called Newburgh Conspiracy. In March 1783, the army was encamped at Newburgh, New York, and becoming increasingly belligerent because of arrears in pay, unsettled food and clothing accounts, and the failure of Congress to provide life pensions of half pay, as of October 21, 1780, the date they had been promised discharge. Armstrong is credited with composing the notorious "Newburgh Addresses," a skillful and emotional appeal in which he urged that the army take justice into their own hands. With some difficulties, Washington soothed the spreading discontent. Congress eventually agreed to give officers full compensation for five years in lieu of half pay and the enlisted men three months' pay. But, having no funds, they could only give the soldiers certificates of indebtedness.

After the war, Armstrong became active in civic and military affairs in Pennsylvania and was a delegate to Congress in 1787. With his marriage in 1789 to Alida Livingston, he moved to Dutchess County, New York, and eventually entered New York politics. He was a United States Senator from 1800 to 1804 and minister to France from 1804 to 1810.

As secretary of war during the War of 1812, Armstrong incurred most of the blame for the disastrous failure of the expedition against Montreal and for the British capture of Washington. He was soon forced to resign and his political career came to an abrupt end. He retired to Red Hook, New York, and devoted the remainder of his life to agriculture and occasional writings.

Armstrong, dressed in a uniform of the period of 1812, appears to be in his fifties. Thus, this portrait may have been painted in New York around the time he was secretary of war. Jarvis, a master of the "speaking likeness," depicted Armstrong with a direct and intense gaze, revealing an underlying fearlessness that borders on ruthlessness. This intensity is somewhat diluted by casual elements of the costume and pose—the third button of the coat is unbuttoned while the left arm is slung carelessly over the back of the chair.

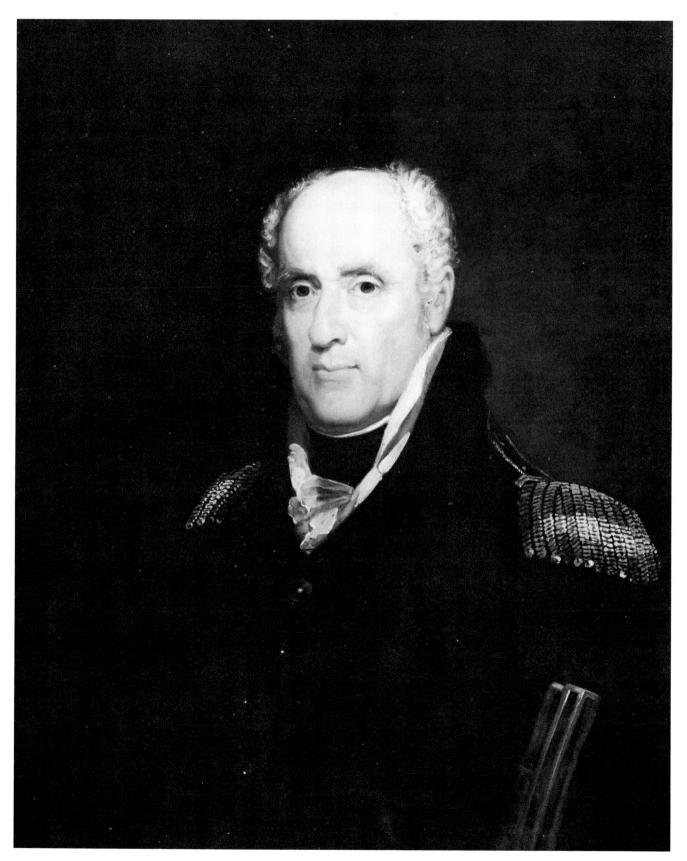

Plate 86

Samuel Chase (*1741–1811*)

Oil on panel 28-1/4" x 23"

1811, Maryland

NATIONAL PORTRAIT GALLERY, SMITHSONIAN INSTITUTION, WASHINGTON, D.C.

Born in Somerset County, Maryland, the son of a prominent Baltimore clergyman, Samuel Chase pursued a career in law and quickly became involved in local radical politics. After 1764 he was a member of the Maryland Assembly where he voiced his opposition to the royal governor. Also active in the Sons of Liberty, he participated in the riotous demonstrations against the Stamp Act, including looting of public offices, destroying stamps and burning the tax collector in effigy. He served on the Maryland Committee of Correspondence and the Council of Safety.

As a delegate to the Continental Congress (1774–1778), Chase urged a total embargo of trade with Great Britain, signed the Declaration of Independence, supported Washington against intrigues, and favored confederation. Along with Benjamin Franklin and Charles Carroll of Carrollton, he went on the unsuccessful mission to Canada to try to win the Canadians over to America's side. He served on numerous congressional committees, but his most significant contribution was the wording of a circular discrediting the British peace proposals of 1778.

Chase's reputation suddenly collapsed toward the end of 1778 when he, along with others, used Congressional information in an attempt to corner the flour market. Not until the mid-1780s does he again emerge as a viable public figure. Pursuing his law practice in Baltimore after 1786, he was appointed chief judge of the new criminal court and in 1791 a member of Maryland's general court.

As a member of the Maryland convention that adopted the Federal Constitution, he opposed ratification and was among the committeemen who suggested clauses protecting trial by jury and freedom of the press. In 1796 Washington appointed him associate justice of the Supreme Court. A federalist sympathizer, Chase served until 1804 when, at the urging of antifederalist Jefferson, he was impeached, primarily for what was considered arbitrary behavior in court. He was acquitted and continued to sit on the bench until his death, although his influence was considerably diminished.

Painted the year of Chase's death, this portrait shows the freshness and robustness of Jarvis's realism. Subtle modeling and brushwork are particularly characteristic during this period.

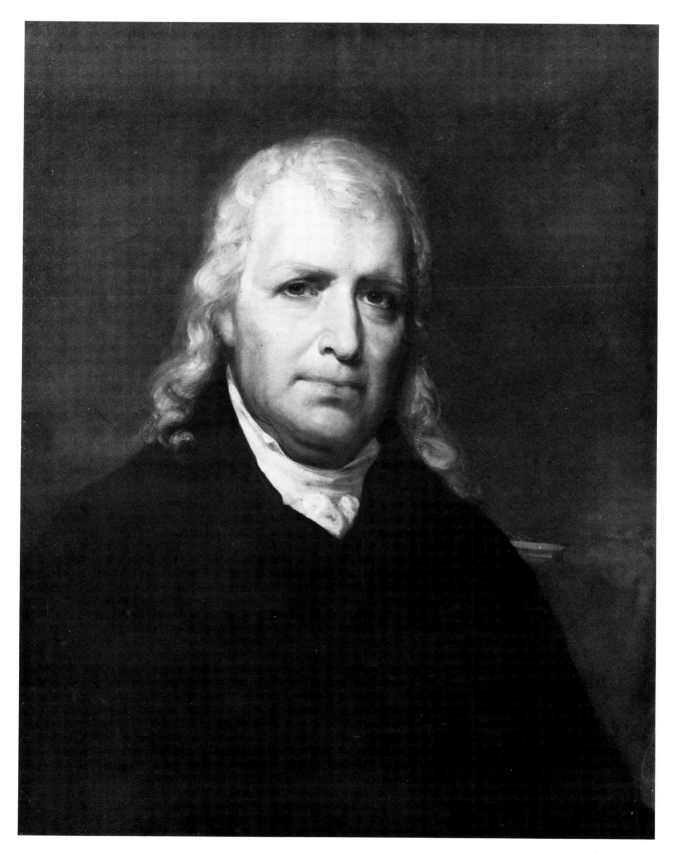

Plate 87

Cotton Tufts (1732–1815)

Oil on canvas 28-7/8" x 22-1/2"

Inscribed, signed, and dated: Hon. Cotton Tufts M.D. A.A.L./
M.M.S. Drawn in the 73rd year of his life 1804/By Benjamin Greenleaf.

THE BOSTON MEDICAL LIBRARY IN THE FRANCIS A. COUNTWAY LIBRARY OF MEDICINE,
HARVARD MEDICAL SCHOOL

A native of Weymouth, Massachusetts, Cotton Tufts graduated from Harvard.
After he introduced in Weymouth a highly successful treatment for "the putrid
sore throat [that] was very prevalent and extremely mortal," he established such
a lucrative medical practice that he was able to offer his service gratis to the
poor. He was related by marriage to John Adams who, as a young man, used to
enjoy visiting the Tufts's small home where he would find a "wild goose on the
spit, and cranberries stewing in the skillet for dinner."

In Weymouth, Tufts served as clerk, selectman, and an influential deacon
of the church. Just prior to the outbreak of the Revolution, he headed a committee
to protest the Tea Act of 1773. Later, in his capacity as chairman of the Com-
mittee of Correspondence, he established a regular method of alarm from town to
town and personally paid for the transportation of two cannon from Salem. In a
letter of May 30, 1775, he sought aid from the Provincial Congress:

> The Bearers hereof wait on you requesting you to [issue] Powder and Ball
> from the Provincial Store for Two small Pieces of Cannon . . . with[out]
> which they must be useless to us. . . . Our scituation [sic] is extremely expos'd,
> And We have [] a Company to guard our shore. . . .

Indeed, Tufts himself closely watched and reported any enemy ship movements in
the harbor, but an attack on Weymouth never materialized.

Tufts was a member of the town committee which approved the Massa-
chusetts Constitution of 1780 and served as state senator from 1781 to 1791. As
a member of the convention of 1788, he voted for ratification of the Federal Con-
stitution. A friend noted that "In regard to politicks, he [Tufts] was a federalist
of that stamp, from whose sentiments, considerate and judicious men of each
party could not widely differ. Discovering in both parties too much of a denuncia-
tory spirit . . . he sided, in the extreme, with neither."

Tufts remained active for the rest of his life in several Massachusetts organiza-
tions, notably the Massachusetts Medical Society of which he served successively
as a founder, councillor, and president.

This picture is Greenleaf's only known portrait on canvas and his earliest
recorded painting. The somber expression of the sitter and the simple, crisp
contours of the figures are typical of Greenleaf's style. The essence of the New
England character is captured by the elimination of superficial decorative details.

Plate 88

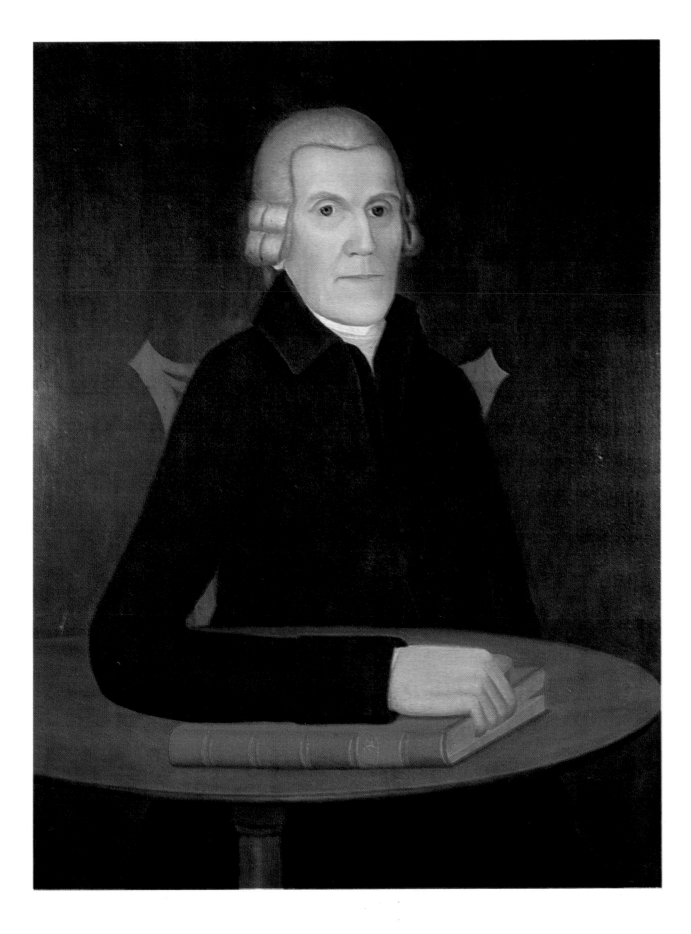

Philip Van Cortlandt (*1749–1831*)

Oil on canvas 36″ x 28″

c. 1810

METROPOLITAN MUSEUM OF ART, NEW YORK

GIFT OF CHRISTIAN ZABRISKIE 1940

A native of New York who grew up in a manor house near Croton, Philip Van Cortlandt assisted in the family land operations, often surveying tracts to be sold, while simultaneously operating gristmills for his father.

In 1775, he became associated with the radical faction of the Revolutionary movement. He served in New York's first Provincial Congress before he was appointed lieutenant colonel of the Fourth New York Regiment. Although serious illness prevented him from participating in Montgomery's expedition against Montreal, Van Cortlandt saw action at Saratoga and was commended for his aid during the Sullivan-Clinton expedition against the Iroquois and the Tories who were cooperating with one another in the war. Van Cortlandt's distinguished services in the Yorktown campaign earned him the rank of brigadier general.

He voted for ratification of the Federal Constitution, served in the State Assembly (1788, 1790) and the State Senate (1791–1793). Elected a member of the House of Representatives in 1793, he was an undistinguished, though conscientious, congressman for sixteen years.

Van Cortlandt retired from politics about 1809 to manage his extensive real estate holdings. In 1824, he reemerged in public life to accompany his old friend Lafayette on his triumphal country-wide tour. Van Cortlandt died at the family manor house.

Probably painted just after Van Cortlandt's retirement, this picture was attributed to Ezra Ames by William Sawitzky. Tradition maintains that Van Cortlandt is holding a letter from Lafayette.

MATTHEW HARRIS JOUETT

George Rogers Clark (1752–1818)

Oil on canvas 23″ x 19″

c. 1815

THE FILSON CLUB, LOUISVILLE, KENTUCKY

George Rogers Clark (whose brother William was to win fame on the Lewis and Clark Expedition) was born near Charlottesville, Virginia. Trained by his father to be a surveyor, Clark in 1772 explored the Ohio River and returned the next year to survey farms for the new settlers coming into the region. After fighting in Dunmore's War (1774), he became a surveyor for the Ohio Company in Kentucky where he soon became a prominent figure.

At the opening of the Revolutionary War, the center of British power west of the Alleghenies was at Detroit under Lieutenant Governor Henry Hamilton. Known as the "Hair Buyer," Hamilton enlisted the Indians to harass the settlers. As a challenge to Hamilton, Clark proposed putting Kentucky under the protection of Virginia. To implement this plan, he would organize a militia and conquer the Illinois country and Detroit. His idea was accepted, and, in the summer of 1778, Clark, with his army of 175 men, captured Kaskaskia, Cahokia, Vincennes, and won over the allegiance of the French villagers and the neighboring tribes.

When Hamilton heard of Clark's success, he organized a counteroffensive, easily recapturing feebly guarded Vincennes. Most of Hamilton's troops were dispersed shortly after the victory, and Clark boldly seized the opportunity to try again. In a difficult 180-mile march over plains and through overflowing rivers, he led his army to Vincennes. Hamilton surrendered on February 25, 1779. The skill and daring of the undertaking was recognized even by Hamilton.

Although Clark's expedition to Detroit never materialized, he continued to play a vital role in maintaining control in the region. He is also credited with saving St. Louis and the rest of Louisiana for the Spanish—then an American ally. Under the terms of the treaty concluded at Paris, September 3, 1783, the Old Northwest was ceded to the United States. Clark's conquest was certainly a factor in reaching the final agreement.

By 1786, Clark's reputation and prestige had greatly declined due to a series of misfortunes. After several ventures had failed, Clark accepted, toward the turn of the eighteenth century, a commission as general in the French army to lead an expedition against Louisiana. But when war between the United States and France seemed imminent, he was asked to surrender his appointment. He refused and took refuge in St. Louis. In 1809, a paralytic stroke and amputation of his right leg forced him to go live with his sister near Louisville, where he died.

Known for his "black penetrating sparkling eyes," Clark is here depicted wearing a uniform of the post-Revolutionary period.

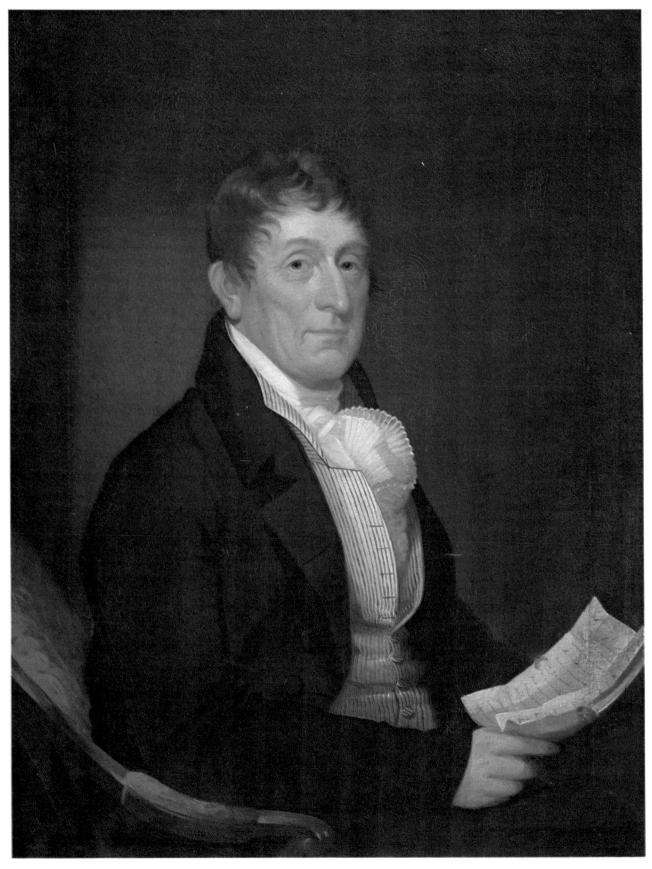

Plate 89

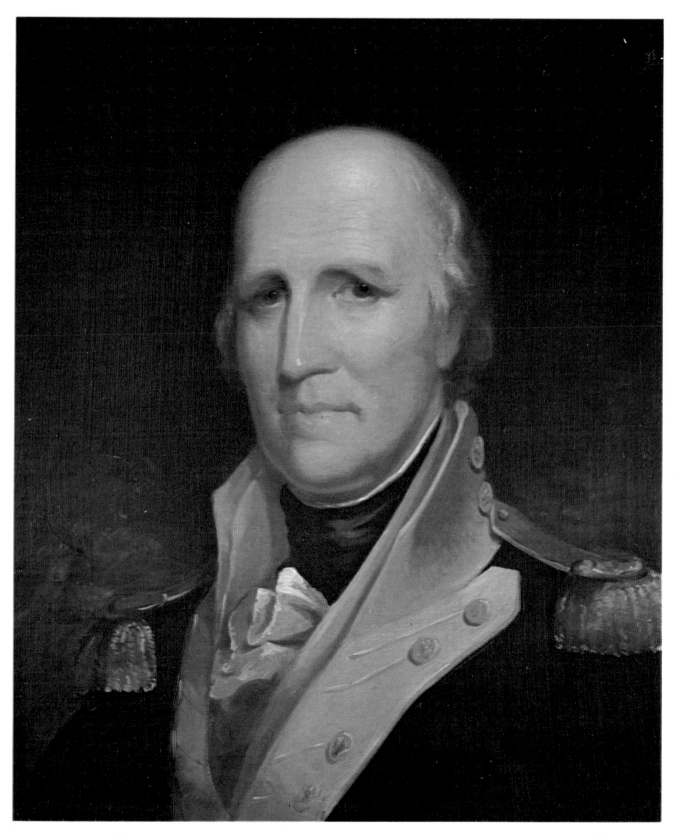

Plate 90

HENRY INMAN

Richard Varick (*1753–1831*)

Oil on canvas 30″ x 25″

c. 1831

Richard Varick was born in New Jersey and moved to New York City in 1775 when he became a captain of the First New York Regiment. He served under General Philip Schuyler in the Northern Department. Later, as an aide to Benedict Arnold, Varick found himself an object of suspicion, despite the fact that a court of inquiry found him innocent of any involvement in Arnold's treason.

Washington demonstrated his faith in Varick by appointing him as one of his confidential secretaries. Varick arranged, classified, and copied all the correspondence and records of the headquarters of the Continental Army. Compiled between 1781 and 1783, the some forty volumes of transcripts are a tribute to Varick's excellent organizational skills. In a letter of January 1, 1784, Washington told Varick that he had performed his task with "great care and attention. . . . I am fully convinced, that neither the present age or posterity will consider the time and labour which have been employed in accomplishing it, unprofitably spent."

The stain now removed from Varick's reputation, he returned to New York in 1784 and became the city recorder. Subsequently, he, along with Samuel Jones, codified the New York statutes. He then served New York successively as speaker of the Assembly (1787–1788), attorney general (1788–1789), and major (1789–1801).

This half-length likeness may have been derived from or perhaps have been a study for Inman's full-length portrait of Varick in the collection of the American Bible Society in New York of which Varick was a founder and, from 1828 to 1831, president. He wears the eagle badge of the Society of the Cincinnati. Varick served as president of the New York branch from 1806 until his death.

JOHN VANDERLYN

Aaron Burr (1756–1836)

Oil on canvas 28-9/16" x 22"

c. 1802–1803

Aaron Burr, the son of an eminent scholar and theologian, was born at Newark, New Jersey. Orphaned at an early age, he was raised by his uncle. He graduated with distinction from Princeton and settled on a career in law.

During the Revolutionary War, Burr distinguished himself as a volunteer on the expedition against Quebec and is credited with the attempt to rescue Montgomery's body. He was briefly Washington's aide, but a mutual antipathy developed that forced him to transfer to General Putnam's staff. An outstanding soldier, Burr fought in New York and New Jersey where he established a reputation for discipline and daring. For reasons of health he resigned in March 1779.

In the 1780s, while building up a lucrative law practice, Burr was also establishing a creditable political career. He served as attorney general of New York under Governor George Clinton and from 1791 to 1797 was a United States senator. Due to a technical confusion in the Constitution, Burr, who was considered to be running for vice president, secured the same electoral votes as Jefferson during the presidential election of 1800. His efforts to take advantage of this confusion failed. As vice president, Burr presided over the Senate and the impeachment trial of Samuel Chase in a manner that earned him praise from both parties.

In 1804 he was nominated for governor of New York. He blamed his disastrous defeat on his old enemy Hamilton. This was one motivation for the famous duel in which Hamilton was mortally wounded.

Later Burr joined James Wilkinson in trying to profit from what seemed an inevitable war with Spain over lands west of the Alleghenies. He was accused of trying to separate an extensive area from the Union, make New Orleans the capital, and install himself as "head of an empire vaster than that which he had lost" to Jefferson in the presidential election. After Wilkinson defected, Burr was accused of treason, but was acquitted at Richmond in 1807. The next few years were spent traveling in Europe where he unsuccessfully tried to obtain official support for various plots against the United States. He returned to America in 1812 and practiced law in New York.

This is one of at least three portraits Vanderlyn painted of his friend and patron Aaron Burr. One is a copy after Gilbert Stuart—the picture that brought Burr and Vanderlyn together—the other is a profile likeness. This depiction is distinctive for the strength of character it portrays. The piercing dark eyes suggest both Burr's vigorous mind and independent nature.

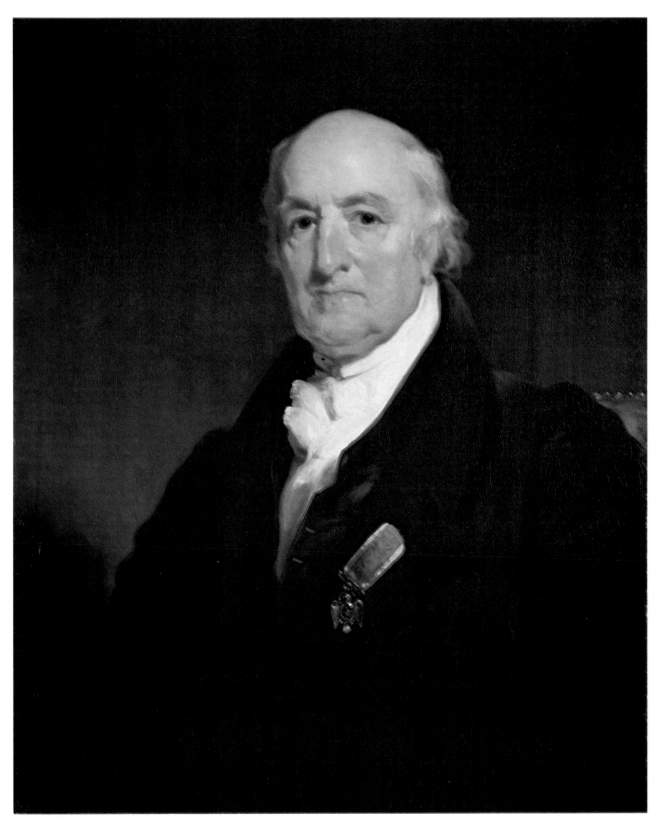

Plate 91

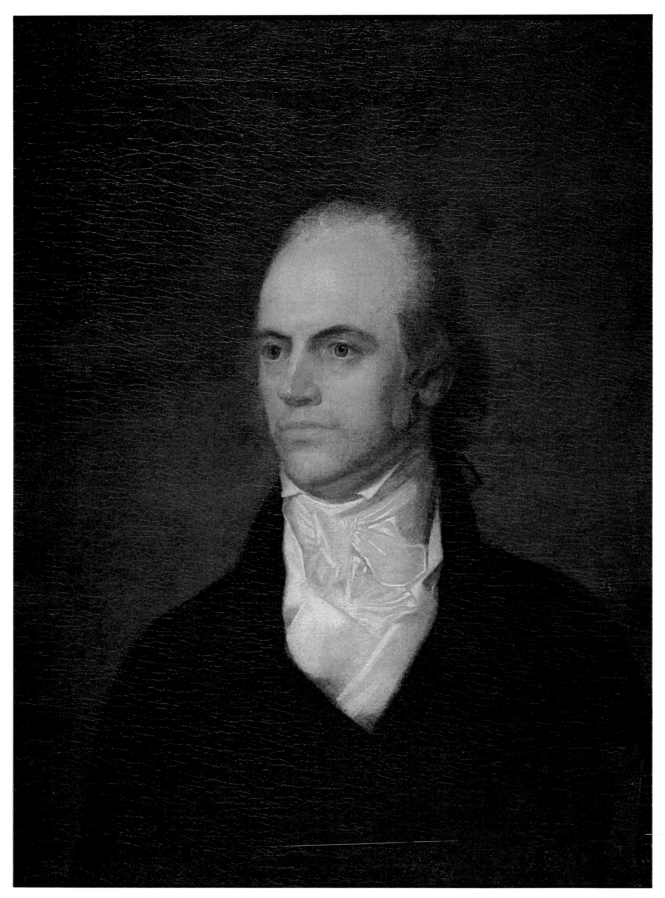

Plate 92

James Monroe (1758–1831)

Oil on canvas 92-1/4″ x 59-1/2″

1819–1820

THE CITY OF CHARLESTON, SOUTH CAROLINA

James Monroe, fifth President of the United States, was born in Virginia. The advent of the Revolutionary War interrupted his studies at William and Mary College, and he enlisted in the Continental Army. Before his retirement from the army in September 1778, he had fought in many of the battles in New York and New Jersey and was wounded at Trenton.

Monroe's political career began in 1782, when he became a member of the Virginia assembly while studying law under Thomas Jefferson, who became a life-long friend. As a member of Congress from 1783 to 1786, Monroe advocated stronger governmental mechanisms than existed under the Articles of Confederation, while at the same time fearing centralization. In the Virginia convention called to ratify the Constitution, he aligned himself with the opponents. A United States senator (1790–1794) and prominent antifederalist, he was severely critical of Washington's administration and particularly opposed the establishment of the Bank of the United States.

After one term as governor of Virginia in 1799, Monroe spent several years in Paris, Madrid, and London on various United States diplomatic missions, notably helping to negotiate the Louisiana Purchase. In 1808 Madison decisively defeated him in the presidential election, and Monroe again became governor of Virginia.

He returned to national politics and served as secretary of state from 1811 to 1817 and secretary of war from 1814 to 1815. During his service as President from 1817 to 1825, he is perhaps best remembered for the famous Monroe Doctrine (1823) in which he proclaimed that the American continents "are not to be considered as subjects for future colonization of any European power."

After the expiration of his last term, Monroe dabbled briefly in Virginia politics and then moved to New York City, where he died.

In 1819 Morse painted Monroe in the White House, patiently waiting for the busy President to dash in for ten- or twenty-minute sittings. Under these frustrating circumstances, this dramatic image was created. Placed in a symbolic setting which merges interior and exterior in a totally unrealistic fashion peculiar to academic painting, Monroe is surrounded by aristocratic paraphernalia traditionally used to ennoble the sitter. The facades of the neoclassic edifices in the background are rendered in perspective, creating a deep space which not only heightens the sense of drama and grandeur but also suggests the seat of government. With minor alterations in pose and surrounding iconographic details, Morse adapted this same composition six years later in his celebrated portrait of the *Marquis de Lafayette* (City Hall, New York).

One of Monroe's daughters liked this portrait so much that she requested a copy of the head. She also told the artist that "her father was delighted with it, and said it was the only one that in his opinion looked like him."

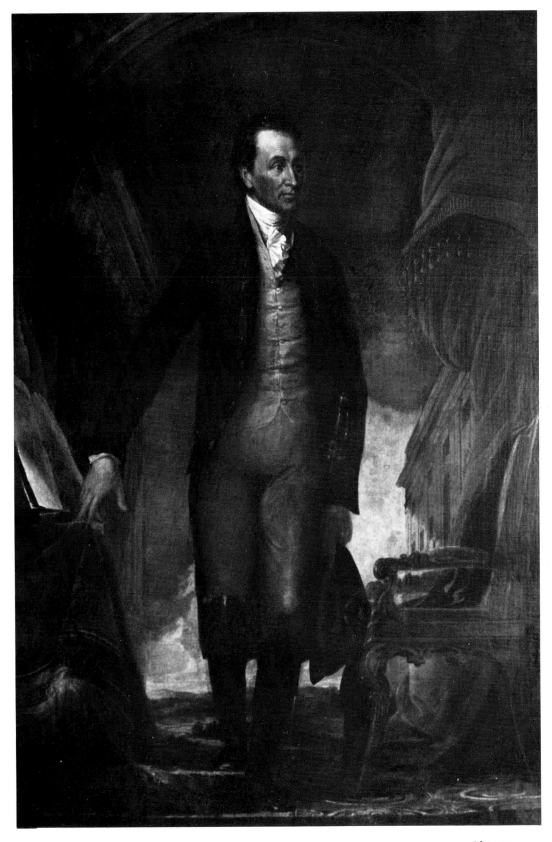

John Stark (*1728–1822*)

Oil on canvas 36-1/4" x 31-3/8" (framed)

c. 1816–1820, Dunbarton, New Hampshire

THE OAK RIDGE COLLECTION

Of Scotch-Irish descent, John Stark was raised in the backwoods of New Hampshire where he developed prowess as an Indian fighter, hunter, and fisherman. Familiar with the wilderness, he devoted his youth to guiding exploring expeditions into remote areas.

Stark established his military reputation in extensive service with Rogers' Rangers in the French and Indian War. Afterwards he helped settle a new township, at first called Starkstown, later renamed Dunbarton.

Upon news of the battles of Lexington and Concord, he immediately reported to Cambridge. He was appointed colonel of a New Hampshire militia regiment which he led with considerable success at Bunker Hill. After the siege of Boston, he helped prepare the defenses of New York City and later distinguished himself in the battles of Trenton and Princeton. But in March 1777, when he was passed over for promotion, he resigned and went home.

That August Stark was appointed brigadier general in the New Hampshire militia. As Burgoyne marched down from Canada, Stark met the large British detachment and won the spectacular and decisive victory which contributed to Burgoyne's eventual surrender at Saratoga. Just before the attack, Stark is alleged to have exclaimed, "There, my boys, are your enemies, the redcoats and tories; you must beat them or my wife sleeps a widow tonight." Shortly thereafter, Congress finally promoted him to brigadier general in the Continental service.

Stark remained active for the rest of the war, becoming a major general in 1783. He retired to his estate where he died at the age of ninety-three.

Morse represented Stark dressed in a uniform of a later period than the Revolution. The portrait artfully captures the psychological strength and depth of character of the soldier: the piercing gaze, the unwavering countenance, the slightly furrowed brow, all work together to create a dramatic image.

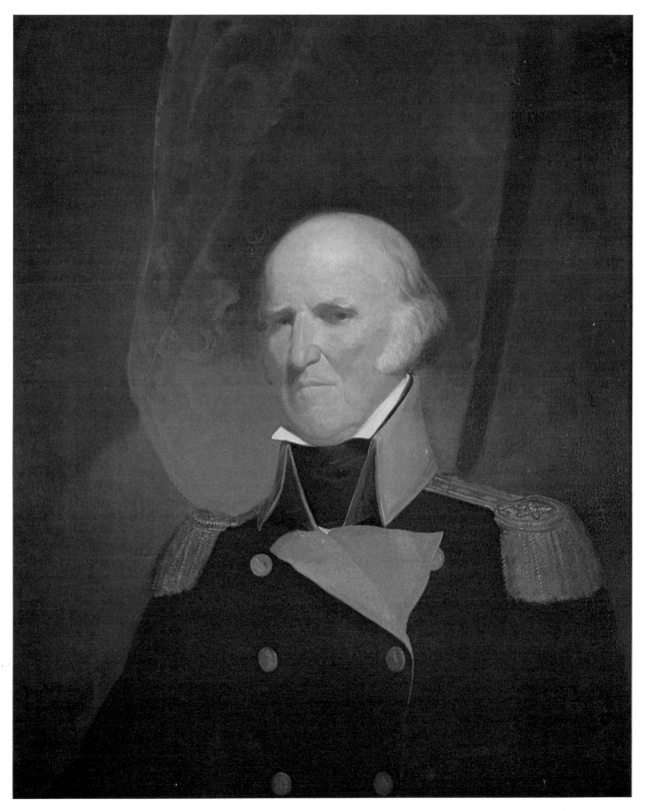

Plate 94

THOMAS SULLY

Jonathan Williams (1750–1815)

Oil on canvas 78″ x 57-1/2″

Signed and dated: TS 1815

UNITED STATES MILITARY ACADEMY, WEST POINT, NEW YORK

Born in Boston, Jonathan Williams received a rudimentary education before he and his brother left for London to be trained as merchants by their great-grand-uncle Benjamin Franklin. In 1776, Franklin was sent to Paris, where Williams, after abandoning his lucrative London business, joined him. The commissioners immediately employed the young merchant as their agent at Nantes to inspect arms and supplies being shipped to America during the Revolutionary war. Outraged when Arthur Lee unjustly charged Williams of abuse of power and appropriation of public money for private purposes, Franklin made no further attempts to place his nephew in public service.

Returning with Franklin to Philadelphia in 1785, Williams established a highly successful mercantile business. Active in the American Philosophical Society and blessed with scientific talents, Williams collaborated with his uncle on some of his later experiments.

Williams's scientific interests brought him into contact with Thomas Jefferson who appointed him in 1801 inspector of fortifications at West Point. Williams became its first superintendent when West Point was established as a military academy. However, inadequate equipment, supplies, faculty, and library facilities impeded the growth of the academy under Williams's leadership. Finally, in 1812, embittered by his failure and slighted because he had not been given command of the New York fortifications, which, in 1805, he had helped plan and supervise, he resigned to serve as general of the New York militia. Elected to Congress in 1814, he died before he could take his seat.

Commissioned by the Corps of Engineers of the United States Military Academy at West Point, Sully noted in his "Register" that he began this portrait on February 14, 1815, and finished it in May. He charged $300. Dressed in a dark blue uniform of the period of the War of 1812, the portly Williams is seated by an open window overlooking New York Harbor. In the background is the circular brick fort, Castle Williams on Governor's Island, which was built under Williams's supervision. Williams's hand rests on what must certainly be the plans for this project.

Charles Henry Hart stated that this portrait is Sully's "unquestioned masterpiece."

William Barton (*1748–1831*)

Oil on canvas 37-1/2" x 28"

c. 1780–1785

THE RHODE ISLAND HISTORICAL SOCIETY, PROVIDENCE
BEQUEST OF THE REVEREND GEORGE FRANCIS CUSHMAN

Born near Providence, Rhode Island, William Barton pursued the trade of hatter for several years. After the battle of Bunker Hill, he enlisted in the Continental Army. In August 1776, he became major of Rhode Island troops. At the time, Rhode Island was harassed by a British detachment under the command of Brigadier General Richard Prescott, a most unpopular English officer because of his ruthless disposition, his contemptuous behavior toward Americans, and his mistreatment of Ethan Allen, who had been captured in a previous campaign. Gen. Charles Lee was then a prisoner of the English, and it occurred to General Barton that if he could capture the hated Prescott, an exchange might be arranged.

In July 1777, with forty volunteers, Barton left Tiverton, Rhode Island. In five boats they crossed the heavily guarded Narragansett Bay, finally landing on the western shore of Rhode Island. The small company crept one mile inland, surprised the British general in a house he occupied near Newport, and successfully carried him off. In due time the exchange was effected.

This heroic deed earned Barton the thanks of the Rhode Island General Assembly and Congress who voted a gift of a silver-hilted steel sword. His exploit greatly helped lift morale at a time when encouragement was most needed. Barton was subsequently wounded and forced to retire from military service.

In his later life, Barton was involved in a lawsuit arising out of his purchase of a township in Vermont. When he lost the suit, he was asked to pay all court costs. Feeling the demand was unconstitutional, he refused on principle to pay the $14. For this trivial sum, he was "detained" in Danville, three hundred miles from his home, for fourteen years. When his old friend Lafayette visited the United States in 1824, he heard of the injustice and secretly discharged the debt so that the old veteran could return home without compromising his principles.

Barton is posed in military uniform. Around his neck hangs what appears to be a brass gorget, a piece of armour originally intended to protect the throat but worn by officers in the seventeenth and eighteenth centuries as a badge of rank. In America, a silver gorget was often presented to the Indians as a symbol of peace. On Barton's left side hangs a sword, perhaps the one Congress presented him for his heroism in Rhode Island.

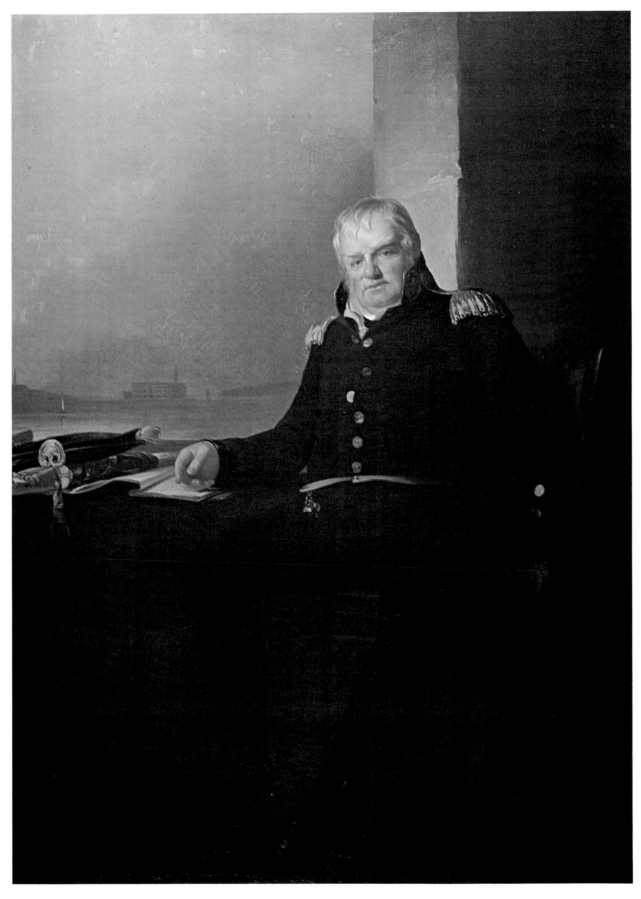

Plate 95

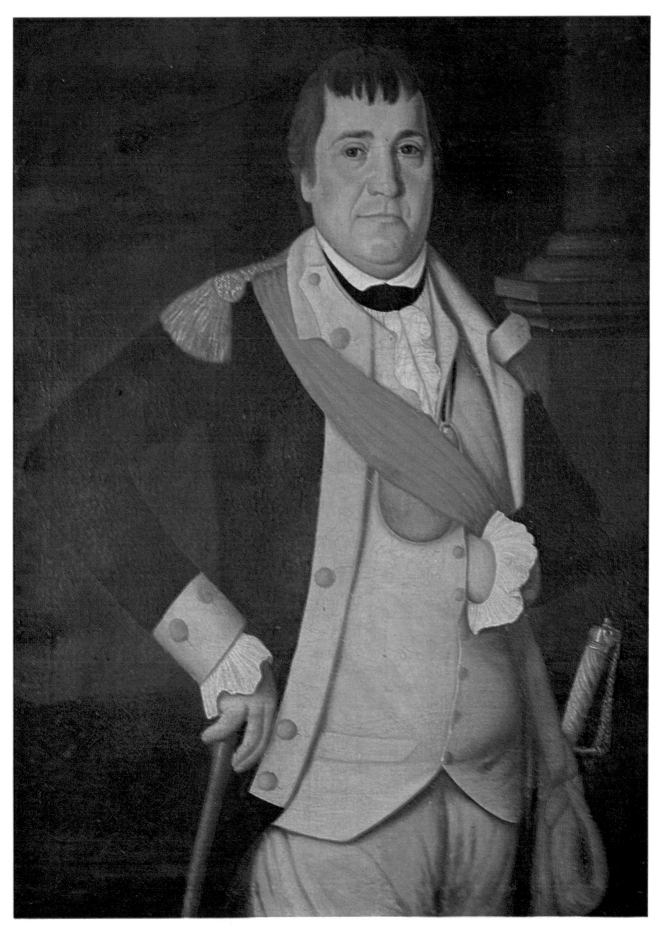

Plate 96

GILBERT STUART

George Washington (1732–1799)
Martha Washington (Martha Dandridge Custis) (1731–1802)

Oil on canvases 48" x 37"
1796

ON DEPOSIT AT THE MUSEUM OF FINE ARTS, BOSTON
LENT BY THE BOSTON ATHENAEUM

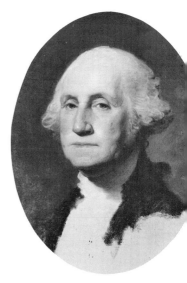

Plate 97

The Athenaeum portrait of Washington, the most famous authentic painting connected with the American Revolution, had not been out of Boston for at least a century before it was loaned to the Amon Carter Museum for the exhibition which is the basis of this volume.

Stuart painted three portraits of Washington from life, each of which he reproduced in many replicas. The first sitting resulted in what is known as the Vaughan type, which, like the Athenaeum head, is bust length but shows the right side of the face. It is particularly admired for its robustness. Stuart then satisfied the social leaders of Philadelphia with the so-called Lansdowne type, which depicts Washington at full length, surrounded by elaborate paraphernalia intended to suggest his noble stature and eminence. Our Athenaeum portrait, the third original likeness, was commissioned by Martha and painted, along with its pendant of the First Lady, in Stuart's studio at Germantown, a suburb of Philadelphia. Before it was completed, Stuart recognized its obvious appeal to a broad public and therefore, whenever the Washingtons asked for the picture, he would say that it was not finished. He wanted to keep the canvas as a model for future replicas. He never finished it. Martha, much to her annoyance, ended up with a replica.

After 1796, Stuart made many versions of the Athenaeum head. In addition, this image was copied by Stuart's daughter Jane and by numerous other nineteenth-century artists. It also appears, in reverse, on the dollar bill. Indeed, so pervasive is this likeness, that it has often been claimed that if Washington should miraculously return to life today and not look exactly like the Athenaeum portrait, he would be considered an impostor.

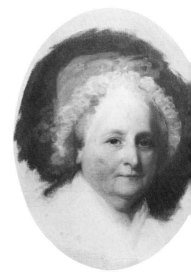

Plate 98

ASHER B. DURAND

James Madison (*1750/51–1836*)

Oil on canvas 24" x 20-3/8"

c. 1833

THE CENTURY ASSOCIATION, NEW YORK

James Madison's political career spanned almost sixty years. As a delegate to the Constitutional Convention, he took the meticulous notes that are the most important record of the proceedings. While many of his ideas were not adopted, he was such an influential member that he has been called "the master-builder of the Constitution." Along with Alexander Hamilton and John Jay, Madison wrote several of the *Federalist* papers which were invaluable in persuading reluctant states to ratify the Constitution. Later, as a representative in Congress, he played a major role in creating the executive departments and in framing the Bill of Rights.

Eventually Madison became a leader of the Democratic-Republic Party. His marriage in 1794 to Dolley Payne Todd, a young widow twenty years his junior, assisted his political career. Friendly and tactful Dolley proved to be a delightful and charming hostess. After a brief retirement, Madison became secretary of state under Jefferson and then the fourth President of the United States.

William Dunlap stated that a portrait of Madison by Durand was executed in 1833, although John, the son of Asher B. Durand, thought that the date was 1832. Commissioned for George P. Morris, editor of the *New York Mirror*, the picture was exhibited at the annual exhibition of the National Academy of Design in 1832 and is apparently the version now in the New-York Historical Society.

The likeness here represented is almost identical to the New-York Historical Society picture. Since the former was purchased by the Century Association from the artist in 1870, it may well be a replica. However, Theodore Bolton in his "The Life Portraits of James Madison" (*William and Mary Quarterly*, VIII, [Jan. 1951], p. 46), noted that "it is impossible to determine which of these portraits is the life portrait and which the replica." He suggested that both may have been done from life.

Plate 99

Biographies of the Artists

EZRA AMES

Ezra Ames was born at Framingham, Massachusetts, in 1768. Apparently self-taught, he first worked as a carriage painter, miniaturist, and decorator in the environs of Worcester, Massachusetts (1790–93). He had permanently settled in Albany by August 1, 1793, when he advertised in the Albany newspapers: ". . . Painting.—Portrait and Sign Painting, Gilding and Limning. The subscriber solicits the patronage of the Admirers of the Fine Arts of Painting, Portraits, Miniatures, and Hair Devices. . . . Signs, Coaches, Chaises, Sleighs, Standards, etc., painted in the best manner . . ."

Producing only four portraits and eighteen miniatures between 1793 and 1800, Ames made his living at this time primarily from odd jobs. He painted signs, sleighs, buckets, furniture, a water tub, a tea cannister, and so on. As a prominent member of the Masonic fraternity in Albany—he was Grand High Priest for several years—Ames received several commissions through members of the brotherhood.

Around 1804 Ames started producing portraits in a rather naïve style. About five or six years later, his style underwent a dramatic transformation when he began assiduously copying the works of John Singleton Copley, Gilbert Stuart, and John Wesley Jarvis. In his new sophisticated manner, Ames contributed to the Second Exhibition of the Society of Artists in Philadelphia (1812) a vigorous portrait of *George Clinton* (replica in the New-York Historical Society). Praised by the press and purchased by the Pennsylvania Academy as its first acquisition, this picture catapulted the forty-four-year-old artist into national fame.

Numbering over 450, Ames's recorded portraits of New York governors, members of the legislature, and the aristocracy of the upper Hudson Valley comprise a faithful and impressive record of the most prominent political and social figures of the era.

Ames was also a banker of sorts, serving first as director and later president of the Mechanics' and Farmers' Bank of Albany. Although elected a member of the American Academy of Fine Arts, he apparently never showed his works in their exhibitions.

Ames, primarily noted as a portraitist, is also known to have painted landscapes, still life compositions (none are located), and miniatures. He died in Albany in 1836.

HENRY BENBRIDGE

Henry Benbridge was born in Philadelphia in 1743. His father died in 1751, and within a year, his mother married Thomas Gordon, a prosperous Scottish merchant. Benbridge's first documented works were decorations, adapted from engravings, for the walls and ceilings of the Gordon home. He studied briefly under John Wollaston who had painted a portrait of the young man's stepfather. Among Benbridge's earliest surviving pictures are mythological subjects based on Old Master prints and portraits of members of the Gordon family. Dating from the early 1760s, his masterpiece of this period is the ambitious conversation piece *The Gordon Family* (Collection: Mrs. Katherine Hellman).

In 1764, Benbridge went to Europe. While sharing living quarters in Rome with Christopher Hewetson, an Irish sculptor, Benbridge traveled to several Italian cities to study Old Master painting. It is possible that he was instructed or influenced by the Italian Pompeo Battoni and the Englishman Thomas Patch.

It was his full-length portrait of *Pascal Paoli* (Collection: Mrs. John Boswell), the Corsican patriot, that launched Benbridge's artistic career. Commissioned by James Boswell in 1768, this picture was admired when it was exhibited at the Free Society of Artists in London the summer of 1769. That December, Benbridge arrived in London where he became a frequent visitor at the home of Benjamin West. At the Royal Academy Exhibition of 1770, Benbridge exhibited two works, one of which was a portrait of Benjamin Franklin.

Carrying back letters of recommendation from Benjamin West and Benjamin Franklin, Benbridge returned to Philadelphia in October 1770. After his marriage in 1771 to Esther (Hetty) Sage, a miniature painter, he moved in 1772 to Charleston, South Carolina. There he succeeded Jeremiah Theus as the most popular limner in the area. Benbridge executed portraits in oil and miniature of the prominent figures of South Carolina.

Benbridge was an ardent patriot. At the fall of Charleston on May 12, 1780, he was taken prisoner by the British and held until December 1782. After a brief sojourn to Philadelphia, he returned to Charleston. A notice appeared in the *Weekly Gazette* of January 9, 1784:

> YESTERDAY se'night arrived here from Philadelphia,
> but last from Virginia, Henry Benbridge, Esq.;
> Historical and Portrait Painter; a gentleman of
> the greatest abilities in his profession. . . .

In 1799 Benbridge met in Norfolk the painter Thomas Sully to whom he may have given some instruction.

In failing health, Benbridge moved back to Philadelphia around 1800 to live with his son Harry. The elderly artist produced very few works during the rest of his life. He died at Philadelphia in 1812.

LOUIS-NICOLAS VAN BLARENBERGHE

Louis-Nicolas Van Blarenberghe was born in 1716 at Lille, France. He was the son of a painter, Jacques-Guillaume Van Blarenberghe, who probably was the young man's only teacher.

In 1751 Louis-Nicolas went to Paris. There he came under the patronage of the Duc de Choiseul who secured him an appointment in 1769 as painter to the War Office. For the decoration of the Foreign Ministry, Van Blarenberghe executed meticulously accurate battle scenes, based on maps and ground plans. Probably deriving his ideas from prints, he also painted a series of views of thirteen European capitals. Eventually hung over the doors in the Hôtel des Affaires Etrangères at Versailles, these works were among the very few Van Blarenberghe did in oil.

Having lost his job at the War Office in 1773, Van Blarenberghe was attached to the admiralty and sent to Brest to paint views of the harbor. He was accompanied and aided by his son Henri Joseph (1741–1826) who by this time had become such a devoted and skilled collaborator that it was impossible to tell the difference between the works of the master and the pupil.

Among Van Blarenberghe's other works are a series of gouaches of battles and sieges of campaigns, which occurred during the reign of Louis XV, and several snuffboxes decorated with miniature landscapes and portraits. He died at Fontainebleau in 1794.

BENJAMIN BLYTH

Benjamin Blyth was born in 1746, the son of a sailmaker from Salem, Massachusetts. There is no information about his youth or artistic training. The first mention of him as a limner appears in *The Salem Gazette* of May 10–17, 1769, in which he announces that he wishes "to inform the Public, that he has opened a Room for the Performance of Limning in Crayons at the House occupied by his Father." His earliest signed work, however, is dated 1767.

Overall, about forty works by Blyth's hand have been recorded. Most are portraits of members of the professional classes, including Revolutionary War officers, clergymen, merchants, and physicians who lived in Salem or the immediate environs. Although primarily a pastellist, he also painted about five known works in oil. In 1781 he copied Charles Willson Peale's portraits of George and Martha Washington (1776) which had been commissioned by John Hancock. Blyth's versions were engraved by John Norman and published by John Coles in 1782. One allegorical composition is also recorded.

After 1782–1783, Blyth, his wife and children all disappear from the records of Salem, although his brother Samuel, a commercial artist with whom Benjamin is often confused, apparently remained active in the area. Benjamin's name appears in 1785 in the marriage records of Norfolk County Courthouse, Virginia. The next year he advertised in *The Virginia Gazette,* published in Richmond, "that he has opened a House . . . for the performance of Limning in Oil, Crayons, and Miniatures." He also sought "a Boy about 14 or 15 years old . . . as an apprentice . . ." No further record of Blyth has turned up in Virginia or elsewhere.

MATHER BROWN

Mather Brown was born at Boston in 1761, the son of a clockmaker. His mother died when he was barely two years old, and he was brought up by his aunts, Mary and Catherine Byles. From his aunt Mary and later Gilbert Stuart, Brown took his first drawing lessons. By 1777 he was professionally painting miniatures as an itinerant artist in Massachusetts and New York, while supplementing his income by selling wine. Having earned enough money, he embarked for Europe in 1780, became a pupil of Benjamin West and a student at the Royal Academy. After 1781 he regularly contributed to the academy exhibitions and was described

as portrait painter to "the Dukes of York and Cambridge." Among Brown's patrons were members of the royal family, notably the Prince of Wales who later became George IV. He also executed portraits of Thomas Paine, John Adams, and Thomas Jefferson, and designed historical works, notably the greatly praised *Marquis Cornwallis receiving as Hostages the Sons of Tippo Sahib,* which was subsequently engraved.

Financial difficulties forced Brown to give up his expensive London studio in 1809, and he spent the next thirteen years seeking commissions in various provincial English towns. During these years, he did not exhibit at the Royal Academy, although he was elected an associate in 1811. He returned to London in 1824 and died there seven years later.

WINTHROP CHANDLER

Winthrop Chandler was born near Woodstock, Connecticut, in 1747, the son of a prosperous farmer. After 1762, he was apparently apprenticed to a house and sign painter in Boston. Nothing is known of his activity until 1770 when, back in Woodstock, he executed his earliest known pictures, the powerful portraits of the Reverend Ebenezer Devotion and his wife.

Chandler painted only within the limited surroundings of Woodstock. Unlike his urban counterparts who drew their sitters primarily from the upper classes, he worked almost exclusively for the rising middle class, many of whom were his friends or related by family.

In 1775 monetary difficulties began that were to plague Chandler the rest of his life. In 1785, perhaps in search of a new market for his talents, he moved with his family to Worcester, Massachusetts. No pictures by his hand can be traced from this period. Evidence suggests he earned a living by house painting and gilding.

When Mrs. Chandler died in 1789, the children were distributed among various relatives, and Chandler moved back to Thompson Township near Woodstock, Connecticut, where he died in 1790.

At least nine landscapes and some thirty portraits, none of which are signed, have been attributed to this artist. Although restricted in numbers and location, his work had a surprisingly great influence on a succession of limners working mainly in Connecticut.

Chandler also seems to have drawn botanical illustrations, although none of these works have been found. According to the obituary in the *Worcester Spy,* he "left a manuscript that discovers that he had merit as a botanist; many plants, the growth of his native county, are . . . not only well delineated, but are accurately and botanically described."

JOHN SINGLETON COPLEY

John Singleton Copley was born in 1738, probably in Boston, the son of Mary Singleton and Richard Copley who emigrated to America from Ireland in 1736.

His father, a tobacconist, died between 1741 and 1748. In 1748 his mother married Peter Pelham, a London-trained mezzotint engraver and portrait painter who was probably Copley's only teacher. When Pelham died three years later, Copley took over his fully equipped studio and, by the age of fourteen or fifteen, produced his first mezzotint, a few portraits, and mythological subjects.

He spent the next few years in intense self-education. Through Pelham's library, he was introduced to history painting and thus developed a desire to become a painter in this grand manner. He copied prints of Old Masters and anatomical drawings.

His first portraits reflect the influence of John Smibert, the European-trained artist whose studio was only a few short blocks away. He was perhaps influenced by John Greenwood as well. By the early 1750s Copley's style showed familiarity with the work of Robert Feke, who had painted in Boston in 1748. As his pictures increased in sophistication, Copley became the most popular portrait painter of the merchant and professional classes. Around 1756–1757 he brought into his style the rococo manner of the skillful English painter Joseph Blackburn who had arrived in Boston in 1755.

Copley's first professional recognition outside of Boston came in 1766 when he exhibited at the Society of Artists (London) a portrait of his sixteen-year-old half brother, Henry Pelham, now known as *Boy with a Squirrel* (private collection). Enthusiastically greeted by Sir Joshua Reynolds and Benjamin West, this picture earned Copley election as Fellow of the Society. Thereafter he contributed works to the exhibitions of 1767, 1768, 1771, and 1772.

As a young man, Copley also worked as a miniaturist and perfected his technique in the medium of pastel.

In 1771 Copley traveled to New York on a painting trip, where he spent six highly successful and productive months. Painting commissions in the early 1770s, however, were adversely affected by the mounting political turmoil. Moreover, while personally sympathetic to the American cause, Copley found himself in the midst of an uncomfortable situation: members of his family, many of his friends and sitters were Tories.

Thus both professionally and politically it seemed timely and expedient to fulfill an early dream and go on a European study tour. He traveled to England, France, Italy, Germany, the Low Countries, studying works by the Old Masters— Raphael, Correggio, Titian, Rubens, Poussin. In Rome he became an intimate friend of the Scottish neoclassic artist Gavin Hamilton who encouraged him to attempt his first history picture, *The Ascension* (Museum of Fine Arts, Boston), which was inspired by the works of Raphael.

In October 1775, Copley settled in London and began a new career. Between 1776 and 1812, he exhibited over forty pictures at the Royal Academy. He was elected a full member in 1779 and was confirmed in 1783 after presentation of a diploma picture.

To meet the immediate needs of his family, Copley initially established his reputation as a portrait painter, his sitters drawn from the lower nobility, landed gentry, and military. It was only in 1778 with the enormously successful composition *Watson and the Shark* (illustrated here on page 63) that his fame extended

into the area of realistic history painting. He worked not in the reserved manner of neoclassicism then so admired, but in the bold, vigorous mode of Rubens.

The 1790s marked the beginning of unfortunate and difficult times for Copley. He increasingly lost influence and prestige in the Royal Academy. His history pictures of this period were not as critically triumphant as his earlier works, while portrait commissions dwindled. His last years were characterized by disillusionment, chronic economic difficulties, diminishing artistic ability, and senility. He died in London on September 9, 1815.

AMOS DOOLITTLE

(See biography of Doolittle on page 152.)

JOSEPH-SIFFRED DUPLESSIS

Joseph-Siffred Duplessis was born at Carpentras, France, in 1725. His first teacher was his father Joseph-Guillaume, a former surgeon who had taken up painting. Thereafter he studied under the Carthusian monk Joseph G. Imbert and from 1745 to 1749 under Pierre Subleyras in Rome. When he returned home, he received several important civic and portrait commissions. In 1752 he went to Paris. Twelve years later he exhibited his first work in the Academy where he became a member in 1774. By that time he was at the peak of his career. He painted innumerable portraits of the nobility and the most outstanding personalities of his day, among them Louis XVI and his queen Marie Antoinette. Losing his fortune during the French Revolution, Duplessis accepted the post of conservator of the Museum of Versailles, a position he held until his death in 1802.

ASHER BROWN DURAND

Asher Brown Durand was born in 1796 at Jefferson Village (now Maplewood), New Jersey, of French Huguenot ancestry. The son of a skilled watchmaker and craftsman, he was apprenticed from 1812 to 1817 to Peter Maverick, a noted Newark engraver. During this time, the portrait painter Samuel Waldo gave Durand rudimentary drawing lessons. In 1817 Durand and Maverick formed a partnership, but by 1820 the student had surpassed the master. Jealousy arose when their firm was awarded a commission to engrave John Trumbull's historical composition *The Declaration of Independence* (1786–c. 1797, Yale University Art Gallery), and Trumbull insisted that Durand, not Maverick, execute the engraving. The partnership was dissolved shortly thereafter. Completed in 1823, the print established Durand's reputation as the foremost engraver in America. Over the next several years he produced plates for banknote vignettes, portraits, and landscapes. For the gift books so popular at the time, he cut several plates after well-known works. His engraving after John Vanderlyn's *Ariadne* was highly acclaimed.

Encouraged by the great New York patron of American art Luman Reed,

Durand abandoned engraving in the mid-1830s and turned his attention to portraiture, genre, and history pieces. By the end of the decade, he was specializing in landscape painting. In 1840, he went abroad and studied pictures in the great galleries of England, France, Belgium, Germany, and Italy. After his return, he devoted himself exclusively to landscape. He sketched and painted views of the Hudson, the White Mountains, the Catskills, Adirondacks, and Berkshires. With his friend Thomas Cole, Durand shares the distinction of being the founder of the Hudson River school of painting. *Kindred Spirits* (1849, New York Public Library), which includes the portraits of Thomas Cole and William Cullen Bryant, is considered his best-known work in this mode. Durand's "Letters on Landscape Painting" were published in *The Crayon* during 1855 and constitute the outstanding statements concerning the theory and style of the Hudson River school.

A charter member of the National Academy of Design, Durand exhibited annually from 1826 to 1870 and served as its president from 1845 to 1861. He died in New Jersey in 1886.

JOHN DURAND

Probably of French Huguenot ancestry, John Durand was active from 1766 to 1782. His earliest known works are portraits of the six children of the Beekman family of New York City, which date from 1766. In 1767 he opened a drawing studio in New York City. While known only as a portrait painter, he harbored other ambitions as well, for the following year he advertised in the *New York Journal* that "The Subscriber having from his infancy endeavored to qualify himself in the art of historical painting, humbly hopes for that encouragement from the gentlemen and ladies of this city and province. . . ."

While he made his home in New York City, in search of commissions he often traveled to Connecticut and particularly to Virginia, where a great many portraits by him have been found. By the later 1770s, Durand disappears. A John Durand exhibited landscapes at the Royal Academy in London in 1777 and 1778, but it has not been determined whether this is the same painter. He reappears briefly in Virginia in 1781–1782.

Unlike the three-dimensional academic mode of Stuart or Trumbull, Durand's *œuvre* reflects the tradition of the naïve, self-trained artist whose flat and linear painting manner stresses surface pattern. His pictures are distinctive for their bright coloring and elegance.

RALPH EARL

Ralph Earl was born in 1751 in Shrewsbury, Massachusetts. Little is known of his life before 1774, when he married Sarah Gates. By this time he had established a studio in New Haven, where he painted his best-known and striking portrait of Roger Sherman (Yale University Art Gallery). While tradition maintains Earl accompanied Amos Doolittle to the sites of the battles of Lexington and Concord

and sketched the scenes which Doolittle transformed into his famous series of engravings, this tale has been questioned because of Earl's pro-British political persuasion. Indeed, his Tory activities soon prompted New Haven's Committee of Safety to give Earl the option of prison or banishment. Thus, having already deserted his family, he embarked for England in the spring of 1778. There he met Benjamin West and John Singleton Copley and was undoubtedly influenced by direct contact with their work and that of those exemplars of the English grand manner, Thomas Gainsborough and Sir Joshua Reynolds. He painted several portraits of the British aristocracy, most notably in Norfolk, and exhibited at the Royal Academy from 1783 to 1785.

In 1785 Earl and his second wife returned to America. He painted portraits and a few landscapes in New York City and New England. After a brief stay in debtors' prison, he spent most of his time in western Connecticut painting former Revolutionary soldiers, prominent landowners, and political figures. By the close of the century, the quality of his work declined and his clientele dwindled. He died of "intemperance" at Bolton, Connecticut, in 1801.

ROBERT FEKE

Robert Feke, the son of an affluent Baptist preacher, was born in Oyster Bay, New York, probably in 1707, as suggested recently by R. Peter Mooz. Unfortunately, there is little documentation of Feke's childhood. It is believed he left home around 1730–1731 and voyaged abroad. In a posthumous contemporary document he is referred to as a "mariner." Whether or not his journeys brought him to Europe and introduced him to European painting has not been established.

Sometime before 1742, Feke, considered the first American-born painter, must have settled in Newport, Rhode Island, for in that year he married Eleanor Cozzens, the daughter of a prominent tailor. Except for brief painting trips he lived there the rest of his life.

Between 1741 and 1745 only eight works painted by Feke have been identified. He seems to have been basically self-taught, although his ambitious *Isaac Royall and Family* places him in Boston in 1741, clearly working under the influence of the English painter John Smibert, as can be seen in a comparison with Smibert's *The Bermuda Group 1729* (1739?).

It is primarily through the evidence of his pictures that his activities for the rest of the decade can be pieced together. After 1745 he is known to have created some fifteen to twenty works annually. In 1745–1746 he journeyed to Philadelphia where he painted members of some of the most important families. In 1748 he spent at least a year in Boston producing some of his best-known works. In November 1749 he returned to Philadelphia, often commissioned by many of the same individuals whom he had painted during his first trip.

The last-known contemporary documentation of Feke places him in Newport in August 1751. No record of his death has been found. Family tradition maintains Feke died at the age of forty-four in the West Indies, where he had voyaged for reasons of health. Mooz contends Feke died 1751–1752.

BENJAMIN GREENLEAF

Benjamin Greenleaf was born in 1786 at Haverhill, Massachusetts. Of humble birth, he ordinarily would not have had the opportunity for a formal education. However, he read everything he could get his hands on and, at the age of nineteen, he began attending the academy at Atkinson, New Hampshire. In 1810, he entered the sophomore class of Dartmouth where he distinguished himself in mathematics. After graduation in 1813, he became principal of a grammar school in Haverhill. The next year, he accepted the post of preceptor of the Bradford Academy in Bradford, Massachusetts, a position he held until 1836. An innovative educator, he was among the first to give illustrated lectures in chemistry, physics, geology, and astronomy. He then served three years in the Massachusetts legislature and, from 1839 to 1848, headed the Bradford Teachers' Seminary which he had helped found. The most famous of the several textbooks he wrote was *National Arithmetic* (1836).

Greenleaf began painting in his late teens, presumably in order to help pay for his education. His earliest recorded portrait is *Cotton Tufts* (Plate 88). Dated 1804, this picture is unique in Greenleaf's *œuvre* because it is the only known work painted on canvas. All the other likenesses were fashioned in reverse on the underside of glass. Generally dating from Greenleaf's early years at the Bradford Academy, these portraits on glass, with their crisp contours, somberness of mood, and lack of superficial details, seem to reflect the spartan New England character. Greenleaf often attached a label to the back of the picture which provided his signature and information about the sitter. There is no evidence that he painted after 1825.

Greenleaf spent his last years writing textbooks, making calculations for almanacs, and in general activities in behalf of education. He died in 1864.

CHRISTIAN GULLAGER

Christian Gullager, portrait and theatrical scene painter, was born in 1759 at Copenhagen. There he studied at the Royal Academy of Arts from 1775 to 1880 when he was awarded the prize Lille Solvmedaille. Tradition maintains that with this medal he received "the privilege of traveling through Europe at the King's private expense for three years." Whether he did travel or study in Europe has not been firmly established. Sometime between 1782 and 1786 he came to New England.

Vital records in Newburyport, Massachusetts, indicate that Gullager married Mary Selman in 1786. He painted several portraits in Newburyport and Gloucester, and by 1789 he was successfully established in Boston. On November 14, 1789, *The Massachusetts Centinel* noted in a column about George Washington's recent visit that "the two best portrait painters of this metropolis," John Johnston and Christian Gullager, were to paint portraits of the general. The Gullager likeness of Washington, dated 1789, is now in the Massachusetts Historical Society.

Between 1793 and 1797 Gullager made several excursions to New York, perhaps to paint scenery for the Federal Street Theatre. In 1798 he advertised in

Philadelphia that he not only painted portraits but "on silks for military and other ornamental purposes." After 1806 he worked in New York and Charleston, South Carolina.

While reportedly a charming and dashing character, Gullager was an insufferable procrastinator, a weakness that ultimately lost him not only a great many commissions, but also his wife. After his divorce in 1809, Gullager is lost track of for several years. He reappears in Philadelphia only shortly before his death in 1826.

JOHN HESSELIUS

John Hesselius, the son of the Swedish-born painter Gustavus Hesselius, was born in 1728, most probably in Philadelphia. He undoubtedly received some early artistic training from his father, although stylistically he seems to have been more profoundly influenced by John Wollaston and Robert Feke. Richard K. Doud suggests that Hesselius may have even "traveled south in the company of Robert Feke, observing his style and working in his company through Maryland and into Virginia."

There is scant information about Hesselius's youth, other than the fact that it was probably spent in Philadelphia. His artistic activity spanned at least twenty-seven years; the earliest known signed and dated portrait is 1750, the last 1777. More than one hundred works have survived. Evidence of his pictures suggests he played the role of the itinerant limner between 1750 and 1760, traveling in Virginia, Maryland, Delaware, and possibly New Jersey. By 1761 he was well established in Anne Arundel County, Maryland, where he spent the rest of his life. On January 30, 1763, he married Mary Young Woodward, widow of Henry Woodward of Primrose Hill near Annapolis. Thereafter he seemed to divide his time among painting, religious affairs, and management of his rather extensive properties. He died on April 9, 1778, and is buried at his estate, Belle-field.

JEAN ANTOINE HOUDON

Jean Antoine Houdon was born at Versailles, France, in 1741. When his father became concierge for the *Écoles Royales des élèves protégés*—a sort of prep school for the French Academy in Rome—the young man's interest in sculpture blossomed. Houdon studied there between 1756 and 1764, principally under Michel-Ange Slodtz and was much influenced by Jean-Baptiste Lemoyne and Jean-Baptiste Pigalle. After four years in the French Academy in Rome, Houdon returned to Paris and was admitted to the Royal Academy. He submitted several plasters to the Salon and by the mid-1770s was considered one of the leading sculptors in France. Among his patrons were the French royal family, Catherine II of Russia, King Gustave III of Sweden, the Duke and Duchess of Saxe-Gotha, noblemen, ministers, statesmen, philosophers, scholars, and theatrical personalities. In 1777 he was named academician of the Royal Academy and was raised to the rank of assistant professor in 1792.

Houdon traveled to the United States in 1785 to make life studies of Washington as the basis for a full-length marble statue, now in the rotunda of the capitol in Richmond, Virginia.

During the French Revolution Houdon had financial as well as space difficulties and was forced to sell many of his sculptures. He was made a member of the Institute of France in 1796, awarded the Cross of the Legion of Honor in 1804, and the following year made a full professor in the School of Painting, Sculpture, and Architecture. Under the empire, he received official commissions from Napoleon, but produced very little sculpture after the Salon exhibition of 1814. He devoted his last days to teaching. He died in 1828.

HENRY INMAN

Henry Inman was born in 1801 in Utica, New York, where he received rudimentary drawing instruction. His latent artistic talents were recognized by John Wesley Jarvis, the portrait painter, who offered to take him on as a pupil. During his seven-year apprenticeship, Inman traveled with Jarvis from Boston to Philadelphia, to Baltimore, and to New Orleans. He generally completed the costumes and backgrounds after the master had executed the face.

About 1823, Inman established his own studio in New York where he painted portraits and miniatures of many distinguished individuals as well as an occasional landscape or genre scene. Among his pupils were Thomas Seir Cummings, with whom he formed a brief partnership, and Charles Wesley Jarvis, the son of Inman's former teacher.

Highly respected by his contemporaries, Inman was a founder of the National Academy of Design in 1826, served as its vice president until 1831, and again from 1838 until 1844, and regularly contributed to its annual exhibitions.

In 1831, Inman moved to Philadelphia and became a director of the Pennsylvania Academy and a partner with Cephas G. Childs, a lithographer. Inman worked very little in this medium, but many of his oil portraits were lithographed by Albert Newsam and other members of the firm.

Despite his considerable success in Philadelphia, Inman returned to New York three years later, where he became even more popular than during his first New York period. In 1844 he was commissioned to go to England and execute the portraits of *William Wordsworth* (University of Pennsylvania) and *Thomas B. Macaulay* (Pennsylvania Academy of the Fine Arts). He died at New York in 1848, only a few months after his return.

While Inman's flattering portraits were the mainstay of his livelihood, he deplored the restricted range of subject matter available to American artists. "I tell you sir," he once said to the critic Charles E. Lester, "the business of a few generations of artists in this country, as in all others, is to prepare the way for their successors; for the time will come when the rage for portraits will give way to a higher and purer taste."

JOHN WESLEY JARVIS

John Wesley Jarvis was born in England in 1780 and was brought to Philadelphia during 1785. In his youth he frequented the studio of Matthew Pratt who had once studied with Benjamin West in London. From 1796 to 1801, Jarvis was apprenticed to the painter and engraver Edward Savage.

Jarvis began his professional career as an engraver in New York around 1802, probably initially cutting plates for commercial purposes. Later he executed several mezzotint engravings. The art market being wide open in New York, he seized the opportunity to paint portraits. From about 1803 to 1810, he was in partnership with Joseph Wood. They advertised that they not only executed miniatures, portraits, and physionotrace likenesses, but taught drawing as well.

Known as a wit and raconteur, Jarvis soon became one of America's leading portrait painters. He was particularly popular with the wealthy and influential members of New York society. In the winters, he traveled south and secured important commissions in Washington, D.C., Richmond, Charleston, and New Orleans. Among his most celebrated sitters were Andrew Jackson and Washington Irving. For the City of New York (City Hall), Jarvis painted a remarkable series of full-length portraits of the military and naval heroes of the War of 1812. In 1814, he took on as apprentices Henry Inman and later John Quidor.

Jarvis was represented at various exhibitions of the Pennsylvania Academy, where he was one of the first academicians. He also showed at New York's American Academy of Arts and at the National Academy of Design.

After 1823, commissions dwindled in New York, and Jarvis traveled all over the south in search of work. He spent most of his time in Virginia and Tennessee. A paralytic stroke in 1834 suddenly ended his professional career. He returned to New York where he died in 1840.

MATTHEW HARRIS JOUETT

Matthew Harris Jouett was born near Harrodsburg, Kentucky, in either 1787 or 1788. Educated at Transylvania University, he briefly dabbled at law before enlisting in the United States infantry at the outbreak of the War of 1812. During his service, he made several sketches of prominent military figures, which he later executed in oil.

After his resignation in January 1815, Jouett turned his full attention to painting. His father lamented, "I sent Matthew to college to make a gentleman of him, and he has turned out to be a damned sign painter."

In 1816, Jouett journeyed to Boston, where from July to October he studied under Gilbert Stuart, who affectionately called him "Kentucky." Jouett's "Notes Taken while in Boston from Conversations on painting with Gilbert Stuart" constitute the most complete and comprehensive statement that exists of Stuart's theory and practice of portrait painting.

John Hill Morgan points out that most of Jouett's bust-length pictures were

"good" but when he "became more ambitious in his composition or attempted to paint hands . . . his lack of full instruction is apparent." He "was at his best when delineating children. . . . He seems to have caught the very spirit and charm of youth. . . . With the possible exception of Frothingham, no pupil absorbed more from Stuart than did Jouett . . ."

Having studied under the "great master," Jouett doubled his prices when he returned to Lexington, Kentucky. J. R. Lambdin noted that "His [Jouett's] well stored mind—his astonishing powers of conversation and companionable disposition, caused his society to be constantly courted, and gave him an amount of employment never enjoyed by any other artist in the west."

During the latter part of his life he corresponded with, and visited in Philadelphia, Thomas Sully, whose romanticized works influenced Jouett's own style.

Jouett painted prominent Kentucky politicians and members of the local aristocracy, many of whom became warm personal friends. He also sought commissions in New Orleans and in towns along the Mississippi River where he often wintered between 1817 and 1827.

Jouett is known to have produced upward of three portraits a week. While none of his paintings were signed, over five hundred works have been attributed to him. He died near Lexington in 1827.

SAMUEL FINLEY BREESE MORSE

Samuel Finley Breese Morse was born in Charlestown, Massachusetts, in 1791, the son of a leading Congregational minister. While attending Yale from 1805 to 1810, he established a local reputation for his ability to draw profiles and miniature portraits on ivory. After graduation, he briefly worked as a clerk in a bookstore, but continued painting. His *Landing of the Pilgrims at Plymouth* won the praise of Washington Allston and Gilbert Stuart and finally persuaded his otherwise reluctant parents to allow him to study abroad.

In July 1811, Morse sailed for England and spent the next four years studying under Allston and Benjamin West. In 1812 he received a Gold Medal from the Society of Arts for his terracotta statuette of *Hercules* (Yale University Art Gallery), modeled as a preparatory study for *The Dying Hercules* (illustrated here on page 65) which, exhibited at the Royal Academy in 1813, received critical acclaim.

In 1815 Morse returned to America and opened a studio in Boston where he hoped to pursue a career in history painting. His *The Dying Hercules* and *The Judgment of Jupiter* received some praise, but no one offered to buy them or commission similar works. American taste in art was still geared to the portrait. Disheartened, Morse reluctantly turned to portrait painting. Unable to compete with Gilbert Stuart's popularity in Boston, he spent the next several years traveling through New England as an itinerant painter. From 1818 to 1821 he wintered in Charleston, South Carolina, where he was an immediate success.

Around this time he created his ambitious *The Old House of Representatives* (1822, Corcoran Gallery of Art) which he hoped would earn him some extra money through lucrative public exhibitions while simultaneously spreading his fame as an artist. It was not a popular success, however, and the scheme failed.

Thereafter Morse settled in New York where, within the next four or five years, his artistic abilities blossomed. One of his best-known portraits of this period is the dramatic full-length *Lafayette* (1825, City Hall, New York), which was so successful that Morse was soon considered one of the leading artists in New York. In 1826 he was one of the founders of the National Academy of Design and became its first president.

From 1829 to 1832 Morse traveled in London, France, and Italy copying the Old Masters. When he returned to New York, he devoted more and more time to electrical experiments—an interest he had held since his university days—which led, in 1839, to his invention of the telegraph. That year he also introduced the daguerreotype process to America. By this time he had completely abandoned painting, although he maintained an active interest in art: he remained president of the National Academy until 1842 and again accepted a one-year term in 1861.

While his artistic career has been eclipsed by his fame as an inventor, Morse was a major artist during the first quarter of the nineteenth century and produced hundreds of highly successful portraits, several historical compositions, and a few landscapes.

REUBEN MOULTHROP

Reuben Moulthrop was born in 1763. Nothing is known of his youth or artistic training. He was primarily celebrated as a wax modeler of portraits and of such pieces as "David going forth against Goliath . . ." Works of this type, none of which is known to have survived, were exhibited throughout Massachusetts, New York, and Pennsylvania, in a kind of traveling waxworks museum.

Moulthrop's painting activity was confined to Connecticut. Beginning in 1788, it spanned a period of over twenty years. Yet only forty works have been attributed to him. His sitters were drawn primarily from the local clergy. The earliest works reflect the influence of Winthrop Chandler. His later works also reflect the influence of Joseph Steward and Ralph Earl. He died at East Haven in 1814.

CHARLES WILLSON PEALE

Charles Willson Peale, born in 1741 at St. Paul's Parish, Maryland, was the son of a schoolmaster. Peale grew up in Chestertown and Annapolis where he received a rudimentary education. At the age of thirteen, he was apprenticed to a saddler and soon expanded his activities to include upholstery, harnessmaking, and silversmithing. In the early 1760s he took a business trip to Norfolk, Virginia, and there encountered his first landscapes and portraits. Although crude, these pictures inspired him to attempt painting. As was his habit, he taught himself by trial and error, trying first a self-portrait, then likenesses of various friends and members of his family. So successful was he that he decided to devote himself to painting rather than his other trades.

On a visit to Philadelphia, Peale met a few artists and acquired Robert Dossie's two-volume treatise *The Handmaid of the Arts* (1758). Subsequently, in exchange

for a saddle he received instruction from John Hesselius. He may also have been influenced by John Wollaston who was in Maryland and Virginia from 1753 to 1757.

The first dated record of Peale as a painter appeared in his advertisement in the *Maryland Gazette* of April 17, 1763. In 1765 he happened on John Smibert's old studio in Boston and later visited John Singleton Copley whose works had a profound effect on his subsequent style.

The following year a group of Maryland gentlemen raised enough money to send the aspiring artist to London, where he lived from January 1767 to March 1769. Peale studied under Benjamin West, who introduced him to the Italian masters, but he also acquired technique in engraving, sculpting, and, in particular, miniature painting. He exhibited in the Society of Artists and was elected a member.

He returned to Annapolis in 1769 and until 1775 was an itinerant painter, making annual visits to Philadelphia where he finally settled in 1776, the same year he joined the Continental Army.

In 1794 he was instrumental in founding the "Columbianum," which, although short-lived, was the first American art academy. It sponsored the first public artists' exhibits ever held in America.

Long-lived, Peale had over sixty years of artistic production. Over a thousand pictures by his hand have been recorded. The subjects include politicians, soldiers, statesmen, merchants, lawyers, women, and children.

In his last years, Peale devoted most of his colossal energy to various inventions, although he still found time to paint occasionally. In 1805 he was one of the founders of the Pennsylvania Academy of the Fine Arts. He fathered many children, several of whom were named after famous artists and pursued the artistic profession of their father. Peale died in Philadelphia in 1827.

JAMES PEALE

Born at Chestertown, Maryland, in 1749, James Peale spent his youth in Annapolis. Like his older brother Charles Willson he too was trained as a saddler. He later took up carpentry and after 1770 made frames for Charles Willson who taught him oil and watercolor painting. Having completed his service in the Revolutionary War, James went to Philadelphia where he specialized in miniatures, although he also painted some portraits, historical subjects, and landscapes. He created two miniature portraits from life of Washington.

At first his style was virtually indistinguishable from Charles's, several of whose portraits he copied. After 1795 his style developed in a more individual direction, often more romantic and lyrical than his brother's. By 1818, his eyesight failing, he abandoned miniature painting and specialized in still life. It is estimated he produced about 100 works in this mode, but so far only about thirty-five have been located. James is best known for establishing—along with his nephew Raphaelle—the American tradition of still life painting that was to last virtually into the twentieth century.

James's life was closely linked with that of his brother. He helped Charles in a variety of activities in connection with the museum of natural history and Revolutionary War heroes. He died in Philadelphia in 1831.

REMBRANDT PEALE

Rembrandt Peale was born in Bucks County, Pennsylvania, in 1778, the son of Charles Willson Peale who gave him his initial artistic training. In 1795 Rembrandt exhibited in the short-lived Columbianum, America's first art academy, and also produced the first of his many portraits of Washington. The next year was spent in Charleston, South Carolina, where he painted portraits for his father's gallery of Revolutionary War heroes. Subsequently, with his brother Raphaelle, Rembrandt founded a museum in Baltimore. In 1801, he took abroad on an exhibition tour one of the mastodons he had helped his father excavate. In London, he briefly studied under Benjamin West and attended classes at the Royal Academy, where he exhibited two portraits.

Upon his return to Philadelphia in 1803, Rembrandt executed likenesses of several prominent figures, the most celebrated one being *Thomas Jefferson* (1805, New-York Historical Society). In search of commissions, he spent the next few years in New York and Boston.

From 1809 to 1810, Rembrandt was in Paris painting portraits for his father's museum. He was offered a place among Napoleon's court painters, but, fearing the political situation, he chose instead to return to the United States. Having come under the influence of French neoclassicism and historical painting, he painted an equestrian portrait of Napoleon which became a major attraction in the artist's Picture Gallery in Philadelphia, which opened in 1811. He also produced two major historical works, *The Roman Daughter* (1812, Peale Museum, Baltimore) and the popular *Court of Death* (1820, The Detroit Institute of Arts).

By 1825 he had settled in New York and succeeded John Trumbull as president of the American Academy of Fine Arts. Between 1828 and 1834, Rembrandt traveled again in Europe and England, painting portraits and copying the Old Masters. He spent his last years in Philadelphia, producing his well-known porthole portraits of Washington and delivering lectures, illustrated with his paintings, about likenesses of Washington. He died in 1860.

CHARLES-BALTHAZAR-JULIEN FÉVRET DE SAINT-MÉMIN

Charles-Balthazar-Julien Févret de Saint-Mémin was born at Dijon, France, in 1770 of a family of lesser French nobility. After receiving a Jesuit education, he briefly served in one of the most famous regiments in France—the Gardes Françaises, part of the household troops of Louis XVI. As a member of the French aristocracy, however, Saint-Mémin was soon forced to flee France during the Revolution. He settled in New York in 1793 where he found his education and background were of little practical use. Since as a child he had dabbled at drawing, he began sketching various views of New York. When they were greeted with praise, he decided to make engravings for commercial purposes. Soon he had completed panoramas, maps, and a series of aquatints representing architectural designs.

Profile portraits were the latest fashion trend, and being mechanically inclined, Saint-Mémin found an easy way to produce likenesses in this mode. Using as a model the profile-drawing machine invented by Gilles-Louis Chrétien about

1787, Saint-Mémin built a physionotrace, an unwieldy instrument that permitted him to transfer mechanically a life-size image onto a sheet of buff-colored paper. Then, free hand, he finished the features and costume in black crayon, heightened with white. With the aid of another device, the pantograph, he reduced the likeness to a miniature size for the purpose of engraving.

Although using basically a mechanical method of drawing, Saint-Mémin did achieve remarkable individuality of character. Between 1796 and 1810 he produced over eight hundred profile portraits, which represent the most distinguished Americans of his day. Among his best-known works are the watercolor and crayon likenesses of the Osage Indians of the Missouri River area, executed in Washington, D.C., and New York in 1804.

In 1798, the yellow fever epidemic encouraged Saint-Mémin to move out of New York. He settled in Burlington, New Jersey, and from there made numerous excursions to Philadelphia, Baltimore, Washington, D.C., Virginia, and South Carolina. Because his eyesight began failing after a two-year sojourn (1810–1812) in France, he returned to the United States and commenced painting portraits and landscapes in oil.

Napoleon's abdication allowed Saint-Mémin and his family finally to return to their homeland. Just before his departure in October 1814, the self-trained artist of noble birth expressed his contempt for the arduous means he had to use in order to earn a livelihood in America. In a dramatic and hysterical moment he allegedly "seized the physionotrace and broke it into bits as though the wooden framework had been the cause of all his woes."

Saint-Mémin spent the remainder of his life in Dijon, where, as director of the local museum, he enjoyed his happiest days. He died in 1832.

HENRY SARGENT

Henry Sargent was born in 1770 at Gloucester, Massachusetts, the son of a prosperous merchant. Toward the middle of the Revolution, Sargent moved with his family to Boston where he continued his education under local tutors. He spent a brief period as an apprentice in his father's mercantile house and then, with no previous training, decided to pursue an artistic career. By 1790, he was copying mezzotints and creating portraits. When John Trumbull saw some of Sargent's work, he encouraged the young man to study abroad.

In 1793 Sargent left for London, where he studied for four years under Benjamin West and at the Royal Academy. Upon his return to Boston, Sargent tried in vain to establish a successful painting practice. Finally, in desperation, he accepted a commission in the army. After serving in the War of 1812, he was for several years a member of the State Senate.

In the meantime he had become the intimate friend of the portrait painter Gilbert Stuart. Although Sargent apparently never studied under the master, John Hill Morgan (1939) suggests that "at least he must have absorbed much from Stuart's conversation and advice." Indeed, when Stuart refused to teach his son Charles how to paint, Charles sought advice from Sargent who presumably passed on some of Stuart's principles. Sargent's best-known work of this period is the

Landing of the Pilgrims (c. 1813, Pilgrim Hall, Plymouth, Massachusetts).

By 1817, incipient deafness caused Sargent gradually to withdraw from public service and devote more time to painting and mechanical inventions. His charming genre scenes, the *Dinner Party* and the *Tea Party* of c. 1820–1825 (Museum of Fine Arts, Boston) represent early examples of a new type of subject matter in American art.

Sargent was made an honorary member of the National Academy in 1840. The year he died, 1845, he was elected president of the Artist's Association of Boston.

JOSEPH STEWARD

Joseph Steward was born at Upton, Massachusetts, in 1753. After graduating from Dartmouth College, he entered the ministry, but illness soon forced him to give it up. Little is known about his early artistic career or training. H. W. French (*Art and Artists in Connecticut*, Boston, 1879) stated that Steward was painting in New Haven when barely "twenty years old." But his earliest recorded picture is the full-length portrait of *John Phillips* which was commissioned in 1793 by the trustees of Dartmouth College. Steward must certainly have been painting before this date since it seems unlikely that such an important commission would have been given to an inexperienced artist of meager reputation.

In June 1796, Steward announced in the *Connecticut Courant* that he had opened a studio in the State House at Hartford and was available for portrait commissions. The next year, he converted his room into the Hartford Museum for "repositing . . . paintings and natural curiosities." By 1840, when the collection was finally dispersed, several thousand articles had been accumulated.

The bulk of Steward's works appears to have been produced between 1793 and 1815. In addition to likenesses taken from life, he was also an accomplished copyist. Among works attributed to him are copies of engravings, sculpted busts, and seventeenth-century portraits of William Penn and Gurdon Saltonstall. He also copied canvases by Ralph Earl, who surely influenced his style.

Dunlap, who considered Steward's portraits "wretched," claimed the clergyman was Samuel Waldo's first instructor.

During his latter years, Steward did occasional preaching, usually filling in for various friends in the clergy. He died in 1822 after a prolonged illness.

GILBERT STUART

Gilbert Stuart was born in 1755 near Newport, Rhode Island, where he spent his youth. The son of a Scottish-born millwright and snuff manufacturer, he displayed an early talent for drawing and is said to have copied prints at the age of thirteen. Aged fourteen, in exchange for drawing lessons, Stuart became the assistant of Cosmo Alexander, a mediocre Scottish portrait painter. In 1772 Stuart accompanied his teacher to Edinburgh. Alexander's death left the young student impoverished. After a great deal of difficulty, he made his way back to Newport, where he began his career as a professional portrait painter. With the advent of

282

the Revolution, portrait commissions diminished and Stuart set sail for London.

After a considerable hardship he became a pupil of Benjamin West. From 1777 to 1782 he lived with West and worked on parts of the master's historical compositions and portraits. During this time he contributed to the Royal Academy and visited English collections to study the Old Masters and contemporary English portraiture. After winning critical acclaim in 1782 with his portrait of William Grant, *The Skater* (illustrated here on page 60) he became one of London's leading portrait painters. His commissions were primarily drawn from the professional segment of the upper middle class. The likenesses, reflecting English portraiture in compositional devices, were appreciated for their truthfulness and dignity.

Stuart, notoriously extravagant and eccentric, was hopelessly in debt by 1787 and therefore decided to accept the Duke of Rutland's invitation to paint in Dublin. Although the duke died before he arrived, Stuart nevertheless remained for five years, relying on the Irish nobility and gentry for commissions.

Sometime in the winter of 1792–1793, again harassed by creditors, Stuart returned to America. He painted the leading members of the social, political and mercantile classes in New York (1793–1794), in Philadelphia (1794–1803), in Washington (1803–1805) and in Boston where he settled in 1805.

Stuart never held formal classes but, as one of the most esteemed artists of his day, he was sought out by many younger painters for advice. Among them were John Trumbull, Thomas Sully, Ezra Ames, Samuel F. B. Morse, and Matthew Jouett. His last years were characterized by continuing financial difficulties and poor health. Stuart died in 1828 in Boston.

THOMAS SULLY

Born at Horncastle, England, in 1783, Thomas Sully was brought to Charleston, South Carolina, in 1792 by his parents Matthew and Sarah Sully, both of whom were actors. Young Sully was introduced to the "rudiments of Art" by his schoolmate Charles Fraser, who was to become a well-known miniaturist. Later Sully received lessons from his older brother Lawrence, also a miniature painter, and briefly from his brother-in-law Jean Belzons, a theatrical scene painter and miniaturist.

In 1801, Sully painted his first miniature from life, a likeness of his brother. About this time he began to record his works in a so-called "Register," a listing of the sitter's name, the dimensions of the canvas, the dates begun and finished, the price, and sometimes a brief comment. Until 1803, when his brother died, Thomas lived and worked with Lawrence in Richmond and Norfolk. In 1805 Thomas married his brother's widow and, at the suggestion of the distinguished actor Thomas Abthorpe Cooper, moved to New York City where he painted some seventy works. Passing through Hartford, Sully went on to Boston where he met Gilbert Stuart, who allowed the young artist to watch the master paint and offered some constructive criticism. In 1808 Sully settled in Philadelphia where he remained the rest of his life.

Under the sponsorship of six friends, he spent the next year (1809–1810) in London. There he visited the studio of the aged Benjamin West and was greatly

influenced by Britain's leading portrait painter Sir Thomas Lawrence, who introduced him to many important individuals, a number of whom became his sitters. Indeed, Sully has been called "the Lawrence of America."

Returning to Philadelphia in 1810, Sully was soon established as a highly successful artist. From his studio and gallery in Philosophical Hall, he produced a large number of portraits and a few important historical compositions such as *Washington at the Passage of the Delaware* (1819, Museum of Fine Arts, Boston).

With Charles Willson Peale's death in 1827 and Gilbert Stuart's in 1828, there were no artistic serious rivals left to Sully. He was at the height of his career. For the second time, he visited England in 1838 and was commissioned by the Society of the Sons of St. George in Philadelphia to paint a portrait of *Queen Victoria* (private collection; sketch, Metropolitan Museum of Art, New York). While there, he was patronized by several other distinguished individuals.

Over two thousand portraits and some four hundred subject pieces are recorded by this prolific artist. Sully was at his best depicting graceful and elegant women and children in a somewhat idealized and romantic manner. "Resemblance in a portrait," he believed, "is essential, but no fault will be found with the artist —at least by the sitter—if he improves the appearance."

Sully was a frequent contributor to exhibitions held at the Pennsylvania Academy of the Fine Arts, the Boston Athenaeum and the National Academy of Design. His *Hints to Young Painters and the Process of Portrait Painting* was posthumously published in 1873. Many of his children became artists like their father. Sully died in 1872.

JEREMIAH THEUS

Jeremiah Theus was born in 1716 in Chur, Switzerland, and emigrated with his family and numerous other Swiss to Orangeburgh Township, South Carolina, around 1735. His early artistic training remains a mystery. He is first mentioned as a limner in the *South-Carolina Gazette* of September 6, 1740, where he advertised that at his new shop "Gentlemen and Ladies may have their Pictures drawn, likewise Landskips of all sizes, crests and Coats of Arms for Coaches or Chaises . . ." Described as the "Limner of Charles Town," Theus dominated South Carolina aristocratic portraiture for over thirty years. Almost two hundred portraits and a few miniatures have so far been attributed to him, but no landscapes have yet been found. He was active in a variety of business, social, and political organizations in Charleston. He died in 1774, leaving a substantial estate.

JOHN TRUMBULL

John Trumbull was born at Lebanon, Connecticut, in 1756, the youngest son of Governor Jonathan Trumbull. He showed an early ability to draw, but his father refused to allow him to study with John Singleton Copley and sent him to Harvard instead. Initially self-taught, he was influenced by Copley's painting style,

Piranesi's prints of imperial Rome, and Hogarth's book *Analysis of Beauty* (London 1753). After graduating (1773), he taught school and painted his first historical compositions.

From 1775 to 1777 he served in the Continental Army, first as a sort of aide-de-camp to General Spencer and then briefly as Washington's aide. Later, as a major of a brigade, he participated in action at Dorchester Heights and witnessed the British evacuation of Boston. In June 1776 he became deputy adjutant general with the rank of colonel and then served in the Northern Campaign against Burgoyne. The following February he finally received his signed commission from Congress, but returned it within an hour because it was dated three months late.

After his resignation, Trumbull briefly occupied John Smibert's old studio in Boston, copying his copies of Italian masters. During the 1780s he studied in London under Benjamin West and attended classes at the Royal Academy.

In 1786 he began his well-known "national history" series, as he called it, a pictorial record of important scenes of the Revolution. Small in format, they were meant to be engraved to "preserve and diffuse the memory of the noblest . . . actions . . . in the history of many; to give the present and the future sons of oppression and misfortune, such glorious lessons of their rights." The next year he was in Paris trying to secure "proper engravers" for his series and there met David, Mme Vigée-LeBrun, and other French artists who, along with Rubens and West, greatly influenced his painting style. From 1789 to 1794 he traveled along the eastern seaboard promoting the sale of subscriptions for his engravings, while collecting portraits of American generals and political figures and studies of the terrain of the battlefields for his historical compositions.

Despondent because of lack of success in selling subscriptions, he temporarily abandoned painting. Between 1794 and 1804, he served as John Jay's secretary on a diplomatic mission to Great Britain, speculated in Old Master paintings, and later was a fifth commissioner in London to oversee the execution of an article of the Jay Treaty.

In 1804 he resumed painting first in New York and then London, but his skill had greatly diminished. By 1816 he was back in New York and appointed director of the American Academy of Art. Through political connections, he was commissioned to paint enlarged versions of his Revolutionary War battle scenes to decorate the capitol rotunda in Washington. Thereafter he painted few pictures and was plagued by financial difficulties.

He published his *Autobiography* (1841) and died at New York in 1843.

Trumbull was also an amateur architect. Among the realized projects were the Congregational Church in Lebanon (1804–1806) and the Trumbull Gallery on the Old Yale campus (1830–1831).

JOHN VANDERLYN

John Vanderlyn, painter of portraits, historical subjects, and landscapes, was born at Kingston, New York, in 1775, the grandson of the naïve limner and house painter Pieter Vanderlyn. His earliest works—wash drawings after Dutch landscape prints and copies after LeBrun's studies of human expression—displayed

such artistic ability that his parents sent him to New York in 1792 to work for Thomas Barrow, the proprietor of an artists' supply shop. Under the sponsorship of a generous merchant, John Pintard, Vanderlyn attended the fashionable drawing school of Archibald Robertson, a minor Scottish artist who had studied at the Royal Academy. At the same time, Vanderlyn copied Gilbert Stuart's portrait of Aaron Burr. Burr found out about it, recognized the talent of this budding young artist, and offered to be his patron. Burr first arranged for him to study in the Philadelphia studio of Gilbert Stuart (1795–1796) and later in Paris (1796–1800), under François André Vincent from whom Vanderlyn absorbed the linear and sculptural style of the French neoclassic school.

For financial reasons Vanderlyn returned briefly to New York in 1801. There he painted several portraits and began two views of Niagara Falls, which he hoped to have engraved in Europe so that he could sell subscriptions.

He returned to Europe in 1803 and spent most of his time in Paris. Like most American artists who studied abroad, his main interest had become historical, not portrait painting. His first important work in this genre was *The Death of Jane McCrea* (1804, Wadsworth Atheneum). Thereafter he rejected American subject matter.

From 1805 to 1807 Vanderlyn, accompanied by Washington Allston, was in Rome. During this time he executed the neoclassical composition *Marius Among the Ruins of Carthage* (1807, M. H. DeYoung Memorial Museum). Exhibited in the French Salon of 1808, it was awarded Napoleon's Gold Medal. His greatest masterpiece, however, is generally considered *Ariadne Asleep on the Isle of Naxos* (1814, Pennsylvania Academy of the Fine Arts), the first important American nude.

After his return to New York in 1816, he began working on the monumental panorama of the *Palace and Gardens of Versailles* (Metropolitan Museum of Art). Intended to capitalize on Americans' curiosity about Europe, it was installed in The Rotunda in New York City which Vanderlyn had built in the hopes of beginning a great national gallery to upgrade the artistic taste of the general public. Amid a lukewarm reception, the whole scheme proved a financial disaster.

In the meantime, Vanderlyn began receiving prestigious portrait commissions from such prominent figures as Andrew Jackson, James Madison, and James Monroe. Nevertheless, perhaps because of his continuing friendship with the unpopular Burr, his success was limited.

Vanderlyn's last years were characterized by disappointments and grave financial difficulties. He finally returned to his hometown where he died in poverty in 1852.

BENJAMIN WEST

Benjamin West, the youngest of ten children, was born in Springfield Township near Philadelphia, in 1738, the son of a former tinsmith. According to his friend and biographer John Galt, West received his first colors from the Indians and sketched his first picture at the age of six. By his eighth or ninth year, his naïve renderings of birds and flowers brought him to the attention of Edward Pennington, a wealthy Philadelphia merchant. Pennington may have provided him with his

earliest artist's supplies as well as six engravings, probably by Hubert-François Gravelot. While visiting his sponsor in Philadelphia, West met the man considered his first teacher—the itinerant English painter William Williams. Williams introduced him to the writings on painting by Jonathan Richardson and Alphonse du Fresnoy which expounded neoclassic values in art.

By 1756 West was working as a successful portrait and sign painter in Philadelphia. After a brief painting trip to New York, he embarked for Italy in 1759. In Rome, he was influenced by the classicizing idiom of the German Anton Raffael Mengs, whose ideas were based on the German theoretician of arts of classical antiquity Johann Winckelmann. Studying the antique and Raphael in particular, he also visited Florence, Venice, Bologna, and finally made a brief and ungratifying sojourn to Paris. En route to America in 1763, he scheduled what was intended to be a short stop in England, but he was so successful in London that he never returned to his native land.

The classical subject and composition of *Agrippina Landing at Brundisium with the Ashes of Germanicus* of 1768 (illustrated on page 44) created a sensation in London and brought him to the attention of King George III. He was appointed charter member of the Royal Academy founded in 1768 and historical painter to the king in 1772. One of his most celebrated pictures is *Death of General Wolfe* of 1770 (illustrated on page 44). In contemporary costume, the scene realistically represents a current national event which is elevated to heroic stature by basing the composition on Old Master formulas and using lofty gestures and expressions. In 1792 West succeeded Sir Joshua Reynolds as the president of the Royal Academy, a position he held, with the exception of one year, until his death.

West was the first American artist to achieve international recognition and, naturally, American students flocked to his studio: among the most familiar were Gilbert Stuart, John Trumbull, Ralph Earl, John Singleton Copley, Charles Willson Peale.

West died on March 11, 1820, in his eighty-second year. He was buried with great ceremony in St. Paul's Cathedral, London.

WILLIAM WILLIAMS

William Williams was born in June 1727 in Bristol, England. His father was probably a seaman. A painter of portraits, conversation pieces, and symbolic landscapes, Williams is also credited with creating one of the earliest known American novels, *The Journal of Penrose, Seaman.* It is this basically autobiographical but fictional narrative in the *Robinson Crusoe* tradition that supplies the main details of Williams's career.

Williams attended the local grammar school in Bristol, receiving what little artistic training he could from an unknown artist whom he often visited. At an early age he went to sea, traveled to Virginia twice, was shipwrecked on the Moskito Coast of Nicaragua, where he spent two years with the Rama Indians, and finally, by the age of twenty in 1747, was established in Philadelphia, painting and giving instruction in drawing and music to "Polite Youth." It was at this time that he met Benjamin West and is thus considered West's first teacher.

In 1760–1761 Williams traveled to Jamaica, where he reportedly had a successful painting trip. He is known as America's first theatrical scene painter; he also painted and ornamented ships. In 1769 he established a shop in New York City, where he undertook painting in general, sign painting, lettering, restoration, and so on. While reliable records indicate he must have produced some 240 pictures in the American colonies and West Indies, only about a dozen have been firmly attributed to him.

Despondent because of the death of his second wife and the subsequent loss of his two sons who were fighting for the American cause during the Revolution, Williams went back to England in 1776. After several unsuccessful artistic ventures, he returned to Bristol and in 1786 entered the Merchants' and Sailors' Almshouse. He died there in his sixty-fourth year on April 27, 1791.

JOSEPH WRIGHT

Joseph Wright, portrait painter, modeler in clay and wax, medalist, die sinker, and etcher, was born at Bordentown, New Jersey, in 1756. His first teacher was his mother Patience Lovell Wright, the noted modeler of profile likenesses in wax. A friend of Benjamin Franklin, she was a purported spy for the Americans during the Revolution. After the death of her husband in 1769, Mrs. Wright moved to New York City where she opened a waxworks. Three years later she moved to London, the children joining her later. There Joseph studied painting under his brother-in-law, the portrait painter John Hoppner, and Benjamin West. In 1780, he exhibited at the Royal Academy a likeness of his mother modeling a wax head.

On a brief trip to Paris the next year, he executed a portrait of Benjamin Franklin based on the well-known pastel portrait by Duplessis, executed in 1778 and in the possession of the statesman. From a slightly altered version he made several copies.

Wright returned to America in 1782, carrying a letter of introduction from Franklin to Washington. He painted General and Mrs. Washington's portrait in 1783 at Rocky Hill near Princeton, New Jersey, and later, in various media, produced several likenesses. From 1783 to 1786 he was in Philadelphia and thereafter in New York City until 1790.

On the founding of the United States mint in Philadelphia, Wright was appointed its first designer and die sinker. His design for the cent of 1792, containing a profile of Washington, was rejected. Wright spent his last years in Philadelphia where he died in 1793, a victim of the yellow fever epidemic.

Selected Bibliography

Abbreviated citations have been used under the bibliographies by artist when the complete citation is listed under general sources. Page numbers are cited in all references to periodicals, but not for books that have indexes. The reader should note that the only complete index to Dunlap's invaluable *History* will be found in the 1969 edition.

General Sources

American Paintings at the Museum of Fine Arts, Boston, 2 vols. Greenwich, Connecticut, 1970.

Art Index . . . , Vol. I. New York, 1929–

Baigell, Matthew. *A History of American Painting.* New York, 1971.

Barker, Virgil. *American Painting: History and Interpretation.* New York, 1950.

Bayley, Frank W. *Five Colonial Artists of New England: Joseph Badger, Joseph Blackburn, John Singleton Copley, Robert Feke, John Smibert.* Boston, 1929.

Belknap, Waldron Phoenix, Jr. *American Colonial Painting: Materials for a History,* Charles Coleman Sellers, ed. Cambridge, Massachusetts, 1959.

Bénézit, Emmanuel, ed. *Dictionnaire Critique et Documentaire des Peintres, Sculpteurs, Dessinateurs et Graveurs.* Paris, 1911–23.

Bizardel, Yvon. *American Painters In Paris,* trans. Richard Howard. New York, 1960.

Black, Mary, and Jean Lipman. *American Folk Painting*. New York, 1966.

Bolton, Theodore. *Early American Portrait Draughtsmen in Crayons*. New York, 1923.

The Britannica Encyclopedia of American Art, Milton Rugoff and others, eds. Chicago, 1973.

Burroughs, Alan. *Limners and Likenesses: Three Centuries of American Painting*. Cambridge, Massachusetts, 1936.

Catalogue of American Portraits in The New-York Historical Society, 2 vols. New Haven and London, 1974.

Cowdrey, Mary Bartlett, ed. *American Academy of Fine Arts and American Art Union, 1816–1852*, 2 vols. New York, 1953.

Dickson, Harold E. *Arts of the Young Republic: The Age of William Dunlap*. Chapel Hill, North Carolina, 1968.

Dictionary of American Biography (DAB), Allen Johnson and Dumas Malone, eds. New York, 1928–64.

Dow, George Francis. *The Arts and Crafts in New England, 1704–1775*. Topsfield, Massachusetts, 1927.

[Dunlap, William.] *Diary of William Dunlap (1766–1839), the Memoirs of a Dramatist, Theatrical Manager, Painter, Critic, Novelist & Historian*, Dorothy C. Barck, ed. New York, 1930.

———. *History of the Rise and Progress of the Arts of Design in the United States*, 2 vols. New York, 1834. New edition, Frank W. Bayley and Charles E. Goodspeed, eds., 3 vols. Boston, 1918. Rev. enl. edition, Alexander Wyckoff, ed., preface by William P. Campbell, 3 vols. New York, 1965. Reprinted with introduction by James Thomas Flexner, Rita Weiss, ed., 3 vols. New York, 1969.

Eliot, Alexander. *Three Hundred Years of American Painting*. New York, 1957.

Fielding, Mantle. *Dictionary of American Painters, Sculptors, and Engravers*. Philadelphia, 1926.

Flexner, James Thomas. *America's Old Masters: First Artists of the New World*. New York, 1939. Reprinted with additions, New York, 1967.

———. *First Flowers of Our Wilderness*. Boston, 1947. Reprinted with additions, New York, 1969.

———. *The Light of Distant Skies*. New York, 1954. Reprinted with additions, New York, 1969.

———. *The Pocket History of American Painting*. New York, 1950.

Frick Art Reference Library. New York.

Gardner, Albert Ten Eyck, and Stuart P. Feld. *American Paintings: A Catalogue of the Collection of the Metropolitan Museum of Art, 1, Painters Born by 1815*. New York, 1965.

Gerdts, William H. *Painting and Sculpture in New Jersey*. Princeton, 1964.

———, and Russell Burke. *American Still-Life Painting*. New York, 1971.

Goodrich, Lloyd. *Three Centuries of American Art*. New York, 1967.

Gottesman, Rita. *The Arts and Crafts in New York*, 3 vols. New York, 1938–1965.

Graves, Algeron. *A Dictionary of Artists Who Have Exhibited Works in the Principal London Exhibitions from 1760–1884*. London, 1884.

Groce, George C., and David H. Wallace. *The New-York Historical Society's Dictionary of Artists in America, 1564–1860*. New Haven and London, 1957.

Hagen, Oskar. *The Birth of the American Tradition in Art*. New York, 1940.

Howat, John K. *The Hudson River and its Painters*. New York, 1972.

Isham, Samuel. *A History of American Painting*. New York, 1905. Reprinted, with additions by Royal Cortissoz. New York, 1927. Revised edition, New York, 1968.

Keaveney, Sydney Starr. *American Painting: A Guide to Information Sources*. (Vol. I. Art and Architecture Information Guide series.) Detroit, 1974.

Larkin, Oliver W. *Art and Life in America*. New York, 1949. Rev. ed. New York, 1960.

Lee, Cuthbert. *Early American Portrait Painters: The Fourteen Principal Earliest Native-Born Painters*. New Haven, 1929.

Lester, Charles Edwards. *The Artists of America*. New York, 1846.

McCoubrey, John W. *American Tradition in Painting*. New York, 1963.

————, ed. *American Art 1700–1960. Sources and Documents*. Englewood Cliffs, New Jersey, 1965.

Morgan, John Hill. *Gilbert Stuart and His Pupils*. New York, 1939.

————, and Mantle Fielding. *The Life Portraits of Washington and Their Replicas*. Philadelphia, 1931.

Novak, Barbara. *American Painting of the Nineteenth Century: Realism, Idealism, and the American Experience*. New York, 1969.

Oliver, Andrew. *Portraits of John and Abigail Adams*. Cambridge, Massachusetts, 1967.

Prime, Alfred Cox. *The Arts and Crafts in Philadelphia, Maryland, and South Carolina, 1721–1785*. Topsfield, Massachusetts, 1929.

Prown, Jules David. *American Painting from Its Beginnings to the Armory Show*. 2 vols. Geneva, Switzerland, 1969.

Quimby, Ian M. G., ed. *American Painting to 1776, a Reappraisal*. Charlottesville, Virginia, 1971.

Richardson, Edgar Preston. *Painting in America: The Story of 450 Years*. New York, 1956. Reprinted. New York, 1965.

————. *A Short History of American Painting*. New York, 1963.

Sadik, Marvin. *Colonial and Federal Portraits at Bowdoin College*. Brunswick, Maine, 1966.

Schwartz, Marvin D. *The Meaning of Portraits: John Singleton Copley's American Portraits and Eighteenth Century Art Theory*. Unpublished Master's Thesis, University of Delaware, Newark, 1954. (Copy in the Frick Art Reference Library.)

Sellers, Charles Coleman. *Benjamin Franklin in Portraiture*. New Haven, 1962.

Sutton, Denys. *American Painting*. London, 1948.

Sweet, Frederick A. *The Hudson River School and the Early American Landscape Tradition*. Chicago, 1945.

Thieme, Ulrich, and Felix Becker. *Allgemeines Lexikon der bildenden Kuenstler*. Leipzig, 1907–.

Tuckerman, Henry T. *Book of the Artists: American Artist Life*. New York, 1867. New edition, ed. by James F. Carr. New York, 1966.

Waterhouse, Ellis K. *Painting in Britain 1500–1790*. Baltimore, 1958.

Whitehill, Walter Muir. *The Arts in Early American History*, with bibliography by Wendell D. Garrett and Jane D. Garrett. Chapel Hill, North Carolina, 1965.

Wilmerding, John, ed. *The Genius of American Painting*. New York, 1973.

Wright, Louis; George Tatum; John McCoubrey; and Robert Smith. *The Arts in America: The Colonial Period*. New York, 1966.

Sources Arranged by Artist

Ezra Ames

Bolton, Theodore, and Irwin F. Cortelyou. *Ezra Ames of Albany. Portrait Painter, Craftsman, Royal Arch Mason, Banker: 1768–1836 . . . and a Catalogue of His Works*. New York, 1955.

Cortelyou, Irwin F. "A Supplement to the Catalogue of Pictures by Ezra Ames of Albany." *The New-York Historical Society Quarterly* XLI (April 1957): 176–92.

DAB

Dunlap, William. *History*.

Henry Benbridge

DAB

Dunlap, William. *History*.

Hart, Charles Henry. "The Gordon Family: Painted by Henry Benbridge." *Art in America* VI (June 1918): 191–200.

Roberts, William. "An Early American Artist, Henry Benbridge." *Art in America* VI (February 1918): 96–101.

Rutledge, Anna Wells. "Henry Benbridge, 1743–1812?, American Portrait Painter." *American Collector* XVII (October 1948): 8–10 ff.; (November 1948): 9–11 ff.

Stewart, Robert G. *Henry Benbridge (1743–1812): American Portrait Painter*. Catalogue of exhibition at the National Portrait Gallery, Smithsonian Institution, Washington, D.C. 1971.

Louis-Nicolas Van Blarenberghe

Bénézit, Emmanuel. *Dictionnaire Critique.*

Decroux, M. Pierre. "Une Famille Lilloise de Miniaturistes: Les Van Blarenberghes." *Bulletin de la Commission Historique du Departement du Nord,* Tome XXX (1914): 140–48.

Player, Cyril. "The Van Blarenberghes, Painters to the Court of Lilliput, French Miniatures of Faultless Intricacy." *Antique Collector* IV (May 1933): 530–33.

Rice, Howard Crosby. *The American Campaigns of Rochambeau's Army, 1780, 1781, 1782, 1783.* Trans. and ed. by Howard C. Rice, Jr., and Anne S. K. Brown. 2 vols. Princeton, New Jersey, 1972. vol. II.

Thieme, Ulrich and Felix Becker. *Allgemeines Lexikon.*

Benjamin Blyth

Burroughs, Alan. *Limners and Likenesses.*

Cole, Ruth Townsend. "Limned by Blyth." *Antiques* LXIX (April 1956): 331–33.

Foote, Henry Wilder. "Benjamin Blyth of Salem: Eighteenth Century Artist." *Proceedings of the Massachusetts Historical Society* LXXI (October 1953–May 1957): 64–107.

Mather Brown

Coburn, Frederick W. "Mather Brown." *Art in America* XI (August 1923): 252–60.

DAB

Dunlap, William. *History.*

Evans, Dorinda. "Twenty-Six Drawings Attributed to Mather Brown." *The Burlington Magazine* CXIV (August 1972): 534–41.

Gay, Frederick Lewis. "Gawen and Mather Brown." *Proceedings of the Massachusetts Historical Society* XLVII (March 1914): 289–93.

Hart, Charles Henry. "Notes on Gawen Brown and His Son . . . Mather Brown." *Proceedings of the Massachusetts Historical Society* XLVII (November 1913): 32–34.

Lee, Cuthbert. *Early American Portrait Painters.*

Morgan, John Hill. *Gilbert Stuart and His Pupils.*

Park, Lawrence. "Mather Brown's 'Portrait of John Adams.'" *Proceedings of the Massachusetts Historical Society* LX (November 1917): 105–6.

Winthrop Chandler

Flexner, James Thomas. "Winthrop Chandler: An Eighteenth-Century Artisan Painter." *Magazine of Art* XL (November 1947): 274–78.

Little, Nina Fletcher. "Winthrop Chandler." *Art in America* XXXV (April 1947) : 77–168.

————. "Recently Discovered Paintings by Winthrop Chandler." *Art in America* XXXVI (April 1948) : 81–97.

John Singleton Copley

Amory, Martha Babcock. *The Domestic and Artistic Life of John Singleton Copley, R.A.* Boston, 1882.

Bayley, Frank W. *The Life and Works of John Singleton Copley.* Boston, 1915.

DAB

Dunlap, William. *History.*

Flexner, James Thomas. *John Singleton Copley.* Boston, 1948.

Frankenstein, Alfred and the editors of Time-Life books. *The World of John Singleton Copley: 1738–1815.* New York, 1970.

Letters and Papers of John Singleton Copley and Henry Pelham, 1739–1776. Edited by Charles Francis Adams, II; Guernsey Johnes; and Worthington Chauncey Ford. Massachusetts Historical Society Collections LXXI. Boston, 1914.

Parker, Barbara Neville, and Anne Bolling Wheeler. *John Singleton Copley: American Portraits in Oil, Pastel, and Miniature, with Biographical Sketches.* Boston, 1938.

Perkins, Augustus Thorndike. *A Sketch of the Life and a List of Some of the Works of John Singleton Copley.* Boston, 1873.

Prown, Jules David. *John Singleton Copley.* 2 vols. Cambridge, Massachusetts, 1966.

————. *John Singleton Copley.* Catalogue of Exhibition at the National Gallery of Art, Metropolitan Museum of Art, and the Museum of Fine Arts, Boston, 1965–1966.

Amos Doolittle

Beardsley, William A. "An Old New Haven Engraver and His Work; Amos Doolittle." *Papers of the New Haven Colony Historical Society* III (1914) : 132–50.

Barber, John W. and Lemuel S. Punderson. *History and Antiquities of New Haven, Connecticut.* New Haven, 1856.

DAB

Doolittle, William Frederick. *The Doolittle Family in America.* Cleveland, 1901–1908.

Dunlap, William. *History.*

Quimby, Ian M. G. "The Doolittle Engravings of the Battle of Lexington and Concord." *Winterthur Portfolio 4,* edited by Richard K. Doud, 83–108. Charlottesville, Virginia, 1968.

Joseph Siffred Duplessis

Belleudy, Jules. *J.-S. Duplessis, Peintre du Roi: 1725–1802.* Chartres, 1913.

Bénézit, Emmanuel. *Dictionnaire Critique.*

Thieme, Ulrich and Felix Becker. *Allgemeines Lexikon.*

Asher B. Durand

Barker, Virgil. *American Painting.*

Craven, Wayne. "Asher B. Durand's Career as an Engraver." *The American Art Journal* III (Spring 1971): 39–57.

DAB

Dunlap, William. *History.*

Durand, Asher B. "Letters on Landscape Painting." *The Crayon* I (January-June 1855): 1–2, 34–35, 66–67, 97–98, 145–46, 209–11, 273–75, 354–55; II (July-December 1855): 16–17.

Durand, John. *The Life and Times of A. B. Durand.* New York, 1894.

Flexner, James Thomas. *That Wilder Image.*

Howat, John K. *The Hudson River and its Painters.*

Lawall, David B. *A. B. Durand. 1796–1886.* Catalogue of exhibition at Montclair Art Museum, Montclair, New Jersey, 1971.

Novak, Barbara. *American Painting of the Nineteenth Century.*

Sherman, Frederic F. "Asher B. Durand as a Portrait Painter." *Art in America* XVIII (October 1930): 309–16.

Tuckerman, Henry T. *Book of the Artists.*

John Durand

Barker, Virgil. *American Painting.*

Dunlap, William. *History.*

Gottesman, Rita. *Arts and Crafts in New York.*

Thorne, Thomas. "America's Earliest Nude?" *William and Mary Quarterly,* 3d series, VI (1949): 565–68.

Ralph Earl

DAB

Dunlap, William. *History.*

Flexner, James Thomas. *The Light of Distant Skies.*

Goodrich, Laurence B. *Ralph Earl, Recorder for an Era.* Albany, 1967.

Goodrich, Lloyd. "Ralph Earl." *Magazine of Art* XXXIX (January 1946): 2–8.

Phillips, John Marshall. "Ralph Earl, Loyalist." *Art in America* XXXVII (October 1949) : 187–89.

Sawitzky, William. *Connecticut Portraits by Ralph Earl, 1751–1801.* Yale University Gallery of Fine Arts, New Haven, Connecticut, 1935.

———. *Ralph Earl, 1751–1801.* Catalogue of exhibition at the Whitney Museum of American Art, New York, and the Worcester Art Museum, Worcester, Massachusetts, 1945–46.

——— and Susan Sawitzky. "Two Letters from Ralph Earl with Notes on His English Period." *Worcester Art Museum Annual* VIII (1960) : 8–41.

Robert Feke

Barker, Virgil. *American Painting.*

Belknap, Waldron Phoenix, Jr. *American Colonial Painting, Materials for a History.*

Bolton, Theodore, and Harry L. Binsse. "Robert Feke, First Painter to Colonial Aristocracy." *The Antiquarian* XV (October 1930) : 32.

DAB

Dunlap, William. *History.*

Flexner, James Thomas. *First Flowers.*

Foote, Henry Wilder. *Robert Feke, Colonial Portrait Painter.* Cambridge, Massachusetts, 1930.

Goodrich, Lloyd. *Robert Feke.* Catalogue of exhibition at the Whitney Museum, New York, Heckscher Art Museum, New York, and Museum of Fine Arts, Boston, 1946.

Mooz, R. Peter. "The Philadelphia Story," in *American Painting to 1776: A Reappraisal,* ed. by Ian M. G. Quimby. Charlottesville, Virginia, 1971.

Poland, William Carey. "Robert Feke, the Early Newport Portrait Painter, and the Beginnings of Colonial Painting." *Rhode Island Historical Society Proceedings* 1907 : 73–96.

Benjamin Greenleaf

DAB

Lipman, Jean. "Benjamin Greenleaf, New England Limner." *Antiques* LII (September 1947) : 195–97.

Christian Gullager

Barker, Virgil. *American Painting.*

Dresser, Louisa. "Christian Gullager; An Introduction to His Life and Some Representative Examples of His Work." *Art in America* XXXVII (July 1949) : 105–79.

Dunlap, William. *History.*

Morgan, John Hill, and Mantle Fielding. *Life Portraits of Washington.*

John Hesselius

Bolton, Theodore, and George C. Groce, Jr. "John Hesselius: An Account of his Life and the First Catalogue of his Portraits." *Art Quarterly* II (Winter 1939): 77–91.

DAB

Doud, Richard K., ed. "John Hesselius, Maryland Limner." *Winterthur Portfolio* 5, 129–53. Charlottesville, Virginia, 1969. (based on unpublished Master's Thesis, University of Delaware, 1963).

Dunlap, William. *History.*

Sawitzky, William. "Further Notes on John Hesselius." *Art Quarterly* V (Autumn 1942): 340–41.

Jean Antoine Houdon

Arnason, H. H. *Sculpture by Houdon.* Catalogue of exhibition at the Worcester Art Museum, Worcester, Massachusetts, 1964.

Bénézit, Emmanuel. *Dictionnaire Critique.*

Chinard, Gilbert, ed. *Houdon in America: A Collection of Documents in the Jefferson Papers in the Library of Congress.* Baltimore, 1930.

Dunlap, William. *History.*

Giacometti, Georges. *La Vie et l'Oeuvre de Houdon.* Paris, 1929.

Hart, Charles Henry, and Edward Biddle. *Memoirs of the Life and Works of Jean Antoine Houdon, the Sculptor of Voltaire and of Washington.* Philadelphia, 1911.

Réau, Louis. *Houdon, Sa Vie et Son Oeuvre.* Paris, 1964.

Thieme, Ulrich, and Felix Becker. *Allgemeines Lexikon.*

Henry Inman

Bolton, Theodore. "Henry Inman, an Account of His Life and Work" and "Catalogue of the Paintings of Henry Inman." *Art Quarterly* III (Autumn 1940): 353–75 and Supplement, 401–18.

DAB

Dunlap, William. *History.*

Gerdts, William H. "Henry Inman in New Jersey." *Proceedings of the New Jersey Historical Society* 78 (July 1960): 178–87.

Isham, Samuel. *American Painting.*

Tuckerman, Henry T. *Book of the Artists.*

John Wesley Jarvis

Bolton, Theodore, and George C. Groce. "John Wesley Jarvis, an Account of His

Life and the First Catalogue of His Work." *Art Quarterly* I (Autumn 1938) : 299–321.

DAB

Dickson, Harold E. "The Jarvis Portrait of Thomas Paine." *The New-York Historical Society Quarterly* XXXIV (January 1950) : 4–11.

————. *John Wesley Jarvis: American Painter 1780–1840, With a Checklist of His Work*. New York, 1949.

Dunlap, William. *History*.

Isham, Samuel. *American Painting*.

Tuckerman, Henry T. *Book of the Artists*.

Matthew Harris Jouett

DAB

Dunlap, William. *History*.

Flexner, James Thomas. *The Light of Distant Skies*.

Floyd, William Barrow. *Jouett-Bush-Frazer: Early Kentucky Artists*. Lexington, 1968.

Jonas, Edward A. *Matthew Harris Jouett. Kentucky Portrait Painter (1787–1827)*. Louisville, 1938.

Martin, Mrs. William H. *Catalogue of All Known Paintings by Matthew Harris Jouett*. Louisville, 1939.

Morgan, John Hill. *Gilbert Stuart and His Pupils*.

Wilson, Samuel M. "Matthew Harris Jouett, Kentucky Portrait Painter; A Review." *The Filson Club History Quarterly* 13 (April 1939) : 75–96. "Additional Notes on Matthew H. Jouett" 14 (1940) : 1–16, 65–102.

Samuel F. B. Morse

Barker, Virgil. *American Painting*.

DAB

Dunlap, William. *History*.

Larkin, Oliver W. *Samuel F. B. Morse and American Democratic Art*, ed. by Oscar Handlin. Boston and Toronto, 1954.

Mabee, Carleton. *The American Leonardo. A Life of Samuel F. B. Morse*. New York, 1943.

Morse, Edward L., ed. *Samuel F. B. Morse: His Letters and Journals*. 2 vols. Boston and New York, 1914.

Prime, Samuel Irenaeus. *The Life of Samuel F. B. Morse, LL.D., Inventor of the Electro-Magnetic Recording Telegraph*. New York, 1875.

Wehle, Harry B. *Samuel F. B. Morse, American Painter*. Catalogue of exhibition at the Metropolitan Museum of Art, New York, 1932.

Reuben Moulthrop

Flexner, James Thomas. *The Light of Distant Skies.*

Sawitzky, William and Susan Sawitzky. "Portraits by Reuben Moulthrop." *New-York Historical Society Quarterly* XXXIX (October 1955): 385–404.

Thomas, Ralph W. "Reuben Moulthrop, 1763–1814." *The Connecticut Historical Society Bulletin* 21 (October 1956): 1–16.

Charles Willson Peale

DAB

Dunlap, William. *History.*

Elam, Charles H., ed. *The Peale Family. Three Generations of American Artists.* Catalogue of exhibition at Detroit Institute of Arts and Wayne State University, Detroit, 1967.

Flexner, James Thomas. *America's Old Masters.*

Pennsylvania Academy of the Fine Arts. *Catalogue of an Exhibition of Portraits by Charles Willson Peale and James Peale and Rembrandt Peale.* Philadelphia, 1923.

Sellers, Charles Coleman. *Charles Willson Peale.* 2 vols. Philadelphia, 1947.

———. *Charles Willson Peale.* New York, 1969.

———. *Portraits and Miniatures by Charles Willson Peale.* Philadelphia, 1952.

James Peale

Baur, John I. H. "The Peales and the Development of American Still Life." *Art Quarterly* III (Winter 1940): 81–92.

Brockway, Jean Lambert. "The Miniatures of James Peale." *Antiques* XXII (October 1932): 130–34.

DAB

Dunlap, William. *History.*

Elam, Charles H., ed. *The Peale Family. Three Generations of American Artists.* Catalogue of exhibition at Detroit Institute of Arts and Wayne State University, Detroit, 1967.

Gerdts, William H., and Russell Burke. *American Still Life Painting.*

Lee, Cuthbert. *Early American Portrait Painters.*

Pennsylvania Academy of the Fine Arts. *Catalogue of an Exhibition of Portraits by Charles Willson Peale and James Peale and Rembrandt Peale.* Philadelphia, 1923.

Sellers, Charles Coleman. *Charles Willson Peale.* New York, 1969.

Sherman, Frederic. "James Peale's Portrait Miniatures." *Art in America* XIX (August 1931): 208–21.

————. "Two Recently Discovered Portraits in Oil by James Peale." *Art in America* XXI (October 1933) : 114–21.

Rembrandt Peale

DAB

Dunlap, William. *History.*

Elam, Charles H., ed. *The Peale Family. Three Generations of American Artists.* Catalogue of exhibition at Detroit Institute of Arts and Wayne State University, Detroit, 1967.

Lester, Charles Edwards. *The Artists of America.*

Mahey, John A. "The Studio of Rembrandt Peale." *American Art Journal* I (Fall 1969) : 20–40.

Peale, Rembrandt. "Reminiscences." *The Crayon* I (1854) : 22; II (1855) : 127; III (1856) : 5.

Pennsylvania Academy of the Fine Arts. *Catalogue of an Exhibition of Portraits by Charles Willson Peale and James Peale and Rembrandt Peale.* Philadelphia, 1923.

Sellers, Charles Coleman. *Charles Willson Peale.* Philadelphia, 1947.

————. *Charles Willson Peale.* New York, 1969.

Charles B. J. Févret de Saint-Mémin

Bolton, Theodore. "Saint-Mémin's Crayon Portraits." *Art in America* IX (June 1921) : 160–67.

Catalogue of Engraved Portraits by Févret de Saint-Mémin 1770–1852, in the Permanent Collection of the Corcoran Gallery of Art, Washington, D.C. Undated.

DAB

Dexter, Elias, ed. *The St.-Mémin Collection of Portraits, Consisting of Seven Hundred and Sixty Medallion Portraits Principally of Distinguished Americans, Photographed by J. Gurney and Son, of New York.* New York, 1862.

Guignard, Philippe. *Notices Historique sur la Vie et les Traveaux de M. Févret de Saint-Mémin.* Dijon, 1853.

Lockwood, Luke Vincent. "The St.-Mémin Indian Portraits." *New-York Historical Society Quarterly* XII (April 1928) : 3–26.

Norfleet, Fillmore. *Saint-Mémin in Virginia: Portraits and Biographies.* Richmond, Virginia, 1942.

Rice, Howard C., Jr. "An Album of Saint-Mémin Portraits." *Princeton University Library Chronicle* XIII (Autumn 1951) : 23–31.

Henry Sargent

Addison, Julia De Wolf. "Henry Sargent, a Boston Painter." *Art in America* XVII (October 1929) : 279–84.

DAB

Dunlap, William. *History*.

Flexner, James Thomas. *The Light of Distant Skies*.

Sargent, Emma Worcester, and Charles Sprague Sargent. *Epes Sargent and His Descendants*. Boston, 1923.

Joseph Steward

Dunlap, William. *History*.

French, Henry W. *Art and Artists in Connecticut*. Boston, 1879.

"Joseph Steward and the Hartford Museum." *Connecticut Historical Society Bulletin* 18 (January-April 1953): 1–16.

Gilbert Stuart

DAB

Dunlap, William. *History*.

Fielding, Mantle. *Gilbert Stuart's Portraits of George Washington*. Philadelphia, 1923.

Flexner, James Thomas. *Gilbert Stuart; A Great Life in Brief*. New York, 1955.

Howat, John K. "A Young Man Impatient to Distinguish Himself: the Vicomte de Noailles as Portrayed by Gilbert Stuart." *The Metropolitan Museum of Art Bulletin* 29 (March 1971): 327–40.

Mason, George C. *The Life and Works of Gilbert Stuart*. New York, 1879.

Morgan, John Hill. *Gilbert Stuart and His Pupils*.

Mount, Charles Merrill. *Gilbert Stuart: A Biography*. New York, 1964.

Park, Lawrence. *Gilbert Stuart, An Illustrated Descriptive List of His Works*, ed. by William Sawitzky. 4 vols. New York, 1926.

Whitley, William T. *Gilbert Stuart*. Cambridge, Massachusetts, 1932.

Thomas Sully

Barker, Virgil. *American Painting*.

Biddle, Edward, and Mantle Fielding. *The Life and Works of Thomas Sully: 1783–1872*. Philadelphia, 1921.

DAB

Dunlap, William. *History*.

Flexner, James Thomas. *The Light of Distant Skies*.

Hart, Charles Henry, ed. *A Register of Portraits by Thomas Sully, 1801–1871*. Philadelphia, 1909.

Isham, Samuel. *A History of American Painting.*

Ormsbee, Thomas H. "The Sully Portraits at West Point." *American Collector* IX (September 1940) : 6 ff.

Pennsylvania Academy of the Fine Arts. *Catalogue of the Memorial Exhibition of Portraits by Thomas Sully.* Philadelphia, 1922.

Sully, Thomas. *Hints to Young Painters.* Philadelphia, 1873; Reprinted, New York, 1965.

————. "Recollections of an Old Painter." *Hours at Home* X (1873) : 69–74.

Tuckerman, Henry. *Book of the Artists.*

Jeremiah Theus

Burroughs, Alan. *Limners and Likenesses.*

DAB

Dunlap, William. *History.*

Dresser, Louisa. "Jeremiah Theus: Notes on the Date and Place of His Birth and Two Problem Portraits Signed by Him." *Worcester Art Museum Annual* VI (1968) : 43–44.

Flexner, James Thomas. *First Flowers.*

Middleton, Margaret Simons. *Jeremiah Theus: Colonial Artist of Charles Town.* Columbia, South Carolina, 1953.

John Trumbull

DAB

Dunlap, William. *History.*

Jaffe, Irma B. *John Trumbull: Patriot–Artist of the American Revolution.* Boston, 1975.

Sizer, Theodore, ed. *The Autobiography of Colonel John Trumbull, Patriot-Artist, 1756–1843.* New Haven, 1953.

————. *The Works of Colonel John Trumbull, Artist of the American Revolution.* Rev. ed., New Haven, 1967.

[Trumbull, John]. *Autobiography, Reminiscences and Letters of John Trumbull, from 1756 to 1841.* New York, 1841.

Wadsworth Atheneum. *John Trumbull, Painter-Patriot; an Exhibition Organized to Honor the Bicentennial of the Artist's Birth.* Hartford, Connecticut, 1956.

John Vanderlyn

DAB

Dunlap, William. *History.*

Edgerton, Samuel Y., Jr. "The Murder of Jane McCrea: The Tragedy of an

American 'Tableau d'Histoire.' " *The Art Bulletin* XLVII (December 1965) : 481–92.

Gardner, Albert Ten Eyck, and Laurence J. Majewski. *John Vanderlyn's Panoramic View of the Palace and the Gardens of Versailles.* New York, 1956.

Gosman, Robert. "Biographical Sketch of John Vanderlyn, Artist." Undated ms. in the R. R. Hoes Collection, Senate House Museum, Kingston, New York. Typed copy at the New-York Historical Society, New York.

Hatch, John Davis, Jr. "The First American Artist to Study in Paris, John Vanderlyn." *International Congress on the History of Art.* Paris, 1959.

Lindsay, Kenneth C. *The Works of John Vanderlyn: From Tammany to the Capitol.* Catalogue of an exhibition at the University Art Gallery, State University of New York at Binghamton, 1970.

Kip, William I. "Recollections of John Vanderlyn." *Atlantic Monthly* XIX (1867) : 228–35.

Miller, Lillian Beresnack. "John Vanderlyn and the Business of Art." *New York History* XXXII (January 1951) : 33–44.

Mondello, Salvatore. "John Vanderlyn." *New-York Historical Society Quarterly* LII (April 1968) : 161–83.

Pritchard, Kathleen H. "John Vanderlyn and the Massacre of Jane McCrea." *Art Quarterly* XII (Autumn 1949) : 360–66.

Review of the Biographical Sketch of John Vanderlyn, published by William Dunlap in his "History of the Arts of Design" with Some Additional Notes, respecting Mr. Vanderlyn, as an artist. By a Friend of the Artist, New York, 1838.

Schoonmaker, Marius. *John Vanderlyn, Artist, 1775–1852.* Kingston, New York, 1950.

Sitwell, Dr. John E. *The History of the Burr Portraits. Their Origin, Their Disposal and Their Reassemblage.* Privately printed, 1928.

Benjamin West

DAB

Dickason, David H. "Benjamin West on William Williams: A Previously Unpublished Letter." *Winterthur Portfolio 6,* ed. by Richard K. Doud and Ian M. G. Quimby: 125–33. Charlottesville, Virginia, 1970.

Dunlap, William. *History.*

Erffa, Helmut von. "Benjamin West at the Height of His Career." *American Art Journal* I (Spring 1969) : 19–33.

———. "Benjamin West: The Early Years in London." *American Art Journal* V (November 1973) : 4–14.

Evans, Grose. *Benjamin West and the Taste of His Times.* Carbondale, Illinois, 1959.

Farington, John. *The Farington Diary,* ed. by James Grieg. 8 vols. London, 1923–28.

Flexner, James Thomas. *America's Old Masters* (1967). (Contains reprint of Flexner's article, "Benjamin West's American Neo-Classicism," which appeared in *New-York Historical Society Quarterly* XXXVI [January 1952]: 4–42).

————. *First Flowers.*

————. *The Light of Distant Skies.*

Forster-Hahn, F. "Sources of true taste: Benjamin West's instructions to a Young Painter for His Studies in Italy." *Journal of the Warburg and Courtauld Institutes* 30 (1967): 367–82.

Galt, John. *The Life, Studies and Works of Benjamin West.* 2 vols. London, 1820.

Hirsch, Richard. *The World of Benjamin West.* Catalogue of exhibition at the Allentown Art Museum, Allentown, Pennsylvania, 1962.

Kraemer, Ruth S. *Drawings by Benjamin West and His Son Raphael Lamar West.* New York, 1975.

Marks, Arthur S. "Benjamin West and the American Revolution." *American Art Journal* VI (November 1974): 15–35.

Mitchell, Charles H. "Benjamin West's 'Death of General Wolfe.'" *Journal of the Warburg and Courtauld Institutes* VII (1944): 20–33.

Philadelphia Museum of Art. *Catalogue of Benjamin West Exhibition.* Philadelphia, 1938.

Sawitzky, William. "The American Work of Benjamin West." *Pennsylvania Magazine of History and Biography* LXII (1938): 433–62.

William Williams

Dickason, David H. "Benjamin West on William Williams: A Previously Unpublished Letter." *Winterthur Portfolio 6*, ed. by Richard K. Doud and Ian M. G. Quimby: 125–33. Charlottesville, Virginia, 1970.

————. *William Williams. Novelist and Painter of Colonial America, 1727–1791.* Bloomington, Indiana, 1969.

Dunlap, William. *History.*

Flexner, James Thomas. "The Amazing William Williams." *Magazine of Art* XXXVII (November 1944): 242.

————. "Benjamin West's American Neo-Classicism with Documents on West and William Williams." *New-York Historical Society Quarterly* XXXVI (January 1952): 5–41.

Gerdts, William H. "William Williams: New American Discoveries." *Winterthur Portfolio 4*, ed. by Richard K. Doud: 159–67. Charlottesville, Virginia, 1968.

Richardson, Edgar Preston. "William Williams—a Dissenting Opinion." *American Art Journal* IV (Spring 1972): 5–23.

Sawitzky, William. "William Williams, First Instructor of Benjamin West." *Antiques* XXXI (1937): 240–42.

————. "Further Light on William Williams." *New-York Historical Society Quarterly* XXV (1941): 101–12.

[Williams, William]. *Mr. Penrose. The Journal of Penrose, Seaman.* Intro. by David H. Dickason. Bloomington, Indiana, 1969. (Original version published in 1815 as the *Journal of Llewellin Penrose, a Seaman*).

Joseph Wright

DAB

Dunlap, William. *History.*

Lee, Cuthbert. *Early American Portrait Painters.*

Kimball, Sidney F. "Joseph Wright and His Portraits of Washington." *Antiques* XV (May 1929): 376–82; XVII (January 1930): 35–39.

Morgan, John Hill, and Mantle Fielding. *The Life Portraits of Washington.*

Journal I (Spring 1969): 19–33.

———. "Benjamin West: The Early Years in London." *American Art Journal* V (November 1973): 4–14.

Evans, Grose. *Benjamin West and the Taste of His Times.* Carbondale, Illinois, 1959.

Farington, John. *The Farington Diary*, ed. by James Grieg. 8 vols. London, 1923–28.

Flexner, James Thomas. *America's Old Masters* (1967). (Contains reprint of Flexner's article, "Benjamin West's American Neo-Classicism," which appeared in *New-York Historical Society Quarterly* XXXVI [January 1952]: 4–42).

———. *First Flowers.*

———. *The Light of Distant Skies.*

Forster-Hahn, F. "Sources of true taste: Benjamin West's instructions to a Young Painter for His Studies in Italy." *Journal of the Warburg and Courtauld Institutes* 30 (1967): 367–82.

Galt, John. *The Life, Studies and Works of Benjamin West.* 2 vols. London, 1820.

Hirsch, Richard. *The World of Benjamin West.* Catalogue of exhibition at the Allentown Art Museum, Allentown, Pennsylvania, 1962.

Kraemer, Ruth S. *Drawings by Benjamin West and His Son Raphael Lamar West.* New York, 1975.

Marks, Arthur S. "Benjamin West and the American Revolution." *American Art Journal* VI (November 1974): 15–35.

Mitchell, Charles H. "Benjamin West's 'Death of General Wolfe.' " *Journal of the Warburg and Courtauld Institutes* VII (1944): 20–33.

Philadelphia Museum of Art. *Catalogue of Benjamin West Exhibition.* Philadelphia, 1938.

Sawitzky, William. "The American Work of Benjamin West." *Pennsylvania Magazine of History and Biography* LXII (1938): 433–62.

Index